Wonder Woman

Library of Gender and Popular Culture

From *Mad Men* to gaming culture, performance art to steampunk fashion, the presentation and representation of gender continues to saturate popular media. This new series seeks to explore the intersection of gender and popular culture, engaging with a variety of texts – drawn primarily from Art, Fashion, TV, Cinema, Cultural Studies and Media Studies – as a way of considering various models for understanding the complementary relationship between 'gender identities' and 'popular culture'. By considering race, ethnicity, class, and sexual identities across a range of cultural forms, each book in the series adopts a critical stance towards issues surrounding the development of gender identities and popular and mass cultural 'products'.

For further information or enquiries, please contact the library series editors:

Claire Nally: claire.nally@northumbria.ac.uk
Angela Smith: angela.smith@sunderland.ac.uk

Advisory Board:

Dr Kate Ames, Central Queensland University, Australia

Prof Leslie Heywood, Binghampton University, USA

Dr Michael Higgins, Strathclyde University, UK

Prof Åsa Kroon, Örebro University, Sweden

Dr Niall Richardson, Sussex University, UK

Dr Jacki Willson, Central St Martins, University of Arts London, UK

**Library of Gender
& Popular Culture**

Published and forthcoming titles:

*The Aesthetics of Camp: Post-Queer Gender and
 Popular Culture*
By Anna Malinowska

*Ageing Femininity on Screen: The Older Woman
 in Contemporary Cinema*
By Niall Richardson

*All-American TV Crime Drama: Feminism and Iden-
 tity Politics in Law and Order: Special Victims Unit*
By Sujata Moorti and Lisa Cuklanz

*Bad Girls, Dirty Bodies: Sex, Performance and
 Safe Femininity*
By Gemma Commane

Beyoncé: Celebrity Feminism in the Age of Social Media
By Kirsty Fairclough-Isaacs

*Conflicting Masculinities: Men in Television
 Period Drama*
By Katherine Byrne, Julie Anne Taddeo and
James Leggott (Eds)

*Fat on Film: Gender, Race and Body Size in
 Contemporary Hollywood Cinema*
By Barbara Plotz

*Fathers on Film: Paternity and Masculinity in
 1990s Hollywood*
By Katie Barnett

*Film Bodies: Queer Feminist Encounters with
 Gender and Sexuality in Cinema*
By Katharina Lindner

*Gay Pornography: Representations of Sexuality
 and Masculinity*
By John Mercer

*Gender and Austerity in Popular Culture:
 Femininity, Masculinity and Recession in Film
 and Television*
By Helen Davies and Claire O'Callaghan (Eds)

*The Gendered Motorcycle: Representations in
 Society, Media and Popular Culture*
By Esperanza Miyake

*Gendering History on Screen: Women
 Filmmakers and Historical Films*
By Julia Erhart

*Girls Like This, Boys Like That: The Reproduction
 of Gender in Contemporary Youth Cultures*
By Victoria Cann

*The Gypsy Woman: Representations in Literature
 and Visual Culture*
By Jodie Matthews

Love Wars: Television Romantic Comedy
By Mary Irwin

*Masculinity in Contemporary Science Fiction
 Cinema: Cyborgs, Troopers and Other Men of
 the Future*
By Marianne Kac-Vergne

*Moving to the Mainstream: Women On and Off
 Screen in Television and Film*
By Marianne Kac-Vergne and Julie Assouly
(Eds)

*Paradoxical Pleasures: Female Submission in
 Popular and Erotic Fiction*
By Anna Watz

*Positive Images: Gay Men and HIV/AIDS in the
 Culture of 'Post-Crisis'*
By Dion Kagan

*Queer Horror Film and Television: Sexuality and
 Masculinity at the Margins*
By Darren Elliott-Smith

*Queer Sexualities in Early Film: Cinema and
 Male-Male Intimacy*
By Shane Brown

Steampunk: Gender and the Neo-Victorian
By Claire Nally

*Gender and Early Television: Mapping Women's
 Role in Emerging US and British Media,
 1850–1950*
By Rosie White

*Television, Technology and Gender: New
 Platforms and New Audiences*
By Sarah Arnold

*Tweenhood: Femininity and Celebrity in Tween
 Popular Culture*
By Melanie Kennedy

*Women Who Kill: Gender and Sexuality in Film
 and Series of the Post-Feminist Era*
By David Roche and Cristelle Maury (Eds)

*Young Women, Girls and Postfeminism in
 Contemporary British Film*
By Sarah Hill

Wonder Woman
The Female Body and Popular Culture

Joan Ormrod

BLOOMSBURY ACADEMIC
LONDON • NEW YORK • OXFORD • NEW DELHI • SYDNEY

BLOOMSBURY ACADEMIC
Bloomsbury Publishing Plc
50 Bedford Square, London, WC1B 3DP, UK
1385 Broadway, New York, NY 10018, USA

BLOOMSBURY, BLOOMSBURY ACADEMIC and the Diana logo are
trademarks of Bloomsbury Publishing Plc

First published in Great Britain 2020

ISBN: HB: 978-1-7883-1411-4
 ePDF: 978-1-7867-3581-2
 eBook: 978-1-7867-2581-3

Typeset by RefineCatch Limited, Bungay, Suffolk
Printed and bound in Great Britain

To find out more about our authors and books visit www.bloomsbury.com and
sign up for our newsletters

*For all the Wonder Women in my life, principally
my mother who is a fantastic role model*

Contents

Series Editors' Foreword

Body image, as many books in this library show, is central to the discussion of gender and sexuality. In recent years, this debate has often centred around the supposed binaries of brains or beauty for women, implicitly rejecting the idea that the two things are not mutually exclusive.

Wonder Woman is a character who has been around since she first appeared in comics in 1941, in a world troubled by its second globalized war in a generation. She was represented in a well-known TV series in the 1970s and, most recently, in a film by Patty Jenkins in 2017. She was even announced as an Honorary Ambassador for the United Nations in the area of girls' empowerment in 2016, to the derision of many feminists who argued that her original message of female empowerment in a world of masculine warfare had been lost in the sexualization of the white female body of popular culture. The UN bowed to the weight of argument and retracted its decision. However, as Ormrod shows in this book, the character of Wonder Woman is not the one-dimensional, beautiful, white, sexualized woman of popular image, but is in fact multidimensional. In a series of arguments based around representations of Wonder Woman, Ormrod suggests that the female action hero can in fact be many things without excluding what is white and what is deemed to be beautiful to a particular gaze. As such, this study intersects with others in the Library that show how body image is multifaceted and also open to wider forces in society.

Theorising gaze is a common theme in many of the books in this Library, and here Ormrod is able to engage in an historical argument around this, focusing on the character of Wonder Woman. Consciously clothed in the American flag, Wonder Woman represents a form of American national identity. This costume design is something Ormrod explores in some detail, charting the historical and cultural shifts that influence the clothing of both Wonder Woman and her sometime alter

ego, Diana Prince. However, as an Amazonian, she is also symbolic of all-female relationships. This is something Ormrod offers a tantalising glimpse of in this book, with particular insight into the ways in which different historical periods have chosen to interpret this aspect of the character. As other books in this Library suggest, gender and sexuality are constantly in a state of flux, with the focus here being the 75 years during which the Wonder Woman character has been in popular culture.

Angela Smith and Claire Nally

Acknowledgements

In researching and writing this book, I am indebted to the following people: Roger Sabin and David Huxley, for advising on the proposal and their support throughout; Ewa Mazierska, Robert Weiner, Valentino Zullo for reading, support and wonderful comments on the drafts; and Rowena Murray, for her advice on the final chapter.

An earlier version of Chapter 2 can be found in *The Ages of Wonder Woman: Essays on the Amazon Princess in Changing Times* © 2014 Edited by Joseph J. Darowski by permission of McFarland & Company, Inc., Box 611, Jefferson NC 28640. www.mcfarlandbooks.com

An earlier version of Chapter 4 can be found in *The Journal of Graphic Novels and Comics*, 2018, 9(6) pp. 540–554 by permission of Routledge. https://www.tandfonline.com/toc/rcom20/current

Introduction

Wonder Woman and the Body in Popular Culture

On 24 August 2017, director James Cameron prompted controversy with his opinion of Patty Jenkins's *Wonder Woman* film in an interview with the *Guardian* newspaper:

> All of the self-congratulatory back-patting Hollywood's been doing over Wonder Woman has been so misguided. She's an objectified icon, and it's just male Hollywood doing the same old thing! I'm not saying I didn't like the movie but, to me, it's a step backwards. Sarah Connor was not a beauty icon. She was strong, she was troubled, she was a terrible mother, and she earned the respect of the audience through pure grit.[1]

The statement prompted a furious response from fans who attacked Cameron's films and his personal life. However, Cameron was correct – to a point – in talking about the need for the fantasy heroine to be more than an objectified icon. His description of Wonder Woman as no more than an objectified icon was misguided but one held by a large percentage of people. For instance, on her 75th anniversary on 21 October 2016, Wonder Woman was appointed United Nations Honorary Ambassador for girls' empowerment. This decision attracted criticism by UN staff who set up an online petition attracting 45,020 signatures calling for the decision to be reversed. They rationalized their protest thus: 'Although the original creators may have intended Wonder Woman to represent a strong and independent 'warrior' woman with a feminist message, the reality is that the character's current iteration is that of a large breasted, white woman of impossible proportions, scantily clad in a shimmery, thigh-baring body suit.'[2]

Despite opposition by Wonder Woman fans, on 16 December 2016 the UN revoked their decision. Neither the UN staff nor Cameron looked at whether a woman cannot be both beautiful and a gritty heroine, or even that there might be a different model for heroism beyond gritty.[3] This point was made by Jenkins, who tweeted in response to Cameron: 'if women have to always be hard, tough and troubled to be strong, and we aren't free to be multidimensional or celebrate an icon of women everywhere because she is attractive and loving, then we haven't come very far have we'.[4]

It does prompt the question: why cannot female heroes be multidimensional? What is at stake in analysing them through debates about objectification? If female action heroes can only be regarded through such debates, then is it surprising that discussion, in academia and wider culture, continually returns to gender and sex? These examples, which speak from a lack of knowledge of the character and all she stands for, raise a contradiction at the heart of Wonder Woman's creation and representation. Both revolve around her sexualized representation and highlight the contradictory nature of the character and the ways her body is represented that seem out of tune with her feminist message.

This book incorporates Wonder Woman's cultural construction with a focus on mainly female bodies in several decades of comic and other media adaptations, to identify how and why she represents such diverse facades to the world. The book spans key stories, mainly in comic books, and each chapter deals with specific decades, from her appearance in 1941 to the present. My aim is to illustrate how comics have responded to changes in cultural perceptions and constructions of female bodies since the early 1940s and, through this, to determine the journey made by women in Western culture in the past seventy years.

The superhero genre is a genre about bodies and their representation and it acts as a metaphor for how we idealize certain types of bodies in wider culture. The idealized body is a fluid concept, for it changes from era to era. For instance, the Superman of the 1960s has more bulk and musculature, and is older than the Superman of the twenty-first century.

However, where male heroes are defined by their musculature, female characters are often defined by gender-specific elements – breasts, waists, hair. As illustrated in the examples above, this can present a paradox between regarding the superheroine as an icon for empowerment or an object of sexualized disempowerment. Wonder Woman presents such a paradox: on the one hand a fetishized sex object, on the other an empowering feminist. In an impassioned argument, Carolyn Cocca states that such representations matter: 'You are more likely to imagine yourself as a hero if you see yourself represented as a hero [...] Marginalized groups have been forced to "cross-identify" with those different from them while dominant groups have not.'[5] The female, according to Cocca, must either identify with media models of female empowerment or cross-identify with the saturation of powerful male heroes on offer. Cocca has a point. Thinking of Wonder Woman, she is relatively unknown through her comic but well known in popular culture. She can be regarded as a 'mobile signifier', well known in broader culture but not through her original stories.[6] Part of the reason she is unknown is that *Wonder Woman* was rarely adapted through media texts until Patty Jenkins's 2017 film. Until then, *Wonder Woman* was known mainly through a television series starring Lynda Carter (1975–79) and in popular culture, where she was encountered through fantasy dress-up, pornography and centrefolds, on the one hand, and, on the other, as an empowering figure for young girls and underrepresented groups such as women and LGBTQIA (lesbian, gay, bisexual, transgender, queer or questioning, intersex, and asexual or allied).[7] Despite her inspirational qualities, Wonder Woman is still regarded as a sexually objectified character whose body is under constant debate. She is, as Jeffery Brown argues, 'overburdened as both a symbol of feminist agency in a genre rooted in masculine power fantasies and as a sexual fetish in visually oriented mediums that continue to present women as erotic ideals above all else'.[8]

* * *

The sexualization of female heroes is an ongoing debate in superhero research and fandom. This goes back to the early superhero comics and the superhero paradigm, Superman, whose costume was modelled on the circus strongman costume, designed to display musculature. The superhero body is clothed in a skin-tight costume that, in most cases, is little more than a costume drawn over a nude figure. The muscular male and the sexual female bodies were products of the overlapping media and comic book industries, comic book industry distribution, creative practices and fandoms. Most focused on male interests for assumed male audiences.

Creators, for instance, were predominantly young men and, as comics progressed through the twentieth and into the twenty-first century, some fans became creators who continued or exaggerated previous art practices and styles.

The critique or focus on the sexualized representation of heroines, particularly Wonder Woman, has been argued many times.[9] This is not my strategy. Rather than critique the disempowered female body, I explore how the female body is culturally and philosophically constructed using a discursive analysis. This was argued in the past by researchers such as Mitra Emad, who used Benedict Anderson's work on the imaginary construction of the nation, focusing on four points in American history and culture – the 1940s, 1950s, 1970s and 1980s – to argue that Wonder Woman's body reflected the cultural mores of these times in relation to her occupation of the private and the public sphere.[10] For instance, in the 1940s, Wonder Woman, like many women joining the war effort, became part of the public sphere but had to conform to traditional female roles of subordination to masculine authority. Dawn Heinecken examined three characters from 1990s television and observed that where violence was externalized on the male body, it was internalized on the female body.[11] I argued that a somatic approach was viable, using the bad girl comics of the 1990s as a case study.[12] The importance of emotion to female heroism was noted by both Heinecken and Jennifer Stuller.[13] Stuller, like Cocca, was concerned about the ways female heroism was represented, claiming that superheroines 'teach us

about our socially appropriate roles, how we fit into our communities, and about our human potential [...]'.[14] Stuller proposed that when we consider female heroism, the male hero myth of redemption through violence is an ineffective model as the female hero's journey is based on love. She argues that love and the family are empowering in certain female hero narratives.[15] By family, Stuller means the supportive group who often gather around, and are inspired by, the female hero.

The supportive and inspirational role of the heroine is built into Wonder Woman's origin and early stories. Her creator, William Moulton Marston,[16] suggested that his heroine would redeem through love, which, he argued, was a specific female quality and could save humanity from war. In his version of *Wonder Woman*, love was not a weakness but a powerful force for redemption. Marston, however, worked on the basis of essentialized gendered identities, since challenged by theorists such as Judith Butler.[17]

This analysis contextualizes the body over several eras from the 1940s as culturally defined, a phenomenological and a social object. The analyses begin from how bodies are represented in the comics, identifying how they are informed by discourses circulating in specific eras. Issues that will be analysed include the markers of identity on the body, such as ethnicity, race, gender and ideas of beauty, and issues concerning the superhero genre, such as the secret identity, costume and masks. The final chapter departs from this model to engage with Wonder Woman within her broader media and cultural compass. In this chapter, the impact of fandom through social media and promotional culture is explored using Thornton's notion of subcultural capital to compare Jenkins's film with the television series starring Lynda Carter.[18]

This chapter begins by examining Wonder Woman's origins and her ideological construction within the context of her first comics in the early 1940s. Her creator William Marston's aims in creating the character, aided by several strong women in his life, laid the foundations for recurring tropes such as her gendered, racial and ethnic identities up to the present. The chapter continues by analysing the various

somatic tropes in *Wonder Woman* that impact on the later chapters of the book.

Beginnings

Wonder Woman was published at a pivotal moment for America, as it was in the same month, December 1941, that Pearl Harbor was attacked by the Japanese, and America entered the Second World War. Characters in the superhero genre, born only three years earlier with the advent of Superman, were already conscripted into the war effort and fought the Axis powers on the battlefront and their agents inside and outside of America. Wonder Woman was no different from her male counterparts. The first Wonder Woman story, recounting her origin, was not even signalled on the cover, but tucked away at the back of *All-Star Comics* 8, December 1941. Wonder Woman featured on the cover and headlined the first issue of *Sensation Comics* in January 1942.

By summer 1942, her signature comic and newspaper strips were published. Comics in the 1940s were distributed and sold on newspaper stands; sales were approximately 25 million to 40 million per month and most comics featured superheroes.[19] Readership was equally male/female and Wonder Woman's popularity was robust enough for her to acquire her own title within six months of first publication.[20] In an era when comics were selling in the millions, her sales figures may have been six figures or higher.[21] Her coverage was given a more general basis when she also starred in her own newspaper strip.

Wonder Woman's origin is told in three separate stories in *All-Star Comics*, *Sensation Comics* and *Wonder Woman*,[22] and is rooted in Greek and Roman myth. She is a princess of the Amazons, daughter of Queen Hippolyta.[23] She comes to man's world to teach and inspire humanity in the ways of love and peace. Wonder Woman's story includes recurring themes of feminism, sexuality, ethnicity, Amazons, magic, science, the Greek gods, immigration and war. It also reflects earlier myths and fairy tales such as Pygmalion and Galatea, Sleeping Beauty, the biblical

creation myth and Samson. The story goes that in ancient times the earth was ruled by Ares, God of War (hereafter Mars) and Aphrodite, Goddess of love and beauty. Under Mars' rule women were mistreated by men, 'sold as slaves – they were cheaper than cattle'.[24] To counter this abuse, Aphrodite created a race of strong, beautiful women, the Amazons, from clay and made Hippolyta their queen. Hippolyta was unconquerable as long as she wore Aphrodite's magic girdle, the source of her power. The Amazons built a marvellous city that seemed inviolable until attacked by Hercules, an agent of Mars. Hercules defeated Hippolyta, appealing to her vanity, and stole her magic girdle and the strength bestowed upon her by Aphrodite. He and his men enslaved the Amazons. Hippolyta prayed to Aphrodite, who returned her strength, and she defeated Hercules. Led by Aphrodite, the Amazons retreated to a haven, Paradise Island, where they built 'a splendid city which no man may enter – a paradise for women only'.[25] The Amazons' disobedience did not go unpunished. Aphrodite ordered them to wear the manacles that Hercules' men shackled to their wrists, 'to teach you the folly of submitting to men's domination'.[26] The manacles became the bracelets of submission. If they were taken off the Amazon became a berserker, imitating man's violence, bent only on destruction.

In this all-female society, there are no children, but Hippolyta carved a statue of a female child and Aphrodite gave the statue life, naming it Diana.[27] Diana quickly demonstrated her superiority to her sisters in her strength and speed. At three she pulled up a tree by its roots, at five she raced deer through the forest. The Amazons commented: 'Already our little princess has the strength of Hercules!', 'The queen's child is swifter than Mercury!'[28] At sixteen Diana was inducted into the Amazon sisterhood, receiving her bracelets of submission and drinking from the Fountain of Eternal Youth, which kept the Amazons forever young and beautiful.

The Amazons' self-imposed exile was interrupted when a plane piloted by Steve Trevor, an American airman, crashed into the sea off Paradise Island. Diana fell in love with him, inventing a purple healing ray to save his life, and nursed him back to health. Aphrodite decided

that Man's world needed Amazon values to inspire peace; consequently she ordered Hippolyta to select the strongest Amazon to return Trevor to America and bring Amazon values to Man's world. Hippolyta declared a contest to choose the Amazon who would take him back and Diana, in disguise, won. Although Hippolyta was horrified, she gave Diana a costume inspired by the American flag and later a golden lasso that impelled those bound to submit to the will of those who have bound them. Once in America, Diana disguised herself as nurse Diana Prince so she can be near Trevor, the man she loves, help him in his war against spies and inspire female equality. To that end, she gathered to her a cadre of female helpers, predominantly Etta Candy and the Holliday Girls, a sorority sisterhood of female helpers.

William Moulton Marston, Harry G. Peter and the Comic Book Industry

Wonder Woman's Amazon roots are significant elements in her story. Indeed, her Amazon ethnicity is integral to the ideological construction of her world. For, unlike Superman and Batman, Wonder Woman's story world is constructed as a 'pure political, philosophical fantasy [. . .] utterly well-realised fantasy world'.[29] She was, as suggested above, created to inspire girls to become stronger and boys to become more loving. These ideas were written into her story as crucial to her mission and they were also meant to influence culture outside of the comic books. As Molly Rhodes suggests, she was not just created to battle the evil of Nazism 'but to be an agent in a culture war *within* the United States'.[30] The Second World War was a time when women were expected to contribute to the war effort by taking on work in industry and the militia. However, although they had won the vote in 1920, by 1941 they still had to combat prejudice and misogyny.[31]

Although she was not the first female superhero, Wonder Woman was the most visually identifiable, as Marston and Peter wisely, in the context of the Second World War, chose to clothe her in the American

flag. Like other heroes such as Superman, her first appearance was in the new format, the comic book anthology. The superhero genre emerged alongside four-colour printing and a new media form, the comic book. The comic book in this era consisted of anthologies of cartoons, collected from the Sunday newspaper comic strips.[32] From their initial use as a means of selling pre-existing comic strips, comic books developed original stories and characters. The most significant character in the change from anthology to character-based comic books is Superman in *Action Comics* 1.[33] The formula for the first Superman story set in place the paradigm for early superhero comics, including the secret identity, the unknown childhood and contentious love relationships.[34] In the consequent explosion of superheroes copying Superman, women appeared as sidekicks or love interests, there to be rescued or to constitute a nuisance to the superhero's mission.[35] It was to challenge the notion of a hero who used only his fists to regenerate the land[36] that Wonder Woman was created by William Moulton Marston, aided by his wife, Elizabeth Holloway, and his lover, Olive Richard.[37]

Marston had an ideological agenda in creating Wonder Woman, for he was not originally a comic book or strip creator. Marston was a 'cultural amphibian', an academic and populist writer who wrote extensively on human emotions and gender.[38] His academic and populist work can be roughly divided into two eras, the academic work up to the mid-1930s and his populist work from the mid-1930s onwards. His ideas and aberrant lifestyle are perceived to be the reasons for his move towards popular work.[39] Marston's academic research and writing were founded upon 'deviant science', a term 'reclaimed by contemporary queer theory' as the art of a revised history of sexuality by contemporary queer scholars.[40] Marston was trained in law and gained a PhD in psychology at Harvard. He worked as a lecturer and researcher in prestigious higher education institutions such as New York University, the University of Southern California and Columbia University, and was a prolific writer, publishing twelve articles and books between 1917 and 1934.[41] His academic career began with empirical studies on human

emotions and subjectivity, using a version of the systolic polygraph lie detector he developed during the First World War. He used the lie detector in experiments on the emotions of returning soldiers and women students at Radcliffe. On the basis of his experiments with the lie detector, Marston devised the Dominance, Inducement, Submission and Compliance system (DISC), which sought to explain human interactions and formed the underpinning values of his creation of Wonder Woman.[42]

Marston and Peter were older than other comic book creators; Marston was in his early fifties, Peter was in his early sixties. Compared with the comic books and strips created, written and drawn by other creators in the superhero genre who were in their early twenties, Marston and Peter articulated the values of the early twentieth century. This is signalled in a curiously dated image on the cover of *Wonder Woman* 1, where she is represented leading a charge of American soldiers on a white horse leaping over the Nazi trenches.[43] Although supposedly set in the Second World War, the image looks more like a First World War scene. Nevertheless, it is an accomplished drawing, yet different from that of the superhero comic drawings by younger artists such as Joe Shuster, Jack Kirby and Jerry Robinson. Peter's panels are more staged and posed. Marston and Peter's work was also accredited, a rare accolade in comics at that time. The ideas and imagery Marston and Peter introduced in these early comics are the benchmark against which most of the later iterations of the character are measured, challenged or remain inspirational sources.

After Marston

Wonder Woman's origin story has appeared in one form or another in the past seventy-five years, but has been adjusted in each era. These revisions are significant because they show how far the comic book industry and the creators' aims change from William Marston's ideological vision and the Second World War's cultural values, and

they have been thoroughly analysed in Cocca's excellent study of superheroines.[44]

As Marston's health failed in the late 1940s, Joye Murchison took over writing some of the stories, and on Marston's death Peter continued to draw the heroine, with the storylines taken over by jobbing writer Robert Kanigher.[45] Marston's vision of a feminist revolution inspired by the war did not happen. Rather, in the early 1950s, more traditional views of female domesticity, consumerism and youth culture were foregrounded in an America intent on returning to more traditional male and female roles. There were also moral panics about perceived threats to traditional, 'common-sense' notions of a white, male middle-class world order. These included the witch hunt to discover communists in American culture prompted by Senator Joe McCarthy and moral panics about juvenile delinquency. Comic books were included in a concerted attack on juvenile delinquency, communism and the feminization of American culture. The attack was spearheaded in 1954 by the publication of *The Seduction of the Innocent* by psychologist Dr Fredric Wertham. Wonder Woman was one of the superhero characters identified by Wertham as psychologically harmful to children. His opinion was based on the 1950s perception of traditional family values in which the wife and mother stayed at home to raise the children and tend the house: 'she is a frightening figure for boys, she is an undesirable ideal for girls, being the exact opposite of what girls are supposed to be'.[46] The fears of the impact of comic books on juvenile delinquency led to the imposition of a self-regulatory system, the Comics Code Authority (CCA), by the comic book industry.[47] In the newly regulated superhero genre, Superman, Batman and Wonder Woman all acquired families and their stories were stripped of any contentious material.[48]

The cosy familial setting of the superhero comic changed in 1960 when Timely, a rival comic book company, published a new superhero comic, *The Fantastic Four*. The Fantastic Four were a group of superheroes who did not wear costumes or have secret identities and continually squabbled, and they inspired a new direction in the superhero genre that made the DC output seem trivial and old

fashioned. Timely Comics renamed themselves Marvel and produced a stable of superheroes that breathed life into the superhero genre, appealing to slightly older and more educated college audiences.[49] Marvel superheroes such as Spider-Man, the Fantastic Four, the Hulk and the X-Men seemed more in tune with teenage markets. Marvel actively courted countercultural teenage markets in the later 1960s, visiting colleges and developing Marvel devotees as a specific fandom. At this time, comic book fandom developed because of companies like Marvel publishing fans' addresses and so enabling them to contact each other. Marvel superheroes had similar life experiences as their readers, and contended with poverty, bullying, sickness and rejection by society and loved ones. Marvel also introduced social realism and countercultural values such as drugs, feminism and civil rights into superhero stories. To counter Marvel's growing popularity, DC Comics updated their superheroes. Wonder Woman was revamped by writer Denny O'Neil and artist Mike Sekowsky, who were charged with bringing Wonder Woman up to date. Accordingly, they took away her powers, costume and Amazon heritage and she became an action chick. Wonder Woman as action chick lasted twenty-four issues and then was hurriedly dropped in the face of feminist criticism, failing comic book sales and DC's desire to return Wonder Woman to her original powers and costume.[50] However, Wonder Woman became foregrounded in the American consciousness through the television series starring Lynda Carter (1975–79), which ran for three seasons. Carter's depiction attracted a fan following, especially amongst gay men and women, that continues to the present.[51] Such is Carter's association with the character that her face was adopted by later artists such as Alex Toth, and was used in the creation of a digital comic, *Wonder Woman '77*, with cover art by Nicola Scott and Phil Jiminez, based on the television series, as well as in the DC team-up comic books *Batman '66* and the *Bionic Woman*.[52]

The 1980s saw a rise in consumerism and public relations culture, the beginnings of global media and a right-wing backlash against feminism under the Ronald Reagan presidency.[53] In the comic book industry, the 1980s also saw the introduction of the graphic novel form,

aimed at promoting comics as a mature media form with adult content. During this decade there was a boom in the sales of graphic novels with the publication of some iconic titles such as *The Dark Knight Returns* (1986) and *Watchmen* (1987) that redefined the superhero genre into something darker and more violent.[54] In 1986 DC Comics simplified its universe, revising its main characters, and Wonder Woman was given a revised origin, as an innocent-abroad character, Diana, Themysciran ambassador to Man's world. Her Wonder Woman title was conferred by a PR agent. George Pérez's revision of the character is much admired by fans and influenced many of the later versions of Wonder Woman up to 2011, whether emulating or resisting his reverential approach.

Since Pérez there has been a multitude of writers and artists, each bringing new supporting characters and reinventing her story. The stories in this era tend to be in constant flux, with new writers and artists who revise Wonder Woman's story world and, in some cases, discard storylines and characters that previous creative teams were developing. This can lead to confusion in readers and a lack of connection. For instance, John Byrne's stories focused on her relationship with Hippolyta and made her into a real, rather than symbolic, goddess. In the 1990s comic books' representations changed due to changes in distribution, point of sale, creation and publishing. It is worth reflecting on how changes in point of sale and distribution affected the representation of Wonder Woman.

In the 1940s through to the late 1970s, comics were sold through newsstands to mass audiences.[55] In the 1940s to 1960 there is evidence that they were read by boys and girls almost equally. For instance, the Market Research Company of America reported that 95 per cent of boys and 91 per cent of girls aged 6–11 read comics.[56] Disparities showed between the ages of 18–30, when 41 per cent of males against 28 per cent of females read comics. Selling to newsstands meant the comics that did not sell could be returned to the publisher. Publishers began to sell directly to specialist shops from the early 1970s and by the late 1970s comics were sold mostly through comic book shops. Comic book shops ghettoized fandom, discouraging women and children from entering.[57]

In the UK, for instance, pornography was sold in the backs of the shops. Trina Robbins notes the circular logic of the comic book industry; publishers assumed women did not read comics so they did not produce comics, leading to women reading fewer comics.[58] Eventually the female market dwindled.[59] As many of the creators were young males for mainly young male audiences, it is of little surprise the representations of women were highly sexualized and at times, such as the 'bad girl' era, little more than softcore porn.[60] Wonder Woman was subjected to a bad girl makeover in William Messner-Loebs and Mike Deodato Jr's short but impactful run of 1992–95 in which Deodato's stunning imagery introduced highly sexualized images of Diana and the Amazons. Messner-Loebs and Deodato Jr introduced a note of discord in the Amazon message of peace and love, showing a darker side of Hippolyta and racial conflict within the Amazons in 'The Contest'.[61]

From the late 1990s to the 2000s the magical origin and Amazon concord were discarded entirely in favour of a more brutal and cynical depiction of the race, reflecting a general escalation in violence in the superhero genre. 9/11 also encouraged creators to question the role of the vigilante in the previous fifteen years. Wonder Woman too changed in this period to become more worldly-wise, in some cases uncharacteristically violent and exhibiting paradoxical behaviour; she committed murder on global television, was the ambassador for Themyscira, was involved in a terrorist war between the Amazons and America, and wrote a spiritual, self-help book.[62]

In recent years, the niche male comic book market has been challenged, with many young women becoming more interested in comics through more thoughtful and cleverly contrived graphic novels in DC Comics' Vertigo line and manga. The positive promotion of female titles in DC and Marvel, more female creators and editors such as Karen Berger, and the development of cross-media narratives (this is discussed in more depth in Chapter 6) also encouraged more girls than ever to read superhero stories.

Contemporary *Wonder Woman* comics have moved away from sexual objectification, possibly due to DC's attempt to appeal to female

audiences. Since 2011, with the New 52 and Rebirth story arcs, Wonder Woman's presence is promoted in the broadest range of comics since the 1940s and increasingly through other media such as film, television and video games. In *Wonder Woman (The New 52)*, Brian Azzarello and Cliff Chiang (2011–14) emphasize her mythic background. She also became Superman's lover in a separate comic, *Superman and Wonder Woman*. The short-lived, but much admired, *Sensation Comics* tapped into her rich back story and her universe. Grant Morrison and Yanick Paquette produced a standalone graphic novel that, according to Morrison, is based upon Marston's philosophy, and Jill Thompson's standalone graphic novel *Wonder Woman: The True Amazon* won the prestigious Eisner Award for graphic narrative in 2017.[63] There are spin-offs in the *Amazon Odyssey*, *The Legend of Wonder Woman* and *Bombshells* and cute character adaptations in *Superhero High* and *Super Powers*, DC's attempt to attract younger audiences. Since the 1990s, Wonder Woman has moved over into other media but, as noted above, to a lesser extent than her male counterparts. Wonder Woman appeared in several children's animated cartoons such as *Superfriends*, *Young Justice* and various *Justice League of America* animated television series and standalone films.[64] Many of these series were promoted through toys and collectables. Her cultural visibility was sustained in fan creativity: collecting, performing in cosplay, fan art, comics, fanfic and 'zines such as *Princessions* in the late 1980s.[65] Her transmedia appeal is promoted in online games, dedicated websites and social media. The success of the standalone *Wonder Woman* film assured her inclusion in the *Justice League* (2017) film and forthcoming DC Extended Universe (DCEU) projects, including a sequel to the first *Wonder Woman* film.

The Superhero Body and the Superheroine Narrative Trajectory

The first issue that should be dealt with is in the differences between the female and the male hero's narrative trajectories. Wonder Woman was

created in the superhero genre, an intensely masculine genre in which violence was endemic. However, she was created to show how love rather than violence could redeem, a different journey from the traditional American hero. According to Richard Slotkin, the American frontier myth, in which the frontier forms the boundary between civilization and savagery, is based upon a mythology of violence.[66] Such violence was necessary within the American mythmaking process to address the necessity of American expansion against the dispossession of land from Native Americans. Slotkin is concerned with explaining the myths that produce a sense of national identity. He argues that the myth of the frontier was developed into a myth of a secular society in which conflicts re-enact previous wars the ways literature processes historical events. Myth represents its beliefs through exemplars of good and evil to demonstrate and affirm ideologies. Myth therefore 'uses the past as an "idealized example"' in which 'a heroic achievement in the past is linked with another in the future of which the reader is the potential hero'.[67] Children perform a symbolic re-enactment of the frontier myth when they play cowboys and Indians. More significantly, later conflicts, such as Vietnam, are couched in terms relating them to frontier wars of the past.[68] The conflicts between settlers and Native Americans were couched in a binary of the civilized war versus the savage war.

The frontier myth is one of violence but it is a story about the male hero. Female heroes do not always conform to this trajectory and it is noticeable that Wonder Woman's most popular story arcs are usually based upon emotion according to Carolyn Cocca.[69] This theme underpins many of the narratives in the later iterations of Wonder Woman and contributes to an atypical heroic journey.

Although constructed out of a different ideological basis, Wonder Woman's appearance and powers are modelled on Superman. Her powers are like Superman's. She is strong, can hear and see extremely well, can leap very high, speaks every language ever invented, including to animals, is super-intelligent and inventive, and in the early stories she is telepathic. Her look is modelled on Superman; her costume comprises the three primary colours inspired by the American flag.

Wonder Woman's Stars and Stripes inspired costume is like several other characters from the Second World War such as Uncle Sam, Miss Liberty, The Shield, Super-American, The Fighting Yank and Captain America. The iconic status of the flag provides readers with instant recognition on the page,[70] and in donning the American flag as her costume Wonder Woman automatically aligns herself with national values.[71] One other crucial aspect of Wonder Woman/Diana Prince's costume is the mask. Male heroes often wear masks to conceal their identities and they show their faces in their secret identities. They 'hide in plain sight'.[72] The mask articulates a fluidity of contemporary identity in which the face is concealed and the body becomes more expressive. However, in Wonder Woman and Superman, the opposite is true. As Clark Kent and Diana Prince, Superman and Wonder Woman conceal their faces behind glasses that act as masks. The concealment is gendered: wearing glasses connotes weakness and femininity in Clark Kent, lack of attractiveness in Diana Prince. In both, the glasses connote the diminution of desirable gender attributes. In their unmasked identities, both bodies become more dynamic and command the comic's panel and page.

Ironically, Wonder Woman's weapons are also the source of her vulnerability for if she is unshackled from her bracelets of submission she becomes a berserker. Her bracelets of submission are used to deflect bullets, originally in the Amazon game, bullets and bracelets, for unlike Superman she is not invulnerable. She has an invisible plane that can carry her between worlds. The weapon that most concerns critics, however, is the golden lasso, introduced in *Sensation Comics* 6. Originally the golden lasso was forged from Hippolyta's girdle, given to her by Aphrodite; it forced those bound to obey the orders of the binder, prompting Wonder Woman to reflect: 'I can change human character! I can make bad men good, and weak women strong!'[73] The lasso later evolved into the lasso of truth, forcing the truth out of those bound by it, no doubt in recognition of Marston's lie detector.[74] Given that she is the iconic superheroine and her weapons (a lasso and manacles) are reminiscent of bondage and sado-masochism in the porn genre, it is

unsurprising to learn that she was the inspiration for other superheroines of the 1940s. 'Good girl art', a style coined in the 1970s by collectors of comics and pulp fiction, represented women in the pin-up tradition with large breasts, wearing skimpy clothing and posing in sometimes titillating situations. Richard Reynolds proposes that the iconography of the subgenre 'takes all the signs of pornographic discourse [...] and integrates them into the context of non-pornographic story structures'.[75] However, as discussed above, this takes a rather simplistic view of Marston's reasons for representing Wonder Woman in this way.

Ethnicity and Queer Bodies: Amazons

Wonder Woman's Amazon heritage is predicated on the exotic and imaginary. The Amazon heritage is a key element in Wonder Woman's story, more so than her secret identity. Wonder Woman's Amazon heritage highlights concerns over ethnicity, gender and sexuality, concerns that repeat cultural issues in the representation of Amazons from Antiquity and recur throughout her history. The Amazons' inclusion in stories in Western culture emphasizes their Otherness, as suggested by Claire Pitkethly: 'Amazon encounters serve to define, through negation, the cultural identity of those who encounter her.'[76]

The Amazons were invented in Greek myths as a warning to men of the Classical world of allowing women too much power.[77] Amazons existed on the margins of maps from medieval times, where they represented one of the monstrous races thought to exist in the unknown lands of America in the early sixteenth century. Marston's depiction of a utopian female society on Paradise Island challenges more traditional models of the Amazons as monstrous and unruly women. However, at the beginning of the twentieth century, narratives of Amazons emerged that might have been influenced by calls for female suffrage. Jill Lepore proposes that in this era 'Amazons were everywhere' and gives as examples a collection of poems by Max Eastman, *Child of the Amazons and Other Poems*, and Inez Haynes Gillmore's novel *Angel Island*.[78]

The Amazons are an integral part of the Wonder Woman universe whether they are present or absent. When present they often constitute a domestic environment or an arena of conflict between Wonder Woman and humanity's world. When missing, they become an absent presence, a source of longing or quest that constantly engages Wonder Woman's thoughts and longings.[79] Of significance in Amazon discourse is their spatial location as liminal, neither here nor there.[80] In Greek and later medieval legends, they existed in unknown lands or on the margins of maps – unruly and monstrous women who must be either tamed or destroyed.[81] In Marston's stories, Wonder Woman's assimilation into American culture demonstrates America's willingness to embrace the racialized Other.[82] In his stories and some of the subsequent versions of Wonder Woman, the Amazons exist in an uncharted location, hidden from the world of men. Marston represents Paradise Island as a utopia, an example to patriarchy of the benefits of female empowerment.[83] Since Marston's death, however, Amazons have either been represented as housewives who turned their backs on patriarchy after the death of their menfolk (1950s, 1960s and Lynda Carter's television series in the late 1970s), a pagan society that worships a female pantheon (1980s and 1990s), a fractured society torn apart by immigration and dissenting disempowered tribes (1990s to the present), or enraged harpies intent on destroying men in response to perceived insults (early twenty-first century). The latest version of the Amazons in Jenkins's *Wonder Woman* focuses on the fetishized female hard body of the action genre, generally considered one of the strongest elements of the film.[84]

Wonder Woman's Amazon ethnicity is integral to her original mission to bring female peace and love to Man's world. In the 1950s and 1960s, under Robert Kanigher, Wonder Woman's mission was to eliminate evil from Man's world, suitable reason for her to remain forever unmarried. Her unmarried, and presumably virginal, status, was very much an integral part of her Amazon identity and her association with the virginal Roman goddess of the moon and the hunt. As Cocca notes, Wonder Woman is one of a kind, created as a queer character, her fortunes fluctuate depending on the social values of each era and her

representation is negotiated between distribution, production and audiences.[85] Greg Rucka, one of the key comics writers of *Wonder Woman* in the past twenty years stated that, as a society of only women, same-sex relationships were inevitable.[86] Despite her love for a man, Steve Trevor, on entering Man's world she gathers a network of women supporters, college girls who combat Nazism by love and allure.

Career Woman/Trickster: Diana Prince

As noted above, Superman set the model for superheroes in the so-called Golden Age and one of the tropes of the superhero identity was the secret identity. Usually the secret identity is a drab counterpart to the hero. Interestingly, Wonder Woman's alter ego, Diana Prince, represented a more realistic depiction of women's lives in the Second World War, where she was shown as an efficient nurse and personal assistant. Nevertheless, she supposedly looked plain and sexually repressed wearing glasses and her hair tied in a bun. However, this did not acknowledge the importance of the character in the Second World War, when the government was concerned with attracting women into the services and industry to help in the war effort. Diana Prince represented the ordinary working woman in the war, a capable professional and a trickster.[87] The secret identity, like abstinence from sex, acted as a taboo to limit the hero's powers, a payment for power.[88] The secret identity connected what in some cases was a godlike being to ordinary human experiences.

Diana Prince's fortunes fluctuated depending on the era in which Wonder Woman was revised. In the 1950s and 1960s, Robert Kanigher had problems reconciling Diana Prince as career woman with a prevailing notion of the woman as belonging in the domestic environment. In the late 1960s, with the emergence of second-wave feminism, Diana Prince emerged from Wonder Woman's shadow to become a mod fashionista with no powers but with exemplary fighting skills.[89] In the 1980s, George Pérez discarded the secret identity and

concentrated on Wonder Woman's Amazon heritage and her diplomatic role. Greg Rucka reinvented the character in 2007 as an agent of the Department of Metahuman Affairs (DMA). Since her revision in the 1980s, her secret identity has become less important until it virtually dwindled away.

Writing about Wonder Woman: The Marston Effect

In Wonder Woman comics, adaptations and academic research, William Moulton Marston is a consistent figure of fascination as much for his colourful life and his unique background as for his ideological and academic agenda in creating the character.[90] Several related themes of feminism, gender, sexuality and fetishism shape the debates on Wonder Woman. Most are closely associated with Marston.[91] Marston is a compelling individual and much of the literature surrounding Wonder Woman is about how he wrote feminist, fetish and bondage themes into the comics. Such is his influence that Noah Berlatsky suggests that one cannot seek to identify these issues from an external perspective but must do so from Marston's beliefs about feminism, bondage and fetishism. However, as Berlatsky notes, Marston's ideas are big and later writers of the character either misunderstand or ignore Marston's vision in their adaptation of the character, such that they 'are thoroughly worthless in almost every respect'.[92]

Two studies were published in the early 1990s, each with a feminist approach: Lillian Robinson's *Wonder Women* dealt with a range of superheroines, relating them to feminist theory,[93] and Robbins also used a feminist approach to piece together the rich history of female characters lost in comics' history.[94] Berlatsky's book is an in-depth study of the creative processes between Murchison, Marston and Peter, and the darker aspects of the character in its depictions of bondage and feminism.[95] Berlatsky focuses on Marston's radical feminist and gender ideologies that were instilled in *Wonder Woman*, proposing that Marston 'saw his comics as a scheme to advance radical ideas and

theories and dreams. As a result, looking at his comics from inside comics is like reading Freud for the plot.'[96] Berlatsky suggests that feminism, queer theory and psychological approaches to analysing the comics are unnecessary as these ideas are already instilled in Marston's ideological impetus. The most authoritative account of Marston's work is by Geoffrey Bunn, in his work on the lie detector.[97] As Bunn is also a psychologist, he provides a sophisticated reading of Marston's psychological research, particularly the DISC model and his place in academia, although he misunderstands the difference between the function of the lasso and the lie detector.

Several studies of Wonder Woman and superheroines deal with comics industry corporations, structure, distributions and fan responses in the development of the character.[98] Philip Sandifer[99] and Tim Hanley exhibit such exhaustive knowledge and detailed analyses of letters pages and production that it is unnecessary to replicate in this book but that are invaluable to those who need this background knowledge. Cocca[100] too exhibits detailed knowledge of the interplay between production, the comic book industry and the audience's reception of the various changes in the comics and Wonder Woman's body. For an overall perspective of Wonder Woman, Joseph Darowski's edited collection provides a broad range of critical positions on the various eras of the character, and the essays deal with diverse theoretical and cultural perspectives including feminism[101] creators,[102] war and politics,[103] career and romance,[104] censorship,[105] and myth.[106] These references will be discussed in more detail in the relevant chapters.

Despite Berlatsky's assertion that one cannot discount Marston's influence on the character, it seems pointless to keep revisiting Marston's philosophy as this has already been discussed at length by Berlatsky, Hanley, Sandifer and Bunn, amongst others. This study uses somatic theory to map changing attitudes and constructions of the body over the seventy-plus years of Wonder Woman comics. A historic/cultural analysis of the superhero is not new. J. Richard Stevens's book based upon Captain America is structured like this book but themed around masculinity and violence.[107] Although he discusses the fluidity of

masculinity, Stevens does not go into detail about the objectification of Captain American's body (indeed, given my discussion of the hero's journey compared with the heroine's above, it would be bizarre if Stevens discussed the objectification of Captain America). Instead he connects the hero's journey directly with the national monomyth and explores Captain America through masculinity and violence.[108] Stevens's chapters parallel those of this book: the Cold War in the 1950s, commercialization in the 1980s, the War on Terror post-9/11 and the transmedia universes of the contemporary media landscape. Stevens concludes that readers and fan activities had a significant impact on the development of the character's values.

My aim differs from Stevens because this book starts from the body and how, over seventy-five years, the comics and other iterations of Wonder Woman are influenced by changing cultural and historical phenomena. Wonder Woman is supposed to represent the ideal female body and spirit. The notion of the beautiful body and mind goes back to the Classical Greek concept of *kalos kagathos* (*kalos* means 'beautiful', *kagathos* means 'virtuous'),[109] and the notion of beauty of mind and body has endured in Western philosophy and art over several centuries. However, Wonder Woman's representation is also influenced by 'dominant "American" ideas about gender, race, and class',[110] and I use the cultural texts of the time to draw a wider cultural analysis from the comics.

There are several recurring issues relating to the representation of Wonder Woman's body and they fall into three categories: the national body, the active body and the fetishized body. Debates on the national body revolve around ethnicity and costume. As an immigrant, Wonder Woman is an outsider in American culture in the early twentieth century. Also, as an Amazon, she represents the barbarian who is tamed and becomes the spokesperson for American values.[111] Wonder Woman is, however, the ideal American immigrant, Caucasian, speaking English and wearing a costume inspired by the American flag.[112]

Wonder Woman's costume, based upon the Stars and Stripes, emphasizes her role as a spokesperson not only for Amazons but also

for America. However, when aligned with the female body it takes on several other elements, such as fetishism. The patriotic costume connotes an acceptance of national values. This can have problems for the hero in times when American values come under scrutiny, as can be seen in Chapter 3, based upon the late 1960s story arc when Wonder Woman renounces her mission, her powers and her costume. Feminism also has an impact on her representation in sometimes paradoxical ways. For instance, her costume and body became the centre of controversy in the early 1970s and 2016, both controversies sparked by feminist debate in these eras. In the early 1970s, feminists were outraged by the comic book stories depowering her, taking away her costume and dressing her up as a desexualized Emma Peel clone. Wonder Woman, who had appeared as the adopted feminist icon on the cover of their flagship magazine *Ms*, was regarded as the ultimate symbol of female empowerment. Led by Gloria Steinem, they protested, and after twenty-four issues DC Comics quickly returned her costume.[113] Conversely, returning to the UN Ambassador debacle of 2016, she was criticized for being a fantasy figure but also, in the spirit of third-wave feminist inclusion, her body was critiqued.[114] These examples make a point about the expectations culture has about women and their bodies and reinforce Mike Madrid's assertion that Wonder Woman is better known for her costume than her mission.[115]

Feminism is also central to Cocca's argument, that the queer construction of the character is compromised in the ebb and flow of eras in which there is a backlash against feminism, a view that is difficult to refute. It is, however, hard to get away from the fact that many superheroes tend to be products of over seventy years of adaptations during which creators inscribe their own vision of characters on previous iterations. This is not the case with Wonder Woman. Marston's feminist vision is central to her mission. It is impossible to think of any other superhero whose creator's ideologies are so important in the various iterations of their stories, and this is borne out in the various analyses of the character. For instance, it is rare for researchers or fans to insist upon a return to Stan Lee and Jack Kirby's concept of The

Fantastic Four or to Bob Kane and Bill Finger's version of Batman. Each reader will have their own understanding of the character based upon when they encounter the text.[116] With Wonder Woman, many fans are loyal to Lynda Carter's interpretation in the television series (1975–79) and Marston's. Consequently, some fans will not tolerate the interpretation of the character by Gal Gadot in films such as Patty Jenkins's *Wonder Woman* (2017). Indeed, a Facebook group was set up based upon promotion of the original Wonder Woman.[117] Rather than making judgements on the worthiness or excellence of the comics and media texts surrounding Wonder Woman, my approach is objective, to examine the knowledges that produce perceptions and expectations of bodies. My aim is to determine what the comics can tell us about expectations of women and their bodies in specific eras. To better understand the issues involved, it is now important to map out the theoretical terrain surrounding somatic theory to identify the types of bodies that may be encountered in this analysis and what is at stake in these representations.

Somatic Theory

In one of the most important pieces of research on the body, Bryan Turner stated that we live in a 'somatic society', a society constantly foregrounding the body in which 'major political and personal problems are both problematized within the body and expressed through it'.[118] Despite the importance of the body, Turner noted that it was rarely considered as worthy of research. Chris Shilling agrees with Turner, describing the body as an 'absent presence'; we acknowledge our bodies through their shortcomings, disease, deformities or aberrations yet choose to disregard it in research.[119] The responsibility for this disregard is often assumed to be Cartesian philosophy as, since the seventeenth century, it promoted the importance of the mind over the body in identity construction.[120] Drew Leder, for instance, suggests dualism's insistence on the self as 'an immortal mind trapped inside an alien

body' contributes to our lack of consideration of our bodies as contributing to our sense of being.[121] Turner and Shilling's work laid the foundations for the expansion of somatic theory through feminist analysis in the 1990s.

Research into the body changed in response to feminist theory of the early 1990s that generated interest in the performative aspects of gender rather than 'given' gendered identities.[122] Feminist theory explored how gender was produced from social discourses and concluded that the body could be regarded as both 'product and process'.[123] The body is a product because of its material presence in the world that we recognise through gender, racial and ethnic, amongst other, characteristics. It is a product of culture that constructs a collective understanding of what we are by our bodies. From the 1990s, the encultured body was conceived as an idealized project of the self, something to be shaped, controlled and presented to conform to society's notions of beauty. However, it was also a carceral body formed through self-discipline, inspired by what Michel Foucault described as the panoptic society.[124] In such a society, people become spectators and performers, fabricating their look and identities to conform to the role of ideal citizens whilst looking at others' responses to their performances. Thus they become docile bodies 'that may be subjected, used, transformed, and improved'.[125] The body is constructed through lifestyle, objects, consumerism and the media in cultural analyses.[126] There is also a place in the book for notions of the phenomenological body, a concept deriving from Maurice Merleau-Ponty but developed in the work of Gilles Deleuze and Felix Guittari, amongst others.[127] This is the body that feels, sees, hears, tastes and moves. Maxine Sheets-Johnstone, for instance, explores the 'somatically felt body' through her analysis of dance.[128] The affective body is a body of the senses, a body that is open to feeling in the world. It is also a body in the process of becoming.[129] This is discussed in Chapter 5 in relation to Wonder Woman as a goddess whose divinity is articulated through affect. This area responds to two different types of bodily merging: the technological hybrid and the bestial hybrid, the former connected with science fiction,

the latter with horror.[130] This type of body is analysed in Chapter 4 when discussing the cyborg body of Doctor Cyber. The cyborg melds the body with technologies in cloning, virtual reality and the cyborg itself. As such it explores technology and the limits of human experience.[131] The horror sensorium examines the emotional effects of horror in media and audiences.[132]

A similar type of body to that of the senses can also be found in the grotesque and its binary, the ideal body. The unruly/grotesque body is the feeling body but it is mired in the lower body stratum, the body of hybridity and the monster, the rebel or the fool.[133] It is the body that exceeds its boundaries. Mikhail Bakhtin compares the grotesque body with its opposite, the perfect classical statue.[134] The latter is polished, smooth and beautiful, an example of high art that (going back to the dualism discussion) reflects the mind and gravity, whereas the latter is a symbol of folk art, mockery and the lower body stratum. The grotesque body connotes excess, hybridity and fragmentation. It is the unfinished body of the gargoyle on the cathedral, a body in the act of becoming. This type of body is discussed in Chapter 3 when analysing the monsters evolving from Cold War *Wonder Woman*. It is also a body that can be aligned with Amazons, as noted above, originally perceived as monstrous women. The converse of the grotesque body is the ideal body, the body of desire. The body is an object that can acquire erotic capital depending on its physicality, as proposed by Catherine Hakim: 'Erotic capital is just as important as human and social capital for understanding social and economic processes, social interaction and upward social mobility.'[135] As noted above, Wonder Woman is constructed through allure and idealized beauty, and her erotic capital opens the way for acceptance and veneration as the female ideal of beauty, wisdom and behaviour. So, her body can be regarded as a benchmark of the changes developing over culture through somatic discourses.

In reflecting on the diversity of responses to the body, it is evident that the body is a fluid concept whose meaning changes culturally and historically. This prompts Shilling to suggest that 'to achieve an adequate

analysis of the body we need to regard it as a material, physical and biological phenomenon which is irreducible to immediate social processes or classifications'.[136] The body is a plastic concept and can be analysed through many foci that change over time and cultures. It can be analysed through lifestyles, shape, ethnicities, as a consumable object, as shaped by consumption and performance.[137] Notions of the body change over time: technologies and their interaction with the body are increasingly foregrounded in later writings; in an ageing society nostalgia, disability and illness are emerging as important areas of study.[138]

The superhero body, a body that acts as a metaphor for human experience, makes a useful case study through which the body and its changes and transformations can be explored. This study does not aim to provide the in-depth detail of industrial practices or the creative processes of other studies such as Sandifer, Hanley or Cocca. For simplicity, I concentrate on several key moments in the comic books and, as this is an approach emphasizing the body, there are no judgements on the worth or otherwise of any creators. Rather, my aim is to show a potentially useful means of analysing bodies in Wonder Woman through her various iterations and to map cultural concerns of the times, mainly about women's bodies, for, as Jeffrey A. Brown notes, '[the action heroine] is one of the most intriguing, progressing and disputed signs of changing gender norms in popular culture'.[139] The approach starts from the comics and the ways they represent bodies. From an initial analysis of these issues and close readings, I relate them to somatic discourses circulating in each era. As noted in the development of Wonder Woman since 1941, her body changes in response to socio-historic values and notions of gender.

Plan of the Book

The chapters pick key moments in Wonder Woman's history to analyse the discursive construction of the body and the conclusions map some of the main characteristics of the intervening years. This is supplemented

by the Appendix which maps diverse story arcs and the themes that drive them.

Several discourses weave through the representations of the character in her eighty-year history. These include consumerism, media, race and gender. The chapters map out how these change across the eras and how this impacts on the ways Wonder Woman and women, in general, are perceived and represented.

Chapter 1 explores Marston and Peter's version of Wonder Woman to show how her body was constructed as the idealised immigrant body, based on the idealised ethnicity of the showgirl. For Wonder Woman to achieve a seamless integration into American culture, she had to epitomize the ideal American female body, and the body of the American showgirl in the tradition of Florenz Ziegfeld and Billy Rose epitomized the ideal female body ethnically and physiologically. However, acknowledging the queer aspect of the character, one can also identify her roots in the seamier side of burlesque and drag.

Chapter 2 recounts how Robert Kanigher appealed to teenage audiences by emphasizing romance and the fairy tale from 1958 to the mid-1960s. Despite seeming to turn his back on reality for a cosy domestic fantasy, the stories in this idyllic world reflected the fears of Cold War America about communism and the atomic bomb. Kanigher diluted and eventually eradicated feminist messages to construct an ideal family life and women's places in the nuclear family.

Chapter 3 examines the use of fashion and the active body of second-wave feminism's new woman in the late 1960s and early 1970s. In discarding her costume and powers, Diana Prince connoted modernity and feminist values. The fashionable body accesses spaces denied to the patriotic costumed body. Central to this chapter is the notion of the costume and what it connotes for the superheroine's body.

Chapter 4 examines the growth of consumerism and promotion in the Pérez era in the late 1980s, when Wonder Woman's secret identity was discarded and she became a goddess. This chapter shows how patriarchy's elevation of the superheroine to deity becomes a burden to other women but also to herself.

Chapter 5 examines Greg Rucka's story arcs of the 1990s and early 2000s charting the effects of globalization and technologies in controlling the unruly female body. This chapter identifies how Wonder Woman's enemies mobilize surveillance to incite right-wing forces and mass media technologies to bring about her downfall.

Chapter 6 revisits Wonder Woman and the family. But, unlike the Cold War family of Chapter 2, this chapter deals with the notion of heroism and whether it is possible for the character to remain the focus of her own story in an age that increasingly attempts to tell it through masculine characters to give a female character (what the producers perceive as) broader global appeal. However, by giving her Zeus as father and a hitherto unknown brother, she becomes a secondary character in her own narrative.

Chapter 7 concludes by analysing how Patty Jenkins's film was developed through comics narratives and how fan nostalgia for these narratives was used to connote authenticity in the promotion of the film. Acknowledging Richard Dyer's assertion that 'Star images are always extensive, multimedia, intertextual', the chapter deals with how convergence culture, transmedia universes and global networks construct the contemporary image of Wonder Woman across diverse media.[140] The chapter concludes by reflecting on future directions for the character based upon contemporary debates around ethnicity, race and gender.

The book concludes by reflecting on the ways the body negotiates and is constructed through various overlapping and intersecting discourses in any specific era.

Beautiful White Bodies

Gender, Ethnicity and the Showgirl Body
in the Second World War

Wonder Woman's appearance in the first issue of her comic of Summer 1942 at once proclaims her exotic credentials: 'Wonder Woman's story is the story of her race. It reaches far back into the golden age when proud and beautiful women, stronger than men, ruled Amazonia and worshipped ardently the immortal Aphrodite, goddess of love and beauty.'[1] The origin story spends much time in laying out the Amazon's origins and how Diana fits into this all-female society. The Amazons are creatures of myth with, as Marston illustrates in later stories, exotic rituals and rites. They worship ancient gods and flout the 'norms' of gender, they are stronger than men, they are scientists, philosophers, trainers and teachers.

The image accompanying this introduction is no less strange; it shows two women, fighting in an arena on kangaroos (kangas) to an audience of women. That Diana belongs to an all-female society that worships Aphrodite suggests she has a queer identity.[2] The introduction continues, she gives up 'her heritage of peace and happiness to help America fight evil and aggression!'[3] She leaves her utopian homeland to help America in their efforts to fight a war. In this endeavour, she is given a costume modelled on the American flag, the Stars and Stripes that suggests her allegiance to America. However, her suitability to align herself with America and gain acceptance is also shown in her body's ethnicity. In her appearance on the cover of *Sensation Comics* 1, January 1942 she had a white face and a perfectly proportioned body constructed from 'oestrogen markers' with large eyes, flowing hair and a

curvaceous figure.[4] Yet, Wonder Woman's body in the Marston comics represents a set of contradictions simultaneously connoting purity/pollution, discipline/anarchy, modernity/nostalgia, love/aggression. Purity/pollution themes are constructed from racial and gender discourses circulating in wartime propaganda and entertainment. Together, many of the discourses surrounding Wonder Woman's body in this era form parallels with the showgirl body of the early twentieth century which epitomized the ideal body of the American woman. This ideal body articulated ideas about women and ethnicities.

Wonder Woman's body shows its inspiration to the showgirl idealized body model in three ways: through her ethnicity, through her agency in public spaces and through the fetishized body. William Marston's ideological agenda is introduced, when applicable, but my aim is not to foreground his ideas as this has already been extensively explored, as discussed in the Introduction, by other researchers.[5] Rather, I broaden my analysis to examine the showgirl body, Second World War propaganda and films in this era to show how Marston and Peter created Wonder Woman as the ideal woman, but in doing so they constructed her from negative body images.

Wonder Woman was created to be perfect. For instance, *Wonder Woman* 10, 1943 aligns Wonder Woman's strength and her perfection when she is measured for shoes, and the assistant exclaims, 'My goodness, Wonder Woman, you're strong but you have perfect beauty measurements!'[6] In another story in the newspaper strips written and drawn by Marston and Peter on 7–9 December 1944, Wonder Woman's measurements are described as 'perfect "Modern Venus" measurements'.[7] Her beauty reinforced Wonder Woman's acceptance in America through her erotic capital.[8]

Wonder Woman's erotic capital was as integral to William Marston's plan as her strength in his often cited quote, 'Give them an alluring woman stronger than themselves and … [boys will] … be proud to be her willing slaves!'[9] Although 'allure', like 'beauty', connotes physical attraction, unlike the neutral qualities of beauty, allure actively seduces and controls, fascinating people with its charm.

Erotic capital made Wonder Woman an ideal immigrant in the cultural melting pot of America in the 1940s when race and ethnicity were integral to notions of American identity.

In turning to ideal notions of beauty and allure, Marston was influenced by the image of the showgirl, popularized in the early twentieth century by theatrical entrepreneurs such as Florenz Ziegfeld, George White and Billy Rose. The showgirl was not only beautiful but she epitomized modernity and racial purity.[10] In contrast, Wonder Woman's main foes epitomize ethnic pollution, disease and physical defections.

They are often Axis agents, led by Mars, God of War, or his underlings, General Greed, the Earl of Deceit, Baroness Paula von Gunther or Doctor Psycho who use force, coercion or violence to achieve their ends. Doctor Psycho, for instance, is a dwarf who hates women because they spurn his stature and ugliness. He has the power of mind manipulation and the ability to make facsimiles of people out of ectoplasm and uses these to turn people against women's inclusion in the war effort. In the early comics, Wonder Woman's arch enemy is Paula von Gunther who takes pleasure in enslaving, torturing and experimenting upon women. Wonder Woman's other major foe is the Cheetah, heiress Priscilla Rich, whose intense jealousy of Wonder Woman causes her mind to split in two causing her animal side to emerge. The ugliness of these foes' natures contrasts with Wonder Woman's positivity and beauty.

The first part of the chapter explores the construction of bodies within the context of Second World War culture, and focuses upon the overlapping discourses constructing race and gender from that period. These can be identified in wartime propaganda and emphasize themes of purity and disease, discipline and anarchy. This sets up the second half of the chapter that deals with Marston's ideas of female empowerment and the showgirl body, the uses of bondage, bodily and mind obeisance to authority and the greater moral good. However, the showgirl body also connotes some of the negative characteristics attributed to Axis agents and foes.

Gender and Ethnicity in Second World War
Propaganda: Pure/Impure, Health/Disease

The production and dissemination of propaganda became more sophisticated from the First World War to the Second World War, mainly through the expansion of technologically more advanced such as mass disseminated radio, sound film and the expansion of the graphic and print media, in advertising through Madison Avenue, the hub of the American advertising industry. From December 1941 the mass media were mobilized in a propaganda campaign. Graphic and film propaganda were sourced through the Office of War Information (OWI) and the Office of Strategic Services (OSS) controlled information and Madison Avenue output. All provided overt propaganda and their main issues surrounded recruitment of soldiers and women into the war effort, public information, rationing, the loose lips campaign, warnings against venereal disease and fund raising in buying War Bonds.[11] Promotional campaigns and Hollywood films emphasized personal responsibility, morality, sacrifice, a united front and duty.[12] Print, broadcast and film propaganda that represented race and gender were informed through binaries such as good/bad, clean/diseased, pure/impure, fantasy/mundane. These binaries were a product of racial and gender discourses that privileged a specific body type – the white male body – as the body of knowledge and power within America.

Much racial and gendered propaganda in the Second World War was based upon the two sets of binaries against targeted groups such as Japanese, German and so-called 'loose' women. The moral panics against these groups bore similarities and were rooted in discourses of bestiality, disease and pollution. Like the racial imagery of poster and cinematic propaganda against the ethnicities of the Axis, stories representing the Japanese and Axis powers from Marston and Peter incorporate elements of disease, madness and the challenge to the controlled body. For reasons of simplicity, I focus on Asians, Mediterranean, Caucasian and Germanic ethnicities but do not delve into African Americans who are analysed in depth by Hanley and Sandifer.

Posters and films promoted the virgin/whore ideology with the sexually active woman as diseased and men as their victims. The 'loose' woman gave herself too freely and, like the racialized body, was zoomorphized, and made animalistic. The War Office released statistics that suggested the loss of seven million days and the discharge of 10,000 servicemen due to sexually transmitted diseases (STDs). Disease was invisible and did not differentiate its victims. The US surgeon general, the US Public Health Service and the Federal Security Agency produced films and posters to combat the spread of STDs. Labelled 'penis propaganda', 'Susie Rottencrotch' films and posters warned against the risk of catching STDs from even the most innocent-looking women. A 1940 poster showed a girl next door warning, 'She may look clean – but . . .'[13] Another poster, again from 1940, showed the 'bag of trouble' woman, face up-lit, her eyes half-closed.[14] She has an almost animal or Asian appearance. The copy states, 'She may be . . . a bag of trouble. Syphilis – gonorrhoea.' Taken in context with the loose lips campaign, the campaigns against loose women take on additional meaning. Loose lips can refer to the lips or female genitalia spreading secrets and disease. The fear of the female body impacts on the depiction of Wonder Woman as discussed below.

Ethnic purity was a dominant racial discourse in America during the Second World War. However, the connection of racial purity with eugenics, the ideology promoted by the Nazis in their campaign to destroy races and people they considered impure or abnormal, was not made in the popular imagination.[15] Certainly eugenics touched upon much superhero discourse which is about the perfect or ideal body. This was explored by Brian E. Hack in relation to Captain America who, like Wonder Woman, was a patriotic hero, but a hero overtly forged out of eugenic principles as a genetically modified super-soldier.[16] Eugenics in Wonder Woman's origin is subtler but no less important for, as Michel Foucault notes, eugenics is crucial to the strategies used by the dominant classes to reproduce the ideal body, a body that reproduces their own image.[17] Women were central to the control of reproduction and child rearing and this made them especially interesting to the eugenics

movement, 'The inclusion of "baby culture" and "prenatal" within the eugenics rubric made eugenics a woman's issue, often linked to patriotism.'[18] Accordingly, the idealized ethnic female body was a crucial component in the racial and cultural mix. Pure women were, therefore, crucial in the popular imagination to maintaining pure racial stock, and colour was a very visual signal of racial types.

Overt racial markers such as physiology and skin colour were more straightforward in identifying those who were not considered typically American. The Japanese were specifically targeted. This continued a cultural history of racial intolerance against Asian people from the mid-nineteenth century when, it was assumed, Chinese workers were taking the work from white manual labourers.[19] Fears of the Yellow Peril culminated in the Chinese Exclusion Act of 1882. Racially charged rhetoric against the Chinese, circulated in popular entertainment and literature from this period and well into the twentieth century.[20] Pulp fiction and films of the early twentieth century depicted Chinese and Japanese with sing-song speech, slanted eyes and lengthy fingernails who had a predisposition to abduct and rape white women in the white slave trade. A wartime propaganda poster, c. 1942–c. 1943, featured an up-lit, sinister Japanese soldier threatening a (presumably) pure American white woman with a knife. The poster states, 'Keep this horror from your home, invest in war bonds.'[21]

When Japan attacked Pearl Harbor, Chinese and Japanese racial features were differentiated and antipathy towards all Japanese extended to those living in America when 110,000 Japanese Americans were held in detention camps. Admiral William Halsey, the commander of the South Pacific forces, used slogans such as 'Kill Japs, kill Japs, kill more Japs!' to exhort his forces. The Japanese were represented as unthinking in their devotion to their emperor. Their bodies were aligned with animals such as cats, apes, snakes or, most often, monkey-like qualities. The Tokio Kid poster campaign is a good example of this evolutionary representation. In this campaign, the Tokio Kid, created by Jack Campbell, is usually represented with pointed ears, enlarged fangs, bow-legged like an ape and holding a bloodied knife. The zoomorphic

image of the Japanese is used in Second World War *Wonder Woman* comics as discussed below.

The representation of other races and even white women thought to be carriers of STDs as animalistic was inspired by eugenics. Eugenics emerged in America from pseudo-scientific writings, evolutionary discourses and cultural concerns dating from the nineteenth century.[22] Many popular anthropology books of the late nineteenth and early twentieth centuries based their arguments on spurious eugenic claims of racial superiority and warned of the 'mongrolization' of America. Madison Grant's polemic *The Passing of the Great Race*, Clinton Stoddard Burr's *America's Racial Heritage* and William Z. Ripley's *Races of Europe* proposed certain Caucasian types as ethnically superior.[23] Ripley's *Races of Europe* divided Caucasians into various types: Nordics (Northern Europe), Mediterranean (Southern Europe) and Alpines (Central and Eastern Europe). Grant argued for the superiority of the Nordic body and character as 'a race of soldiers, sailors, adventurers, and explorers, but above all, of rulers, organizers, and aristocrats . . .'[24] It is significant that Marston and Peter's Wonder Woman fits the Nordic body model as discussed below.

Certain Caucasian ethnicities gave concern, particularly Southern and Eastern Europeans after the Bolshevik Revolution of 1917 in Russia. The Immigration Act of 1924 (Johnson–Reed Act) limited the number of Jewish, Eastern and Southern European immigrants to 'maintain the racial preponderance of the basic strain of our people and thereby stabilize the ethnic composition of the population.'[25] The ideology underpinning the quote is influenced by eugenics and reflected the prejudices of one of the Act's authors, Senator David Reed. The previous year, Reed told the *Washington Post*, 'Experience shows that the people from south-eastern Europe are more or less difficult to Americanize.'[26] Reed suggested that these ethnicities were of poor stock and less likely to make a meaningful contribution to maintain 'American stock up to the highest standard – that is, the people who were born here'.[27]

However, there is a paradox here, for the notion that one race should be superior to any others clashes with the myth of America as a cultural

melting pot in which 'each element retains its unique taste while co-existing alongside other elements'.[28] This contradiction is explained by Brian Fry who proposes that the American national white race was constructed through nativism, 'a collective attempt by self-identified natives to secure or retain prior or exclusive rights to valued resources against the challenges reputedly posed by resident or prospective populations on the basis of their perceived foreignness'.[29] Thus, the proposed indigenous white race in America could then construct their ideal bodies from specific Caucasian ideals.

Women and the War Effort

It is doubtful whether Wonder Woman and William Marston's feminist agenda would be condoned in any other era except the Second World War. Not only did Marston incorporate proto-feminist values in the stories, the paratext of the *Wonder Woman* comic incorporated feminist messages. For instance, the 'Wonder Women of History' series by Alice Marble included biographies of Florence Nightingale, Edith Cavell and Madame Chiang Kai-Shek.[30] In the latter, Madame Chiang is praised for organizing 300,000 women air-raid workers 'to win this war and establish universal peace'.[31] This statement accorded with Second World War propaganda and the rhetoric in *Wonder Woman*, for the government and Marston were united in aiming to attract more women into employment and the militia.

Wartime employment opened opportunities for women's work in aircraft factories, science, teaching and flying planes in addition to joining the armed forces. When America entered the Second World War, women had their own military branches with the formation of the Women's Army Auxiliary Corps (WAAC) in May 1942, which was quickly abolished to make way for the Women's Army Corps (WAC) in July 1943. The WACs enjoyed the same pay and conditions as their male counterparts. The navy too had its female branch, Women Accepted for Volunteer Emergency Services (WAVES) and the Marine

Corps Women's Reserve attracted 23,000 women. The army and navy too attracted 76,000 women for their Nurse Corps. In all, approximately 350,000 women served in the military attracted by the prospects of adventure as much as fulfilling their patriotic duty.[32]

Women were also needed in industry and office work. The feminist version of women's role in the Second World War claims that in the war they became equals of men in employment and the militia but they were forced back into the domestic sphere once peace returned. Rosie the Riveter, that other great icon of female emancipation in the war, seemed to fit into this narrative. She was a housewife who joined the war to help her man and was happy to return to the kitchen when the war was over.[33] The war was not the great leveller claimed by feminists. Women were given low-grade employment and their work was often undermined or decried by discrimination.[34] Nevertheless, they found themselves with more money, increased status and independence.[35]

Expectations of women in the workplace and militia were mixed. It was assumed women were not as dependable as men and they would place family responsibilities before their work duties. There was a media campaign against female absenteeism which was counteracted by a campaign extolling 'presenteeism'. In the Armed Services, male personnel often criticized, bullied or even sexually harassed women and in 1943 there was a slander campaign against WAACs claiming they were promiscuous. An example of this can be seen in the letters sent by Coast Guardsmen to the *U.S. Coast Guard Magazine* 1943 claiming women joined for the glamour.[36] As Lori Landay notes, 'The rhetoric of the home front relies upon the good woman as a faithful, sincere, hardworking participant in the public as well as private spheres, but only inasmuch as her independence and productivity were for the greater good and ... if her feminine appearance was preserved.'[37] It was important to encourage women to help in the war effort, at a time when propaganda seemed to locate women as potential dangers to male health, and there were few supporting systems to help women to balance work and private life. Many criticisms of female employment ignored the real difficulties encountered by women who were expected to do a

full-time job but also fulfil their domestic duties. Crèches were not widely available and when a woman could not get a friend or relation to take care of her child they would take them to work.

Like Rosie the Riveter, also created through graphic art, Wonder Woman's alter ego Diana Prince served an inspirational purpose in demonstrating the strength and bravery of the ordinary working woman.[38] She showed female agency through her engagement in public life and spaces. Wonder Woman's dual identities, which reflected the female domestic and public negotiation of lifestyles many women faced in the war, connoted her trickiness and an affinity to the showgirl in the plain secretary/glamorous alter ego identities.[39]

In America in the Second World War, Hollywood and the entertainment industries set up venues across the country where ordinary soldiers could meet famous stars. Stars would entertain American soldiers in camps under the United Services Organizations set up in 1941. In the Hollywood Canteen, stars such as Bette Davis would dance with and entertain soldiers. The musical film *Hollywood Canteen* was produced to celebrate this meeting of the ordinary with the extraordinary.[40] Another film, *Pinup Girl* starring Betty Grable, mirrored the Wonder Woman/Diana Prince plain secretary, glamorous alter ego.[41] As Lori Landay (1998) observes in her comparison of Wonder Woman and *Pinup Girl*, Lorry Jones works as a plain secretary by day but, by night, she entertains soldiers as Laura Lorraine, a glamorous hostess in the USO.[42] Although Diana Prince is considered plain (despite continual references to her lack of appeal, she was not unattractive), she is no milksop and exhibits quick wits when faced with physical threat. In *Sensation Comics*, 2, February 1942, when ordered to drug Steve by Doctor Poison, she switches the drug for saline solution.[43]

The tensions between the perceived professional role of women and their wartime activities were explored in two stories, both featuring Marva Psycho, wife of Doctor Psycho. They began in *Wonder Woman* 5, June/July 1942, when one of his female slaves tells Mars, 'American women are warriors – WAACS, WAVES, secret agents! 10 million

British women are in war service, 30 million Russian women.' Mars interrupts, 'If women gain power in war they'll escape man's domination completely! They will achieve a horrible independence! I won't tolerate giving women the slightest freedom!'[44] Mars outlines his ideological agenda to his war council: 'Women are the natural spoils of war! They must remain at home, helpless slaves for the victor! If women become warriors like the Amazons, they'll grow stronger than men and put an end to war!' The Duke of Deception employs one of his agents, Doctor Psycho, to 'prepare [...] to change the independent status of modern American women back to the days of sultans and slave markets, clanking chains and abject captivity'.[45] Doctor Psycho forces his fiancée, Marva, as an unwilling medium, to conjure up living ectoplasm. To utterly defame women, Psycho summons the ultimate arbiter of American truth, George Washington, to warn America against giving women too much power. In a public meeting, the fake Washington declares, 'Women must not make shells, torpedoes, airplane parts. They must not be trusted with war secrets or serve in the armed forces. Women will betray their country through weakness if not treachery!'[46] Washington then goes on to predict that women's carelessness will destroy a munitions plant.

Posing as Colonel Darnell, Steve Trevor's commander, Psycho tricks three female agents into stealing secret documents to reveal their irresponsibility. However, he is unmasked and sent to prison. After he is defeated Marva complains that submission to her evil husband Doctor Psycho has ruined her life: 'But what can a weak girl do?'[47] Wonder Woman is not sympathetic and urges Marva, 'Get strong! Earn your own living – join the WAACs or WAVES and fight for your country!' This message was constantly reiterated in Marston's stories. Hence, Doctor Psycho's origin story illustrates both Marston's ideologies about female empowerment and the mind/body dichotomy. Marva's mind is weak: she allows a man, Psycho, to use her body to conjure living ectoplasm. She complains she had no choice, but there is always a choice and her weak will damages her reputation. With Psycho's action in covering his own body with the facsimile of George Washington, a

president famed for truth in American culture, Marston demonstrates the impossibility of knowing the truth of the body by sight alone.

A second story in *Sensation Comics* 20, August 1943, continues Marva Psycho's journey to empowerment.[48] This story came at the time when the smear campaign against women in the militia was at its height as noted above.[49] Steve and Diana investigate a saboteur at Camp Doe. Camp Doe commander General Standpat, his name connoting his resistance to change, believes women are untrustworthy and is annoyed when Steve presents his second-in-command, Diana Prince: 'you deceived me major! I certainly didn't think you were bringing a woman lieutenant!'[50] Steve, as a true American hero responds, 'Sorry General, but Miss Prince happens to be an expert at detecting sabotage.' The General is not convinced and orders them to ride with the luggage: 'Alright! Bring your petticoat staff – but not in my car! You and *Lieutenant* Prince will ride with my luggage in the car behind!'[51] In effect, Steve and Diana are relegated to the role of camp followers, the traditional female role in the armies, consisting of families and women who serviced the needs of soldiers whether domestic, medical or sexual.

General Standpat's contempt and suspicion seem well founded when he is shot and states that a woman did it. His aide who takes over describes the WAACs as hysterical and proposes to place all the women under arrest. Diana gives the WAACs a lie detector test and discovers Marva Psycho has taken her advice and enlisted in the WAACs. However, Marva claims she has been framed for the attack on the General. To clear her name, Marva uses the magic lasso to force Diana to take her place on punishment duty. Under Diana's inspiration, the WAACs complete a twenty-hour job in fifteen minutes. Marva and Diana eventually discover the real criminal is Stoffer, a German spy, impersonating General Scott. General Standpat is forced to present them with medals.

With this story Marston illustrates women's potential for wartime work but also for independence from male tyranny whether domestic or in the workplace. However, as shown in the discussion about wartime propaganda and the Susie Rottencrotch campaign, suspicion of women

was not confined to their roles in the militia but also in concerns about purity and disease centred upon the sexually active and racially constructed female body.

Ethnicity, Beauty and the Showgirl Body

Part of Marston's plan was for Wonder Woman to overcome opposition and make slaves of men through her beauty and strength. Her beauty, as proposed above, was that of the national beauty ideal of the all-American girl, the Ziegfeld Girl or the Gibson Girl. Both models of femininity were icons of popular female beauty and models for young girls' behaviour in the early twentieth century.[52] Charles Dana Gibson's Gibson Girl was young, sporty and fashionable. She appeared in cartoons in popular magazines such as *Harpers*, *Colliers* and *Scribners*. The Ziegfeld Girl, along with the Gibson Girl of the early twentieth century, claimed to 'glorify the American girl' but, as Linda Mazejewski illustrates, they represented the beautiful white body in an era where 'a national white race was being delineated along sexual lines'.[53] The Gibson Girl and the Ziegfeld Girl represented early twentieth-century notions of the modern American Girl as 'a racial creation' in a time of national upheaval and mass immigration.[54]

The alignment of the superheroine with the musical star is not new. Bukatman draws parallels between the bodies of the superhero and the musical star.[55] He proposes that they share similar functions in that their bodies are both expressive and performative: expressive because the expressivity of the face is displaced onto the body performance and performative because, 'Superheroes enact a full-bodied, kinetic performance, very comparable to bodily performance in musical films.'[56] The body thus substitutes for the face in providing emotion, characterization and action. One can see this in some of Harry G. Peter's long shots of Wonder Woman leading the Holliday Girls in Marston's stories. This body expressivity and performance can be identified in Ziegfeld's approach to the showgirls' bodies in *The Ziegfeld Follies* in the

ways they moved. Certain body types of showgirl were suited to pose as beauty objects whilst others danced. The Ziegfeld showgirl body was classified through a hierarchy of beauty (by Ziegfeld himself) and this was organized along ethnic lines. The showgirl body was defined along negative lines of what she was not: Jewish, black, Asian or Latino. Ziegfeld girls were classified by height and performance: showgirls, named 'the A-Team', were statuesque and at the top of the hierarchy, their roles principally being to walk 'slowly down staircases or across the stage'; smaller girls performed dances and were dubbed 'ponies' or 'chickens'.[57] An example of the body types can be seen in the MGM film *Ziegfeld Girl* (Leonard, 1941) which follows three performers in the Follies: showgirls Sandra Kolter (Hedy Lamarr), Sheila Regan (Lana Turner) and the shorter, plainer Susan Gallagher (Judy Garland), the typical pony. Incorporating Susan, the pony, into the Ziegfeld stable implied that all types of female body and beauty could aspire to become an American beauty. In the film, Susan was quickly relegated to the chorus line as her body did not conform to the Ziegfeld ideal but her vocal talent raised her above the chorus line, a role usually assigned to the pony.

In describing the ideal American female face, Mizejewski states that at this time, '"Straight Americans" have [a] straight nose and short upper lips, as opposed to Jews, African Americans and "mongrel" ethnicities suddenly populating North American cities [of the early twentieth century]'.[58] Ziegfeld used a pseudo-scientific system to define Nordic. White Caucasian thus became the ideal type of female beauty and intelligence similar to that of Lamarr (who strongly resembles Wonder Woman).[59] It is also worth noting that Ziegfeld claimed in an article that there were distinct differences between the blonde, brunette and redhead types. William Marston also performed experiments that aimed to identify emotional responses to the representations on screen in his role as consultant to Universal and Paramount film studios. He conducted experiments with his lie detector in 1928 on blondes, redheads and brunettes from Ziegfeld's Broadway shows, classifying their responses to emotional stimuli on films such as *Flesh and the Devil*

(1926) and *Love* (1927).[60] The experiments were set up as objective and scientific aiming to identify whether hair colour influenced whether a girl was excitable or not and capitalized on debates circulating in popular culture at the time, for instance with the publication of Anita Loos's *Gentlemen Prefer Blondes* and the film *Blonde or Brunette*.[61] Marston concluded that 'brunettes enjoyed the thrill of pursuit, while blondes preferred the more passive enjoyment of being kissed'.[62] One can identify this in Wonder Woman stories. Wonder Woman is brunette and often distant to Steve Trevor, yet she enjoys the thrill of his wooing when he asserts his masculine command.

Despite the use of technology to support his claims, Ana Olenina argues that Marston shaped his theories according to his own preconceptions: 'his interpretation of these seemingly objective signs reflected preconceived ideas he drew from popular culture of this time'.[63] It is tempting to surmise the extent of Ziegfeld's ideas of female beauty on Marston as he came to similar conclusions about temperament in women. Furthermore, both were influenced by their perceptions of race formed from popular texts of the early twentieth century. Marston, for instance, argued his experiments proved a connection between the blonde gold-digger of Anita Loos's novel who exhibits a cold detachment in gaining her objectives and her 'heritage of … Northern ancestry, warriors and adventurers'.[64] In citing this connection, Marston showed the influences of earlier pseudo-scientific and anthropological studies of race and ethnicity, discussed above.

The Ziegfeld girl, and by extension Wonder Woman's body, is also constructed through fashion, consumerism and public spaces. Mizejewski connects the display of the Ziegfeld girl's body in *The Ziegfeld Follies* with the department store in which the shop window becomes a site of spectacular pleasure for the modern woman because it offers displays of the exotic and fantastic. Here, it is also worth noting body display is contained within the window frame, a neat metaphor for the comics panel. This can be seen in Wonder Woman's window-shopping trip on her arrival in America *Sensation Comics* 1, January 1942, where she regards with some interest the fashions.[65] Whilst she is

a spectator of fashions she is also regarded with curiosity, admiration and censure. She attracts varying comments: the negative from older, plain women, the positive from men. For instance, an old woman states, 'The hussy! She has no clothes on!' A second states, 'The brazen thing!' A third accuses her of attention seeking, to which a man responds, 'Sour grapes, sister. Don't you wish you looked like that!', and 'Boy! What a honey!'[66] Most tellingly a boy suggests she might be 'some sort o' publicity stunt for a new movin' pitcher'.[67] In other words, through her beauty and dress, she is identified as a part of the entertainment industry. As if to cement her relationship with consumerism and the entertainment industry, Diana is signed up by theatrical agent Al Kale. She quickly learns of the symbolic value of money and its potential for bringing out people's dishonesty when Kale double-crosses her and steals her earnings. Diana catches him and takes back her money.

Race, Gender and Pollution in *Wonder Woman*

As noted above, discourses surrounding race and gender in Second World War propaganda often concerned disease and pollution and several of these themes can be found in *Wonder Woman* stories. Stories representing the Axis powers – the Germans, Italians and Japanese – from Marston and Peter incorporate elements of disease, madness and the challenge to the controlled body. A story from *Wonder Woman* 4, December 1943 distinguishes the Chinese from the Japanese by featuring as its protagonist a Chinese girl, Mae Wu, captured and tortured by the Japanese. She is 'most carefully' whipped and set free to come to America to tell her story and display her scars. The story proposes the Chinese as taller and more beautiful than the Japanese whom Mae Wu describes as dwarves and monkey-men. The Japanese speak like snakes with an emphasis on 's' consonants; at the same time, they are elaborately polite. This supposedly illustrates the Japanese slavish mentality and worship of their emperor but it belies their actions which are cruel and disrespect female rights.

The Japanese set fire to Mae's village, kill every man and take off the women to become slaves. Perhaps the most significant incident of all, the inscription of marks upon the human body illustrates the differences between Japanese and American methods and honesty. Wonder Woman realizes the whipping marks are a code that gives Japanese agents in America a message: '4 stripes one way, 3 another – could mean a date – 4th month, 3rd day – April 3rd!'[68] Body issues of injury, disease and identity are identified in truths told by the body. Mae has scars on her back that inform Wonder Woman of the Japanese plan to infect female American bodies with a bacillus and Marston emphasizes the fiendishness of such a plot in a note: 'There are many diseases known to medical science which attack one sex but not the other. The common form of color blindness though inherited through women, does not affect females, but only males. It is not surprising, therefore, that Japanese scientists could find a madness germ which would drive women crazy while leaving men unharmed!'[69]

In other words, the Japanese plan to attack the purity of the bloodline, fouling the bloodstock with a viral attack using Japanese gnats to drive American women insane. The symptoms of this attack are similar to venereal disease such as neurosyphilis in which the sufferer is afflicted with mental deterioration and psychosis. The plot is resolved when Wonder Woman transfers a list of Japanese agents to Paula von Gunther's back by photo sensitive chemicals, a list she later develops to aid the Allies. The comparison of American with Japanese tactics could not be clearer. Japanese methods in conquering other races rely on violence and contamination of the body, whereas American methods of helping other races are non-invasive, peaceful and respectful of other bodies. The cruelty of one against the sensitivity of the other reflects their comparative invasion techniques on the bodies of other cultures.

The purpose of citing this story is to show how the body becomes a locus of national, ethnic and gendered knowledges. In addition, as noted above, the gendered and racialized body also becomes a centre for disease and corruption.

Love in Chains: Bondage, Discipline and Submission

As proposed in the Introduction, the heroine's journey is, in many cases, predicated upon love rather than violence. Stuller argues, a superheroine's love 'is the impetus, but becomes integral to their strength, and thus the success of their missions'.[70] This differs from the male model of heroism based upon violence and the frontier myth in American culture.[71]

Wonder Woman's mission in Marston's stories is to teach humanity the Amazon ways of peace and love. Unlike male superheroes, she redeems evil through love. In this aim, she expressed a key aspect of William Marston's ideas, for he believed peace can only be achieved if women become active rulers. Marston argued that, unlike men who are driven by greed and appetite, women are ruled by love and, given sufficient training, could become effective leaders of humanity, love leaders.[72] The whole point of Marston's philosophy is that a love leader must be strong and responsible. She must rule through loving domination. Women had to be re-educated to eschew the distractions of modern society so they could become responsible love leaders.[73] The prime examples of love leaders in Marston's stories are the Goddess, Aphrodite and Hippolyta who train Diana in leadership. In turn, Diana is a love leader to Etta Candy and the Holliday Girls, Paula von Gunther and several other women whom she redeems because she believes they can be good. It is significant that, when Wonder Woman wins the contest to reform man's world in the newspaper strips (8–10 June 1944), she is carried aloft by the Amazons who shout, 'Hola! Hola! Hail our Princess Diana- Amazon champion and future conqueress of the world of men!!'[74]

Marston's ideas on female empowerment and sexuality were forward-looking and controversial within the context of the 1940s but they matched wartime values of self-control and self-sacrifice for the greater good. Marston suggests this in a letter to Dr Sones: 'Wonder Woman frees slaves but not so they can lose control but so they can submit to loving masters – bad masters are dictators such as Hitler, Mussolini who dominate through selfish reasons of their own greed

and wickedness it is the responsibility to everyone 'never to submit to a non-loving person'.[75] Bondage was integral to this ideal and Marston's use of fetishism and bondage were misunderstood, condemned or brushed over by later creators, critics and feminists.

However, I do not wish to disregard Marson's use of bondage as irrelevant. There is an excessive amount of bondage as Hanley asserts in his meticulous statistical comparison of the bondage in the first ten issues of *Wonder Woman* and *Captain Marvel*, another superhero who seemed constantly to be restrained. Hanley demonstrates that, although Captain Marvel was tied up more than the average hero at about 2 per cent of the time, his bondage paled in comparison with Wonder Woman at 11 per cent. He concludes, 'When your worst is the same as the other guy's best, that's a substantial amount.'[76] Lepore also notes the 'careful, intimate detail, with utmost precision', with which Marston describes the scenes for Peter to draw.[77] For instance, in *Wonder Woman* 2, Fall 1942, Marston writes:

> Put a metal collar on her with the chain running off the panel ... Have her hands clasped together at her breast with double bands on her wrists ... Between these runs a short chain, about the length of a handcuff chain – this is what compels her to clasp her hands together ... This whole panel will lose its point and spoil the story unless these chains are drawn *exactly* as described here.[78]

However, if the bondage is considered only as a narrative trope, without understanding the message of the restricted body, then, like so many later writers and artists, there is the risk of producing stories only to titillate. Wonder Woman's bondage served a double purpose: both to titillate but also to reinforce female empowerment.

Wonder Woman's victory over bondage aligned her body with the symbolism of the suffragette movement in the early twentieth century.[79] Lepore argues this convincingly giving as an example Margery Sanger's delivery of a lecture on suffrage while chained and her influence on Harry G. Peter. Of the latter, Lepore suggests Lou Rogers, a feminist cartoonist, worked on the staff at *The Judge* magazine and Harry G.

Peter 'sometimes filled in for her'.[80] However, Peter had much stronger ties to the suffragette movement and a greater influence on the styling of the character than is often supposed.[81] Like Marston, he was an advocate of women's rights and produced artwork for 'The Modern Woman' (1912–17) which was an editorial in the *Judge* magazine. The similarities between Rogers's drawing of a suffragist breaking free of her bonds in *Tearing off the Bonds* for *Judge* magazine, 19 October 1912, and Peter's illustration of Wonder Woman breaking the bonds of prejudice, prudery and man's superiority to accompany William Marston's article for *American Scholar* 1944, are convincing.[82] Both figures stand upright and break free of bonds that are labelled with the ideologies restraining their freedom. Given the influences on Peter and Marston's work, there can be little wonder that chains, submission and empowerment are interconnected. In fact, Marston's stories about bondage, slavery and imprisonment are designed to inspire and inform the reader about the importance of loving domination and submission to loving authority outlined in his DISC model.

It is impossible to detach Marston's feminist message from his themes of bondage and fetishism for the messages underpin and are the raison d'être for the stories themselves.[83] Hanley asserts: 'Dismissing the bondage imagery to focus on the positive, feminist aspects of Wonder Woman means that one would have to dismiss the theory of submission that's at the root of bondage. By cutting away those roots, you lose the foundation of Wonder Woman's feminism as well … Wonder Woman was feminist and fetishist.'[84] Berlatsky proposes, 'Marston, Murchison, and Peter insist that condemnation of sexual violence can, and must, coexist with an embrace of sexual fantasy.'[85] The domination/submission principle is illustrated in Wonder Woman's weapons, the bracelets of submission and the magic lasso that are instruments of love supplied by the two loving dominatrices, Queen Hippolyta and the goddess Aphrodite. The magic lasso compels people to obey her whilst bracelets of submission curb the Amazon's appetite for domination.

The magic lasso is introduced in *Sensation Comics* 6, forged from Hippolyta's magic girdle. Aphrodite tells her, 'Whomsoever thy magic

lasso binds must obey thee.'[86] Wonder Woman reflects, 'I can change human character! I can make bad men good, and weak women strong!'[87]

The bracelets of submission, so invaluable in repelling bullets, also serve to curtail Wonder Woman's power. When they are removed, she becomes a berserker, ruled by appetite and male greed for power. The negative effects of appetite can be identified in *Sensation Comics* 19 when Wonder Woman's bracelets of submission are removed by her enemy, Mavis, who believes they are the source of her power.[88] With dismay Wonder Woman thinks, 'I'm not weak – I'm too strong. The bracelets bound my strength for good purposes – now I'm completely uncontrolled! I'm free to destroy like a man!'[89] With her unfettered strength, Wonder Woman wreaks havoc. Her rampage is curbed when Paula binds her with the golden lasso and orders her to 'Stop this mad orgy of strength – relax, I command you!' The last panel of this story shows Paula von Gunther welding Wonder Woman's bracelets 'tighter than ever'. Wonder Woman states, 'It's wonderful to feel my strength bound again – power without self-control tears a girl to pieces!'[90]

As noted above, in all of Marston's stories, there is a clear matriarchal line of female love leadership passed down from female to female ruler. Aphrodite passes her wisdom to Hippolyta and both train Wonder Woman to be stronger. In turn, Wonder Woman acts as love leader to the Holliday Girls, Etta Candy and Paula von Gunther, her arch-enemy. Paula is evil and kills without mercy. However, in *Wonder Woman* 2, Wonder Woman discovers Paula is acting out of love for her daughter, Gerta, held captive by the Nazis. Once Wonder Woman saves Gerta, Paula volunteers to go to Reform Island where she undertakes ten tasks for Aphrodite as penance. Paula is given to Wonder Woman for reform and from that day uses all her energies to support Wonder Woman. To ensure she is an able love leader Wonder Woman ties herself up with her magic lasso and commands herself to be a loving ruler reflecting, 'It's a tremendous responsibility to shape another girl's life and I **must** do it right!'[91]

In Marston's stories, the loving domination of the parents is crucial to the upbringing of the child and controlling his or her appetite.

Marston proposes that dominance is one of the first emotions evinced in human behaviour and he argues that strong parenting applied with love is the answer.[92] Children understand the necessity of loving domination and they enjoy the control of a loving person rather than having their own way. For instance, in *Wonder Woman 2*, when being beaten in a Martian tournament the narrator comments, 'The paddle descends and Wonder Woman is reminded of her childhood days and her mother's strong right arm.'[93] In *Wonder Woman 7*, Wonder Woman is once again called upon to become a love leader, this time for Gerta, who, like her mother, exhibits aggression towards her Amazon teacher, going so far as to throw a piano at her. Gerta is scared by her anger and explains to her teacher, 'I want to do as you say, Mistress Kathra! But sometimes I just c-can't.'[94] Wonder Woman refers to a magic sphere that foretells the future only to find that Gerta will become as ruthless and cruel as her mother because her aggressive dominating ways were not curtailed. 'You must find some new influence that will change her personality and make her loving and submissive', Hippolyta tells her.[95] Wonder Woman encourages Paula to take responsibility by ordering Gerta to obey her commands and Gerta obeys her mother out of love. Thus, Marston demonstrates that the most effective means of encouraging someone to submit to domination is through love. Wonder Woman advises Paula to take Gerta to America 'and teach her love and obedience'.[96]

Marston believed female domination was redemptive on individual levels and throughout society. Marston's utopic vision was that America would be ruled by a matriarchy in a thousand years as outlined in his popular philosophy book *Try Living* (1937). He explores the idea in *Wonder Woman 7*, in which Wonder Woman, Steve and Etta travel in ecoplasmic form to the future, AD 3004, which is a utopia with a female American president. However, men are constantly attempting to seize power and Professor Manly, head of the Manly Party, convinces Steve to run for president. Diana and Etta run against him. However, the Manly Party cheat and rig the vote and Steve wins the election. When he discovers the deception Steve refuses to bow to Manly's dictates and

is imprisoned.[97] He is saved by Wonder Woman and Diana Prince becomes president. Hippolyta states, 'Steve and all men are much happier when their strong, aggressive natures are controlled by a wise and loving woman!'[98] As Berlatsky suggests liberation is not possible without bondage.[99]

The motivations for bondage are significant in whether it can be regarded as aggressive or passive. An aggressive example of binding features in *Wonder Woman* 6. It is the first story starring the Cheetah, the alter ego of Priscilla Rich, a rich girl who is envious of Wonder Woman. Priscilla plans to humiliate Wonder Woman in public by showing how she may be restrained by excessive binding. Not content with shackling her and limiting her mobility with an iron collar around her neck, Priscilla also subdues her with the Brank 'a leather mask worn by women prisoners in St. Lazare Prison, France. It covers the entire face and muffles a prisoner's voice!'[100] The Brank silences women but also makes them the subject of mockery as their speech is unintelligible. This effectively restrains the unruly female body, reflecting the Amazon as a monstrous tribe on the margins of culture, unable to speak Greek and so deemed barbaric. That it is done in public is also significant. Beard notes how 'many women claim to find they have an "awkward relationship" to the domain of public speech – while putting it in the context of the western tradition of silencing women, and defining the males of the species as the *speakers*'.[101] Silencing women – through bullying, imprisoning, mockery or torture – are part of this diminution of their status. Hilary Radner corroborates this notion for she observes that patriarchy positions women to appear rather than speak.[102] It is significant that in this story the silencer is a woman not a man but it illustrates that patriarchy works and is perpetuated to turn women against each other.

This story evoked a quite different response in some audiences. A soldier wrote to Marston that he experienced erotic pleasure from seeing beautiful women bound and chained: 'Have you the same interests in bonds and fetters that I have. Have you studied such implements of confinement as you picture and write about? Have you

actual references to such items as the "Brank", the leather mask, or the wide iron collar from Tibet, or the Greek ankle manacle? Or do you just "dream up" these things?'[103] The soldier's letter inspired criticism in DC against Marston's bondage from Josette Frank and questions from Max Gaines, the co-publisher of All-American Publications who published *Wonder Woman*. In response, Marston wrote to Max Gaines, stating that erotic fantasies were fine so long as they were loving.[104] When bondage becomes sadistic it becomes a problem. He dismissed the writer as subject to his own unfettered emotions and that he was 'more feminine than the average male' and 'emotionally disorganised'.[105]

Conversely, an example of loving (but misjudged) domination is recounted in *Sensation Comics* 9, in a rare instance of Wonder Woman in a domestic setting.[106] To set the context of this story it is necessary to return to *Sensation Comics* 1. Wonder Woman decided she must take on an alter ego so she could be near Steve Trevor. She found Diana Prince, a nurse, crying on the steps of the hospital. Diana wanted to fly away to find her fiancé, Dan White. Wonder Woman gave Diana her earnings from her foray into the entertainment industry and took her place as Diana Prince. Several months later Diana (Wonder Woman) and Steve were confronted in a restaurant by Dan, now married to Diana Prince, who accused her of being unfaithful.[107] Dan returned home to his wife who begged him to let her become a nurse again so they could afford food for their baby. Wonder Woman agreed to swap places with Diana White. However, Dan chained her to the stove to stop her going to work. 'What a perfect caveman idea!' she exclaims. After Wonder Woman saved Diana from kidnappers and Dan's invention of a disintegrator shell was adopted by the army, Diana White returned to married life and motherhood. Wonder Woman observed, 'I'm glad to get my position back. But I envy you yours, as a wife and mother.'[108]

Although Dan White was not a wicked man, he abused his authority over his wife. Marston seemed to condone this for Dan was not punished in the story's conclusion and his wife, Diana, was content to return to her domestic duties once she saved her family from penury. One possible reason for this lack of condemnation was that Dan White

shackled his wife to the stove out of love. However, this resolution differed from many stories in which men mistreated their wives and women were admonished by Wonder Woman for submitting to cruel rule. Dan White may have shackled his wife through love, but as a man he was unable to rule her wisely, and she strode out of the house in frustration to get a job and feed her babies. He was only able to rule with her consent and her actions in asserting her agency were those of a love leader. However, Diana White could not rule effectively either as she had not been trained in leadership authority. According to Marston, this could only happen in the future. Marston suggested 'woman must be taught to use her love power exclusively for the benefit of humanity and not for her own destructive, appetitive gratifications, as so many women are doing, under the present appetitive regime', a concept in keeping with the notion of wartime individual sacrifice for the greater good.[109] Although women could begin to make inroads into equality, thanks to war, Marston did not believe they were ready to rule and bring about a female Utopia. He set his stories of a peaceful female-run society in either advanced nations, like the Amazons or Eros, the Utopia ruled by Marya (discussed below). Also note, his story of 'Wonder Woman for President' was set in AD 3004. He believed that a move towards female empowerment could begin after the war but a woman would not be president for another 1061 years.

Loving Domination and Submission in Institutions

Marston's main institutions for female authority are prisons, colleges, sororities and the workplace, and it is in the context of these spaces that the differences between male and female rule are defined. Marston's ideal prison is ruled by women who enact loving submission unto their prisoners and this was shown in Reform Island, the Amazon prison used to reform Paula von Gunther and her slaves, amongst other Wonder Woman villains. The gender construction of these spaces is no accident, but careful contrivances within a feminist agenda in which the

rituals of bondage and punishment are comedic and instructive. Beta
Lambda College, home of Etta Candy and the Holliday Girls, and
Paradise Island are both places both of pleasure in sorority rituals and
religious festivals where secretive girl culture enacts playful punishments
and sexy initiations. These all-female places epitomize the erotic
daydreams of men represented in S&M pornography and pulp novels.
For instance, on Reform Island, girls are made stronger by wearing ball
and chains which strengthen their muscles. In *Sensation Comics* 27,
1944, Paul von Gunther's slaves astound everyone after their
imprisonment on Reform Island by displaying their strength and
athletic abilities. In the same issue, Gay Frolliks, a girl framed for murder
by her fiancé, is forced to have fun. After a regime of dancing, skating
and enjoyment Gay forces her fiancé to pay for fun clinics across
America. Thus, fun as punishment empowers Gay.

Masculine institutions and prisons, however, are the reverse of
female-run prisons for they force prisoners into submission through
cruelty and crushing their spirits. Nowhere is this better illustrated than
in a story in *Sensation Comics* 11, in which Wonder Woman and her
friends travel to the Planet Eros through their astral bodies using dream
as a fantasy portal to make their bodies become immaterial.[110] Once on
Eros they discover the topsy-turvy prison system ruled by Marya,
Planetary Mother and Supreme Judge where young people are
imprisoned from the age of fifteen and punished by freedom. This is
explained by Marya: 'our prisons are designed to give the prisoners
perfect happiness'. Prisoners dance, become athletes, learn man-
fishing[111] and electrical engineering. However, the prison system has
thrown up a problem in Rebla, a girl who excels but who, when freed
and sentenced to serve as ruler of Transmountainia, discovers that
ruling is not as much fun as being a prisoner and retreats into her
laboratory. When a government force is sent to arrest her, she retaliates
by leading an army and shooting government forces with her paralysis
guns. She installs jails run by men in which to imprison her foes. Rebla's
forces defeat Wonder Woman and her allies and she allows herself to
surrender to Dominus, whom she has made Supreme Ruler of Eros.

Then she discovers her mistake, for the male jailer's idea of discipline is about curtailing pleasure and inflicting pain. 'To think I wanted to be a prisoner and let men like that rule in my place!' she sobs.[112] Rebla helps Steve to save Wonder Woman and order is restored by Marya who allows Rebla to return to a female-ruled prison. Rebla, like American women of this time, is weak and too interested in culture and enjoyment to take responsibility. She allows men to rule and, in doing so, subjects the prisoners to cruel and aggressive domination.

Domination, submission and individual responsibility are aligned; the onus is not only on the dominator to rule responsibly but in the freed slaves to renounce the rule of a bad master. An instance of this can be found in *Wonder Woman* 3, when Paula von Gunther's slaves refuse to work unless in chains. They attack the Amazons, crying, 'You can't free us! We'll die rather than be free!' The Amazons observe, 'They're fighting for woman's bondage – the Hitler principle that women must remain men's slaves!'[113] 'I can't understand these girls', their jailor, Mala, tells Wonder Woman who responds, 'You could if you knew women in the man-ruled world! They want to be slaves because they are afraid to be free and compete with men!' Then she ponders, 'A good mistress could do wonders with them!'[114] To free Paula von Gunther's slaves from her psychological control, Mala and Wonder Woman trick Paula into attacking Mala. The slaves 'leap on Paula their fury at her cruelty to one they have learned to love destroys completely the hypnotic influence of their former mistress'.[115] The Baroness cannot comprehend why her slaves attack her. Wonder Woman tells her, 'Love is always stronger than fear'. The girls insist they will be Mala's slaves. Mala instructs them, 'If I'm your mistress I'll make you strong and fearless like Amazon girls! No fetters during athletics-unlock your chains and come swimming with me!' In this example and that of Gerda, submission is encouraged through love rather than coercion.

Even institutions ruled by women are sometimes cruel when the woman forgets or ignores her natural disposition to love. Hence, in *Sensation Comics* 8, August 1942, the girls working in Gloria Bullfinch's department store are underpaid and one of them, Molly, becomes ill

through malnutrition. Gloria is misled by her fiancé, Guigi del Slimo, and Mr Goggins, the store manager, both in the service of the Axis powers. Wonder Woman hypnotizes Gloria to believe she is Ruth Smith, an ordinary worker. Once she discovers what her employee's work experience is, Gloria realizes her responsibilities as an employer.

Like all of Marston's stories women support each other. Molly's friend Helen steals vitamin pills to help her and goes to jail. The Holliday Girls are recruited to bring the evil-doers to justice. Gloria raises the girls' wages and restores justice and compassionate female rule.

Once women become love leaders they can dominate men through their allure. Marston argues that the female body is a dynamic machine. He challenged Freud's phallocentricism in an idea that was expressed thirty-four years later by Luce Irigaray: 'women's erogenous zones never amount to anything but a clitoris-sex that is not comparable with the noble phallic organ, or a hole-envelop that serves to sheathe and massage the penis in intercourse [...] the penis being the only sexual organ of recognized value.'[116]

Stories involving the Holliday Girls usually include an element of seduction where they capture or entrap the enemy through their allure. The first time the readers are introduced to the Holliday Girls is in *Sensation Comics* 2, when Wonder Woman devises a plan that will capture the enemies through seduction and free Steve Trevor. The Holliday Girls dress in similar costumes to a chorus line, with colourful short skirts or culottes, cheerleader hats and carrying their weapons, musical instruments. Wonder Woman is instantly connected with the Holliday Girls when she presents herself at Holliday College and her costume is mistaken as that of the new band costume. She informs Etta Candy, 'We need a hundred pretty girls brave enough to capture dangerous men!'[117] Wonder Woman tells the Holliday Girls, 'I warn you! There will be great danger! These men are killers! We have to march into the very muzzles of their rifles and machine guns! If any girl wants to quit, this is your last chance!' To which the girls respond with their mantra, 'If they're men, we can catch them!'[118] The army of a hundred beautiful girls that follow Wonder Woman into the trenches are nothing

less than her chorus line. Interestingly, this line-up of showgirls as army is also replicated in the final musical number of *Pinup Girl* a few years later in which Betty Grable/Lorry Jones lead a chorus of members of the Women's Army Corps in a complex drill for 'Cadence'.

The Holliday Girls also seduce their enemies by dance and music. In *Sensation Comics* 16, Etta Candy is to be married to Prince Hylo Goulash but he is a Gestapo agent, Karl Schultz.[119] Marston conflates Eastern European with Western and all Southern ethnicities under the blanket description Latin. When the Holliday Girls and Wonder Woman are imprisoned by Italians disguised as Mexicans, Wonder Woman notes that 'all Latins love music'.[120] She orders the Holliday Girls to play a dance tune for, the Italians 'cannot resist the lure of the girls' music – they ask their prisoners to dance!' As they are distracted, Wonder Woman escapes. Again, the Holliday Girls state they can capture men. Thus, the concept of capture of the penis by the vagina is enacted in the Holliday Girls' seduction of Axis agents. They act as Wonder Woman's chorus line, as Marston states that chorus girls and dancers captivate men through love mechanisms; they act as a model for positive dominance.

Conclusions

This chapter has laid out some of the interconnecting discourses shaping Harry G. Peter's and William Marston's original conception of *Wonder Woman*. Of necessity, it misses some aspects of the stories but it sets up the uses of dominance and submission underpinning Marston's ideologies and Peter's influences in constructing the look of the heroine. These messages were misunderstood by some members of the *Wonder Woman* editorial board. Josette Frank criticized the prevalence of bondage and sadomasochist symbolism, claiming in a letter, 'Personally I would consider an out-and-out striptease less unwholesome than this kind of symbolism.'[121] Marston was bullish in his defence: 'I will get you half a dozen [testimonials] from *real*

authorities, parents, teachers, educators, psychologists of national standing like Rhine, [...] who consider Wonder Woman a remarkably wholesome and constructive story strip.'[122] DC Comics assistant editor Dorothy Roubicek was given the task of responding to complaints and went so far as to draw costumes that revealed less flesh and make suggestions for fewer bondage scenarios – suggestions Marston ignored, declaring that 'There is a great danger in letting ignorant people monkey with delicate machinery'.[123] However, this did not prevent criticism and misunderstandings of the use of bondage and fetishism in the comics from other writers and artists producing good girl comics, comics that represented beautiful women, often in compromising situations of bondage and fetishism in this era.[124]

After the war, Marston's vision for female empowerment did not happen. Philip Sandifer observes that much of Marston's energy faded. This was probably due to his failing health for he became ill by the mid-1940s, and his vision could not be sustained outside of the war and America's need to secure a return to full employment for returning soldiers.[125] When Marston became ill towards the mid-1940s his punishing writing duties were taken over by Joye Murchison under his instruction.[126] Marston died on 2 May 1947 but his stories continued until the late 1940s, although more sporadically. Sandifer makes an exhaustive analysis of the transition from Marston to the next acknowledged Wonder Woman writer, Robert Kanigher, although Sandifer proposes there was possibly another writer.[127] On the DC Database Joye Murchison's writings are acknowledged but for *Wonder Woman*, 22 February 1947, 29 July 1947 and 30 August 1947 no writer is cited.[128] Peter continued to work sporadically on the comics until 1957, sometimes completing interior artwork with cover illustrations produced by Irwin Hasen and Bernard Sachs.[129] Peter died on 2 January 1958 and the art duties passed to Ross Andru and Mike Esposito.

The Marston and Peter stories set up tropes for later representations of the character that became problematic aspects of her representation. For how might a strong female character be represented in an era of

conformity and the return of traditional family values based upon essentialist notions of gender roles? As Robert Kanigher became the regular writer for the comic, gradually the feminist message of Wonder Woman was diluted and this has been well documented by Hanley and Sandifer.[130] Kanigher's transformation of the character from empowered woman to a gentler, more submissive character was in line with the post-war perception of the traditional woman and her role in the world. As the next chapter shows, the 1950s saw a return to the domestic environment of many women. Wonder Woman was no exception, but her family and domestic setting were located in a fantasy virtual environment.

'Here Be Monsters'

The Mutating, Splitting and Familial Body of the Cold War

Robert Kanigher's writing stint (1947–67 and 1972–73) is the longest of any in Wonder Woman's history, yet his work is the most overlooked or disparaged. For instance, Philip Sandifer states that Kanigher's writing style showed 'no identifiable style or interests, no ideology or beliefs; his most distinguishing characteristics lie in his adaptability and the sheer volume of his output'.[1] Tim Hanley notes that Kanigher seemed more concerned with filling six pages with action rather than explanations or any logical narrative development.[2] Kanigher was also not averse to repeating the same story. Sandifer and Hanley suggest that Kanigher gradually moved away from Marston's feminist agenda to respond to the changing political climate of a more reactionary era in the 1950s in which marriage and romance became the consistent theme. Reading the comics, it is difficult to disagree; however, some fascinating themes run through the stories that reveal concerns with culture in the late 1950s and early 1960s, the height of the Cold War between the West and the Soviet Union.

In fact, Kanigher's *Wonder Woman* stories articulated concerns of the era for, as Lori Maguire observes, the six-week period between story production and publication meant that their content reflected real cultural and technological fears.[3] Superficially, 1950s America seemed a time of affluence and stability, a golden age of family and traditional values where men were breadwinners, women were contented housewives and children were innocent and happy. However, this was also the era of moral panics, fear of communism, juvenile delinquency

and homophobia. As Craig This suggests, the threat of communism extended to homosexuality and feminism.[4] There was also discontent amongst groups who did not seem to share in the advancement of white male privilege, especially Afro-Americans and women. After the war, women were expected to return to the kitchen, become perfect housewives and mothers, and defer autonomy to their husbands. However, Betty Friedan's 1963 polemic *The Feminine Mystique* debunked the myth of female contentment in being a housewife, claiming that the home was a kind of concentration camp.

The return to roles in which women were assigned to the home to become housewives and mothers can be seen in comics of the later 1940s which emphasized romance and marriage. In *Sensation Comics* and *Wonder Woman* stories of this era Wonder Woman's agency was gradually eroded with a growing emphasis on romance and marriage. Her eroded agency was signalled in a softening image. Wonder Woman's boots from the 1940s gave way to Greek sandals tied with ribbons. *Sensation Comics* 94, November/December, 1949 cover was criticized because it depicted Steve Trevor carrying Wonder Woman across a river. Despite a growing emphasis on romance and marriage, Wonder Woman was forbidden to marry Steve Trevor because by doing so she could no longer be an Amazon. Therefore, Steve had to fall in love with Diana Prince before Wonder Woman could be his. This was explained in *Sensation Comics* 97, May/June 1950, when Wonder Woman became editor of the 'Hopeless Hearts' Department on the *Daily Globe*. In this role, she encountered prejudices against women in the workplace and the conflict of professional versus marital responsibilities. She pined after, but was unable to marry, Steve Trevor because her marital responsibilities might interfere with her crime-fighting. The editor Mr. Matthew, who bears a striking resemblance to William Marston, doubts her abilities to run the department, 'Fools! – She may be a wonder, but she's still a woman! And she'll fail! If men couldn't do the job, neither will she!' These comments seem tame compared with the tasks Wonder Woman had to achieve on behalf of women in the war detailed in the previous chapter, but they show how women's prospects had shrunk by 1950.

After Marston's death, Alice Marble's 'Wonder Women of History' page count dwindled from four pages to one by *Wonder Woman* 66, the last issue in which it appeared.[5] New features on romance and weddings took over. The Holliday Girls and Etta Candy disappeared over time. The new story arc targeted teenage girls, and Kanigher hailed them with stories of romance and fairy-tale fantasy, but *Wonder Woman* will also have been read by broader audiences because they were sold through newsstands and drug stores.[6] However, comics fandom was beginning to develop starting with letters pages and then comicons, and Sandifer claims the changes in fandom led to Wonder Woman's deteriorating popularity in the 1960s.[7]

Interestingly, the superhero stories in *Sensation Comics* during the late 1940s gave way to female-orientated stories by issue 97, May/June 1950. In this issue the stories included 'Headline Heroines' about 'Gallant Gwendolyne Garvin' who died in the attempt to save young Juanita Hardy from drowning but died of a weak heart.[8] 'Doctor Pat' was a continuing series about Doctor Pat Windsor, like Wonder Woman continuously harassed by her boyfriend, *Picture Weekly* reporter Hank Lee, to become his wife. The third continuing series was 'Romance Inc.' about a romance agency. The move towards female interest stories grew through the late 1940s and included the introduction of Lady Danger and Alice Marble's 'Wonder Women of History' feature from *Wonder Woman* comics. 'Wonder Women of History' was introduced from *Sensation Comics* v1 83, November 1948 and other regular strips were 'Astra, the Girl from the Future'.

The stories in *Sensation Comics* indicate changes in comics audiences and content for, in 107, January/February 1952, Wonder Woman was taken off the cover and the stories inside were given over to the horror genre. The interest in horror was signalled in this issue with an advertisement for *Star Spangled Comics* promoting a ghost story along with Robin, the Boy Wonder and Tomahawk stories, and was probably a response to the growing popularity of the genre led by EC Comics. The salacious and disturbing content in horror comics, particularly EC Comics, was an inciting factor in an attack on the moral dangers of comics. Comics were attacked in a Senate Committee and by the

Women's Catholic League. However, as noted above, the most devastating blow was in the book *The Seduction of the Innocent* by psychologist Fredric Wertham.[9]

Dr Wertham worked with children in his New York practice and, through little evidence and some falsifications, he blamed delinquency on comics.[10] At a stroke, comics content was infantilized with stories founded upon family values and superheroes' crime-fighting activities shackled by the prohibition of excessive violence. Of superhero comics, Wertham claimed, 'The superman conceit gives boys and girls the feeling that ruthless go-getting based on physical strength or the power of weapons and machines is the desirable way to behave.'[11] He likened the superhero to the effects of 'the Nietzsche–Nazi myth of the exceptional man who is beyond good and evil' and its effects on Nazi youth. The superman myth degrades human endeavour. Adding gender to his critique, Wertham described Wonder Woman as 'a horror type. She is physically powerful, tortures men, has her own female following, is the cruel, "phallic" woman. While she is a frightening figure for boys, she is an undesirable ideal for girls, being the exact opposite of what girls are supposed to want to be.'[12] In this critique Wertham ignored Marston's original ideals in creating the character, and from his description of the torture of male characters by Wonder Woman. It is unlikely he read many of the comics. Further, in his assumption she was the opposite ideal of female aspirations, he ignored what later feminist writers like Friedan were to claim were the domestic captivity of housewives and mothers. This argues that Wertham attacked Wonder Woman to contain her feminist agenda.[13]

Wertham's attack on comics led to the instigation of the Comics Code Authority (CCA), a comics industry self-imposed set of regulations that limited salacious or violent content in comics and stories. The CCA guidelines were specific on crime; the word was never to be shown in isolation or emphasized on the comics cover. For Wonder Woman, guidelines on crime, marriage and female bodies were important. Criminal behaviour should be treated as abhorrent and should always be punished with a clear moral message for the reader. Physicality should not show deformities or nudity. It also suggested that, 'Females shall be drawn realistically without exaggeration of any

physical qualities.' Further, as an independent career woman and crime fighter, Wonder Woman did not fit the traditional model assigned to women after the war so it was logical that she became a target of cultural concerns. In considering his assertion that Wonder Woman transgressed traditional gender roles, Craig This's claim that Wertham attempted to limit her feminist agenda seems sound.

One result of the CCA was that Superman and Batman suddenly developed families, girlfriends, best friends and super-pets, and they had to negotiate the necessity for marriage with the needs of fighting crime. Often the justification for bachelorhood was the fear of criminal retribution against their spouses. Yet, bachelorhood was a cultural trap to be balanced against the possibility of homosexuality. Therefore, the male hero had to be desirable but unavailable.

Like Superman and Batman, Wonder Woman suddenly acquired a family, although as discussed below a much stranger, though no less cosy, family than her male colleagues for it consisted of herself in three incarnations: Wonder Woman, Wonder Girl and Wonder Tot. The cosiness of the content was reflected in the artwork and the familial set-up of Paradise Island. The stories conjured up scenes of family contentment and happiness and this new setup began with a revision of Wonder Woman's origin story in May, 1958, v. 1 98.

For his revision, Robert Kanigher employed Ross Andru and Mike Esposito, known for their work with romance comics, to produce the artwork in a revision of Wonder Woman's origin.[14] They softened Wonder Woman's image from a warrior woman to a teen romance heroine with doe-eyes and full lips. Andru and Esposito, however, brought an energy to the style and composition of *Wonder Woman* artwork. They introduced a more dynamic, visual storytelling style than that of Peter, with cropped images, close-ups and unique facial expressions.[15] Robert Kanigher also introduced charming, yet bizarre, story arcs featuring the Wonder Family: Wonder Woman, Hippolyta the Wonder Queen, Wonder Girl and Wonder Tot. Many of the plots were modelled on or reflected fairy-tale narratives, filled as they were with genies, giants, dragons, and mythical gods and goddesses. Wonder

Woman lived an idealized family life. The stories were aimed at teenage and young female audiences. Yet these stories also reflected the realities of the Cold War, then at its height. The Wonder Family was a family without a father, a situation common in many American households after the war. The family was also attacked by nuclear threats in the shape of a nuclear monster that continuously returned. The fantasy space of Kanigher's Paradise Island became even more fantastic for Wonder Woman's siblings; Wonder Girl and Wonder Tot were her former selves who co-existed through magic technology, specifically a magic projector that created 'impossible stories'.[16]

In these 'impossible tales', *Wonder Woman* reflected the climate of fantasy resulting from the hysteria caused by Cold War propaganda in American culture, a paranoia manifested in the monstrous and grotesque bodies prowling the borders of Paradise Island for monsters and their monstrous bodies represent a response to the cultures and the realities that produce them.[17] They perform dual narrative functions reflecting cultural concerns but also functioning as narrative forces that inhabit the borders of the story world to preserve power structures. The Cyclops, one-eyed giants of *The Odyssey*, signify the foreign in Classical Greece because they represent the opposite of Greek democracy in their anarchic behaviour, extreme individualism and cannibalism.[18]

The places of monstrosity – the borders between reality and fantasy – were negotiated in *Wonder Woman* through technological apparatuses. Wonder Woman's invisible plane and lasso respond through an electronic-responder that recognizes the vibrations of her voice.[19] The blurring of the boundaries of science and magic meant to appeal to American teenage girls through nostalgia for a magical past but curiosity about a technological future.

Culture, Comics and the Cold War

A nation is constructed through its enemies, the shadowy Others of ideology. This is certainly true of America after the Second World War,

for no sooner had Hitler been defeated than America perceived a new threat to its own power and world stability in the Soviet Union.[20] Peter Kuznick and James Gilbert note that Cold War culture in America gave rise to the threat of nuclear catastrophe, tempered by the fear that full-scale nuclear conflict constituted too great a threat to life on earth to pursue an outright assault on the enemy nation.[21] The conduct of war therefore changed after the Second World War, and powerful nations such as America and the Soviet Union transposed their conflicts to third nations such as Vietnam or Korea. America attacked communist ideology through supporting insurgency, indulging in covert warfare abroad whilst pursuing an aggressive anti-communist propaganda campaign in its own borders. America was not alone in its propaganda campaign, for it became a tool of the Cold War, with both sides attempting to demonstrate their enemies' sinister plans for world domination. In America, this virtual ideological war translated into a fear and hatred of socialism and a hysterical paranoia around impending nuclear war. The McCarthy witch hunts, Hollywood films, comics, television shows, books and newspapers organized vitriolic attacks against communism and the enemies within, 'Seeing the world through this dark, distorting lens and setting global and domestic policies to consider them fanciful as well as real threats was and is, then, the largest impact of the Cold War.'[22] The end of the 1950s saw the greatest number of bomb shelters built in American backyards and 'duck and dive' exercises carried out by American schoolchildren. William M. Tuttle argues that this induced a contradiction in the ways children of this era were raised with the fear of death as a constant threat on the one hand and nurturing and open and permissive child rearing on the other. Death was a constant threat in the 1950s.[23] Many families had lost loved ones in the war, but government propaganda and public service messages reminded people of the threat of nuclear war. Atomic bomb rhetoric suggested there was nowhere to hide from nuclear fallout, for 'primal fears of extinction cut across all political and ideological lines'.[24] However, much of the anti-communist rhetoric was based on deception practised by the Soviet government as Khrushchev,

the leader, concealed the true extent of Soviet weapons. In fact, the Soviet Union's weaponry amounted to only one-tenth of American stockpiles.[25] The Cold War, therefore, was a virtual war with no hand-to-hand combat, based on hysteria, fallacy and a propaganda war of ideas against Soviet ideology.

This meant that the Cold War was based upon fantasy. It was fuelled by the fear of communism taking over the minds of Americans and an atomic bomb that may or may not be detonated. The family in Cold War America was a refuge from these fears, a domestic space of retreat and safety. The Wonder Family too existed in a fantasy land, Paradise Island, a retreat from reality. Yet, beyond its shores dwelt monsters that could and would attack the sanctity of the family.

The return to conservative values had a clear gendered approach with the family as its focus. Elaine Tyler May, for instance, argues that fears of communism and the destructive potential of atomic power in the Cold War encouraged the channelling of sexual energies into family life and conformity.[26] Women particularly had a difficult role in containing male sexuality: '[female sexuality] had to promote both abstinence and promise gratification; it had to indicate its presence by absence'.[27] The most crucial elements in family life, the parents, were regarded as models for correct behaviour while also being deemed culpable for the problems faced by society and their offspring in later life.

Dramas, sitcoms and films represented motherhood and domesticity as the only natural lifestyles for a woman. However, motherhood was both revered and deplored. Fear of female power seemed all-pervasive, especially in the mother's poisonous effects on her male offspring. In *Generation of Vipers* Philip Wylie describes excessive dependence on the mother as momism.[28] He likened the bad mother to monstrous women of myth – Medusa, Proserpine, the Queen of Hell.[29] In her content analysis of *Ladies Home Journal*, Joanne Meyerowitz notes that even women's magazines condemned idleness and frivolity, as it poisoned the next generation.[30]

Fathers too were constrained to be the ideal role model for their male offspring. However, masculinity was in crisis at the perceived

weakening of masculine influence in the family and workplace. *Playboy*, for instance, ran a campaign against the feminization of America, claiming that men were becoming soft and domesticated.[31] William Attwood, George B. Leonard and Robert J. Moskin bewailed the decline of American masculinity, claiming the causes as the absent or workaholic father figure and over-dominant mother.[32] This position was corroborated in *Better Homes and Gardens* (1958), which advised fathers to be on their guard against the over-dominant mother: 'You have a horror of seeing your son a pantywaist, but he won't get red blood and self-reliance if you leave the whole job of making a he-man of him to his mother.'[33]

The introduction of a father, possibly Theno, Hippolyta's long lost love, into the storyline is significant.[34] Where Marston suggests Wonder Woman was the product of parthenogenesis, asexual reproduction through the Goddess Aphrodite, the father's authority is reinstated in what must have been, within this socio-cultural context, a transgressive family. In 'The Secret Origin of Wonder Woman', Hippolyta and the Amazons, distressed by the loss of their men folk through wars, set sail to find a land where war is unknown.[35] Sailing through dangerous waters, the Amazons encounter a whirlpool, seas of ice and fire and finally a sea of gases that mysteriously transports them to an island paradise. Pallas Athena appears to inform them that, 'You have passed through the mists of eternal youth! You will always remain as you are providing you *never* leave this island!'[36] In this statement, Athena condemns the Amazons to a metaphoric prison – a situation similar to the domestic environment that Betty Friedan was to bewail in *The Feminine Mystique*. However, it is not totally void of liberation for the Amazons exist in domestic environments without male regulation.

This story introduces Wonder Girl as a teen. Wonder Girl is instantly represented as a wonder child who is perfect in body and spirit, a loving daughter and socially responsible. She is a daughter in training to be Wonder Woman, looking up to her future perfect self. In their journey to Paradise Island, Wonder Girl shows her prodigious powers and skills

as she single-handedly constructs their boat in one night and saves the Amazons from drowning.[37]

To make up for her absent father, Kanigher produced the perfect extended family environment in Paradise Island. Hippolyta is presented as the exemplary mother, caring, wise and just, qualities that she exhibits as Wonder Queen. Yet, despite her duties as queen, Hippolyta is a mother with normal maternal concerns and fears. For instance, when Wonder Woman ventures into a dangerous situation, Hippolyta muses: 'As a mother, I can't help worrying! But as an Amazon Queen …'[38] Earlier in that issue when Wonder Tot fails to learn how to catch air currents and falls, she is rescued by Hippolyta. When Wonder Tot tearfully asks her if she can try to fly again, Hippolyta states: 'No different than any other mother, I was concerned for my baby's safety and had to ignore the tears in her eyes.'[39] On a number of occasions Hippolyta's self-sacrifice is noted by her daughters who all agree that she is the real Wonder Woman.[40] Wonder Woman's previous selves, Wonder Girl and Wonder Tot continually show their loyalty and reverence for their older sibling by training hard to become Wonder Woman and comparing her excellence with their own efforts, often to their own detriment. In these stories Wonder Woman demonstrates her skills as a weaver, knitter and seamstress when she makes a dress for a fan from a pair of curtains, although in the same issue she admits she is a poor cook.[41] Kanigher's stories were filled with the camaraderie of Wonder Woman's extended family, Wonder Girl's romance with Mer-Boy and Bird-Boy, and Wonder Tot's adventures with Mister Genie. The stories also foreground exotic Amazon rituals, usually testing the endurance and skills of their bodies, and their battles with strange mythological creatures.

The stories exist in the fantasy quasi-domestic world of Paradise Island but Kanigher injects an extra dimension of fantasy with his invention of the impossible story. The impossible story is produced by Wonder Woman's splicing together the film from the magic-eye camera in a narrative collage to form stories of interaction between herself and her younger selves, a type of virtual reality.[42] The remainder of the

chapter deals with the story arc of the impossible Wonder family stories produced from these limitless spools of film.

The Impossible Family and the Menace of Multiple Man

The first story in the Impossible Family story arc is issue 123, 'The Amazon Magic-Eye Album!', in which a 'unique, automatic, multiple-lens magic-eye camera' photographic album is introduced as a means of capturing moving images of Wonder Woman in various stages of her development.[43] This story is an introduction to what became the Wonder Woman equivalent of the imaginary tale in Superman stories.[44] The following issue also runs a story of the magic-eye camera due to fan demand. On the splash page of 'The Impossible Day' the inset caption states: 'Science says it's impossible! and we agree! But, the Amazing Amazon still does!'[45] 'The Impossible Day' features the entire Wonder Family in 'three places at one time'. This seemingly impossible event is accomplished through the magic-eye camera. The action begins when Steve and Diana Prince come across cave drawings, millions of years old depicting the Wonder Family battling a Tyrannosaurus Rex. Diana thinks that 'It is impossible [...] but at the same time it did happen', and this prompts a flashback to Paradise Island at the Wonder Woman Clubhouse. Diana and Hippolyta are going through the fan mail and discover that thousands of readers want to see more tales of the impossible family. 'I wish I could fulfil their request! Impossible though it is!' Wonder Woman says. Hippolyta instructs her to come to the experimental photo lab.

The magic-eye camera functions in a similar manner to Henri Bergson's notion of memory.[46] Memory, argues Bergson, is experienced as duration but it comprises two types. 'Pure' memory is an unedited bank of memories of all our past experiences that we can draw on to inform our world. These memories can be brought back by external stimuli such as photographs, smells and sounds. The second type is the

memory image – an image drawn from pure memory image and once recalled it becomes part of the present; we can step into the memory through our recollection of the memory image. As Hippolyta explains the magic-eye camera, it is almost an exact description of Bergson's notion of the way memory functions with the snapshots functioning in a similar way to pure memory: 'Each snapshot is the first of millions! You press a button and it becomes exactly like a movie – with sound!'[47] The splicing together of the images do not totally conform to ideal image memory; rather they act as an assemblage:

> These are shots of you as a child [...] as Wonder Tot [...] walking down the steps of the palace. Now I'm going to run off shots of you and Wonder Girl in the same place, although at a different time naturally! There! I've added pictures of you and me [...] walking down those same steps![48]

Wonder Woman exclaims: 'It really looks as if the impossible is happening! As if the whole Wonder Woman Family is together at the same time and the same place!'[49] The last sentence demonstrates how, through this technology, the boundaries of time and space are blurred but also memory can be edited and reinterpreted. As an example, Hippolyta splices together a shot of Wonder Tot balancing a feather with Wonder Woman balancing on a finger to make it look as though Wonder Woman is balanced on Wonder Tot's finger.

A comparison might also be made here to the magic-eye camera and television.[50] Like television, the magic-eye camera produces teasers – significant moments at the beginning of the story to entice the reader into the plot.[51] For instance, scenes such as Wonder Girl and Mer-Boy in the City Beneath the Sea confronting a giant cobra, Wonder Tot falling from a tower and Wonder Woman fleeing from an unknown threat are extradiegetic teasers to prompt audiences to buy the comic but intradiegetic teasers for the Wonder Family to investigate. The Queen rewinds the pictures to the beginning of the story like an early version of a video player. The magic-eye camera presents a technology that is futuristic whilst reminiscent of television and

the ways it was regarded in 1950s American culture as a technology of fantasy.

In the 1950s, television increasingly displaced radio and print media as the principal source of entertainment and instruction for children and it had a unique quality that other media did not possess, in the ways it blurred time and space, fact and fiction. Alan Nadel, for instance, notes that television seemed like magic in the 1950s as it brought 'out there' into the home, thus providing 'citizenship, undaunted by distance, unobstructed by topography untainted by rhetorical manipulation'. First it brought the outside into the home through 'invisible waves'. Second, through television documentaries, news and fictions, one might encounter 'real life' within the living room. As Pat Weaver, Head of NBC programming, described in 1952, through television the viewer has 'full contact with the explanations of every mystery of physics, mechanics and the sciences [...] being exposed to the whole range of mankind's past, present, and the aspirations for mankind's future'.[52] Television was thus perceived as the 'apparatus of reality'.[53] In this way, television reconciled the impossible with the real.

Just as television brought the 'out there' to the living room, so the magic-eye camera domesticated the fantastic in Paradise Island. The magic-eye camera, like television, collapses time and space, bringing together Wonder Woman in different stages and places of her life, to produce an incredible narrative. As such, the magic-eye camera was an antecedent not only of video but also the virtual reality machine. It not only totally immersed the individual into a story, the fantasy became reality. So, in 'The Magic-Eye Camera', when a picture of Diana fleeing an unseen antagonist is shown, she is inserted into the snapshot using a molecular-reassembler projector.[54]

She emerges into a world where inanimate objects take on a life of their own. Just as fantasy became reality in the story, so the comics invited fantasy into reality outside the narrative. The panel showing the real body of Wonder Woman transposed over the snapshot of her fleeing an imaginary opponent also raises issues of time and duality. There are two Wonder Woman bodies in this image but they exist in

different time frames and in the same space. Of all the media, comics is the only form that can simultaneously display past, present and future at the same time conflating time and space. Scott McCloud discussed how, on the comics page, time is experienced through eye movement. The panel being read at any specific time represents the present. The panel to the left represents the past and the panel to the right represents the future. Unless the reader reads the page in a different order. However, the reader's eye can also take in the entire page, experiencing past, present and future simultaneously. In discussing how the reader experiences time and space through page layout and panels, Scott McCloud states, 'Wherever your eyes are focused, [on the comics page] that's now. But at the same time your eyes take in the surrounding landscape of past and future.'[55] It shows that even a writer as critiqued as Kanigher had a sound grasp of the potential of the medium to conflate time and space and, in these stories, his idea of the virtual camera is positively inspired.

The duality of the character in this story is repeated throughout these impossible stories. The story ends with Wonder Woman proposing that readers 'drop a card to Wonder Woman's Clubhouse and tell me whom you'd like to see! Wonder Tot [...] Wonder Girl [...] Wonder Woman [...] Wonder Queen [...]!' This invitation proposes the intrusion of the fantastic into the domestic of American life in the 1950s and 1960s, where the reader enters the fantasy of Paradise Island and can be lost in the virtual reality of the magic-eye camera. The boundaries between reality and fantasy are constantly confused, a situation akin to Jean Baudrillard's notion of schizophrenia in *The Ecstasy of Communication*.[56] Baudrillard suggests that the contemporary individual is subjected to so many images and media representations that they induce a state of hyper-reality where the real cannot be distinguished from the simulation.[57]

The Impossible Family stories come at the height of the Cold War and it is possible to draw connections with the climate of hysteria and paranoia arising from the threat of nuclear war because Kanigher locates monstrosity and the family within a virtual situation. The virtual

situation of the stories parallels the virtual situation of the Cold War, a war fought through ideologies. Jacques Derrida argues, it is impossible to discuss nuclear war with any authority because it has not, as yet, been waged: the 'terrifying reality of the nuclear conflict can only be the signified referent (present or past) of a discourse or a text'.[58] Therefore, nuclear war can only be understood through discourse and 'fabulous textuality'. As Derrida argues, because this war is based upon rhetoric and a catastrophe it can only be imagined. This suggests that fantasy and fictional literature would be of equal merit as evidence in discussions of nuclear war.[59]

As a genre of the imagination and the potential for technological development, science fiction is well located to postulate on the potential of nuclear energy to mutate, disintegrate and fragment bodies. The science fiction and fantasy texts of the 1950s and 1960s attest to this in films such as *The Attack of the 50 Foot Woman*, *The Incredible Shrinking Man* and *Them*. These grotesque bodies, often monstrous, and ever evolving appeared in superhero comics of the era, especially Marvel Comics that seemed predicated upon radiation as the inciting incident for the origins of characters such as Spider-Man, the Fantastic Four, The Hulk and the X-Men. In DC comics grotesque and monstrous bodies could also be found in the exploits of the Superman Family. Jimmy Olsen and Lois Lane's bodies mutated becoming fat, aged, gigantic, shrunken and animal-like.[60] The mutated grotesque body was, therefore a staple of comics' content in this era.

In *Wonder Woman* monstrous bodies abounded. Numerous stories feature fragmented or doubled bodies in which Wonder Woman competes against herself, mirror or robot versions of herself. Issue 98, for instance features 'The Million Dollar Penny!' in which the Amazons masquerade as Wonder Woman so Hippolyta cannot give Diana preferential treatment.[61] In issue 100 Diana competes against a herself from Dimension X.[62] In the Magic-Eye stories, she adventures alongside earlier versions of herself, Wonder Girl and Wonder Tot. The stories also feature versions of Wonder Woman in which her body is fat, gigantic, shrunken or elongated. In addition, her foes often display

monstrous bodies whether as hybrid creatures, mermen, bird men or giants. All these types of grotesque body can be found in the Impossible stories and the stories featuring the Wonder Family.

Monstrous Bodies

The Multiple Man stories begin when the Wonder Family encounter a nuclear test explosion just offshore of Paradise Island, and to prevent the fallout from hitting their island they create a cyclone to disperse the fallout. However, the Amazons 'are unaware of the fantastic creature emerging from the blazing core of the nuclear explosion [. . .] a creature fashioned out of unknown elements [. . .] assuming multiple shapes'.[63] A full-page panel incorporates three encrusted panels showing the changing shapes of Multiple Man from the atom, to a metal pillar and finally a giant. Multiple Man's aim is to destroy whatever stands in its way. It assumes the shape of a missile heading towards Paradise Island. No matter how many times the Amazons destroy Multiple Man, it returns in a different form, its mantra, 'Whatever I want – I take! Whatever stands in my way – perishes! Nothing can stop me!'[64] The only way Hippolyta can destroy the menace is to sacrifice herself and take it back in the past, to prehistory where she and her Wonder Children can defeat the creature.

In the second Multiple Man story, 'The Return of Multiple Man', Hippolyta receives yet more requests for another impossible story and this time it begins with Multiple Man attacking a plane piloted by Steve Trevor.[65] The Wonder Family defeat it by creating a whirlwind that prompts Multiple Man to change into sand. The sand is gathered up but slips through their fingers before they can dispose of it. Multiple Man then transforms into an iceberg and then into a volcano. This time the Amazons create a vacuum through funnelling the creature into outer space.

The final Multiple Man story, 'The Attack of the Human Iceberg', begins when the Amazons are frozen by Multiple Man, renamed

Nuclear Man, the Nuclear Menace.[66] Where the creature was silent or chanted in previous stories, in this tale he is more articulate – he aims to destroy Paradise Island so he can make the world his plaything. In this story Wonder Woman invites a fictitious reader, Carol Sue, to join her on Paradise Island. The party in honour of Carol Sue is interrupted by an attack of Multiple Man. Multiple Man turns into a giant ball and crashes against the underside of Paradise Island, inducing an earthquake. He finishes by turning into a giant clam that Wonder Woman's lasso binds and cracks. The story ends with Wonder Woman enjoying Carol Sue's party.

What is of significance in these stories are the fragmented bodies of giants and the Wonder Family, the former through the cutting up of the body in the comics' panels, the latter in the doubling of Wonder Woman and her virtual family. The doubling of bodies in the cut-up panels reflects what Rosemary Jackson suggests is the significance of fragmented selves in fantasy literature: 'The many partial, dual, multiple and dismembered selves scattered through literary fantasies violate the most cherished of all human unities: the unity of "character".'[67] Indeed, doubles and multiple selves have haunted fantasy narratives since the late eighteenth century and this, argues Jackson, is the reason for its subversive qualities, as it offers a challenge to the integrity of the narrator as the point of contact between the reader and the story. An unreliable, fragmented narrator highlights the problems of representation because it shows the impossible as possible. Body modification through splitting, doubling and mutating are shown with little realistic explanation within fantasy. Jackson proposes that fantasy satisfies our desire for what Lacan describes as the imaginary stage, a stage of life before the subject becomes inducted into society when they feel free to express their darkest desires, act without restriction and experience plenitude: 'Fantasies try to *reverse* or rupture the process of ego formation which took place during the mirror stage, i.e. they attempt to re-enter the imaginary.'[68] Doubling is a desire for the imaginary and is represented in the doppelgänger or copy, but also through grotesque and monstrous bodies such as the giant and the

miniature. In *Wonder Woman*, as in many superhero narratives, doubling often happens through technology. The previous section showed how Wonder Woman and her Impossible Family are the result of technological collage. It is tempting to connect this with the effects of television on audiences in fragmenting their identities, inducing a false consciousness, by overlaying their values with ideologies encoded within the media texts.[69]

Doubled and fragmented identities play a major part in the superhero genre in the alter ego but also the hero's relationship with the antagonist. Wonder Woman's alter ego, Diana Prince, is not foregrounded in the *Wonder Woman* comics under discussion in this chapter.[70] Instead, domestic doubling consists of Wonder Woman's three selves. Monsters and foes represent other aspects of the doubled body and fragmented identities permeating Wonder Woman's world.

Wonder Woman in the Cold War features evil and benign doubled bodies in Wonder Woman's earlier selves (the Impossible Family), robots, mutating rays, magic and parallel worlds. The monsters of these stories, like all monsters, are a warning, to challenge and test the power of the hero and at the same time identify the fears within culture.[71] In many of these stories the body is tested. Indeed, monstrous foes challenge the very cornerstone of American culture in this era, the family. The fears felt by Americans over such threats to the family are replicated in *Wonder Woman* in a series of gigantic foes intent on invasion. Stories featuring giant creatures, foes and Wonder Woman's expanding or shrinking body accounted for 90 per cent of the output between 1958 and 1963.

Gigantic foes evoke similar themes clustering around the elements, fragmentation/duality and gender. First, giants are nearly always male, apart from one story, 'The Human Charm Bracelet', where the giant Tooroo's wife Rikkaa is introduced. Tooroo lives on Planet G in a different dimension, and he collects earth's landmarks. Included in this collection is Wonder Woman, Steve Trevor and the invisible plane. Tooroo plans to present these to his wife, Rikkaa, on a charm bracelet.[72] Second, giants tend to be argumentative, aggressive and stupid. This

is in keeping with their fairy-tale and mythic roots, but also in their alignment with parental figures. Anne Lake Prescott notes how giants can seem both commanding and threatening but also childish.[73] To emphasize the magnitude of their bodies, giants' bodies are usually fragmented into body parts. For instance, in 'Wonder Girl in Giant Land', Wonder Girl is sent into another dimension when she hitches a ride on a rocket.[74] In this dimension giants challenge her to compete with them for the safety of the earth. In one test, she competes against a giant to leap across a chasm and to win this she rides on his back. The relative sizes of Wonder Girl and the giants suggests the relationship between the gigantic and the miniature. Susan Stewart notes that, 'the miniature makes the body gigantic, the gigantic transforms the body into the miniature, especially pointing to the body's "toylike" and "insignificant" aspects'.[75] In her challenge to the giants, we see only their hands and feet which seem monstrous compared with Wonder Girl. However, Wonder Girl is able to resolve their disputes in a mature manner, belying the implied weakness of her toylike insignificance.

The threat posed by Multiple Man as a shape-shifting atomic menace connects with Cold War culture and the threat to the family. Multiple Man conforms to ancient stories of giants and their bodies, particularly in fairy tales and myths. Indeed, the Multiple Man narratives are similar in structure and storytelling to the fairy tale. Kanigher uses oral storytelling devices such as repetitive language to provide a rhythm to the story to make a modern nuclear Wonder tale. Multiple Man's chant in the first story – 'The Impossible Day!' – 'Whatever I want [...] I take! Whatever stands in my way [...] perishes! Nothing can stop me!' – is repeated throughout the Wonder Family's futile attempts to slow him down.[76] Likewise, the ways Multiple Man's voice is described with each incarnation is another example. His first appearance from the core of the bomb, where he emerges from the core of the atomic explosion, depicts the way in which from the minuscule emerges the giant, like the gigantic mushroom cloud emerging from an atom. Multiple Man's voice is 'something *felt* like an icy wind blowing against one's face'.[77] In his second transformation, as a molten menace, Multiple Man's voice 'is felt

rather than heard … a voice like the breath from a furnace'.[78] In his flame form he is dampened by asbestos, and the lead that is produced from this smelting is fashioned into a bracelet by Hippolyta. Hippolyta takes the bracelet into the past when it takes over her mind, and there Multiple Man transforms into a Tyrannosaurus Rex, its voice 'like steam hissing from a locomotive'.[79] Multiple Man's voice is not heard in these transformations but is an intangible presence, and this is indicative of his unfixed, amorphous body state.

As in many fairy tales, Kanigher uses the rule of three, as rising action, to organize the plot: three daughters, each more powerful, clever and strong than the last; three tests to be completed each more powerful and devilish than the last. They demonstrate both the hyperbolic exhibition and the antagonist challenge narratives: the Wonder Family compete against each other to outwit and destroy the nuclear menace, but they continually rise to the tests he places on them through his transformations. In this, Multiple Man is also likened to an indestructible sorcerer who returns to test the Wonder Family. This type of tale is found in the fairy and folk tales that Antti Amatus Aarne and Stith Thompson describe, such as 'The Magician and his Apprentice' and 'The Giant Without a Heart'.[80] In the former, two magicians engage in a contest to see who can outwit the other through magical transformation. In the latter, an evil giant or sorcerer can only be destroyed by discovering where he has hidden his heart or soul. In its gigantic form, Multiple Man's body is reminiscent of the Classical Greek Titans, precursors and parents of the Greek gods. The Titans, according to Stewart, are brutish and connected with the earth, nature and the infinity of the sky.[81] They represent the chaos that comes before the order and law installed by the Greek Pantheon, spearheaded by Zeus. Like giants in folklore, Multiple Man is constructed around discourses of the natural. Stewart notes that 'the gigantic represents infinity, exteriority, the public and the overly natural'.[82] Giants' bodies can be identified within the description of landscape – the headland, the foothill – or else the traces of mythic conflict and activities, as in the stories that were created to explain the Giant's Causeway or Stonehenge,

'the order and disorder of historical forces'.[83] Multiple Man is an elemental giant who can become sand, water and metal, and his body has no solidity. Multiple Man's body connotes fragmentation, the nebulous and the grotesque. First, he is impossible to contain within a comic panel as a unified entity. In 'The Attack of the Human Iceberg!' his body is broken up by the panels down the left-hand side of the page.[84]

This disrupts the reading of the page; the arrows between the panels enjoin the reader to read down rather than from left to right across the page. Second, Multiple Man as a giant becomes the binary body to the minuscule. For instance, the Wonder Family stick to Multiple Man's body, like flies to a flypaper. He also emerges from the atom. Third, he is a shape shifter, his body is inconstant and in continuous process.

The fluid body of Multiple Man, like all grotesque creatures, is unfinished and abject. The abject body, often connected and derived from the grotesque, challenges and disrupts the boundaries of the body and culture and reminds us of humanity in its animal form.[85] It also challenges representation and order, for monstrous bodies cannot be classified. They appear at the borders of thought and language, 'lavishly bizarre manuscript marginalia, from abstract scribbling at the edges of an ordered page to preposterous animal and vaguely humanoid creatures of strange anatomy that crowd a biblical text'.[86] As Jeffrey Jerome Cohen notes, the monster is the harbinger of a category crisis, 'they are disturbing hybrids whose externally incoherent bodies resist attempts to include them in any systematic structures'.[87] Certainly, scientific rationality is not possible against the unruly monstrous body; it is not one genus but many – monsters dwell on the horizon at the edge of the known and invite new ways of thinking about the world 'the monster's very existence is a rebuke to boundary and enclosure', a 'living embodiment' of Derrida's notion of the 'supplement' it denies 'either/or'.[88] Instead, it postulates 'and/or'. Multiple Man, as a shape shifter, certainly disrupts boundaries – he transforms and his identity is nebulous, denying the notion of identity. For example, in 'The Return of Multiple Man!', the villain is drawn as amorphous mass with no

outline. In this story, his body cannot be contained by the comic's panel
and he cannot speak; rather, he grunts and growls. His body is fluid,
changing from wind to sand, to water and ice. It warns of the ubiquity
of radiation. As noted above, when the Wonder Family gather up the
sand forming his body, it trickles through their hands.

Conclusions

Wonder Woman's mythic roots are seminal to why monsters were
represented through fairy tale and myth. As noted above, monstrosity
and unruly bodies in these stories reflect nuclear fears in B-movie
science-fiction films such as *The Attack of the Fifty Foot Woman* and *The
Incredible Shrinking Man*.[89] These representations also show similar
cultural influences in comic narratives from the Superman family to
Marvel's monster comics and their atomic age superheroes. However, in
Wonder Woman the cultural anxieties over fragmented, splitting selves
are displaced from the alter ego, so central to masculine heroes, into the
many freakish and monstrous bodies that inhabit the frontiers of
Wonder Woman's fantastic world.

Like all monsters, Multiple Man cannot die. Like all monsters, a trace
element remains; as Cohen notes, 'No monster tastes death but once.'[90]
The trace element is in the painting of a caveman showing the Wonder
Family controlling the monster. This image shows a trace of the monster
but also blurs fact and fantasy, for the impossible day produced through
virtual reality is recorded on wall paintings, thus preserving the story
through history. While the Impossible Family's adventures take place in
a virtual reality, they become real, much like the postulations of atomic
war that might, at any moment, erupt into reality. Multiple Man's attacks
on the Wonder Family within a virtual reality emulate the founding of
Cold War rhetoric upon fabulation. In reality, children must learn to
'duck and dive', families must build bomb shelters for a bomb that is
never dropped and weapons must be stockpiled for a battle that will
never happen.

Wonder Woman comics in the mid- to late 1960s were hindered by the lack of good villains, a critique also levelled at the title by Sandifer. The most interesting villain was Multiple Man. However, Kanigher frequently forgot his backstory, his character, his speech patterns and even his name, so there was little continuity. Wonder Woman's other villains were either giants, monstrous double versions of herself, or hybrid, mythical beasts. These tended to be one-offs, often unnamed and with little character other than being monstrous.

Other Kanigher villains tend to be memorable for the wrong reasons. The most often cited is Egg Fu, a giant Chinese egg, who was an Oriental stereotype and spoke in sing-song English.[91] Mouse Man was a miniature villain who appeared in The Academy of Arch-Villains and was aided by his Mouselings – a collection of wild mice under his control.[92] His ploy in criminal activities was to scare women into dropping their jewellery. That his prison was a bird cage made him more ridiculous. The only other regular villain was Angle Man, who first appeared in 1954 as a criminal who used strategic angles to plot crimes.[93] These characters were ludicrous foes for a superheroine with powers similar to those of Superman and they did not conform to the most effective arch villain profile as an inversion of the heroes.[94] For instance, Batman's antagonists are bizarre and often crazy and they tend to act as foils for Batman's self-discipline and control. Superman who is vaunted for his strength is opposed by Luther, whose intelligence and invention are Superman's foil. The closest antagonists to Wonder Woman are often those who are opposed to her agency or attack her through jealousy such as Doctor Psycho, a misogynist, the Silver Swan and Cheetah who envied Wonder Woman's beauty, Circe, enemy of the Amazons, who appeared in George Pérez's 1987 reboot (chapter 4), or Veronica Cale who envied Wonder Woman's success (Chapter 5).

There is one other significant story arc in the Kanigher run of *Wonder Woman* and that is in the return to the Golden Age. The return to the golden age of William Marston comics began with issue 156, August 1965, in 'The Brain Pirate of the Inner World!' It begins with Wonder Woman reflecting, 'Fans always talk about … the "Good Old

Days!"... I'll ... take a look at those magazines in "The Dream Merchant Book Store" to see what all the shouting's about?'[95] Once in the comics shop, Wonder Woman is incorporated into a story featuring the brain pirate and the Holliday Girls. Andru and Esposito replicate Peter's artwork although Kanigher misunderstands the Holliday Girls' attitude towards Etta Candy. The story ends with an admonition to readers, 'This is not the end! ... but the beginning ... if you demand it ... for Wonder Woman to bring back the Golden Age of heroes and villains in one spectacular tale after another!'[96] A fan writing in issue 157 stated, 'I'd like ... to know whether other readers feel as you do. That a return to the past is indicated ... I am eagerly waiting for a reaction to *Wonder Woman* No. 156.'[97] The story must have been popular because, by issue 159, the stories were all based on those of the Golden Age, beginning with an origin that followed Marston's original, complete with the parthenogenesis birth. DC attempted to make their comics more upbeat by adding a jazzy black and white strip over the top of the titles. This appeared in the cover of *Wonder Woman* 161, April 1966. The covers consistently referred to the Golden Age and Kanigher incorporated Golden Age villains like Doctor Psycho, Paula von Gunther and Giganta in his stories but they lacked the creative invention of Marston's stories. Also, by 1966 Marvel Comics impacted upon audiences with their new types of heroes.

By 1968 it was apparent that DC Comics were becoming dated when compared with their rivals Marvel. Hippy counterculture influenced the development of the superhero genre which became more realistic, adopting real world political and social developments. In the late 1960s, to make her more relevant, Wonder Woman's creators took away her powers, her Amazon heritage and her costume, and gave her a whole new cast of secondary characters and villains in what was to be one of the most controversial periods in her history.

The New Diana Prince!

Makeovers, Movement and the
Fab/ricated Body, 1968–72

In 1968, an advertisement in the back of *Wonder Woman* 177 signalled a new story arc for one of the most radical revisions in Wonder Woman's seventy-plus years. The copy read: 'Can you believe you're looking at Diana Prince? In the next issue she'll turn around – and you won't believe your eyes!! But the most startling change is yet to come – Yes, the really big change is coming to – Wonder Woman!'[1] The image promised much. It showed a woman's back, presumably Diana Prince's, striking a fashion model strut and dragging a coat behind her. She was dressed in a fashionable orange tunic and striped green tights, the opposite of her usually dowdy, grey military uniform. This revamped version of Wonder Woman depicted a Diana Prince at the opposite end of the cool scale from the dowdy, military secretary. Previously Diana Prince was little more than a cardboard cut-out figure with no private life as noted in a fan letter: 'Diana doesn't "live". We know nothing of her character except she's a nurse, and in current issues, she is spending fewer and fewer panels in this identity.'[2] This was a profound revision because the creators, Dennis O'Neil and Mike Sekowsky, not only revised Diana Prince, they erased Wonder Woman from the stories. Riding on the spy craze of the mid-sixties, as Diana Prince she became a boutique owner, action chick and style icon.

The changes in *Wonder Woman* from 1968 to 1972 arose from political and cultural critiques in American politics of the late sixties that impacted on comic books of that time. Wonder Woman voluntarily

renounced her powers when the Amazons had to move to another dimension to replenish their magical energies. She stayed in the mortal realm to clear Steve Trevor of a murder charge. Even though Wonder Woman gave everything up for Steve, he died. Before this, though, she transformed herself into Diana Prince, fashionista, businesswoman and adventuress. After Steve's death, Diana was accompanied by her mentor, I Ching, a Chinese monk who taught her martial arts and Eastern mystical philosophy. Together they travelled the world as adventurers battling evil. However, Diana's battles were not only physical but symbolic as they were wars of fashionable bodies and the spaces they inhabited.

This chapter explores how fashionable bodies in the late sixties and early seventies disrupted spatial, psychological, symbolic, racial, gendered and geographic borders in *Wonder Woman* 178–203, 1968–72.[3] The stories in this era were underpinned by issues of spatial identities in which Diana Prince travelled between dimensions, around the globe and claimed space in her neighbourhood. The interdimensional travel was undertaken to confront threats to the Amazons. The global travel was for her to defeat the nefarious plots of Doctor Cyber, an evil inventor intent on world domination. The incursions to the frontiers of America and beyond were juxtaposed with narratives of the neighbourhood in which Diana tackled criminal countercultures or gangsters. Social commentary stories included issues of equal pay, beauty and the exploitation and objectification of female bodies but these happened near the end of the run. Prior to this, the stories focused on travel to defend and extend American's borders.

This patrolling of American borders hails back to the frontier myth and became a cultural obsession in late 1960s America. The frontier was a concept that John F. Kennedy introduced in his presidency of the early 1960s in his New Frontier speech, accepting the Democratic nomination for president (15 July 1960).[4] Kennedy proposed looking forward to the future prosperity of America, to defeat domestic inequalities and to extend the limits of the American frontier: 'we stand today on the edge of a New Frontier – the frontier of the 1960s, the frontier of unknown opportunities and perils, the frontier of unfilled hopes and unfilled

threats'.[5] Kennedy's assassination in 1963 inspired America to extend their frontier in the space programme and beyond American borders to Vietnam. The movement of bodies to challenge American borders is seen in the *All New Diana Prince* stories.

The stories were originally scripted by Dennis O'Neil with art by Mike Sekowsky and began at no. 178. Sekowsky took over scripting and art from no. 182. The main themes constructing the stories of this era were modern/traditional, control/limitation, access/exclusion, youth/age, beauty/the grotesque. The stories revolve around the significance of clothing and fashion but also issues of dualism and the balance of mind and body in making and performing the ideal female of the late 1960s. These ideas are articulated in makeovers of Diana Prince and Doctor Cyber, the one transformed through self-discipline into a docile body, 'a body that can be subjected, used, transformed and improved',[6] the other through quick-fix solutions like plastic or cosmetic surgery. The superheroine costume, in this era, no longer speaks for justice and liberty and this issue is discussed below. Instead, through training, Diana Prince fashions and presents her body as a commodity. Conversely, Doctor Cyber uses her mind to become rich and powerful but once her mind descends into madness her body quickly follows. Both women construct and perform identities through their clothing and the spaces they inhabit.

The Fashionable Body and the Superhero

Most theoretical studies of fashion begin by asserting the importance of the relationship between clothing and the body. Jennifer Craik, for instance, states:

> Clothing does a great deal more than simply clad a body for warmth, modesty or comfort. Codes of dress are technical devices which articulate the relationship between a particular body and its lived milieu, the space occupied by bodies and constituted by bodily actions. In other words, clothes construct a personal *habitus*.[7]

Fashion controls the body by encouraging the wearer to change their mode of dress and body shape to conform to beauty conventions of any particular era. Fashionable outer clothing is structured by the underwear and the body beneath. Craik goes further in claiming that clothing constructs a person's *habitus*. *Habitus* is the deep-seated knowledge, "'unconscious dispositions, the classification schemes, taken-for-granted preferences which are evident in the individual's sense of the appropriateness and validity of [her] ... taste for cultural goods and practices" as well as being "inscribed on to the body" through body techniques and modes of self-presentation.[8] The clothed body makes a statement about the wearer in presenting and performing identities. In these stories, fashion and the makeover effect the transformation of Wonder Woman to Diana Prince, a paradoxical transformation in the context of the superhero genre.

The makeover narrative in which an individual is transformed to conform to an ideal image is usually seen in female genres such as the rom com or the melodrama. However, the superhero genre could also be regarded as a makeover genre as it too is about physical and styling transformation, in which a drab alter ego transforms into a dynamic action man wearing figure hugging clothes to show off his musculature. For, at the heart of the makeover is transformation, from plain to beautiful. Transformation in makeover narratives is about conformity and acceptance of cultural 'norms' and expectations. For men, in broader culture, it is in a hard, muscular body. For women it is a beautiful body, fashionably clothed. However, there are exceptions in which the makeover conforms to specific contexts such as subcultural or professional identity in which performance of identity plays a role. For instance, in *Grease* (1979) clean teen Sandy has a makeover to become a sexy rocker. Danny is made over from greaser to clean teen. The context of the makeover is also significant for, as Erving Goffman notes in *The Presentation of the Self in Everyday Life*, face-to-face interaction usually involves a performance of identity within the context of the encounter.[9] Goffman also considered the disparate roles played by women in performing their identities and these involve

styling their identities: 'she is polishing her equipment, but not in battle; she is getting her costume together, preparing her make-up, laying out her tactics'.[10] In the sense of the public figure emerging from the private space, the drab alter ego transforming into the active public figure, the superhero, like the woman, performs a dual role. However, with the *All New Diana Prince* the makeover is inverted so the glamorous superhero identity becomes the unexciting other, because she is regarded as an establishment figure. Worse, she is old-fashioned.

Transformation and makeovers form a key component in many superhero narratives in which the masquerading body performs fragmented identities between the alter ego and the superhuman. The costume is a key component of this transformation, the switching of drab everyday wear for gaudy costume and marking the ordinary from the extraordinary.[11] Often, the superhero cannot act without changing into his or her costume and the costume becomes the identifying feature of the superhero within the comic's page through 'amplification through simplification'.[12] The reader can follow the costumed body of the superhero, which enables instant recognition for the reader of the progress of the superhero body through the comic's page. Costumes, as Barbara Brownie and Danny Graydon suggest, 'represent [...] an inversion of one's nature'; they allow the individual to perform an identity alien to themselves.[13] For instance, Diana Prince, the dowdy, shy career woman, is the inversion of the beautiful, assertive Amazon princess, Wonder Woman. However, this dichotomy changes in the late 1960s, for the transformation is from the glamorous Wonder Woman to the fashionable Diana Prince who, at one point, revels in her gloriousness proclaiming: 'Wheeee! I'm a butterfly on the first day of spring!'[14] There were sound reasons for this change in what was considered an acceptable powerful female body from the almost goddess-like powers of the Amazon to the kickass action heroine in mod clothing. Consumerism and fashion were not new issues for *Wonder Woman*; her first encounters with American culture included browsing in a department store window.[15] However, the department store in the 1930s connoted modernity, where women could engage in

public spaces to take pleasure in creating modern female identities. In the later 1960s, the focus of young female consumption was the boutique.[16] The boutique was a place of transformation and was associated with female agency and the active body.

The Doctor Cyber storyline appeared in nine out of the twenty-five issues between October 1968 (*Wonder Woman* 178) and December 1972 (*Wonder Woman* 203). There were three main Doctor Cyber story arcs: the death of Steve Trevor (178–82), the Hong Kong caper (187–8) and the Tribunal of Fear/Beauty Hater (199–200). In the first storyline, Diana infiltrates the murky, hippie world of the Tangerine Trolley Niteclub to prove Steve Trevor innocent of murder. To fit in with the subculture, she updates her wardrobe and becomes a mod fashion icon. She also discards her powers. The death of Steve Trevor and the Hong Kong Caper story arcs involve Diana and I Ching travelling across continents that become battle zones in their struggle with Doctor Cyber. In the final story arc, Diana is hired to protect Fellows Dill, a Hugh Hefner-like entrepreneur, who incurs the wrath of the Tribunal of Fear for his exploitation of women. In the conflagration following one of their encounters, Doctor Cyber's face is disfigured and in the final story she attempts to steal Diana's face with a face graft to regain her beauty. The three story arcs develop from typical popular spy plots, similar to Umberto Eco's notion of the spy narrative as chess game, towards the exploration of contemporary political and ideological issues such as beauty, feminism and gender.[17] The pseudo-spy story arc featured the all-new Diana Prince travelling the world with I Ching and was known as either the 'I Ching era' or the 'white suit era', because after wearing miniskirts and mod clothing in the earlier stories, towards the end of the twenty-five-issue run, Diana Prince began to wear white clothing.[18] The 'white suit era' coincides with the beginnings of second-wave feminism and in this era feminists claimed Wonder Woman as their icon. This had an impact on the continuation of the series.

The series' inability to address relevant feminist issues forms the basis of some critiques.[19] Others suggest that the era presents a critique

of feminism.[20] All of these discussions are mired in the connections between Wonder Woman and second-wave feminism. Whilst this is a perfectly valid approach, this chapter takes a tangential approach to feminism, locating it within its wider cultural context and exploring how Diana Prince is revised as an action heroine with no specific costume, and also how her body articulates female agency in its transformations and performance of the hip action chick identity.

Counterculture, Fandom and the Comics Industry, 1968–74

The reason for the makeover of Wonder Woman was twofold: the influence of countercultural values on heroism and changes in the demography of fandom. Heroes who articulated countercultural values appealed to the older teenage and college student audiences and subcultural audiences. Comics' audiences were growing older and wanted more mature and realistic storylines.[21] Comic fandom was developing, a result of comics publishers publishing fans' addresses in the letters pages, which meant that fans could communicate with each other. The later sixties saw the beginning of comicons and fanzines, an offshoot of fantasy and science-fiction fandoms.[22]

Countercultural values of younger audiences articulated notions of freedom of expression, peace and movement, through losing oneself either in drugs or travel.[23] The questioning of macho heroism spanned films, television and comics with younger, countercultural audiences criticizing American values. For instance, a film such as *Easy Rider* critiqued American values and the notion of the frontier myth through its subversion of the West and the road trip.[24] In this cultural climate, DC Comics's superhero stable, in which the heroes were universally admired and rarely questioned, looked outdated compared with their rivals in Marvel comics. Marvel Comics used a mixture of realistic soap opera narratives, clever marketing and promotion to appeal to students, fans and countercultural sensibilities.[25] The key concepts

in Marvel superhero's construction were relevance and realism; heroes squabbled amongst themselves, repaired and dry-cleaned their costumes, endured bullying at school, prejudice, got sick and had money troubles.

DC attempted to respond to changing comics audiences with pop art black and white banners and attempts to make heroes more relevant or realistic. Writer Dennis O'Neil, who updated Batman, Superman, Green Lantern and Green Arrow, was tasked with updating Wonder Woman. The twenty-five issues in the *All New Diana Prince* were masterminded by O'Neil and artist Mike Sekowsky, with writers such as fantasy author Samuel R. Delaney and artists such as Dick Giordano and Don Heck contributing material in the latter issues. There are significant similarities and differences in O'Neil's approaches to the characters. *Wonder Woman* and *Green Lantern/Green Arrow* were heralded as 'new' and contemporary in the banners above the titles ('Forget the old! The New Wonder Woman is here!', 'All-New! All-Now!'). The respective quests of the two characters separated along gender lines.

Between 1970 and 1976, Green Arrow and Green Lantern were forced to confront their hero status through a questioning of national morality.[26] They went on an *Easy Rider*-type trip across America to right injustices and challenge racial and class inequalities. In this way, they articulated national American values of redemption in the frontier myth. Diana's travel emulated the American frontier by travelling the globe, but rather than emphasize political inequalities, she articulated ideas about fashion and saved, or was saved by I Ching, her quasi father figure.[27] As Jennifer Stuller and Dawn Heinecken state, the heroine's journey is predicated upon love and emotion, the domestic space and family, rather than violence or cleansing the land of corruption.[28] I Ching, as a father figure, is an important difference between the male and female hero's journey. Stuller notes: 'A consistent theme in stories about the female super, or action, hero is that she is reared or mentored by a man rather than a woman.'[29] In earlier iterations of Wonder

Woman, she was mentored by her mother, Hippolyta and Aphrodite. She needed no father figure. However, with her mother's absence, Diana Prince fell into the narrative trope identified by Stuller in which the heroine's mother is usually absent in mentoring the female hero. When Wonder Woman visits the Amazons, she discovers Hippolyta lying comatose.

In her travels, Diana Prince's focus is on the personal rather than the national. On Green Lantern's and Green Arrow's road trip across America they are also accompanied by a father figure, one of Green Lantern's mentors, a Galactic Guardian.[30] However, he accompanies them to learn from them how human beings cope with American problems rather than to dispense advice. There is also a gendered difference in superheroes losing their powers according to Jason LaTouche. O'Neil forces Green Lantern and Superman to confront the real world, humanizing them and 'expanding their core strengths and ennobling their role as superheroes'.[31] Conversely, as LaTouche notes, when Wonder Woman gives up her powers and costume, her core strengths and sense of purpose are undermined.

O'Neil's, Sekowsky's and Delany's stories were contemporary and dealt with female beauty, women's rights, urban crime, the dark side of the hippie counterculture and Chinese communism. Towards the end of the series, Samuel Delany planned a six-part story arc dealing exclusively with feminist issues such as equal pay, education and abortion. Ironically, the reboot incurred the wrath of feminists.

Modernizing Diana Prince

In the first issues of this story arc, as suggested above, DC Comics's intentions are clear: they aim to depict a character who expresses the modern 'all new' female body. The modern female body in this era is represented by movement, youth, rebellion, consumerism and agency. In the early stories, Diana Prince's body is the centre of attention in

public spaces such as shops, fashionable parties, nightclubs, the street
and global holiday destinations.[32] However, where O'Neil used a
Hollywood model of rebellious antiheroes such as Billy and Wyatt in
Easy Rider for his revision of Green Lantern and Green Arrow, there
was no equivalent female model, except in the spy and action genre.
Women's bodies in the spy genre articulated modernity, feminism,
fashion, consumption and sexuality. Their sexuality was founded upon
the impact of the contraceptive pill and growing notions of female
equality arising from the civil rights movement in the late sixties. The
series also presented ambivalent views on youth culture; superficially it
espoused youth and modernity whilst criticising counterculture and
social issues.

As in all Wonder Woman stories, Diana is the standard of beauty
against which all characters are compared. She exemplifies Cartesian
notions of a perfect balance of mind and body in which the mind
controls the flesh. Doctor Cyber begins by being beautiful but she
suffers disfigurement which sends her on a quest to regain her lost
beauty. Cyber articulates the grotesque body that reflects a similarly
distorted mind. However, in these narratives Diana Prince and Doctor
Cyber express active female agency; they inhabit the world around
them rather than being condemned to domesticity. They take pleasure
in gazing upon themselves and their dress articulates power in their
rivalry rather than being chosen to attract men. In dressing, they express
ideas of the female active body circulating in the 1960s that foreground
the lived, vital body at ease with itself.[33]

Chief among changing notions of beauty and the female body was
the notion of the New Woman. The New Woman was promoted in
television, magazines and best-selling books by feminists such as Helen
Gurley Brown, author of *Sex and the Single Girl* (1962) and the editor of
Cosmopolitan. *Cosmopolitan* began publishing in 1965 and was
promoted as a 'handbook for the working girl'.[34] The New Woman was a
single career woman who did not depend upon a family for a sense of
identity or worth. She took pleasure in making herself attractive
through clothing, make-up and the beauty fix. Above all, she was single.

The New Woman wore the mod-inspired fashion of London, especially the miniskirt, and the shorter the skirt the more emancipated the body. Mod fashion connoted youth and female agency and was displayed in boutiques that attracted young people through their small scale, individualized fashions and an informal shopping experience.[35] Designers promoted the miniskirt using young, active female models such as Twiggy and Jean Shrimpton. In boutiques, models danced on raised platforms. In fashion photography, models jumped, cycled and ran.[36] This was different from the stilted poses, older profile and upper-class superciliousness of the *haute couture* models of the late fifties and early sixties. However, as Becky E. Conekin suggests, it was not a clean break but built upon fashion photography of the 1950s as promoted by the 'Young Idea' in *Vogue*. Youth fashions in the 1960s, principally from Britain, were promoted in America under the 'youthquake' banner by magazines such as *Life* and department stores such as J. C. Penney's and Macy's, who bought or commissioned designs from Mary Quant, André Courrèges and Pierre Cardin.

Diana's somatic journey from dowdy secretary to action chick differed from that of Doctor Cyber because, inspired by the pop aesthetic of the spy genre and its fascination with fashion, consumerism and movement, she demonstrated visual female agency in the comics panel. This story arc took as its inspiration television shows of the early to mid-1960s such as *The Avengers*, and James Bond films.[37] From *The Avengers*, Diana Prince took the pop aesthetic. From James Bond, she took global travel. Bond, like many tourists, could perform various alter egos in glamorous lifestyles that included fast cars, fine food and drink, and sexual encounters with beautiful women. The spy genre introduced a new type of assertive action heroine, one that *Wonder Woman* reflected in her style and body movement. The female spy could take care of herself and did not need a man to save her. This new woman was constructed through a combination of factors from the rise of second-wave feminism and its vocal proponents such as Gloria Steinem, Germaine Greer and Betty Friedan, and the popularization of the contraceptive pill which enabled women to be as free as men to express

their sexuality. The pill was a double-edged sword; although it enabled women to enjoy sex without the fear of pregnancy, cultural perceptions of female sexuality were mired in traditional views of female virtue. Earlier exultation in feminist debate over the pill providing female sexual freedom gave way in the early 1970s to suggestions that women should have the right to say 'no'.[38] However, Diana Prince could not explore sexuality because of the Comics Code Authority and its perceived teenage readership. Instead, Diana and I Ching were continuously engaged in conflict with Doctor Cyber without engaging in the realities of late 1960s politics, civil rights and cultural inequalities.

Pop Aesthetics, Female Spies and Consumerism

Pop, as a cultural phenomenon, saturated films, television and comics and was expressed particularly in the spy genre. The popularity of James Bond films inspired numerous spy and gentlemen detective narratives in television, film and comics. Bond films were increasingly detached from Cold War politics and departed from previous representations of imperial heroes, such as H. Rider Haggard's Allan Quartermain, because, as Michael Denning notes, Bond was defined by his relationship with commodities such as cars, technical gadgets, fine wines, food and luxury goods.[39] The emphasis on commodities was adopted from Bond by television series imbued with pop and consumer aesthetics. For instance, *The Avengers* (1965–68), *The Man from UNCLE* (1965–68) and films such as *Our Man Flint* (1966) detached the spy from his/her politicized and national agendas towards camp and style.

The pop aesthetic was modelled on camp, mod fashions and avant garde art. Mod style was inspired by art and emerged in Europe from the late 1950s. It exemplified the superficial for it 'not only embraced but amplified the neuroses of late twentieth century capitalist life – its obsession with surfaces and commodity fetishism'.[40] *The Avengers* was

hugely influential because of its two protagonists, John Steed (Patrick Macnee) and Emma Peel (Diana Rigg), who were a scientist and action heroine. Both took pleasure in the consumption of fashion, cars and the hedonistic lifestyle, usually ending an episode clinking glasses of champagne. Kingsley Amis, for instance, described the pair as a couple of freelance detectives 'who knock off a couple of world-wide conspiracies in the intervals of choosing their spring wardrobe'.[41] Emma Peel epitomized the modern woman whose trouser suits, courage and active body with martial arts expertise exemplified a new attitude to the female body and consumption.[42] Liz Smith from *Cosmopolitan* described Emma Peel as 'an internationally educated symbol of the jet-age female [who] fights fast, free, and furious with every technique from karate to her own brand of "feinting"'.[43] Emma Peel also attracted designers such as Jean Varon, reputed to be the designer of the miniskirt, to design a range of garments that could be stylish and functional for an action woman.[44] Chief in this collection were catsuits, an all-in-one trouser suit, which became known as Emma Peelers.

Comics also featured spy heroines in series such as *Secret Six*, *Nick Fury, Agent of SHIELD*, *The Girl from U.N.C.L.E.* and *Lady Penelope*.[45] Apart from Emma Peel, the inspiration for the *All New Wonder Woman* was comic-book heroine Jet Dream who appeared in *The Man from U.N.C.L.E.* series, issues 8–20, as a secondary story plotted by Phil Wood and, significantly, drawn by Mike Sekowsky. Jet Dream lived on an island named No Man's Land, with her stunt girl counter-spies ('my petticoat brigade') under the leadership of Agent Martin Brown. The counter-spies were a 'for hire' organization and all were experts in various martial arts. Their gadgets and machines, devised by Cookie Jarr, included gas bombs in lipstick holders, in effect making weapons out of consumable goods. Many characteristic tropes from Wonder Woman are present in these stories: morally ambiguous lovers as in the episode 'Achilles Heel',[46] white costumes, martial arts expertise and the use of sophisticated gadgetry and machines.

Feminism, Costume and the Active Female Body

In the late 1960s countercultural values and political corruption changed attitudes towards the superhero, especially the superhero who supported the establishment. Nowhere was the establishment-supporting superhero more evident than in the heroes sporting the patriotic costume modelled on the national flag. The Introduction and Chapter 1 have proposed that the reason for Marston and Peter's use of the patriotic costume was to ensure that Wonder Woman, an immigrant to America, was visually identified as loyal to the nation through wearing the flag and possessing beauty commensurate with American nativism. However, the countercultural values that pervaded the social fabric of America led to protests against the Vietnam War, racial and female inequalities and political corruption in Washington. Burning the American flag became a visual sign of protest, resulting in 1968 in Congress passing the Federal Flag Desecration Law that made the 'defacing, defiling, burning, or trampling' on the flag a crime.[47] So it is significant that Wonder Woman renounced her title and costume in 1968.[48]

The white costume in *Wonder Woman* connotes purity but also a clean slate and new beginning. Sekowsky and Don Heck discarded the notion of one costume in favour of a variety of white outfits from a white miniskirt to white trouser suits. Despite this, the white outfit had aesthetic impact, for it was an absence, a blank space on the page. In the highly coloured comics of the late 1960s, it is simple to pick out Diana's body progressing through the panels. In wearing these outfits, Diana also adopted the pop aesthetic of the spy-fi genre, but she also made a political statement about feminism through her body with her fashion choices and her active body within this clothing system.

Second-wave feminism developed in the mid- to late 1960s from the civil rights movement, with criticisms such as in Friedan's *The Feminine Mystique* that domesticity was stifling for women and calls for equality of pay and prospects in the workplace.[49] Notions of gender difference were questioned with a perception that, where men's bodies were taken for granted, women's biology held them back. Simone de Beauvoir

articulated this when she suggested that, 'A woman has ovaries, a uterus: these peculiarities imprison her subjectivity, circumscribe her within the limits of her own nature.'[50] Culturally, patriarchy constructed women through the culture/nature binary which, feminists argued, led to women being considered inferior. The binary assumed specific masculine and feminine qualities. Harriet Whitehead and Sherry B. Ortner, for instance, argued that culture transforms nature from raw materials and thus represents 'human consciousness and its products'.[51] Feminists themselves, however, were not immune from ascribing specific qualities to men and women. Greer and Friedan, for instance, claimed that women should cease cajoling and manipulating and instead use superior masculine values of 'magnanimity, generosity, courage'.[52] Such calls for the display of perceived masculinised qualities seemed to negate the very essence of gender equality second-wave feminists claimed, and can be critiqued through perceiving gender as more fluid, a debate that emerged in third-wave feminism in the 1980s. Judith Butler, for instance, suggests that gender is a performative masquerade.[53] We can assume different gendered positions in performances that replicate a type of cross-dressing, shrugging different identities on and off. In addition, the culture/nature binary is not necessarily the hierarchical model that patriarchal discourses might assume, for culture needs nature against which it can construct itself.

The culture/nature binary also underpinned debates about fashion in the late 1960s and early 1970s. Second-wave feminists critiqued fashion and consumerism because it was based upon culture/nature, in which the production of consumer goods and objects is deemed masculine whereas consumption and fashion, regarded as superficial and empty-headed, are coded as feminine. It is unsurprising that production, which powers capitalism, is the positive element in the binary. In this model women consumers are positioned as 'passive, dependent and gullible'.[54] Feminist debates claimed fashion of the 1950s fetishized and imprisoned women's bodies in uncomfortable or restrictive clothing like stiletto heels and corsets. The unstructured fashions of the 1960s such as the miniskirt, conversely, connoted

modernity and freedom for the female body. However, the new types of clothing that emphasized the unrestricted body were as draconian as corseted 1950s fashions. Ultra-thin and androgynous models such as Twiggy set up impossible goals of body shape for women. Fashion, claimed feminists, forced women into adopting plastic man-made female identities; thus fashion became a type of 'false consciousness'.[55] Fashion repressed more vulnerable workers such as women and children who often worked for low wages to produce fashionable garments.[56] To counter fashion ideology, feminists proposed that women might dress in trousers and present a natural look and, through the blurring of the presentation of gender, reclaim a 'real' female identity. The natural look was the key to authentic female beauty, something that Diana might express in wearing white trouser suits.

These critiques can be countered with later research into female consumerism and fashion which, it is suggested, enable female empowerment through pleasure in self-creation. After the Second World War, female identities were constructed through the nexus of consumerism and beauty.[57] Consumerism enabled women to make themselves beautiful irrespective of male approval. A significant part of this self-creation was in the makeover which women did to achieve a moment of 'gloriousness'.[58] Feminists claimed that the feminine quest for beauty subverted patriarchy in two ways: by destabilizing the male gaze which is defunct in the face of female pleasure and agency; consumerism and fashion also enable female empowerment through experimentation with goods in creating new identities and the adoption of new lifestyles. Further, restrictive clothing and fetishized fashions enable female empowerment; the stiletto being a sign of power.

Diana is presented as having the ideal natural female body, but this naturalness conceals contrivance in rigorous training. The training through which Diana tests and drills her endurance is shown in several issues. Her mind controls her body. Conversely, Cyber's body constantly changes and evolves as her mind escalates into madness. Diana and Cyber use fashion, lifestyle and consumerism to effect transformations through makeovers.

Makeovers, Space and Female Agency

Wonder Woman adopted ideas from female genre texts in its extensive use of makeover plotlines to transform and empower women. Although in the early comics women transformed themselves for men, by the later stories, they transformed as self-creation and reinvention. Makeover provided access and empowerment in public and private spaces but also expressed empowerment through beauty and, if not beauty, coolness. The ways makeovers empower female characters can be illustrated through the bodies of Diana Prince, Cathy Dawson and Doctor Cyber. Extra-diegetically, Diana Prince was given the ultimate makeover by her creators, but the narrative is filled with makeovers. Diana Prince has two makeovers: the first self-motivated, driven by her love for Steve Trevor; and the second by her would-be lover, English nobleman Reginald Hyde-White.

In these makeovers, Diana, Cathy and Cyber exhibit differing attitudes towards how they inhabit and control space. Diana's makeovers provide access and empowerment over forbidden and restricted places such as the Tangerine Trolley Niteclub and London high society. Doctor Cyber's attitude towards makeover and fashion is capricious. At first, she is playful in her use of fashion to claim space and then obsessive in her drive for beauty. Cyber, like Diana, commands public and global spaces.

Clothing, as noted above, is responsible for presenting differing identities and lifestyles and this is evident throughout *Wonder Woman*. Where in the previous *Wonder Woman* stories Diana Prince transforms through magic, in this new storyline consumerism is the magical incitement to transformation. The makeover is a recurring trope in women's genres such as the melodrama, the romcom and the musical, where the transformation is effected to make the heroine a good little capitalist and then get a man. The film *Now Voyager*, for instance, establishes the format in which plain, neurotic Charlotte Vale is transformed into an assertive woman able to defy her domineering mother and family.[59] This early model establishes recurring tropes in

the makeover film including the mentor, usually male, who, like Pygmalion, oversees the transformation of his Galatea.[60] Diana herself makes the decision to change to help Steve by infiltrating the Tangerine Trolley Niteclub. She reflects this cannot be done as Wonder Woman, using Alex Block's description of her: 'I'm not a woman, but a freak who will send her beloved to his death.'[61] She also cannot do this as Diana Prince, 'a nobody'.

There are three clothing systems presented in Diana's transformation: the uniform, the costume and fashion, all shown on the cover of issue 178. All three connote cultural control over the body.

The cover of no. 178 shows the transformation of Diana Prince through her three different identities: the superheroine, the military maid and the mod chick, with the latter clearly positioned as superior. To the top left third is a facsimile of an old *Wonder Woman* cover showing Wonder Woman and Military Diana against an orange background. Wonder Woman and Military Diana's bodies are restricted physically and symbolically by their clothing. Physically the military body, as Foucault argues, is controlled through repetitive movements and discipline.[62] It is a body controlled by the institution, its place in the hierarchy is instantly recognizable by colour, shape and decorations.[63] As suggested above this was an era when American values were questioned and military uniform, like the patriotic costume, connoted compliance with American politics, foreign policy and imperialism. A further negative aspect of Diana's military uniform is its drabness, compared with the vitality of Diana's fashionable body. Diana in the early 1960s conformed to the model of a 'mouseburger', a single woman who could not get a man and so fulfil a woman's natural role in life as a wife and mother. By the late sixties the perception of the mouseburger changed with the *Cosmopolitan* New Woman project, in which Helen Gurley Brown proposed the mouseburger as the New Woman.

The makeover enables the individual to perform different identities. In the case of Diana Prince, it overlays her previous military *habitus* with that of the swinging chick, a New Woman. Diana's first makeover is depicted as a montage that conflates time and space.[64]

It is effected much like the transformation of the alter ego into superhero, in the blink of an eye. The before and after on the comic's page are spatially as distant as is possible. The eye travels down the page from the top left in a spiral following Diana's progress, thus stretching out the space through eye movement. The background in the top and bottom sections of the page are psychedelic swirls that show the before (top left) and after (bottom right). The middle-section background is blank leaving a space to show the decisions Diana makes in restyling herself. The clothing, like much mod fashion, has the effect of flattening out the body.[65] The human body thus became part of a design code that transforms it into a master design surface.[66] In this surface design code, the fashionable body of the spy pop text visually reflected superhero aesthetics, itself dominated by the costume as visual signifier.[67] The black and yellow cape and hat Diana wears flatten out her body, while the two-dimensional clothes surround her, reminiscent of the cut-out doll wardrobes from romance and fashion comics from the forties onwards such as *Millie the Model, Katy Keene* and *Patsy Walker*. Cut-out dolls also presented the opportunity for readers to makeover their favourite characters and readers sent in their drawings and suggestions for fashions which were featured in the comic.

Another aspect of Diana's body challenging borders is in the disappearance of the border in this comics page, which bears similarities to the fashion drawings shown in comics such as *Millie the Model*, except that, unlike Millie, Diana's active or transformed body continuously disrupts the comics panel. In 'A Death for Diana!' she demonstrates her new martial arts skills under the guidance of I-Ching to PI, Tim Trench. On page 8, her 'relentless conditioning' is shown, where I Ching advises her they are 'techniques which make of the human body an instrument of more-than-human-power'. Diana is shown using yoga to control her underwater breathing, meditating to 'free [the mind] from the human flesh. Ultimately, you will be able to send your mind where mortal forms may not go!'[68] The page dispenses entirely with panels. Instead, Diana's body is shown in various stages of her training. On page 12 Diana

demonstrates some martial arts moves on Trench. Sekowsky uses panels at odd angles to unbalance the page's composition as Diana tips over Trench's chair, lands on him and demonstrates a chop to his neck to complete her victory.[69] Diana's body, in a purple and yellow catsuit, bursts out of the panels on the page, forcing Trench's gun hand into the gutter. Diana's agency on the comic page is shown again in 'The Tribunal of Fear', in which she trains to protect Fellows Dill from the Tribunal of Fear that intends to assassinate him. Again, there are no panels; instead, Diana's body is scattered over the page, training 'for sixteen hours a day, seven days a week, she punishes her body to bring it to the peak of perfection'.[70] Again, the images of bodily training are tempered with mind over body yoga meditation.

Diana's second makeover is provided by Reginald Hyde-White in Carnaby Street, London. This makeover is more traditional in approach as it is facilitated and paid for by a man, Diana is passive and her transformation constitutes an acceptance of being defined by a man.[71] Sekowsky's rhetoric affirms this – 'Happiness for any healthy, red-blooded young gal, is bedecking herself in the latest fashion finery' – familiar hyperbole that could have been taken straight out of a Marvel comic.[72] As noted above, this makeover facilitates Diana's entry to London society and the spaces she and Hyde-White inhabit by transforming her identity. Fashion becomes a means of identity masquerade whilst also socially constraining the individual. The uniform and the costume conceal the self – the uniform subsumes the 'real' identity within the institution, the costume conceals the alter ego. The superhero costume may connote the vigilante, maverick body. Paradoxically, however, it conceals the masquerading self, whilst revealing the body on display, the extraordinary concealing the ordinary.[73] Fashion, too, bears similarities to the function of the costume for it conceals the self, projecting an alternative version of identity through style and its reference to a specific performative identity. However, unlike the restrictive nature of the costume, in *Wonder Woman* 178–200 Diana is superficially freed from the constraints of national and institutional boundaries by fashion.

In her uniform and costume Wonder Woman was prevented from accessing certain spaces as her apparel connoted American foreign policy. Whilst fashion seemed to constrain the body, as a universal cultural language, it enabled movement across national boundaries. In 1971, for instance, in *Wonder Woman*, 197 a reader noted the possibilities for Diana's new fashionable *persona*: '[she] doesn't need to be a Wonder Woman in costume, because she now goes international, wearing the latest in clothes, using her brains, and martial arts ... she can be more open in her pursuits while in 'plain clothes' instead of announcing herself with her costume'.[74]

This is shown when Tim Trench, I Ching and Diana decide to travel to Bjorland in Europe.[75] Trench states: 'get packed! We're gonna take ourselves a European vacation!' The bottom three panels of the page show how time and space are condensed 'within hours the trio begins their hunt [...] A giant jet lifts them off American soil.' The next panel shows the plane landing, it 'carrie[d] them thousands of miles across and ocean, and deposits them in a small European country'.[76] This fashionable Diana expressed notions of the spy as tourist and *flâneur*, roaming the earth unlimited by institutional and national restrictions. As such, like other fictional spies, she became the ideal tool for an examination of 'duty to a higher authority (the state) and the individualism produced by the new consumer culture'.[77] The spy was the ideal tourist, travelling to exotic destinations on what Louis Turner and John Ash describe as the 'pleasure periphery', the borders of the developed world.[78] The spy may belong to a national institution but they have a free roaming nomadic lifestyle and are nationless, traversing borders as required to defeat global criminals.[79]

The Uncontrolled Body and Uncontrolled Mind of Doctor Cyber

Of all of the female characters Doctor Cyber displays the most fluid performing identity, ranging from masculinized cyborg to colonial

coquette and ultimately arch fiend. Doctor Cyber is signified by
liminality and a body becoming through style and spatial appropriation
and domination. Like Diana, Doctor Cyber is responsible for her own
makeovers and those of her henchwomen, whom she dresses in mod
uniforms. However, Cyber's makeovers are predicated upon violence
and domination. Cyber also exhibits more agency than Diana.

Diana's use of fashion and consumerism and her body connoting
female agency in the comics panel was discussed above. However, she
failed to connote female agency in the narrative. The villain usually
incites action in the spy and the superhero genres.[80] Her antagonist
Doctor Cyber manipulates Diana and I Ching's movement into specific
locations from where she can destroy them. This manipulation, as noted
above, reflects similar narrative strategies used in James Bond books and
films in which the spy and villain combat in an elaborate chess game.[81]

In addition to manipulating the movement of Diana and I Ching's
bodies, Cyber challenges the boundaries between animal and machine.
She performs anarchic identities and somatic manipulation. In short,
Cyber epitomizes Donna Haraway's notion of the cyborg.[82] In a famous
quote Haraway states, 'I'd rather be a cyborg than a goddess.'[83] Thus, she
refutes second-wave feminism's belief that a woman can be empowered
by her return to powerful female archetypes such as the goddess (a
concept discussed in the next chapter). However, the goddess is based
upon the female body made up of flesh and articulated through the
female body. Haraway proposes the cyborg, a creature poised between
reality and myth, is a paradigm on which to empower oneself. The
cyborg challenges classificatory systems and binaries such as human/
animal, human/machine and physical/non-physical, and opens oneself
up to more fluid ways to think about gender, race and identities. The
cyborg, and Doctor Cyber, by extension, has the potential to cause
anarchy by the challenge to traditional boundaries. Haraway points to
two possibilities with cyborg control. The first in an apocalyptic war, as
she notes (in a similar sentiment to Marston), a masculine 'orgy of war'.
However, cyborgs also offer the potential for people to embrace
heterogeneity rather than homogeneous identities. Taking a concept of

Jacques Derrida here, the cyborg challenges us to break down Western philosophic binary thinking.[84] Rather than think of the world through 'either/or', which excludes and creates opposition, think of the world as inclusive, 'and'.

As a patchwork creature made up of animal and machine parts, the cyborg does not ascribe to essentialist notions of gender; rather it has the potential to cause chaos by its refusal to ascribe to the either/or of male or female. This can be identified in the reader's introduction to Doctor Cyber whom I Ching refers to as 'he'. I Ching tells Diana how Cyber enacts a plundering of the developing world in her colonial enterprise for world domination. He explains that Doctor Cyber's agents destroyed his temple, looting it for treasures.[85] I Ching's quest to stymie Doctor Cyber reflects an ideological position similar to William Marston's notion of domination: 'I pursue Doctor Cyber for reasons of love! I love humanity … and if Doctor Cyber's plans of conquest are realized, men and women will be reduced to living automatons … slaves to do his bidding.'[86] I Ching suggests Cyber is 'half man, half machine'.[87] This is disproved when the reader is introduced to Cyber, a glamorous woman.[88] Cyber's expertise in the manufacture of machinery such as gyros or transportation and weapons gives credence to I Ching's assertion that she is a cyborg. This is borne out when her 'sweeties' attack Diana, I Ching and PI Tim Trench. Cyber's violence extends physically and psychologically. Psychologically, Cyber brainwashes her agents, for when I Ching proposes hypnotizing one of them the agent responds: 'I couldn't give it to you if I wanted to! Doctor Cyber has conditioned me with hypnosis!'[89]

Unlike Diana whose body takes control of the public and domestic space, Doctor Cyber appropriates liminal/no man's land spaces. She has secret bases underground, in the sea and in remote mountain villages. She transforms these spaces, using fashion and style, as a colonial enterprise. Her use of a Westernized parody of national costumes signals her cultural and physical appropriation of territories. Central Europe takes on Austrian or Swiss lederhosen or furs. In Hong Kong she takes on the garb of Suzy Wong. England is typified by class, fog and

heritage as, for instance, in Cyber's appropriation of a Tudor mansion in London. In this location, Cyber makes playful allusion to English heritage by dressing in a historical merger of mock cavalier and Tudor fancy dress complete with a neck ruff and swashbuckling outfit. Cyber's outfit incorporates masculine signifiers – trousers and cape – that 'produce the effect of an internal core or substance, but produce this over the surface of the body, through the play of signifying absences that suggest, but never reveal, the organising principle of identity as a cause'.[90] The notion of gender as a superficial effect rather than an indication of a core identity disrupts the idea of an ultimate, knowable truth about genders. The conclusion that Butler draws from the unknowable truth about genders is that they 'are only produced as the truth effects of a discourse of primary and stable identity'.[91] Her fluid approach to gender and ethnicity articulates her cyborg mutability.

In the course of the story arc, Doctor Cyber's style transforms from playful villain to arch fiend. This transformation results from an accident that scars her face. Her style changes to the archaic, a heavy, long robe and an iron mask worn over her face, a style choice that makes visual her cyborg attributes. She then changes her persona to reflect her imprisoned identity and inhabits dungeons, underground prisons and torture chambers. Her ironic sense of humour transforms into vengeful seriousness. She blames Diana for this accident, and vows to take vengeance by stealing her face.

As discussed above, women in the late sixties adopted a more active approach to beauty, their pleasure in consumerism and revelling in their 'gloriousness' challenged traditional notions of female passivity and beauty. Beauty in this era was expressed through the active female gaze and the stylish, dynamic body. The old-fashioned beauty of the mindless, sexualized female body of the fifties is encapsulated in the storylines 'Tribunal of Fear' (199) and 'The Beauty Hater' (200).[92] In these storylines Diana is recruited by Fellows Dill, 'king of the beautiful women', who runs an empire based upon girlie magazines and a nightclub like the Playboy Club. Taking *Playboy*'s concept of women as

sexual objects, submissive and subservient, Dill's hostesses are dressed as milkmaids, subservient and presumably sexually available. It is a notion of femininity that is based upon 1950s perceptions of women as objects or possessions. It reiterates an opinion of the *Playboy* philosophy as anti-feminine and anti-feminist (rather than as a response to Hefner's perception of the 'womanization of America').[93] *Playboy* represented the pin-up or Playboy bunny as passive and stupid, unlike the new concept of the female body articulating their own agency.[94] This depiction of woman as stupid and passive is a reaction against the notion of the *Vogue* woman who Hugh Hefner in 1962 accused of being 'unfeminine, antisexual and competitive rather than a complementing counterpart to the American male'.[95] Dill proposes that Diana dress in this costume to act as his bodyguard: 'I dress you like one of my regular girl servants ... milkmaids, I call 'em!' Diana responds: 'Nothing you could possibly do or say would persuade me to put on one of those ridiculous ... costumes!' She ignores the fact that for several years she did, in fact, wear a similar skimpy, ridiculous costume. That these types of costume ultimately originate in burlesque and the objectification of the female body is ironic.

The bodies of Diana Prince and Doctor Cyber look different superficially – the one beautiful in mind and spirit, the other warped by physical disfigurement and hatred. Yet both are transformed by obsession: the former through rigorous self-discipline, the latter through obsessively buying beauty. Both use consumerism to effect their transformations; Diana Prince sells her body as a bodyguard, Doctor Cyber buys quick fixes such as surgery and clothing to change her appearance. The former relies on her human body to transform herself. The latter relies on cyborg technology, cosmetic surgery and the knife as transformation. Both perform lifestyles through clothing and the spaces they inhabit. Both are bodies becoming – Diana Prince becoming a lean, toned body through repetitive training similar to the methods used to train the military body to make it docile.[96] The training is so effective that the body moves without thought. Diana's training gives balance to her mind and body. Doctor Cyber's mind though

brilliant does not have self-control; she is a dupe of consumerism and thinks she can buy people and things.

The makeovers in the *Wonder Woman* stories in this era are twofold: transforming the clothed body through consumerism and the phenomenological body beneath through rigorous training. As Craik notes, they are dependent on each other. Diana's rigorous training enables her to wear the unforgiving mod clothing of the late sixties. Her body also commands various spaces through female agency but also fashion. Whilst supposedly espousing youth, the comics tended to articulate traditional values. They favour dualism in which the mind controls the flesh through ascetic practices, meditation, yoga and rigorous training.

Diana's body articulated all the paradoxes of the idealised female body in the late 1960s: it was coded as natural yet produced through the body's commodification to look and move in a specific manner. The fashionable body enabled freedom of movement between countries and expressed female agency. However, the perceived freedom of movement came at the cost of supreme self-discipline. Although the early stories in this series emphasized Diana's agency, she still expressed assumed values and characteristics of essential femininity: vanity, histrionics and narcissism. She still yearned for a man and cried when inevitably betrayed. Like Diana, Doctor Cyber also attempted to fabricate her body to appeal to masculine perceptions of female beauty. Cyber's makeovers emphasized her need to become beautiful by artificial means which to feminism connoted a plastic man-made type of woman.

Mod Diana did not last. Feminists wanted the original costume and Wonder Woman's powers restored. They campaigned for its return through their flagship magazine *Ms* and several articles written by editor Gloria Steinem. Such was Steinem's enthusiasm for the original female role model, star-spangled tights, superpowers and magic lasso, she put Wonder Woman on the cover of *Ms* issue 1 in 1972, striding over American suburbia. The gist of Gloria Steinem's attack on this new incarnation was that the new version of Wonder Woman did not express

feminist values of 'strength and reliance … sisterhood and mutual support … peacefulness and esteem for human life, a diminishment of both "masculine" aggression and of the belief that violence is the only way of solving conflicts'.[97] It was clear, however, that Steinem and other feminists who critiqued the new Wonder Woman had not read the 1960s comics but were hailing what they considered Marston's golden era and, in some cases, Kanigher's stories from the 1940s onwards.[98]

As the progenitor of this transformation in the character, Denny O'Neil asserted: 'I thought I was securing a feminist agenda by making her self-reliant. I now see [the feminist] point'.[99] O'Neil and Sekowsky's revision of Wonder Woman did make an impact for it foregrounded the role of the alter ego. It also reinforced Wonder Woman's relationship with feminism. Some fans and creators regard it as a curious cul-de-sac in the character's history, others regard it as a disaster and yet others as an experiment that was not allowed sufficient time to develop. Yet there is affection for the white costume era in its constant quoting by creators; in Greg Rucka's storyline 'Who is Wonder Woman?' (2006), Diana Prince joined the Department of Metahuman Affairs (DMU) dressed in a white suit.[100]

It was assumed that Steinem and second-wave feminists were the driving force behind DC's U-turn on the character. However, the extent to which feminism can be held responsible for the restoration of the super-powered heroine and her costume is questionable. Dick Giordano, the artist for the last issues of the series, suggested that 'the sales of the de-powered version had more to do with its demise than any pressure brought by Ms Steinem [. . .] Besides, the Teen Titans got their costumes back at about the same time, without pressure from Steinem'.[101]

After Diana Prince: The Pre-Fab Feminist Body

The comics after Diana Prince regained her powers and costume saw the introduction of characters such as Nubia, her sister, made from black clay, then transported off to Slaughter Island by Ares to be reared

as the Amazon's enemy. Nubia, the invention of Robert Kanigher for *Wonder Woman* 204, January–February 1973, was a nod to the Civil Rights movement, Black Power and the blaxploitation genre. However, there was still 'passive racism' in the paucity of people of colour in the comics, an issue taken up in Chapter 7. Steve Trevor was resurrected (twice) and killed (twice). However, he was now much less controlling and accepting of her power in these rebirths.[102] The strongest theme to emerge in this era was in the connections with feminism, a connection that was increasingly emphasized in the comics. Between 1972 and 1986 *Wonder Woman* comics rhetoric falls into two very broad eras: 1970s feminist, 1980–86 feminist backlash.

The early 1970s saw more feminist rhetoric in the comics at a time when the women's liberation movement was at its height and Wonder Woman was the banner icon for the movement. Not only was she featured on the cover and inside the feminist magazine *Ms* but editor Gloria Steinem also edited a collection of golden age Wonder Woman stories in 1972. Wonder Woman featured in feminist literature; for instance, the magazine for the Los Angeles Women's Center magazine, *Sister* (1973), featured a cartoon in its campaign for women to take control of their bodies from male doctors in which Wonder Woman seizes a speculum from a doctor and proclaims, 'With my speculum, I *am* strong! I *can* fight!' So it was in the interests of DC to show the character was in tune with political movements, particularly one to which she was so closely aligned, to articulate on what they assumed were strong feminist values.

Even whilst they articulated feminist rhetoric, the 1970s comics, produced by men, often only paid lip service to feminism. For instance, in *Wonder Woman* 199, March–April 1972 at the height of the women's liberation campaign, Denny O'Neil describes a typical evening with Diana Prince listening to music and reading. He first defines her by her beauty, then her capability as a fighter, then her musical interests. It is an instant picture of her private life but posits that a woman without a man is unfulfilled as she still yearns for Steve Trevor: 'She exchanged her immortality for a human existence, with all its pain and sorrow, to be

near the man she loved. And then she saw him spill his blood on cold stones, held his hand as a final sigh whispered through his lips already dead ... She *wants* to love ... She can't – not now.'[103]

The problem was that in most media Wonder Woman was written and drawn by men who, at best, misunderstood or paid lip service to feminism, at worst either ignored it or revised it to conform to their own ideas of what women's liberation should be. An example of the differing expectations of a woman compared with a man can be seen when Wonder Woman regained her powers and costume for she insisted she had to prove herself by undertaking twelve labours to rejoin the Justice League. This quest was overseen by the various members of the league but it was a quest that was not expected of non-powered male members such as Batman and Green Arrow.[104] It was rationalized as necessary because Wonder Woman insisted on a series of tests to prove herself worthy.

The editors of *Wonder Woman* also played a role in influencing the feminist messages of the comics. Ruth McLelland-Nugent shows how, under Julius Schwartz and Martin Pasko, a more feminist agenda is expressed. One can see this in the covers of that era as they frequently feature macho male antagonists such as the Cavelier, a man who mesmerized women, the Gaucho (who describes himself as 'a real man') and the Red Panzer, a Nazi. These characters, however, did not have the rich qualities of other heroes' foes. Also, some of the covers showed Wonder Woman bound, sometimes with Hippolyta, or strapped to a phallic-shaped bomb, another allusion to the historical notions of Wonder Woman's perceived kinky bondage roots.

The early 1980s saw a move towards right-wing rhetoric resulting from Ronald Reagan's presidency (1981–89). This was an era in which films and television changed the representations of women in an anti-feminist backlash (dealt with in more detail in the next chapter).[105] Some of the comics featured the Amazons but in competition with each other, bickering and jealous of each other or else going mad. Editors taking over often devised their own interpretation of feminist rhetoric. In number 304, June 1983, Eddie Colon refuted William Marston's

assertion that 'Wonder Woman proves that women are superior to men because they have love in addition to force'.[106] Colon reinterpreted feminist messages of equality with the proviso that men and women are different adding the patronising and vague 'and what wonderful differences'.[107]

Of more significance, in this era were attempts to bring a live action version of Wonder Woman to the television. The first adaptation of Wonder Woman was a comedy in 1967, *Who is Diana Prince?*[108] On viewing the four-minute pilot one is in no doubt why it was not taken up by a television company as it ignores Wonder Woman's whole *mythos* in favour of a one-joke narrative, that of the drab daughter being a superhero. As noted above, in 1974 a pilot film was a made for television starring Cathy Lee Crosby as a non-super Wonder Woman wearing a short skirt over a star-spangled leotard. The film reflected the non-super Diana Prince comics of the early 1970s and was well received but when commissioning a series, ABC returned to the roots of the character giving her the classic costume and, to a certain extent, the origin story.

Wonder Woman (1975–79) starred the unknown Lynda Carter. It ran for three seasons and fifty-nine episodes. The first season, *The New, Original Wonder Woman* (1975), was set in the Second World War. It drew on some of Marston's stories, with villains such as Paula von Gunther, Gargantua and Fausta Grables. The show featured strong feminist messages and themes of redemption through love rather than violence.[109] CBS picked up the show in seasons two and three, renamed it *The New Adventures of Wonder Woman* and updated the setting to the 1970s. The third season ran for thirteen episodes before it was cancelled due to costs. Although the series used some of Marston's original stories it omitted the Greek pantheon, Aphrodite's message of women as love leaders and parthenogenesis. Instead the story returned to Robert Kanigher's origin of the Amazons retreating from man's world because of wars. Like the 1950s comics, Paradise Island was a suburban retreat and, like the comics of the 1970s, the Amazons were depicted wearing see through negligée-like costumes.

Wonder Woman was one of several shows, including *Charlie's Angels*, *Police Woman* and *The Bionic Woman*, of the late 1970s starring female protagonists. The protagonists were usually single, career women produced at the height of second-wave feminism to appeal to a growing market of single women and wider audiences.[110] The disparity in audiences' values led, as Levine notes, to the necessity of balancing feminist messages with wider audience expectations.[111] Therefore, female representations in these shows were paradoxical and mediated through sexuality and fantasy in what was described as the 'jiggle Factor'.[112] The aesthetics of the 'jiggle factor', as noted above, was in a sexualized representation of female stars, mainly in ABC television series. Lynda Carter understood how her image was consumed: 'I never meant to be a sexual object for anyone but my husband ... I hate men looking at me and thinking what they think. And I know what they think. They write and tell me.'[113] Yet Carter's performance was underpinned by her erotic appeal and even when defending herself by deflecting bullets, her pose exaggerated her cleavage. Her bracelets, like manacles, also fetishized the image and were a reminder of the bondage encoded in her representation. So even though the series articulated feminist rhetoric, this was contradicted by the imagery and could be seen in the use of the female action body.[114]

Wonder Woman's body in the television series was limited by budget, technology and cultural expectations of the female action body. The origin borrowed much from Robert Kanigher's *Wonder Woman* but it had a stronger feminist message, yet female agency was limited as much by attitudes as the fetishized costumes.[115] The stylized, static choreography of the female action body continued throughout the first season – for instance the fight sequences in episode twelve where Diana and Steve travel to Argentina to discover a secret formula, involve pushing, throwing and shoving men around 'as if they were pebbles'.[116] Seasons two and three saw the character become much more physical and throw punches and kicks. By the third season each episode was set in a three-act structure with four transformations and two action sequences.[117] Lynda Carter's Wonder Woman was constructed more for

her beauty and her presence was predicated on caring and redemption through love rather than violence. Like the comics, the feminist messages were stymied by television's need to sexualize the character. Perhaps, in this era, the world may have been waiting for her and the power she possessed, but Wonder Woman was still bound by societal expectations of female behaviour and potential. Nevertheless, this iteration inspired intense devotion in fans and a connection between Carter as Wonder Woman in the popular imagination. Lynda Carter became the best-known and most iconic representation of Wonder Woman until 2017. The Patty Jenkins film drew inspiration from Carter's representation and it was to Carter that fans turned when evaluating the new Wonder Woman, as discussed in Chapter 7.

The Goddess, the Iron Maiden and the Sacralization of Consumerism

In 1987 Wonder Woman was rebooted as part of a wholesale rebooting of the DC Universe in the 'Crisis on Infinite Earths' story arc. Wonder Woman's origin was rewritten by Greg Potter, Len Wein and George Pérez. Pérez initially pencilled the stories but took over writing and art in no. 19, June, 1988. It is probably one of the most respected iterations of the character, for Pérez returned to Marston's parthenogenetic birth, rationalizing it as the – mainly female – gods birthing the Amazons and Diana. Pérez wrote sixty-one issues of *Wonder Woman* and his revision affected her representation up to her reinvention in The New 52 in November 2011.[1] In his revision of Wonder Woman, Pérez also discarded her Diana Prince secret identity and Steve Trevor as her love interest. Instead, Diana was cast as a diplomat for the Themysciran Amazons in Man's world, a living example of how Amazon values could create a perfect being. Pérez made Diana more vulnerable emotionally, sensitive to nature and potentially inspirational for the women around her. However, Pérez's stories also reflected how Wonder Woman's perfection could be a problem for other women in the stories. Influenced by spiritual and feminist discourses of the mid-seventies onwards, he made her into a goddess-like fantasy figure split into two identities: Diana, Princess of Themyscira and Wonder Woman, a brand in consumer culture. The discourses constructing Wonder Woman as goddess clashed with other discourses circulating in popular culture and politics that aimed at disempowering female autonomy, and highlighted paradoxes with Wonder Woman as female and feminist icon.

In the early issues Wonder Woman lived in a universe ruled by the Greek Pantheon where the Amazons communed with Greek gods and

goddesses. Issue 1 recounts how the Amazons are the souls of women murdered by men.[2] Their souls are stored in the womb of Gaea, the Earth Mother and rebirthed by the Greek goddesses, Aphrodite, Hesta, Demeter, Artemis and Athene, and the Greek god, Hermes who became her mentor in Man's world. The Amazons are granted blessings by the gods and are so successful that the Kings of Greece send their champion, Herakles, to defeat them. Herakles tricks Hippolyta into giving him the source of her power, Gaea's Girdle, and enslaves the Amazons. The Amazons are saved by Athena who leads them to Paradise Island, a space in a different dimension where they are granted immortality and build a great city, Themyscira. However, Themyscira is built over Doom's Door, a portal to Hades, where the evils of the world are held captive. For their disobedience, the Amazons are cursed to guard Doom's Door for eternity. Diana's birth mirrors that of her sisters. Hippolyta yearns for a child and she is informed that when she was murdered, she was pregnant; it is her unborn child calling to her. Under the direction of Artemis, Hippolyta forms a clay image that is transformed into a child, reflecting the birth of Adam, the first man, whose name means 'red clay', by God. The gods then bestow their blessings on the child.

In the creation myths of the Amazons and Diana, Pérez articulates the mediaeval theory of typology in which the Old Testament acts as a prophecy, or a type, for events in the New Testament, the antitype which mirrors the events of the type. For instance, the creation story of the Old Testament is mirrored in the New Testament with Christ as the New Adam. Accordingly, the birth of the Amazons reflects the birth of Diana; both are birthed in a lake by parthenogenesis. Athena, leading the Gods, tells them: 'You are a chosen race . . . born to lead humanity in the ways of virtue . . . the way of Gaea! [. . .] Therefore does Athena grant you wisdom that you may be guided by the light of truth and justice!' Artemis, goddess of the chase, adds: 'I, Artemis, grant you skill in the hunt! Demeter shall make your fields fruitful!'[3] Hestia, goddess of the hearth, bestows a city. Aphrodite grants the gift of love. Hestia states: 'Forevermore, you shall find strength in these gifts. They are your sacred birthright . . . They are your power!'

Diana's virginal birth reinforces her divinity. The boons of the gods are bestowed on Diana in a scene reminiscent of that where the gods designate the Amazons as the Chosen Race but also nodding to the 1950s logline of *Wonder Woman*, proclaiming:

'I, Demeter, grant her power and strength, like that of the earth itself!' 'I, Aphrodite, give her great beauty and a loving heart!' 'I, Athena, grant her wisdom!' 'I, Artemis, give her the eye of the hunter and unity with the beasts!' 'I, Hesta, grant her sisterhood with fire . . . that it may open men's hearts to her!' 'I, Hermes, give her speed and the power of flight!'[4]

Just as the Amazons are the Chosen Race, Diana is the Chosen One of the Amazon race and the gods. She competes in and wins the contest to travel to man's world bearing Amazon values of love and peace. Once there, Diana lives in Boston with archaeologist Professor Julia Kapatelis and her daughter Vanessa. Diana is promoted as Wonder Woman by Myndi Mayer who runs a PR company. Gradually the Amazons reinstate links with Man's World, inviting delegates from the United Nations and Diana's friends to visit and experience the Amazon way of life. Diana is the only person who can travel freely between Themyscira and Man's World, thanks to a gift of flying sandals from Hermes. As she is a creature of fantasy with great powers in Man's World, she is regarded by some as a goddess, and this image is promoted by Myndi Mayer's promotions company.

Pérez's reinvention of Wonder Woman is the first instance in any story arc up to 1987 when she is represented as sacred and it reflects a similar sacralization of Superman, also an earthbound god, in this era. Superman's sacralization arose partly from the influence of the *Superman* film in 1978[5] which, as noted in earlier chapters, emphasized the messianic qualities of the narrative connecting it explicitly with the American frontier myth and the story of Moses.[6] John Byrne's revision of Superman of 1986 used the film's evocation of the American small-town hero in the big city and turned Clark Kent into the focus of the myth. Where previously Clark Kent was Superman's alter ego, Superman became Clark Kent's fantasy other and the focus was on the mortal rather than the god as hero. Diana, Princess of Themyscira, is spiritual

and private. Unlike Superman/Clark Kent in both her identities she is perfection in body and mind and there is a conflation of the natural and socialized body in both Wonder Woman and Diana.

In Pérez's *Wonder Woman*, there is an emphasis on Diana's upbringing as the only child on Paradise Island. In man's world, she is an innocent abroad who spends much of her time trying to understand and negotiate the complexities of patriarchy. Where Wonder Woman in Marston's first story was seduced and duped by capitalism in her fascination with fashion and her forays into the theatre, Pérez's *Wonder Woman* is transfigured by consumerism. As Wonder Woman she is a brand, a fantasy figure, something she acknowledges: 'To many I am a myth. A mythological daughter of a mythical queen from a mythical land. Yet I am real.'[7] Other characters regard her as sacred but also a fantasy figure. For instance, Eddie Indelicato, a police officer, describes her as:

> a goddess, or what a goddess ought to look like. Firm, round curves packed into a tiny, tight, armor-plated American flag. Her hair was a cascade of lustrous black curls [...] gentle sultry voice, flavored with an accent both exotic and musical. It was like hearing my name for the first time. 'Eddie', I thought, 'You are definitely having the best dream of your life'.[8]

His use of 'what a goddess ought to look like' and the dream inject elements of the imaginary into his perception of Diana.

Pérez critiqued consumerism and popular culture which used beauty and sexuality as weapons to turn woman against woman and destroy those who attempted to become successful career woman. Much of the critique is aimed at consumerism and how it promises, yet cannot deliver the plenitude and fantasy it offers, but how it disempowers female autonomy in the process.

Capitalism, Feminism and the Politics of Health

The 1980s was a time of extremes: stock-market boom and bust, the growth of lucrative health and beauty industries, and the emergence of

viruses resistant to antibiotics. In America, there was a perception that too many compromises had been conceded to second-wave feminism and a backlash against feminism began to challenge issues such as abortion and employment rights. These factors played a part in the rise of third-wave feminism which developed from the mid-1980s. Third-wave feminism also criticized second-wave feminism which, it claimed, concentrated on the rights of affluent white women to the detriment of marginalized groups such as women of colour, the disabled and the poor.

Third-wave feminism was spear-headed by two influential books: Susan Faludi's *Backlash: The Undeclared War Against Women* and Naomi Wolf's *The Beauty Myth: How Images of Beauty Are Used Against Women*, both published 1991.[9] These books attacked the patriarchal control of women's cultural disempowerment that had grown more oppressive during President Ronald Reagan's right-wing political administration (1980–89) and was predicated upon essentialist gender roles, 'traditional' family values and hard masculinity.[10] Faludi and Wolf claimed that the feminist backlash aimed to reinstate patriarchal power against what was perceived as the shrinking differences between male and female political, economic and cultural power. However, the backlash was not a coordinated or even conscious attack on women's autonomy; rather it consisted of several disparate cultural and political strategies that together increasingly disempowered women. These strategies developed from the late 1970s and became steadily more oppressive during Ronald Reagan's administration.

The media and political spin proposed a cultural difference between the macho Reagan, and 1970s presidents Richard Nixon and Jimmy Carter. Nixon and Carter, it was implied, damaged America's global standing through corruption and a perceived feminization of American politics. In the 1970s presidents were presumed to characterize America's reduced status in the world. Symbolically American politics and world standing were characterized by soft, lazy, diseased, or addicted racialized or feminized bodies. Susan Jeffords suggests that Reagan's alignment with Hollywood 'links one image popular and

national narratives, making them somehow the same story'.[11] Reagan's
hard body was the symbol of the new macho political machine: white,
courageous, hard-working and aligned with the land, encouraging
family values whilst ordering more single parents back into work and
limiting abortion rights.[12] In short, Reagan's aim was, through a
reassertion of American masculinity, to restore America's place as the
global power and reassert traditional family values. In this macho
America, Wonder Woman could potentially be regarded as an unruly
woman, flouting patriarchy. However, Pérez shows how her effortless
beauty unwittingly damages women around her. Thus, rather than
galvanizing women to become stronger and change patriarchy, women
focus on attempting to conform to Wonder Woman's impossible ideals
of beauty.

Faludi details the ways women were excluded from governmental
offices and decisions either by being sidelined or allocated ineffectual
roles, purged from office, excluded from meetings, statistics not being
collected or women's groups had funding cut. Those who criticized the
political system were deemed subversive and the administration
became a 'sea of white male faces'.[13] In the family, woman's place as the
wife and mother were regarded as crucial to stability. This was also not
a wholly male attack on female rights. New Right women proposed
anti-feminist stances, asserting that second-wave feminism's claims of
female fulfilment in careers were unfounded. Beverley LaHaye, for
instance, led the attack on feminism from a Christian point of view
with her books such as *The Spirit-Controlled Woman* (1976) and she set
up groups that supported marriage such as Concerned Women for
America, supporting women's right to domesticity.[14] The Reagan
administration also challenged abortion rights. Benefits were cut to
encourage single mothers to find employment. Whilst there was
administrative support of female domesticity, single parents were also
encouraged to return to work although this was usually low-paid or
menial work.

Differences between media representations of women changed in
line with cultural attitudes to women in the workplace. In superhero

comics it took the form of physical rather than emotional attack or the cancellation of superheroine titles. Marvel's *X-Men* introduced two goddess-like superheroines, Jean Grey/Dark Phoenix and Storm, in 1975. Jean Grey had telekinetic powers but when possessed by the Phoenix force became the cosmically powerful Dark Phoenix. Jean Grey reasserted her identity and died in an act of self-sacrifice as she could not contain the Dark Phoenix's powers. Storm controlled the weather and was regarded as a benign goddess in her native Kenya. However, in the 1980s she was depowered. Several female characters in the late 1970s and early 1980s, including *Ms Marvel* (1977), *Spider-Woman* (1977), *She-Hulk* (1980) and *Dazzler* (1980), starred in their own titles. All but Dazzler derived from male heroes. By June 1983, *Spider-Woman* ceased publication and *Dazzler* ceased publication in 1985. Other female characters did not fare well. Spider-Woman died and was depowered. Ms Marvel's powers and memory were absorbed by Rogue, a villainess who later became an X-Man. She was impregnated when raped by her son from the future. Female characters in DC Comics also suffered physical attack. Supergirl died in the *Crisis on Infinite Earths* reboot of 1986. Of the *Teen Titans* comics that debuted in 1980, Starfire suffered enslavement, torture, experimentation and possibly sexual exploitation, and Raven was depowered and suffered a split in her personality due to her demon parentage. The unfortunate fates of the many superheroines in comics were noted by fan Gail Simon, who constructed the website Women in Refrigerators, which was to become influential in twenty-first-century comics.[15]

In films, as the late 1970s developed into the 1980s, the single professional woman became represented as mad, bad or selfish. Hollywood films in the 1970s and early 1980s depicted women challenging inequalities and injustices in the workplace in films such as *9 to 5*, marriage and women's domesticity in *The Stepford Wives*.[16] An early example of the sea-change mood swing from empowered to selfish was shown in *Kramer vs. Kramer*[17] in which Joanna Kramer abandons her workaholic husband Ted and their seven-year-old son Billy to 'find herself'. The film criticizes Joanna's selfishness by maintaining that Ted's

fifteen-month parental stint is worth more than her previous seven
years of nurturing. It also does not attack the legal system for forcing a
child to choose between two parents, or corporate America for its refusal
to provide its employees with reasonable working practices to respond
to parental obligations.

Single and career women fared no better; they were depicted as
either unfulfilled and unhappy, unfeminine or obsessive and violent
marriage wreckers. The latter were the dark women and they were
juxtaposed with light women (invariably domesticated wives or hyper-
feminine bimbos). Susan Faludi illustrates how the film that set the
trend, *Fatal Attraction*, depicts the protagonist Alex Forrest as betrayed
and destroyed by an illicit relationship with a married man, Dan
Gallagher. Alex, a violent, potentially murderous, home wrecker, is
eventually killed by Dan's wife, Beth.[18]

Capitalism demands bodily control and the construction of docile
bodies, especially in women's bodies. Body culture in this era saw a
move from the soft body towards the hard body as politically and
culturally acceptable. Beauty was politicized and used to attack feminine
emancipation, as noted by Wolf: 'like the gold standard . . . it [the beauty
myth] is determined by politics, and in the modern age in the West it is
the last, best belief system that keeps male dominance intact'.[19] Consumer
and right-wing forces, shaping gender representations and cultural
expectations, changed perception of body regulation. To fit into a more
public setting, the body and its maintenance were increasingly regarded
as the individual's responsibility.[20] The emphasis on the well-toned body
was supported by the fashion industry. Thierry Mugler celebrated evil
women of Hollywood, aliens and dominatrices in highly stylized
garments of vinyl, leather and metal with wide shoulders, clinched
waists and styles that fetishized power. These types of clothing reflected
nostalgia for the 1940s femme fatale, the spider woman aligned with the
futuristic cyborg. The 1980s saw the rise of supermodels, women whose
faces endorsed global brands such as Diet Pepsi and who started to rival
Hollywood stars for their glamour and affluence. Image was all. The rise
of supermodels and the power dressing promoted in haute couture

called for more slender bodies; as Joanne Entwistle suggests, they form a reciprocal arrangement of the body/self in the articulation of identity.[21] Alongside these cultural phenomena, booming diet and exercise industries emerged.

Selling the perfect body was a consumer project and facilitated by exercise books and home videos produced by stars such as Jane Fonda. Fonda's exercise products were infused with Beverly Hills glamour. The videos were often located in studios that were made to look like gritty urban landscapes or else glamorous exercise academies. They promoted a lean, youthful, energized look but, in line with political and cultural ideology, their underpinning values were the heteronormative, domesticated and monogamous body.[22] Naomi Wolf and Susan Faludi argued that these changes in body culture represented the backlash and attempts to control female emancipation. Similar restrictions were imposed in previous eras when it seemed that female calls for emancipation challenged the status quo. For instance, as shown in the previous chapter, although the corsets and tight clothing of the Victorian age seemed to bind the female body, the seemingly free 1960s body, like the androgynous *garçonne* of the 1920s, was another type of restriction. It relied upon the female body becoming androgynous or else pre-pubescent. Developing this type of restrictive body practice, 1980s fashion depended upon total exposure of the body as the nude body, a machine made taut and toned by gym workouts and strict dieting. The insistence on idealized or impossible body shape and style distracted women from the more important issues associated with equality. What is of more significance is, as in the 1960s, lean body shape was presented as natural, a product of self-discipline rather than the shaping bodywear and corsets of earlier eras.

Along with this more supposed natural female discourse was one that promoted 1970s second-wave feminists' attacks on scientific knowledge.[23] Science, it was claimed, either ignored or diminished female agency in evolution and the development of civilization. For instance, anthropological models ignored women's part in the development of human evolution histories and religions that either

ignored or vilified women's contribution to a culture were challenged.[24] Religion in particular came under attack for its misogyny by feminists such as Merlin Stone, Starhawk, and Carol P. Christ and Judith Plaskow who took as their inspiration Robert Graves's *The White Goddess* to argue that Neolithic and Bronze age cultures were matriarchal but that their religions were suppressed and vilified by Indo-European invaders.[25] This notion was expounded in the 1972 *Ms.* publication *Wonder Woman*,[26] in which, along with Gloria Steinem's introduction, there was an interpretive essay by Phyllis Chesler based upon the discourses constructing Amazons.[27] Chesler repeated many of the ideas of Stone et al. whilst providing little empirical evidence to support her arguments. Nevertheless, these authors contributed to the growth of goddess cults and neo-paganism in the 1970s. Thealogy, the study of the goddess rather than the god, evolved from these neo-pagan religions.

Neo-pagan practices also incorporated naturism and nature worship. Neo-pagans believed that 'divinity is inseparable from nature and that deity is imminent in nature'.[28] Two main goddesses attracted neo-pagans; Gaea the earth mother and the Roman moon goddess Diana. Dianic Wicca was founded by Zsuzsanna Budapest, an American author, feminist and witch, and founder of the anti-rape movement Take Back the Night. These neo-pagan religions were mainly taken up by the middle class, often academics, and they were criticized by the third-wave feminists in the mid- to late 1980s, as in Donna Haraway's assertion 'I'd rather be a cyborg than a goddess', noted in the previous chapter.[29]

Neo-pagan feminist values influenced Pérez's revision of Wonder Woman which represented Diana as connected with a goddess/ superheroine model that emerged in the comics of the 1970s. In Marvel, Ms. Marvel and The Valkerie, both members of the Avengers, articulated feminist values. Two of the X-Men, Storm and Phoenix, as noted above, were virtual goddesses. Both were intoxicated with their bodies' powers and the joy of flight. At DC Starfire/Koriand'r a member of Teen Titans (themselves derivative of *X-Men*) was a princess who could fly and shoot star bolts from her hands.[30] Koriand'r was a clear influence on Diana for she was created by Marv Wolfman and George Pérez. Like

Wonder Woman, Koriand'r was an innocent abroad and had a relaxed attitude to nudity, going so far as to pose for a centrefold in a girlie magazine. These quasi-goddesses tended to stay within their superhero circles in their relationships, so their powers appeared less remarkable than those of Wonder Woman whose cast of supporting characters were ordinary people. All represented a negotiation between consumerism and the sacred that also emerged in this era. Pérez explored the relationship of consumerism and the sacred to reveal how consumerism profanes the sacred.

The Sacred, the Profane and the Mundane

In contemporary culture the boundaries between the sacred and the secular constantly leak into each other.[31] There are similarities between consumer practices and behaviours and the sacred transcendent experience. The sacred is constructed against its binary opposite, the profane.[32] The sacred can be identified through contact with practices and relics such as sacrifice, ritual and myth.[33] Together these elements can be incorporated into overlapping themes such as the body, objects and narratives. The sacred manifests itself through the disciplines imposed upon the body in asceticism, ritual, ecstatic experiences, sacrifice and contamination (whether good or evil).[34] Objects become sacred through mythic narratives, for instance in creation stories, in giving gifts. However, according to Victor Turner and Edith Turner, the sacred cannot be explained through logic; if the creation story is analysed then it becomes touched by profanity and loses its mystery. Narratives, objects and the movement of bodies also underpin notions of communitas. Communitas is an intense communal spirit expressed in a shared ritual experience. This might be in a celebration, a christening or a pilgrimage in which people collectively turn their backs on the mundane world and engage with the sacred. Turner and Turner note that such communal endeavours involve the crossing of thresholds, rites of passage and engagement with liminal spaces and states.

The profaning of the sacred by the intrusion of the mundane world can be seen in *Wonder Woman* v. 2/38, 'Forbidden Fruit' (1990), when the paradise of the Amazons is profaned by a visit to Themyscira by mortals. When mortals from the UN visit Themyscira, the Amazons invite them to the Feast of Five, 'a holiday that combines elements of Christianity's Easter, Judaism's Passover, and the Islamic month of Ramadam'.[35] This feast commemorates the origin myth of the Amazons, a mixture of myth and religious narratives. Themyscira is the Garden of Eden but it is discovered when the Amazons escape the horrors of man's world through the parting of the seas by Poseidon.

Themysciran culture is based upon an Edenic nostalgia in which the rural and the urban coexist in perfect harmony, described in an article by Lois Lane: 'Themyscira. The Troy of Priam. The Athens of Pericles. The Rome of Julius Caesar. A city of the ages and for the ages, built of marble and sandstone, acropolis and agora ... alive, thriving, stirring and spectacular'.[36] Like the Garden of Eden, crops, hunting and fishing are bountiful, expressed by a delegate invited to the Feast of Five on Paradise Island '[the] soil is incredible, almost virgin in its purity'. However, this perfection is then compared with the imperfections of the outside world. 'Once home was like this. Before Drought and war and pestilence. Before the hatred caused the food to rot in its sacks upon the docks ... so that guns could be transported instead.'[37]

However, when Lois Lane analyses the isolation and consequent naivety of the Amazons, describing Themyscira as a 'Grecian Never-Never Land'[38] with Diana as Peter Pan 'leading us all to a second childhood filled with fairy dust and wonderful thoughts',[39] she trivializes and brings reality to this sacred Eden. She ponders, 'paradise is ... such a fragile dream. What harm in letting the sleeper continue for a while?'[40] Like Eden, Themyscira can be destroyed when the denizens of Doom's Door escape and, in 'Forbidden Fruit' the Amazons' downfall is expedited, Eden-like, when the apples of discord are eaten at the sacred banquet. Through contamination, the apples cause conflict at the feast. The trivial, therefore, profanes the sacred space of Themyscira. When Diana enters man's world, she is constructed as sacred through her

power, her spirituality, her beauty and consumerism; the latter profanes her sanctity.

In contemporary culture, the sacred manifests itself in politics, science, sports, art and music.[41] For instance, themes surrounding rock music can evoke the sacred in the ecstasy of being carried away by the music, taking drugs and the worship of the rock star.[42] The secular is sacralized through the objects consumers set apart and the spaces they choose to occupy or that become special to them. Sacralization is not random but associated with hierophany, the manifestation of the sacred through a person, place or object. Hierophany is usually only recognized by a few chosen acolytes.[43] The sacred is also imbued with mystery and inspires awe in what Mircea Eliade describes as kratophany, the sacred power of a thing, 'that combine[s] fascination and devotion with repulsion and fear'.[44] As a sacred being, Diana becomes more than the sum of a woman; her body manifests power.

Collectively these themes locate Diana/Wonder Woman as a hierophanous object and divine being. However, her promotion to goddess raises some significant problems for herself and those around her in the trivialization but also the fantasy aspects of consumer culture.

Marketing the Sacred: The Goddess and the Iron Maiden

In man's world, Diana is adopted by Myndi Mayer's PR company and her image is promoted with her new brand, Wonder Woman. Diana is represented as a sacred being through body, objects and narratives. She has joy in her natural body that is granted powers beyond the ordinary. Diana's body expresses the joy of 'being in the world'[45] through flight and 'the thinking body'[46] in tune with its surroundings, experiencing them through synaesthesia. Flight incorporates the feeling of the wind with the sounds of the woods and nature. Like her Amazon sisters she revels in the health and power of her body claiming, 'there is no greater exhilaration than the sheer joy of flying . . . the incomparable sensation

of pure unbridled freedom!'[47] Diana thus experiences ecstasy akin to
the religious experience through her joy in her body.

Diana is also worshipped as a messianic figure by followers of a
Diana Cult on a Greek island. In *Wonder Woman* 47, 'Common Ground',
her sister Troia confronts the group who describe her as 'the savior's
sister'.[48] Her devotion marks her out as divine, if not a goddess, then a
priestess and cipher for the gods, or a sacred being, as she takes on many
of the attributes of her Roman goddess namesake: chastity, hunting and
affinity with the woodland. Her royalty also designates her as having
direct communication with the gods: she often wanders naked through
the woods to pray and later in the series, she has visions.[49]

Diana is divine through her costume, based upon the American flag
– itself a sacred object – her lasso of truth and her bracelets. Her
costume is also sacred because it is a tribute to the sacrifice of a mortal
woman, Diana Trevor, Steve Trevor's mother, who fought alongside
the Amazons to contain a demon escape. Her lasso of truth is forged
from Gaea's Girdle and through this Diana's power gathers power from
the earth.[50]

Diana's divinity is signalled by the ways time operates for her and the
Amazons. They are immortal and exist in mythic time: for immortals
time has little meaning.[51] Time becomes significant in Diana's
construction as goddess for her body is immortal; before her entry to
man's world, she has never seen a child nor an older woman. Nowhere
is this foregrounded more than in the representation of Vanessa and
Julia Kapatelis. Both are at liminal stages of female life, Julia in the
menopause and Vanessa at puberty, the one at the end of her fruitful
years, the other at the beginning. These life events demonstrate time as
linear, measurable by date and time. It is significant that these types of
narrative cannot be told through the male body and there is a parallel
tale in Robert Kanigher's Magic-Eye Camera stories of the Wonder
Family. The Wonder Family consists of Wonder Woman at three stages
of her life defined by her name at these points: Wonder Tot, Wonder
Girl, Wonder Woman and her mother Wonder Queen. In Pérez's story
'Time Passages', Vanessa, a tempestuous teenager, cannot wait for the

rite of passage of her first period and announces this in a letter to her mother: 'Please note ... that on this date, at precisely 1.40 in the afternoon, [I] ... became a W-O-M-A-N! ... Now that I've grown up, I promise I won't be [stupid] anymore.'[52]

These rites of passage are not celebrated on Paradise Island as the Amazons are immortal. Time passes differently for them. Time is cyclical. The sacred moment, however, as Mircea Eliade argues, can be experienced through rituals that, 'imitate a celestial archetype'.[53] An example of this imitation of the mythic moment is provided when the Amazons stage a theatrical event replicating their origins for delegates of the UN.[54] This moment, however, is tainted by the incursion of profane time. Lois Lane records the event in a photograph and an article for her newspaper. She trivializes this sacred moment in two ways, by fixing it in linear time but also debasing a sacred ritual, describing it as 'an afternoon matinee at Themyscira's equivalent of the neighborhood Cineplex'.[55]

Consuming/Consumed by the Sacred

As noted above, the encounter of linear and sacred time trivializes the sacred. Similarly, the effects of modernity in commodification and marketing also desacralize the sacred.[56] This is expedited in two ways; the trivialization of the sacred through selling kitsch and the affinity of the sacred with the profane. An example of this is in Myndi Mayer, Diana's PR agent, selling Wonder Woman dolls for $150, bracelets of submission to teenage girls or posters so successfully that Mayer writes: 'On the merchandising front it seems that stores nationwide can't seem to stock enough Wonder Woman material. Add to that the licensing of Diana's own monthly comic book [...] various Wonder Woman clothing and motions lines, huge profits are being expected across the board.'[57] These objects are misused because they introduce a note of 'mere commercialization' into what is sacred. Further, posters are used as pinups or are degraded with profane graffiti. The bracelets are supposed

to be symbols of female empowerment but they become the means of establishing high school cultural hierarchies where poor children, who cannot afford them, feel disenfranchised.

Wonder Woman's beauty is a blessing and curse for her mission. As discussed in the introduction, in the West beauty is regarded as an attribute of the moral and good but, as Wolf suggests, 'if a woman is born resembling an art object, it is an accident of nature ... it is not a moral act'.[58] Diana is fashioned by Hippolyta as an art object before her transformation to mortal. As an art object, her beauty is idealized and there is a distance between her and other women – she can never understand the trials they endure to become beautiful, or even acceptable. This idealization of her body and mind is particularly detrimental to her relationships with men and women in man's world especially in the 1980s. This was an era, as noted above, when politically and culturally the body was used as a means of controlling and setting women against each other.

As Wonder Woman in man's world, audiences come to her lectures to see her rather than hear her message. At one point, she despairs and asks, 'Will I leave man's world having taught people nothing more than my name?'[59] Although branded as an empowering figure for young girls and women, her perfection is also a problem. Young girls desire the accessories marketed under her name. Older women feel uncomfortable around her both personally and because she is a threat to their relationships with men. Her friends Etta and Vanessa are wary of allowing their partners to meet her too often. Vanessa, for instance, knows that Barry, the boy she has a crush on, is only interested in her so he can meet Wonder Woman. She practises telling Wonder Woman to stay away from him.[60] Etta Candy confesses, 'You make me feel weird, uncomfortable ... Maybe it's because you're so pretty and you never had to diet'.[61] Capitalism and the consumer society in effect turns Diana into the iron maiden.

In this narrative trajectory, other characters attempt to emulate Diana's beauty, in some cases with tragic consequences. Pérez reveals the conflict between socialized and natural bodies especially in certain

characters who express this conflict in their responses to Diana/Wonder Woman. The characters who express a range of often confused attitudes to Diana are Myndi Mayer, Diana's enemy the Silver Swan and Vanessa's friend Lucy Spear. All three desire some aspect of Wonder Woman that in previous eras did not pose a problem. However, given the beauty myth proposed by Wolf, in the late 1980s Wonder Woman *is* the iron maiden, and presents a trap, an impossible ideal, that disempowers women. The Silver Swan's story is an example of the negative influence of the iron maiden. As a foetus she is exposed to radiation and is born deformed. She falls prey to Henry Cobb Ambruster, a weapons manufacturer who experiments on her transforming her into the Silver Swan, a beautiful and powerful villain able to fly and use hypersonic powers to disable her opponents. She hates Diana for her beauty and claims that consumerism is 'promoting Princess Diana as some sort of feminine ideal no real woman could ever hope to become'.[62] The remainder of the chapter identifies how the iron maiden metaphor destroys Myndi Meyer and Lucy Spears, two women who seem to have the beauty, power and intelligence to progress far in the world but instead are destroyed by ambition and desire.

Myndi Mayer and Lucy Spear

Myndi Mayer is a good example of the ruthless businesswoman, condemned by 1980s media and political rhetoric. She is a shrewd manipulator but one who falls for the myth that a woman can have it all, which many 1980s films attempted to discredit. In Myndi's first appearance she represents what Joanne Entwistle claims is the reciprocal arrangement of the body/self in the articulation of identity (noted in the previous chapter).[63] Myndi is introduced in issue 7, 'Rebirth'.[64] Her body is constructed spatially and temporally in four panels emphasizing an aspect of her stylish dress, presence and her embodiment. The first panel emphasizes the sound of Myndi with her entry into the story as a fur coat and a pair of stylish stiletto heels 'tak, takking' across the tiled

Harvard floors. The second panel emphasizes smell, her cigarette smoke wisps across a third of the panel, caressing the 'No Smoking' sign, her presence announced by students' reaction shots. This is a woman who does not care about the accepted rules of society. The third panel demonstrates her excess. Gold bracelets adorn her wrists and she has immaculately manicured nails of bright red. The fourth panel is an over-the-shoulder shot of Julia's astonished reaction on opening the door. Myndi wastes no time in informing Julia she wants to manage Wonder Woman and promises she can make it profitable for her, an offer Julia refuses. Myndi, however, is not easily deterred. She ponders, 'If I want to ink the Diana dame, I'll have to get on the professor's good side'.[65] The next time Myndi appears she is transformed into a homespun girl-next-door, dressed in jeans hair tied back with slides and a pen substituting for her cigarette. Even so, she cannot totally perform the role, letting slip that with Diana's looks 'you're going to be a lot easier to sell [...] er [...] promote than I'd thought'.[66]

Even in death Myndi is defined by her adoration of designer clothes and brands. This is noted by detective Eddie Indelicato describing her corpse:

> When we got there, Myndi Mayer, the controversial 'Publicist to the Stars', was just lying there – a shattered porcelain doll in an Evan Picone suit, the scent of fancy perfume still traceable through the smell of spilt booze and smothered cigarettes. You could tell the girl had class, and the money to pay for it. She had the pampered body of a showgirl. Even the coroner's outline flattered her. I'd seen photos of her. She was about forty but still a looker, in a plastic sort of way.[67]

The coroner's chalk outline drawn around Mayer's corpse suggests it is a metaphor of a canvas on which the designer brand collection can be displayed.[68] Juxtaposed with the artifice of Mayer's corpse is a poster of Wonder Woman, the one so alive and vital, the other the object of the forensic team.

Myndi is the 1980s typical representation of the unfulfilled career woman presented by Faludi – a 'slave to her ambition'.[69] Myndi's downfall

is twofold. She allows a man, Skeeter La Rue, a drug pusher, to control her. Worse, she lives a fantasy life. Her need for fantasy is revealed in a story by one of her college friends, Cassie, who claims that Myndi spun a story that her father was a fashion consultant claiming he made her dress. Cassie knows that the dress is from Saks on Fifth Avenue. Even Myndi's death is not straightforward as what looks like murder is, in fact, a drug overdose; like Madame Bovary, consumption of poison connected with consumption of things literally kills her. The sacred and profane are expressed in Diana and Myndi's attitudes towards responsibilities and ethics. Myndi requests that Diana sprinkle her ashes over the waters around Paradise Island.[70] She offers Diana a large sum of money to do this but Diana is surprised that Myndi could not understand that she would have done it for nothing. Diana articulates the attitude that the sacred cannot be trivialized by mere capital.

Lucy Spear, like Myndi Mayer, represents a girl who lives through the fantasy induced by consumerism and dies using a consumable sacred object. Lucy presents the facade of a successful girl. She is a cheerleader, smart, she never gets less than 95 per cent in school assignments, she is popular with boys and exceedingly pretty. Despite her popularity, maturity and beauty, Lucy is unhappy. She feels she cannot live up to her parents' or society's expectations. Although she is more mature than Vanessa she yearns for a childhood she feels was never hers and this may be a reflection of her parents' attitude and expectations. Her father wants to keep her as a child. When she had her first period Lucy's father 'cried like a baby'.[71] Her mother sends out conflicting signals. When Lucy requests a Wonder Woman doll, her mother tells her she is too old to play with dolls.

The significant moment in Lucy's life is a liminal moment at a carnival held in Beacon Hill. The story 'Chalk Drawings' runs parallel to the aftermath of her suicide. That this is a carnival is significant for, as Mikhail Bakhtin suggests, the carnival is a time of chaos in which cultural hierarchies are turned upside-down.[72] At carnival time, official time is suspended and there is no life outside of the carnival: 'During carnival time life is subject only to its own laws ... It has a universal

spirit; it is a special condition of the entire world, the world's revival and renewal, in which all take part.'[73] Carnival is a time when the typical values of the world are turned on their head. Thus Vanessa describes how this carnival time transforms 'our little cosmopolitan neighborhood [into] a slice of real Americana. There was a fresh innocence between us, instead of our typical urban paranoia. Strangers actually smiled at each other and good friends laughed.'[74] While carnival time is connected to sacred time in that it is cyclical time, in this story sacred and profane time are juxtaposed. The story of this sacred moment is juxtaposed with linear time and Lucy's funeral. Vanessa's memories of this idyllic time are tempered by her memories of Lucy's mockery of her childishness and her remonstrations that Vanessa stop obsessing about when her breasts will develop. When a street artist produces a chalk drawing of Lucy and Vanessa on the pavement, Vanessa profanes the moment with a photograph. The sacred moment of plenitude when all is right with the world is captured by the artist, the chalk drawing is fixed by the photograph. That moment is washed away with the rain, but recalled through memory.

While Vanessa envies Lucy's popularity with boys and her fully formed female body, Lucy wants possession of the sacred thing, Wonder Woman. She fills the void by blackmailing her parents to buy Wonder Woman branded goods to create a collection claiming, 'See this doll? Cost $150. Lucy begged us to buy it. I said she was too old for dolls ... She said if Vanessa could have the real thing in her house she could at least have a doll.'[75] For Lucy, however, the doll is a simulation of the goddess, much like the icon was a substitute for God in the Middle Ages.[76] When her consumer goods fail to provide the plenitude she craves, Lucy steals her mother's car keys and suffocates herself with another sacred product, her father's car.

Myndi and Lucy fall prey to the fantasy and desire of consumerism. Eddie Indelicato the detective investigating Myndi Mayer's death unwittingly identifies a connection between Myndi and Lucy: 'I (Eddie Indelicato) stared at the photos of Diana, and of Myndi Mayer, another beautiful bird who just wanted to keep flying higher. Until she ran out

of sky.'[77] In contemporary culture, Pérez suggests, real life cannot offer the plenitude of consumerism. Myndi constructs a fantasy world for herself but it is significant she also chooses to take a career in peddling PR dreams. Lucy also constructs a fantasy world with her simulations of the sacred in her collection and Wonder Woman doll.

In both Myndi Mayer and Lucy Spear's stories, chalk comes to symbolize the fragility and finality of life. Myndi's dead body is surrounded by the drawn outline. Lucy's image is drawn in chalk by the street artist, only to be washed away by the rain. The chalk drawing washed away by the rain is a metaphor for the fragility and impermanence of mortal life just as the chalk outline represents Myndi's dead body.

Conclusions

In this story arc, Pérez constructed a goddess paradigm for the representation of Wonder Woman that was to endure for twenty-three years.[78] It was modelled on an ideal feminist figure connoting power tempered with essentialist feminine virtues of peace, love, justice and forgiveness. Pérez shows that when a woman, even the most accomplished woman, is elevated to a deity, she becomes an impossible ideal, an unbending, unforgiving iron maiden. This reflects Wolf's and Faludi's theses that consumerism deflects women's aspirations from equality towards self-absorption. Their desire for consumer products they assume can make their lives perfect, obscures their understanding of the boundaries between fantasy and reality. Yet, for Pérez, Diana's divinity is not the problem; it is supposed to empower women. Rather, for Pérez the issue is what happens when consumerism appropriates and distorts divinity, something with which even Diana would agree, as she disapproves of the money made through selling replica bracelets of submission for ludicrous prices.

In reflecting the feminist critique of specifically 1980s consumerism and the objectification of female body perfection, Pérez's revision of Wonder Woman addressed the cultural obsessions and violences of his

day, just as Marston reflected the traumatic political and social issues through which Wonder Woman's mission was conceived. By connecting the sacred realm of the Greek gods in all their physical perfection with the profane realm of mankind, obsessed by the demons of consumerism, Pérez created a Wonder Woman who articulated how beauty could be used as a means of manipulating women.

Pérez's revision and Wonder Woman's sacralization as a saintly figure worked against her in the late 1980s and into the 1990s, for female action heroes and superheroines were entering a new phase when female morality equated with prudishness. The late 1980s and early 1990s was the era of violent, hyper-masculine superheroes with extreme musculature and pin heads. Superheroines became *uber* violent, silicone-breasted, waspy-waist bad girls. The bad girl phenomenon was driven by changes in comics production, distribution systems and the perceived fan demographic. Up to the late 1980s, writers and artists had little autonomy or creative control over their own creations. Neither did they receive any royalties from their invention of new characters. In 1992 several artists and writers from Marvel including Todd McFarlane, Rob Liefeld and Jim Lee formed their own company, Image, where creators were allowed to keep copyright on their creations. Image comics were often derivative of Marvel and DC characters. For instance, superheroine Glory, created by Rob Leifeld, was the daughter of Amazon Lady Demeter and demon Lord Silverfall. She was raised and trained by the Amazons to be their greatest warrior. She also fought in the Second World War.

Bad girl heroines were sexualized and extremely aggressive. Series such as *Glory* or *Lady Death* featured the protagonists in lingerie specials posed in impossible pornographic positions with orgasmic facial expressions, licking blood from swords. But they were also drawn to appeal to the perceived fan base comprising over 90 per cent 17–26-year-old males.[79] In such a market Wonder Woman's sales dropped and, in response, DC employed fan favourites William Messner-Loebs and Mike Deodato Junior to update Wonder Woman from a worthy good girl into a kick-ass bad girl. Messner-Loebs's story

arc depicted Diana losing her Wonder Woman role to bad girl Artemis. Artemis was a member of the Bana-Mighdall tribe of Amazons and she was filled with arrogance. Her arrogance led to her death and Diana took over the title once more. This run saw Diana and Artemis's bodies depicted in typical bad girl style with elongated, muscular bodies and pin heads, wearing scanty, fetishized clothing and striking softcore porn, brokeback poses.[80] The run was loved and condemned in equal measure by fans and, despite its brevity, is still regarded as an important moment in Wonder Woman's history.

In 1995 Messner-Loebs and Deodato Jr. were replaced by John Byrne. Although Byrne was respected in the superhero comics culture for his work on Superman and X-Men, fans complained about his emphasis on bondage and torture scenes; for instance in *Wonder Woman* v. 2, 105 where she is tortured by Darkseid, the demon god who rules the dystopian planet, Apokolips.[81] Byrne resurrected Artemis and had Hippolyta become Wonder Woman in the Second World War. It was Byrne who finally made Diana into a real goddess when she died in number 127, November 1997, and was resurrected as the Goddess of Truth.[82] This deification was withdrawn several issues later. Diana's elevation to godhood was resurrected in The New 52, a revision of the DC Universe after 2011, when she became a demi-goddess as Zeus and Hippolyta's daughter.[83] In an interesting revision of the dying/reviving god narrative paradigm, writer Brian Azzarello had Diana kill Ares, God of War, to become the War God reborn, an issue discussed in Chapter 6.[84]

Taming the Unruly Woman

Surveillance, Truth and the Mass Media Post-9/11

Wonder Woman stories during 2000–11 are confusing with the rapid introduction and removal of new supporting characters and story arcs, sometimes within five or six issues of each other. In all, in an eleven-year span there were seven new writers. Each time a new writer was appointed, they changed backstories and discarded supporting characters of the previous creative teams to introduce their own cast, a fate that was not accorded to Superman or Batman. In addition to the rapid turnover of creative teams, Wonder Woman was rebooted twice between 2003 and 2011. The first reboot was in 2010 by Michael Straczynski. In 2011 a complete reboot of the DC Expanded Universe took place in which the main characters' backstories were revised. This was called The New 52. The result of these revisions was that the character lost definition and consistent backstory leaving readers confused and often angry.

This chapter deals with the work of the writer often assumed to produce the longest-running, most consistent and polished stories of the period, Greg Rucka. Fernando Gabriel Pagnoni Berns attributes the success of Rucka's stories to his creative approach and well-conceived characters that 'are framed in the echoes of a real event that shocked and changed the history of not only America but the whole world'.[1] As Berns states, Rucka's stories responded to a drastically changing global and domestic political climate; they were produced in the aftermath of 9/11.

September 11th, 2001 marked a change in America's belief in its invulnerability to attack on its shores when an Islamic group, al-Qaeda,

hijacked four airplanes, two of which they crashed into the North and South towers of the World Trade Center in New York. The third crashed into the Pentagon in Virginia. The last crashed into a field near Shanksville, Pennsylvania. In all, 2,996 people were killed and 6000 injured. It led to acts of retaliation by the USA and their Allies that included an invasion of Afghanistan to strike at the Taliban regime who sheltered al-Qaeda and an invasion of Iraq. Internally it resulted in escalation of hate crimes and suspicion of Islam and foreigners, and a strengthening of anti-terrorist arrests and convictions. Rucka made Diana the Themysciran Ambassador and this, according to Berns, enabled her to reflect 'the doubts and determinations of a nation which faces the dilemma of answering terror with terror or attempting a diplomatic response'.[2] It also enabled him to address issues of Diana's foreignness, a hoary issue after 9/11 when other races and religions, such as Islam, were increasingly treated with suspicion and incomprehension in the West.

The main storylines by Rucka span 2002 to February 2006 and are part of volume 2. His first story, *The Hiketeia* (2002), was a standalone graphic novel.[3] The Hiketeia, which shapes and drives the narrative, is a ritual that calls for the obeisance of a supplicant in return for protection. The supplicant vows: 'I offer myself in supplication, I come without protection. I come without means, Without honor, without hope, With nothing but myself to beg for protection.' *The Hiketeia* evokes Marston's notion of submission and domination and, as Sandifer notes, draws connections with the bondage scene.[4] However, in the context of Rucka's run on *Wonder Woman*, *The Hiketeia* demonstrates Wonder Woman's strangeness to Western values and perceptions and it sets the tone for Rucka's construction of the character as a foreigner with strange values and customs baffling to Western comprehension.

The Hiketeia begins with Batman's relentless pursuit of a murderess, Danielle. This is foiled with the intervention of Wonder Woman. Danielle previously performed the hiketeia with Diana which obliges Diana to protect Danielle against Batman. However, there is a twist. Danielle has murdered four men in vengeance for her sister's abuse and

death at their hands. Batman submits to Diana's authority by performing the hiketeia. However, Diana rebuffs this strategy as an abuse of the ritual. Batman clearly does not understand the full meaning of the ritual and regards it as a strategy to defeat Diana. *The Hiketeia* reveals the clash of values between American and Amazon values, a clash that leads to Diana's eventual downfall.

A brief summary of some of the stories in the Rucka years shows some of the key recurring tropes of his run. They arise from suspicion and paranoia, and are based upon manipulation and surveillance strategies used by her opponents to attack her. In 'Join the Mission', *Wonder Woman* v. 2, 195, Wonder Woman's role as the Themysciran ambassador is laid out. Rucka introduces the staff of the Themysciran Embassy from the point of view of Jonah McCarthy, her new intern. They are her press officer Peter Garibaldi, his two sons Martin and Bobby, her attorney Rachel Keast and Ferdinand, a minotaur and her chef. Jonah McCarthy's name, however, is a signal that he is untrustworthy and intolerant; Jonah is a jinx who imperils any enterprise and McCarthy is based upon Senator Joe McCarthy whose right-wing ideology thrust America into persecution, uncorroborated allegations, trials and anti-communist hysteria in the Cold War.

The connections between the Cold War and the post 9/11 paranoia inform Rucka's stories. Both cultural climates feature a clash of ideologies. Both are based on propaganda and false information. Diana is opposed by two global institutions headed by two, apparently philanthropic individuals, Morgan Edge and Veronica Cale, but whose beneficent appearances mask manipulation and evil. Maxwell Lord is the head of the Chimtech Consortium and described as 'a man known to millions as a philanthropist and humanitarian of the highest order'.[5] However, he is also the Black King, head of global organization Checkmate. Checkmate is originally a government agency concerned with checking metahuman power. However, Rucka shows that corruption and ambition can cause a government to lose control of such an organization. Veronica Cale heads global corporation Cale Anderson Pharmaceuticals (CAP). She opens centres for disadvantaged girls.

However, she is envious of Diana and plots her downfall by arranging protests outside the embassy through right-wing politician Darrel Keyes's Protect Our Children group. The protestors' minds are further manipulated by Doctor Psycho, whom Rucka updates from Marston's original misogynistic dwarf to become telepathic and warped.[6] Under cover of the disorder, Darrel Keyes is shot and the blame placed on Diana's supporters. In a further story arc, Cale is recruited by Circe and the Gorgons to organize a battle between Diana and Medusa. This match is broadcast to global audiences but this battle shows the extreme strategies Diana is prepared to employ to defeat Medusa when she deliberately blinds herself so she will not be petrified. She is, therefore, able to thwart the Gorgons' attempts to turn global audiences to stone.

Global broadcasting is again employed in showing the battle between Maxwell Lord and Diana. Lord manipulates Superman's mind so that he attacks Batman and Wonder Woman. Wonder Woman breaks the spell, temporarily, by binding Lord and Superman with her lasso. In asking Lord how she can stop him, Lord, unable to lie, responds only by killing him. Diana then kills Lord. Lord's death prompts a signal to a satellite Brother Eye to initiate attacks on Themyscira by Observational Metahuman Activity Constructs (OMAC).[7] OMACs are humans whose bodies are transformed into cyborgs by nano-technology and they operate under the control of the OMAC Project.[8] The Amazons are forced to defend themselves and they create a purple death ray, a warped version of the purple healing ray, to destroy the OMACs. Again, the battle is broadcast to global audiences. Appalled and in the aftermath of the carnage, Diana disbands the embassy and orders the Amazon nation to leave the mortal plane. Thus, her enemies destroy her by destroying her reputation.

The main themes explored by Rucka are founded upon the relationship between power and truth, both concepts explored by Michel Foucault. Foucault showed how the confessional of the Church in medieval times was diffused into secular culture from the late eighteenth century through the practices of the clinic, the psychiatrist and the justice system.[9] These and other institutions required subjects

to speak their truth through their sexuality, psychology or morality. In this way knowledges were constructed of the gender, pathology, criminality and psychology of individuals that provided a construction of normality. The construction of 'norms' encouraged people to conform to notions of gender, sanity and morality.

In Rucka's stories one can identify the ways Foucault's ideas are put into practice through surveillance and the construction of knowledges. Knowledges can be constructed from surveillance represented by the eye motif in Rucka's stories.

Knowledge is not fixed, however, for it is subjective and can be manipulated. Thus, there are many notions of truth and they rest upon the value systems of individuals and organizations. For instance, Diana's enemies' notions of truth are often founded upon their assumptions of women's place in the world or their Christian values. Therefore, they do not recognize her truth as an Amazon.

In these stories information flow and truth are manipulated through the mass media. Rucka's stories are driven by the paranoia and suspicion of metahumans, Chosen Ones and powerful women. Wonder Woman's enemies fear her difference and her potential to destroy the world, as they know it. The adversaries in these stories, Veronica Cale and Maxwell Lord, are billionaires who control the flow of news at a global level. Batman also plays a hand in her downfall: first he condemns and then shuns her for the killing of Maxwell Lord. However, he is also culpable in the attack on different Others when Wayne Enterprises create the technology of the Brother Eye satellite to gather information about metahumans to defeat them should the need arise. Like Lord, Batman distrusts the might of his peers and their potential to turn on humanity. However, Batman misjudges the potential of technology to be controlled by malevolent individuals bent on destruction. Maxwell Lord hacks into the technology so that it responds only to his orders. He places a command in the system to destroy all metahumans should he ever be killed. Paradoxically, Lord is a metahuman who can control and manipulate minds and, in becoming the Black King, he heads Checkmate, an organization dedicated to limiting the power of superhumans.

Despite a seeming clear-cut demonstration of power and antagonism from Diana's enemies, however, there are layers of manipulation and motivations going on in the stories that pose ethical and moral dilemmas. Power is not just an act of domination but is implicated in the judgements made upon individuals' actions for, as Foucault argues, 'Power is everywhere; not because it embraces everything, but because it comes from everywhere.'[10] People think they act autonomously when they are being controlled by others. Those who seem weakest have as much power as those at the head of powerful organizations. Often those that seem powerful either cannot or will not intervene in certain desperate situations, and actions that are taken with the best of motives are judged unethical or immoral. In the chapter I use three examples from the comics that exemplify the surveillance, manipulation and judgement permeating culture following 9/11; the prelude and battle between Medusa and Wonder Woman, the killing of Maxwell Lord, and the recriminations and moral judgements between Diana and the Amazons following the attack of Brother Eye. Each of these story arcs exemplifies the themes of surveillance, manipulation and moral judgements that infiltrated the political and cultural climate after 9/11.

Post 9/11: Comics, Politics and American Culture

Berns notes that after 9/11 there was a new normality in American political and cultural sensibilities.[11] The terrorist attacks reshaped the ways American culture perceived Otherness and foreigners and the responses were shaped around previous wars and cultural clashes in American history. Like the frontier wars, where settlers acted as though they were innocent victims, after 9/11 responses included the justification of taking moral retribution on behalf of the free world.[12] Enemies were described as 'certain races [that] are inherently disposed to cruel and atrocious violence'.[13] This language incorporated a racial element in the designation of the enemy, a theme taken up in much of the 9/11 rhetoric. Elisabeth Ankar notes how news rhetoric, at this time,

adopted the narrative structures of melodrama.[14] George Bush launched a Global War on Terror (GWOT), citing the unprovoked attack on a 'peaceful morning' and an attack on freedom, stating: 'Fellow citizens, we'll meet violence with patient justice – assured of the rightness of our cause, and confident of the victories to come. In all that lies before us, may God grant us wisdom, and may He watch over the United States of America.'[15] Thus, the enemy was constructed as violent and unreasonable while America, with divine support, acted out of 'patient justice' based upon reason and temperance. Bush acknowledged it was difficult to identify the enemy and the campaign would be unlike any other: 'It may include dramatic strikes, visible on TV, and covert operations, secret even in success.'[16] Thus, a secretive element was infused in the American response.

Rhetoric and mass media narratives in news reporting and dramas in film, television and newspapers were influenced by 9/11 and reflected what Susan Faludi argued in *The Terror Dream* as a cultural daydream in which truth, fantasy and reality were blurred as America came to terms with the notion of a terror attack.[17] Faludi suggested that the destruction of the Twin Towers signalled a symbolic castration of capitalism and American masculinity. This symbolic disempowerment of masculinity and capitalism invoked a crisis in masculinity, itself a reflection of a similar cultural concern of the 1950s Cold War era. America's response to 9/11 was to return to a mindset of the 1950s, a supposed golden era of stability in which women were delegated to 'traditional' gender roles.

However, 9/11 only quickened a process already under way for there was a backlash against female autonomy prior to this. In an interview for CNN, on 8 November 2001, controversial critic of feminism Camille Paglia argued that men had become feminized in contemporary culture: 'There is a serious problem with masculine identity. Boys have no model of manhood. In the upper middle class, a man is expected, once he's turned out by Ivy League education, let's say, to become like a woman.'[18] As if to encourage a return to more 'traditional' gender roles after 9/11, there was a downplaying of female heroism in representations and news

reports. For example, in her analysis of news reportage, Justine Toh noted how, in 9/11, the term, 'firefighters' was substituted by 'firemen' and women were not shown on posters proclaiming the heroism of the public services.[19] American politics became more right-wing and dismissive of women's rights. The anti-feminist backlash is reflected by Greg Rucka in the condemnation of Wonder Woman and the Amazons by Diana's enemies and the right-wing factions they nurture.

In comics stories, the boundaries of fantasy and reality also blurred. Comic-book stories after 9/11 in Marvel and DC Comics shared similar concerns. Both companies believed they had to rationalize why superheroes were not present to save people when the attack on the Twin Towers took place, thus conflating reality with fantasy. Even supervillains, who had undertaken heinous crimes from genocide to mass murder, joined with heroes in grieving for the dead. For instance, in *The Amazing Spider-Man* v. 2 36, Marvel heroes were joined by their foes, Doctor Doom, Kingpin and Magneto, in the aftermath of the destruction. Doom, tears in his eyes, mused: 'Because even the worst of us, however scarred, are still human. Still feel. Still mourn the random death of innocents.'[20]

After 9/11 heroism in culture and comics was also evaluated. Firefighters, police, medics and ordinary individuals were represented as acting heroically in extraordinary situations in culture. This was also true of comics where the lone vigilante was regarded with suspicion and increasingly contained by institutions, laws and government agencies. The instigation of regulatory institutions and laws offered the potential for conflict amongst characters between those that bowed to, and those who challenged, the establishment. At Marvel, a major story arc, 'The Civil War' (2006–07), written by Mark Miller, was prompted when The Superhero Registration Act was passed.[21] The Superhero Registration Act responded to an accident when supervillain Nitro, in a reality television show, blew up an elementary school, six hundred people and several superheroes taking part in the television show. This led to closer supervision and scrutiny of superhero activities by the government. The Superhero Registration Act constrained heroes to

work under official regulation and disclose their secret identities. The disagreements amongst major characters, even those on the same teams, led to war and, eventually, tragic consequences for some characters. Spider-Man's disclosure of his secret identity led to attacks on his friends and family. Captain America was assassinated. Hero was turned against hero in the stories.

Similar issues to Marvel's output occur in Rucka's *Wonder Woman*. They include the effects of surveillance in the reality television show and how it reveals the destructive actions of metahumans. In DC superhero Comics institutions such as the OMAC Project and the Department for Metahuman Affairs (DMA) were set up to spy upon and limit superhero agency. These were featured in *The OMAC Project* mini-series leading up to the *Infinite Crisis* story arc. Surveillance and recording technologies appeared in these stories that aided OMAC and Checkmate in containing and regulating superhuman agency. Wonder Woman and the Amazons were of interest as Themyscira lay close to the American mainland and Amazon technology, more sophisticated than that of America, was deemed a threat to American security. Amazon culture and values, so different from that of America, were also incomprehensible and alarming to right-wing and Christian groups.

Diana's values differ from those of humanity on several counts including her religious and spiritual beliefs, her feminism, her vegetarianism, and her commitment to ecological issues and animal rights. These issues are used to target her as a foreigner and alien by her enemies.

Diana begins as naïve in the face of human manipulation and malevolence but as Themysciran ambassador and superhero she dwells mainly in the public sphere. Consequently, it might seem she has no secrets or issues on which she can be attacked. Certainly, this seems to be Diana's stance. However, definitions of wrongdoing or transgression can vary according to who is scrutinizing the information and the values on which they base their concept of 'normal'. Her enemies head technological and global corporations that have mass media outlets or networks of followers at their disposal. Often her enemies, such as

Darrel Keyes, are right wing, Christian and intolerant. They consider Diana and all superheroes as threats to the safety of humanity and who have the potential to threaten 'the American way of life' as they perceive it. In the last story arc of the series, Diana shows more understanding of her enemies' strategies and she realizes that the broadcast battle is meant to convince audiences of the Amazons as warmongers. She orders the Amazons to leave the earthly plane.

The lack of understanding between Diana and humanity extends to her peers in the superhero community. This is shown in an encounter between Diana and the Flash tackling a forest fire in *Wonder Woman* 196, 2004. The issue opens with an ecological disaster, a forest fire. Diana is introduced a few pages later when she demonstrates her skill in speaking with animals, a skill that also differentiates her from humanity and bears a similarity to Walt Disney's Snow White, further highlighting her as fantasy figure. A bluebird alights on her shoulder and informs her of the forest fire. 'Most animal speech is vague at the best of times, so it is hard to make out ... but he speaks of light and catastrophe.'[22] Diana establishes that homes and humans are safe, and tells firefighters the fire must be allowed to run its course. Before she can finish, she is interrupted by the arrival of the Flash who assumes responsibility: 'You can sit this one out, Diana. I'll work around the fire at speed, cut off the air that's feeding it.'[23] Diana prevents Flash from stopping the fire: 'The forest needs this fire ... it's how it grows, it's how it stays healthy.'[24] The following page shows their discussion recorded by monitoring equipment. The panels to the left of the page are shaped like television screens and, instead of speech bubbles, their conversation is detailed like subtitles below the screens. Diana explains: 'Death is necessary, Flash. It is part of life, and if we say life is a blessing, we must say that death is a blessing, as well.'[25] The bottom screen shows an over-the-shoulder shot with Diana watching the Flash running off in the distance. His parting comment, 'Next time I won't stop. No matter what you say,' is an ominous portent for her future relationship with the male members of the superhero community. The right-hand side of the page is a full body shot of Diana against the fury of the fire sadly agreeing there will be trouble in the future.

Diana's actions are partially a result of her body's immortality which gives her a long-term view of the workings of nature and the regeneration of the forest. These, however, are a mystery to many mortals who deal in the short term and whose instinct is to save the forest creatures and the trees from destruction.

In a further misunderstanding of human values, Diana conducts a promotional tour for her philosophical book *Reflections: A Collection of Essays and Speeches* and is confronted by members of the public, as in Pérez's account of Diana conducting a promotional tour, less interested in her ideas than the minutiae of her love life and invisible plane.[26] Her quip to a question about whether she has a boyfriend – 'I don't, no, not at present. I should add that I don't have a girlfriend either' – exacerbates potential antagonism against her lifestyle.[27] Her habitus in an all-female society proclaims her as a queer character who recognizes same-sex relationships as normal, an aspect of Diana that was highlighted by Greg Rucka in his comments on his run of the character.[28]

Diana's easy acceptance of single-sex relationships is considered abnormal to some groups. Darrel Keyes, head of Protect Our Children, describes his antipathy to her 'lifestyle and a belief-system that right-thinking Americans find, frankly, disgusting'.[29] His hatred is based on the Amazons' worship of 'pagan gods' and their sexuality that promotes 'a lifestyle of depravity and deviance'.[30] He also protests about her clothing in which 'she parades around like a stripper'.[31] In a subtle allusion to Marston's notions of submission and dominance and the ways they impact on prison reforms, Keyes states he is against the Amazons' 'radical notions on prison reform'.[32] Even an issue as bland as vegetarianism is regarded by Keyes's followers as transgressive when he states that she 'thinks meat is murder ... just go back where you came from ... you pervert'.[33] The venues for the book promotion are picketed by Protect Our Children protesting against her depravity proclaiming 'Amazon Equals Alien'.[34] Protect Our Children shut down eleven Myndi Mayer Centers that championed girls and women's support, education and empowerment. As Keyes and his followers affirm, 'There'll be no more cults to Wonder Woman [...] no more worship of false gods'.[35]

Supporting and manipulating Keyes is Veronica Cale. Cale arranges the protests so they can be 'clearly identifiable to the media'.[36] She organizes Little and Winn Public Relations to analyse the book on the ways it can be attacked. The report reads, 'Wonder Woman has left herself open to attack on multiple issues and multiple fronts'.[37] However, Cale has her own agenda and when Keyes and his followers become a nuisance she arranges for Keyes to be assassinated, manipulating it to look like it was coordinated by Diana's followers.

The Fatale Gaze: The Banality of Images and Captivated Audiences

In his use of surveillance and manipulation, Rucka reflected the paranoia that prevailed after 9/11 when surveillance and incitement to appear 'normal' were more important than ever. For instance, after 9/11 The Patriot Act was instigated which permitted the Federal Bureau of Investigation (FBI) to intercept documents and communications from suspected terrorists without redress to court injunctions. In 2002 the FBI became an agency devoted to counterterrorism.[38] Discussing the change in attitudes towards surveillance after 9/11, and writing at the same time as Rucka's stories, David Lyon notes: 'the "age of terror" is turning its surveillance gaze on ordinary citizens in unprecedented and unconscionable ways. This atmosphere of suspicion is perhaps the political parallel to climate change – global chilling.'[39]

Eyes are a major motif in these stories from Veronica Cale's scrutiny of Diana on the television and CCTV footage, Circe's gaze on Cale, the gods' surveillance of Diana and each other, to Medusa's attempts to kill humanity through her petrifying glare.

Surveillance is an ambiguous term for it can refer to the collection of information to provide protection but such information is also used to control and regulate individuals, a notion developed below.[40] Michel Foucault proposes, for instance, that we live in a disciplinary society that does not exert force to influence subjects but, instead, uses 'a whole

set of instruments, techniques, procedures, levels of application, targets' to encourage individuals to self-regulate and conform to a culturally accepted 'norm'.[41] Surveillance can consist of people watching each other and reporting on suspicious behaviour to the increasing use and growing sophistication of surveillance technologies.[42] John Gilliom and Torin Monahan note the connection between the constant scrutiny of people and the drive of organizations and governments to discover the 'truth of the individual', when they claim that 'information societies are necessarily surveillance societies'.[43] A price we pay to live in the free society is that government and institutions rationalize the use of surveillance as the means of ensuring that it protects ordinary citizens by collecting information to prevent attack or abuse of their freedoms.[44] It is also used to limit freedoms.

Diverse technologies are key factors in the strategies used to surveille people and organizations. Technology is used to gather information on consumer practices in the use of online shopping, credit cards and loyalty cards. DNA testing is now able to determine inherited diseases and ethnic origins, and is used in police procedurals and, in the future, could be used by insurance companies to determine disputes and claims. At a more mundane level CCTV is used to monitor public spaces such as shopping malls and schools. This information is increasingly delivered into the public domain. Thus, private information becomes public property. The growth of CCTV transforms private spaces into public spaces and Greg Rucka's stories are full of surveillance footage that is made available to media corporations for broadcast to mass audiences. This leads to a further type of surveillance, sousveillance. Sousveillance, as Steve Mann and Joseph Ferenbok (2013) state, is the act of the many gazing on the few.[45] In the case of *Wonder Woman* the sousveillance becomes a means to destroy her psychologically.

There are several types of surveillance in Greg Rucka's storylines. Some surveillance does not involve technology. It consists of the individual watching and reporting on the activities and ideas of those closest to them. McCarthy, for instance, infiltrates the Themysciran Embassy to spy on Wonder Woman for Checkmate, an organization

devoted to destroying the power of superheroes. McCarthy seems dedicated to Wonder Woman's ideals. In his interview for the job, when asked why he wants the post, he replies, 'Because she makes a difference',[46] a statement that could be read in both a positive and negative sense. Nevertheless, whilst Jonah seems overawed by Diana's presence, Rachel Keast, Diana's PR woman, is suspicious of his motives.[47] When Diana mentions that Jonah is charming, Keast replies, 'If *you* say so, Madame Ambassador.' When Diana learns of his true intentions, Jonah expresses concerns about metahumans and the Amazons: 'you're a threat [...] you and all your 'sisters' [...] preach peace but know war [...] you're a god and we're all bugs by comparison'.[48] His assertion reveals the levels of mistrust felt by people over Diana and the Amazons.

Surveillance that involves magic also appears, for instance, in magical scrutiny of the gods on humanity through reflective surfaces. The demi-goddess Circe monitors mortals through a magic sphere or she sees her daughter Lyta through a mirror. The gods look down on humanity from a scrying pool in Olympus, sometimes with dangerous consequences. Hera discovers Zeus gazing on the Bana-Mighdall Amazon Artemis and, in anger, kicks Themyscira into a different location, ninety miles off the American Carolinas.

Most surveillance in the stories is realized through technologies whether operated by the militia, CCTV or television broadcasting, and as described in the examples above. In many instances female surveillance is the deadliest gaze of all, from Circe's crystal ball, to Hera's fury at the scrying pool and Veronica Cale's constant scrutiny of Diana to identify anything in her behaviour that could be attacked.

Two examples of the fatale gaze, the destructive female gaze, can be identified in the actions of Veronica Cale and the gaze of the Medusa. Veronica Cale's whole lifestyle revolves around surveillance. Early on the reader is introduced to Cale lounging on the sofa watching Keyes Protect Our Children protesting outside a bookshop where Diana speaks. While watching the exchange between Diana and Keyes on television, Veronica Cale condemns Diana for her strange values 'all that stuff about women and equality and sexuality and blaming people

for the state of the world [...] if she thinks she can just publish her kind of perversity, attack *our* [my emphasis] core values'.[49] Cale hungers for power and recognition and is jealous that the wealth and power she struggled to achieve seems to come naturally to Diana. Yet it is a strange statement from a woman who also experienced the inequalities of patriarchy for Cale's story represents the rags-to-riches American Dream, a claim she herself makes: 'I am rags to riches, I am everything the Wonder Woman pretends to be. And the difference is I earned it [...] through my blood, sweat, and tears ... if there is a Wonder Woman in this world [...] it's me!'[50] Cale's mother was a stripper/hooker who got pregnant but she ensured her daughter was well educated.[51] Cale's story demonstrates how, within the *Wonder Woman* narrative, life experience and social systems disadvantage smart but poor women and turn women against each other. Cale and Wonder Woman's relationship is similar to Karen Hollinger's notion of the Hollywood 'anti-female friendship film', a genre that explores destructive female relationships in which one female manipulates and controls another. This film genre cautions women against close relationships with each other; it also 'obscure[s] other issues related to women's position in society, relieve men of any responsibility for women's problems, and suggest, instead, that women should grant men primary importance in their lives because they are the only ones upon whom women can rely'.[52] Even when Diana helps Cale, freeing her from attack and captivity by Doctor Psycho, Cale still mistrusts and plots her downfall.

Cale's paranoia is reflected in the architecture of CAP Pharmaceuticals in which CCTV and surveillance is everywhere.[53] The CAP Pharmaceuticals building, shown in *Wonder Woman* v. 2 205, 'Bitter Pills (3/3)', is made of glass, and is a transparent goldfish bowl of a workplace where secrets seem impossible. Page five shows the ubiquity of surveillance. The first panel is a god's view shot of Diana entering the reception, an impersonal space decorated with white tiles and walls and grey carpets. Diana is monitored with security staff tracking her on CCTV. Page six intensifies the surveillance. Diana and her contact, Doctor Anderson, enter the reception, again shown through a god shot

but positioned as if taken by a security camera. On the wall next to them is another security camera. The second panel shows the security guard monitoring them with a bank of screens. Despite the constant surveillance and the transparency, the building hides secrets such as a hidden laboratory in which Cale conducts experiments on Doctor Psycho and Vanessa Kapetalis/Silver Swan. There is a secret room in which she tortures and eventually murders Kimberly Dunn, an employee of Little and Winn Associates PR company, who leaked information to Diana.[54] Cale, however, is also a victim at the mercy of Circe and the Gorgons, and eventually Doctor Psycho, who takes over her mind and takes her place. She is bound and hidden by Doctor Psycho in a cupboard. In fact, the eyes constantly deceive people through manipulation throughout these stories. In his attempt to escape, Psycho manipulates the security guard into believing Diana is the Joker attacking Doctor Anderson.[55] The CCTV camera, showing raw footage that is not edited, shows the true image of Diana holding Psycho.

The eyes become central in *Eyes of the Gorgon*, a five-part series in *Wonder Woman* 206–11 (September 2004–January 2005). In this series, the demi-goddess Circe seeks the support of Medusa and her two Gorgon sisters to recover her child Lyta held by the Amazons. Eyes and surveillance are significant motifs in these stories but surveillance is a malignant phenomenon: looking at Medusa means death through petrification and Circe manipulates television cameras so that global audiences are compelled to watch Medousa and Diana's fight. Medusa's ultimate aim is to turn the whole of humanity to stone. Circe uses a crystal sphere and identifies Veronica Cale as an ally who can publicize the event. Events reach climax when Medusa turns Peter Garibaldi's son Martin to stone and Ares arranges a battle, to the death, between Medusa and Diana.

In *Wonder Woman* 210, January 2005, page 2, Diana and Medusa confront each other in the contest held in the Yankee Stadium, the Bronx. The battle is refereed by Ares and controlled by Circe who puts a spell on the cameras to prevent the broadcast being disrupted:

The spell ends five minutes after one of them is dead. Trust me, I've done this trick with televisions before. With the world as her witness, Medusa will slay Wonder Woman. And then … well, it's a live global transmission … I'd estimate you'll have some forty million viewers glued to their sets for this moment of bread and circuses.[56]

The construction of the page is a reminder that this event is televised and the subject of surveillance to mass audiences. It opens with Stheno, Medusa's sister, looking into the camera lens in the Yankee Stadium. However, Diana thwarts the plan by first binding her eyes to deny Medusa's gaze. When driven to extremes, she blinds herself before killing Medusa.

Diana's actions are driven by necessity. As a warrior she calculates what is necessary to win the battle, a strategy noted by Ferdinand, her chef, who states of the Amazon code: 'The sword is never drawn in haste, nor swung without need.'[57]

Audiences react to the battle in a variety of ways. At first, they think it is staged. In a climate where one cannot believe one's own eyes, where paranoia pervades society, can one trust one's own judgement? An example of audiences' incapacity to tell the real from fantasy is shown in their responses to the battle. Audiences conflate fantasy with reality: 'The trailer looks awesome.' 'The CGI looks totally fake.' 'This is just like that movie.'[58] When people realize the action is real, the scenes are intercut with responses of the audiences. For instance, on page 11 bar patrons urge Diana on as if it were a boxing match: 'Yeah!' 'Nail that &*$#!' Other patrons ignore it and carry on drinking. Medusa knocks Diana down and prises her helmet off only to find she has bound her eyes. When Diana decapitates Medusa, in a splash panel the three panels below show incredulous audiences' shocked responses from different angles – gazing up at the screen, in a bar where people in the foreground ignore the action and in close-ups of other people they hug each other in shock.

The examples of Medusa and Veronica Cale and their attacks on Wonder Woman show how women, themselves victims of patriarchal violence, attack each other. In her relationship with Veronica Cale,

Wonder Woman reveals a recurring problem with the character. William Marston's original aim was to create an inspirational female character. However, when filtered through the lens of specific eras Marston's aims of inspiration can become warped. In his attack on comics, *Seduction of the Innocent* (1954), Dr Fredric Wertham's claim that Wonder Woman was a morbid ideal inadvertently addresses these later representations of the character. Although Pérez and Rucka also aimed to show Wonder Woman as an inspirational character, when filtered through consumerism in the 1980s and Otherness/terrorism in the early twenty-first century her perfection can be warped, misunderstood or misused.

Manipulation, New Ways of Looking and the Judgemental Gaze

Rucka's stories reflected the current state of broadcast technologies in the mass media coupled with their context in powerful globalized corporations and how this impacted upon the relationship between the mass media and audiences. The early twenty-first century saw the globalization of mass media corporations, their consolidation into fewer global conglomerates and an exponential rise in global media technologies such as the internet.[59] The growth of digital and telecommunication technologies in the early twenty-first century resulted in images and ideologies being disseminated in global flows almost instantaneously.[60] Increasingly sophisticated software enabled ordinary people to manipulate and edit material. Mobile phones with high-quality cameras could create art, or record news stories. Previously, media were experienced in a top-down flow from media producers to mass audiences. Now ordinary people responded and produced their own materials. These new types of communication systems led to a potential democratization of news reporting where events could be recorded and shared easily. According to Nicholas Abercrombie and Brian Longhurst, contemporary audiences conform to a spectacle/

performance audience paradigm in which everything may be regarded as a spectacle to be gazed upon, registered and controlled, and 'Being a member of an audience is no longer as exceptional event, nor even an everyday event. Rather it is constitutive of everyday life.'[61]

New media technologies enabled audiences to intervene in media production, particularly that of news footage. Ordinary people had access to more unedited information and images of modern warfare than at any time in history. Raw footage could be posted on social media. However, new software enabled ordinary people to manipulate materials for themselves and upload this material to social media. Mirzoeff claims that this proliferation of images leads to 'The paradox of visual culture [which] ... is everywhere and nowhere at once.'[62] He describes this as the 'banality of images' which produces new ways of gazing where watching is marked by casual looking and glancing. Further, the unprecedented access to raw footage juxtaposed with suspicion of editing and structuring practices in institutional news reporting contributes to a climate of suspicion with the truth of news stories. This suspicion results in contemporary notions of fake news, a topic that has since become important in the era of the Donald Trump presidency. Rucka's stories predict the prevailing issue of fake news with raw footage manipulated then released to global audiences. For instance, Diana's encounter with the Flash, discussed above, is broadcast but her explanation of why she thinks the forest fire should be allowed to burn unimpeded is obscured by interference and crackling.

News and reality were challenged in other ways, for instance the development of reality television that blurred truth and fiction through its use of surveillance. In her study of reality television, Annette Hill noted that it 'focus[es] on spectacle, emotion and personality', thus encouraging new types of spectatorship and 'a new aesthetics of the real'.[63] Such shows that promised truth and reality, also used manipulation. *Big Brother* was based upon a panopticon-like environment in which ordinary people were locked in a house and constantly observed by cameras. Audiences voted contestants off each week. However, *Big Brother* manipulated situations to sway audiences' opinions of the

various participants and, as participants performed their identities to influence audiences' opinions of them, the voting often favoured those who presented the most effective narrative. In this way entertainment shows like *Big Brother* articulated new types of spectatorship that imposed moral judgements upon the participants.

In the *Wonder Woman* comics after 9/11 truth is manipulated through PR spin and the dissemination of surveillance footage to global broadcasters by Wonder Woman's enemies. An example of surveillance and its malignant effects is in Brother Eye's surveillance technology that seizes control of people's bodies. Individuals become the prisoners of cybernetics which control their bodies and minds. The name Brother Eye (a corruption of Big Brother) and the surveillance is signalled by the eye motif on the OMAC chest. However, Brother Eye could also be regarded as a metaphor for the effects of television and surveillance in contemporary culture. In this manipulative climate, Rucka used the chessboard as a recurring motif to show how Diana's enemies calculated her downfall whether in Jonah McCarthy and his girlfriend playing chess in the park,[64] the flooring on which Maxwell Lord manipulates Superman into attacking Wonder Woman which comprises black and white tiles[65] and the tiles on the floor of the embassy kitchen where Jonah is confronted.[66] The latter two panels are framed from the god shot perspective.

Media manipulation is evident in the events leading up to Maxwell Lord's killing in self-defence by Diana in *Wonder Woman* 219, 'Sacrifice 4/4'. As the head of Checkmate, Maxwell Lord is coded as the Black King. Presumably, in this scenario, Superman and Diana are the White King and Queen respectively.[67]

Maxwell Lord's manipulative powers are aligned with those of the mass media. Unbeknownst to television audiences, Lord controls Superman's mind, manipulating him into believing he fights Doomsday, a creature that he believes killed his wife, Lois Lane. Lord tells Diana, fighting for her life against Superman's onslaught, 'He believes what I want him to believe, he sees what I want him to see.'[68] Diana, however, gifted with the vision of the god of truth, is impervious to this manipulation. Lord claims that he has spent several years threading

paranoia into Superman's psyche: 'As long as I live, Superman is mine to control.'[69] Diana employs her own manipulation, binding Superman with her lasso so he can see the truth. But as Lord states 'you can't keep this lasso on me forever'.[70] Wonder Woman cannot withstand Superman's onslaught. She ties Maxwell Lord with her lasso and demands to know how she can defeat Superman without killing him. Unable to tell a lie when bound by the lasso, Lord responds, 'Only by killing me.' Wonder Woman, therefore, snaps Lord's neck. This act results in Wonder Woman's trial for murder and her subsequent imprisonment. However, more damaging for Wonder Woman is the destruction of her reputation, for her act is broadcast around the world. People now distrust and attack Wonder Woman, her supporters and the Amazon race.

In these stories, people continuously gaze upon and make judgements on others' morality just as moral judgements are made on participants of reality television shows. This is particularly crucial for the women in these stories for, as Julia O'Reilly notes in her study of judgement of female heroism, judgement is gender biased and a way of limiting female agency: 'For female superheroes, the trials are imposed upon them by the institutions that sanction their power as a way to limit their agency, thus exposing their weaknesses. In contrast, male superheroes use their powers to affect the outcome of such trials in their favour, therefore underscoring their autonomy.'[71]

Wonder Woman is particularly prone to the judgement of others. Her origin story is predicated upon a trial between herself and her sister Amazons and she chooses to become a hero but can only achieve this through trial by combat. When she blinds herself, Batman orders an evaluation of her effectiveness in battle to determine whether she is worthy to remain in the Justice League. Wonder Woman is naturally able to pass the test. However, she asks Superman, 'If our positions were reversed, would he have tested you, as well?' Superman and other male heroes tend not to have to prove themselves but Superman responds, 'I'd have already resigned from the League.'[72] Wonder Woman continuously seeks the good opinion of the public and her peers, mainly Batman and Superman. When she kills Maxwell Lord, Batman and

Superman shun Diana. Diana attempts to explain her actions to Batman: 'I am not ashamed of what I have done [. . .] I did what was required to save not only Kal [Superman], but countless others.'[73] Batman responds, 'Get out.'[74] His face in shadow compared with Wonder Woman's reaction shot increases the sense of his disgust and utter rejection of Diana. The composition in the final panel of this page is framed as a god shot, a judgement on both, as Diana leaves the room. The rejection frames the entire page as the three smaller panels are encrusted within the frame of Diana's exit. Similarly, when Diana takes an injured civilian to a health centre she experiences suspicion and fear from civilians, and she reflects: 'It couldn't kill my body. So instead it has killed my mission. So instead it has killed my name.'[75] Significantly, although Batman creates the technology that eventually leads to the death of many people imprisoned in the OMACs, he is not condemned like Wonder Woman.

Maxwell Lord's death releases a code for the OMACs to attack Themyscira. OMACs take over thousands of innocents enclosing them in cybernetic shells and forcing them to attack Themyscira. In effect they are metaphorical suicide bombers. Diana is faced with a dilemma: should she destroy them and kill the people imprisoned in the units, or should she allow them to kill her fellow Amazons? The battle between the OMACs and the Amazons is broadcast by the mass media but, as noted above, people look but do not act. The US military look on and do not intervene, with the orders: 'under no circumstances are we to engage with them for fear of reprisal'. However, Rucka's stories are about people and gods being able to do little but look on. The Teen Titans, Justice Society of America and Justice League of America are unable to interfere in the battle between Diana and Medusa. The Minotaur chef Ferdinand, who knows the ways of gods and people, states:

> Understand this . . . This is not just a fight between Diana and Medousa. This is Athena and Poseidon making war over slights that are millennia old. It's a contest of gods, now, as much as their agents, with Ares bearing witness standing in judgement over a challenge that will be decided in muscle and steel. And as a battle governed by gods we have no place in it. We can do nothing but bear witness.[76]

In stating this, Ferdinand identifies the conflict by proxy taking place throughout the stories. In *Wonder Woman* v. 2 224, page 1, the gods watch the battle and its outcome continuously, scrying in water, but do not intervene. Mother Neith remonstrates with Athena: 'Pallas there is still time to stop this.'[77] Pallas Athena informs Mother Neith that if the battle is stopped it would mean another worse on in a few years, a reason that echoes Diana's motive in letting the forest fire burn. Page 4, panel 1 opens on statues of the gods that are perfect, unbending and immortal like the gods. The narrator states, 'The Gods have a plan.'[78] Panel 2 shows the god's eye shot of the OMACs surrounding the Amazon homeland: 'We are not to know their minds. We are not to guess their designs.' Panel 3 a close-up of the dead. The fourth Etta Candy's horrified gaze as she puts down her binoculars and the intercut panel connects panels three and four: 'The Gods test us and in doing so test our faith.' The fifth panel introduces the concept of moral judgement and is an over-the-shoulder shot of Etta gazing on Themyscira which is alight: 'We do not always pass their tests.'

The gods, however, are also judged. Io, a blacksmith and a god-fearing Amazon, is tasked with recreating the purple healing ray into a death ray. She has grave fears on this strategy, 'For over three thousand years I have never questioned [the gods] wisdom. But not all of our gods are wise.'[79] Io prays to the gods, begging their forgiveness for creating the purple death ray. Around her the statues of the gods, immortal, unfeeling stone, gaze on blankly.

The final sequence in Rucka's stories form a symmetry: the moral judgements imposed upon Diana after Lord's killing parallel those that she visits upon the Amazons. The visuals, the narrative structure and the rhetoric mirror each other.

Both situations are founded on impossible moral dilemmas that parallel real world situations. Is killing valid to defend oneself? The individuals imprisoned inside the OMACs can be likened to the suicide bombers who have been brainwashed into committing terrible acts. Just like suicide bombers, their brains and bodies are controlled and destroyed. The OMACs also come from the east to attack Themyscira. In

Diana's attempts to save the OMACs, she calls for reason to prevail and articulates the reservations felt by people at a purely vengeful retaliation for 9/11. In both situations, the ones who kill are expelled in two scenes that are rendered in similar fashion. Diana orders the Amazons to leave the mortal plane, a scene echoing the image of Diana ordered to leave by Batman. In both scenes Io and Diana seek forgiveness but know it is impossible. Both scenes are depicted from a god's eye view, a judging gaze. In both, grey predominates as if to indicate that the supposed moral dilemma is ambiguous. In the aftermath of the OMAC attack, Diana to the left of the double splash page gazes at the bodies of the dead innocents exposed from their cybernetic shells. In the encrusted panel, Io states: 'I know there will never be the words to make this right. I know there will never be forgiveness for this sin.'[80] Artemis expresses the moral dilemma the Amazons faced: 'and while we struggled to do that, we should have let them murder us?'[81] The scene is in greys and blues, reflecting the morally ambiguous nature of their actions. Diana stands out in pink and gold. She reprimands the Amazons: 'these were victims not villains! We needed to save them, not slaughter them!'

Ultimately, however, in these stories who is manipulating whom? The apparent manipulator is the one being manipulated by a superior force. Cale manipulates Psycho, but Cale is also controlled by Medousa and her sisters working with Circe and later by Psycho. The gods manipulate each other. Ares controls Eros and through him, Zeus and Hera. Thus, power is diffused. Despite the efforts of Cale and Circe to attract and hold television audiences, their responses vary from horror to sympathy, pity to indifference.

However, those who are weakest also hold power. Diana's actions are judged by television audiences, Io and Diana judge the gods. Thus, as Foucault states, 'Power is not something that is acquired, seized, or shared, something that one holds onto or allows to slip away; power is exercised from innumerable points in the interplay of nonegalitarian and mobile relations.'[82]

The most effective way Diana can be damaged is through her emotions and her reputation. This is typical of the heroine's journey

discussed in previous chapters. Her enemies destroy her reputation by focusing on her seemingly inexplicable values as an Amazon. In this sense, they attack her through emphasizing her strangeness and foreignness whilst comparing them to the 'normal' ideologies of right-wing, Christian and patriotic America. As Jennifer Stuller points out, by attacking the female heroine in this way, it detaches her from her family including the group of followers or supporters, the quasi-family, she gathers around her. After the Amazons leave the mortal plane there are only three Amazons left in the world.[83] It is also worth noting that, despite the information gathered about the Amazons and Diana, humanity still does not understand them.

The writers after Rucka continued to develop the tension between America and the Amazons as Other. Written by Will Pfeifer with art by Pete Woods, *Amazons Attack!* (2007) was a six-part mini-series with thirteen crossovers into four other titles.[84] In this narrative event the Amazons, led by Hippolyta and Circe, attacked America, indiscriminately slaughtering men, women and children. The connection between the Amazon attack and 9/11 were unmistakable and reinforced by the use of news reportage and the political responses to the attack in the narrative. The story reinforced tensions between the Themyscirans and the Bana-Migdhall, the latter held responsible for the escalating conflict. The twist in the story also played on the manipulation of the various factions by the New Gods and Granny Goodness, godlike beings who vied for power with the Olympian gods.

Amazons Attack! was a complex story made difficult to follow by crossovers over various titles. Even the collection into a graphic novel was difficult to follow and the Amazons' actions seemed entirely out of character. The story showed little of Rucka's sensitive portrayal of moral condemnation in which all sides seemed culpable to a lesser or greater extent.

In 2008 Gail Simone took over writing duties and her stories, like Rucka's, handled Diana's origins, the Amazons' rituals and heritage along post 9/11 paranoia sensitively. Simone's run lasted from *Wonder Woman* v. 3, 14, January 2008 to 44, July 2010. She also contributed to

Wonder Woman 600, August 2010. Simone's stories followed up and developed Rucka's plots with a similar sensitivity to the surveillance and manipulation. She began by challenging Diana's birth as idyllic in *The Circle* which told how Hippolyta's birthing of Diana was regarded by those close to her as a betrayal.[85] Simone's stories revealed a conflict between men and women between gods, mortals and government agencies. There were attacks on the Amazons and Diana first by Nazis, then Zeus who attempted to depose the Amazons as the warriors of the gods, then the Department of Metahuman Affairs. The attack on women from the Department of Metahuman Affairs centred on surveillance but, as in the Rucka stories, it revealed that the attack was manipulated by Doctor Psycho controlling Sarge Steel, the head of the DMA. A list of the story arcs and their themes can be found in the Appendix.

Whose Story Is It Anyway?

Revisiting the Family in the DC Extended Universe

From 2011, DC rebooted and rationalized their entire universe – twice: first in 2011 with The New 52 and June 2016, in the Rebirth reboot. The New 52 story arc was prompted by the Flashpoint storyline in which the Flash attempted to change history but, in doing so, shunted the DC universe into an alternative timeline. In his attempt to restore the status quo, he created a new universe, that of The New 52. The Rebirth reboot returned the DC extended universe (DCEU) to its pre-Flashpoint time but it also incorporated elements from The New 52. The Rebirth reboot rationalized titles, reinstated certain characters such as Wally West (the Flash) and Ray Palmer (the Atom), and redesigned characters such as Harley Quinn and Wonder Woman.[1]

As part of the DCEU Wonder Woman's representation and narratives are in flux, a flux created by the tension between her utopian and feminist agenda versus violence and masculine hero trajectories based upon family relationships. These ideas are tempered by the producer's beliefs of her appeal to wider audiences, sometimes against fandom's perceptions of who and what Wonder Woman is. Some aspects of the character were criticized by fans because they seemed to discard the feminist credentials imbued in Wonder Woman's origin and mission. In analysing the revisions to the character, some concerns of fans, such as the changing birth and her reinvention as a warrior princess, are contextualized within the development of the DCEU and the cultural and political milieu, particularly in issues of the family.

In their revision of Wonder Woman's origin, Diana was given a father, Zeus, a revision that extended across the DCEU into the 2017

Patty Jenkins *Wonder Woman* film and subsequent comics story arcs. The New 52 narratives included the *Wonder Woman* comic written by Brian Azzarello and drawn by Cliff Chiang, over thirty-six issues. In this iteration of her story, Diana was born of the love between Hippolyta and Zeus. The New 52 consolidated Wonder Woman's position as one of the DC Trinity, the three heroes, including Superman and Batman, who constituted the cornerstone of the DCEU. She exemplified diversity and equality with stories dwelling on her Amazon heritage and her female qualities such as compassion. These qualities offered the potential to capture a broader range of global audiences and female audiences and explore the nature of heroism away from the masculine model of violent heroism. However, as this chapter shows, in the *Wonder Woman* comic, her story was appropriated by the stories of several male characters, each assuming they were the Chosen One and resulted in an exploration of the masculine-based messiah myth rather than female heroism, an issue that was, in part, mitigated by the values imbued in her brand in Patty Jenkins's film, discussed in the next chapter.

According to Jennifer Stuller, this focus on masculinity is typical of female-centred stories as men traditionally 'hold the authoritative positions in the public sphere'.[2] The reason for the emphasis on masculine-centric stories is lack of imagination from male writers who have control of most of the stories. Stuller notes that even fairy stories, traditionally told by women, feature the absent mother and centre on the father figure. The absent mother was a product of her time, in the eighteenth and nineteenth centuries, when female death in childbirth was a part of everyday life. Yet, even in these much safer times for women in childbirth, the male-centred story persists. In contemporary culture, the mother is set aside in male and female quests: 'The traditional quest is a search for the father, who will initiate the hero into the world.'[3] This emphasis on the male-centred narrative seems partially valid in the gender divide of the creators who have revised Wonder Woman in the DCEU. For instance, female creators such as Renae de Liz, who wrote and drew *The Legend of Wonder Woman* and Patty Jenkins, director of *Wonder Woman* (2017), seem to have a sensitive

approach in enabling Diana to respond to evil in her own fashion, with compassion and tenderness. It is not only female creators who can produce sensitive stories about the character. George Pérez, Phil Jiminez and Greg Rucka are well known for their thoughtful stories about Wonder Woman. However, as discussed below, two creators writing in the DCEU, Brian Azzarello and James Robinson, hijack her story away from a female-led hero trajectory to that of a male-centric narrative. Stuller playfully suggests that male creators who thrust a father-centred narrative on a heroine's story are working out their own daddy issues. However, Stuller asks the pertinent question: why does this masculine-centred narrative model still recur in contemporary culture when women have achieved a degree of equality?

The notion of the father and the masculine-based narrative, as discussed in the Introduction, can be found in Joseph Campbell's hero monomyth[4] and Slotkin, Lawrence and Jewitt's notions of the American hero monomyth.[5] Campbell, as Stuller notes, claims that finding the father is finding the destiny and that the character is inherited from the father. In Campbell's eyes, the heroic narrative is about masculinity, and as one of the most significant contemporary narratives the superhero story is most often founded on the father/son relationship. Richard Reynolds, for instance, dwells upon this in the Superman and Batman stories in which the hero's story is intimately bound up with that of his father.[6] Marvel, too, foregrounds the father/son relationship in stories of Tony Stark (Iron Man), Reed Richards and Peter Parker and his quasi-father figure Uncle Ben (amongst other hero stories). The hero story is one of a coming to terms with responsibility and adulthood, as Peter Coogan neatly states, 'Selfish boys turned into selfless men.'[7] However, as Carolyn Cocca argues, stories matter.[8] They forge role models in disadvantaged, disempowered and marginalized groups.[9]

In all but two examples, Stuller illustrates how the female heroic quest is in search of or prompted by the father. Wonder Woman, however, presents a notable exception to the regeneration through violence male model of heroism. Hers is purely female-focused narrative trajectory from her beginnings and the parthenogenesis birth was

integral to this because it encouraged a female-focused narrative
trajectory based upon redemption through love. In her quest for peace,
she is supported by a female family network of Amazons and a pseudo
family in the Holliday Girls. The theme running throughout these
models of heroism, is the family, specifically Diana's relationship with
her parents and siblings. Families – chosen families are the groups of
people the heroine gathers to her 'Collaboration with friends, family, or
community is common to the female hero – not because she is incapable
of succeeding on her own, but because she is more successful when she
recognizes, encourages and utilizes the talents of others.'[10]

The revised origin had a massive impact on Wonder Woman's story
for it not only flouted her philosophical origins in female mentoring, it
also introduced a more familiar masculine heroic narrative trajectory to
the comics and narratives. From her beginnings, Wonder Woman
challenged the male hero narrative paradigm. She was mentored by her
mother and Aphrodite. Her mission, although impelled by love for a man,
was to become a worthy love leader, and, more importantly, a female love
leader. Revising her origins so that Zeus is her father has implications for
this story. His negligence and absence prompts Diana's siblings to search,
or long for, his presence and, in their longing, they become embittered
and violent. Zeus's consistent philandering also has its effects in Hera's
wholesale slaughter of any of his children, of the need to keep them secret
against her fury, but also in their hunting down by other antagonistic
forces such as the New God, Darkseid. Nevertheless, Zeus's negligence is
explained as the fault of his wife Hera's fury and he is absolved of blame.

The first revision of the character in The New 52, was produced by
Brian Azzarello and it focused on Diana's relationships with the Greek
pantheon. To create his storyworld, Azzarello returned to the brutality
and violence of the original Greek myths. Azzarello inserted a
patriarchal narrative trajectory into her origin and he also emphasized
family violence. The revised DCEU Rebirth story arc in 2016 took some
of Azzarello's ideas such as Zeus as absent father and developed Diana's
sibling ties by giving her a brother, Jason. In both versions of Diana's
story, she is not the Chosen One. She is either a mentor or protector of

the Chosen One, who is either her brother/father or her twin brother. In both story arcs, Diana is saved by Zeus's intervention.

Zeus as protective figure is also a narrative element in Patty Jenkins's 2017 film where his less desirable qualities of philandering and negligence are discarded in favour of his heroism so, when the other gods are murdered by Ares, it is Zeus alone who creates the Amazons, saves humanity through self-sacrifice and, in doing so, dies at the hands of Ares. The film, therefore, turns Zeus into a heroic, nurturing character. This is not the only way the film departed from the comics. When Diana enters man's world the female heroism of the Amazons vanishes. Instead of her all-female family, she gathers a pseudo family group of male characters as her battle colleagues.

In the DCEU comics Wonder Woman's narrative is male-centred, and focuses mainly on her father and, by extension, her half-siblings (mainly brothers), a more traditional heroine's story. The reasons for this are possibly because DC, Azzarello and Chiang decided the emphasis on the parthenogenesis birth and her extensive all female background were less commercial than a traditional male-centric narrative. However, in emphasizing her familial relationships, the writers reflect concerns about family life and relationships and a wider political struggle between right-wing and liberal ideologies that were mirrored in the changeover from a Democrat, Barack Obama, to a Republican president, Donald Trump, in 2016. This chapter deals with the consequences of this revision of the character as brand: why it was deemed necessary within the contemporary media landscape and political climate; how the new revision of the character reflected cultural and political concerns about families; and how it changed the nature of the character and her mission.

The DCEU

The opening stories of Greg Rucka's run in the Rebirth stories featured an interesting dilemma for Wonder Woman as she searched for the truth of who she was in the multiple stories that seemed to fill her world. As

Rucka suggested in his earlier iteration of *Wonder Woman* (see Chapter 5), there were many truths and reality was often a construct through fake news and media manipulation. As noted above, in the DCEU revision of Wonder Woman she is given a father, Zeus. Although this seemed to flout William Marston's original premise for the character, that of the all-female mentoring pseudo family, the father figure is not new; for instance, I Ching in the 'white suit era' (Chapter 3) or Theno, her implied father in Robert Kanigher's stories of the late 1950s (Chapter 2), fulfilled the father-figure role (even if the latter was absent). Theno's fatherhood was only hinted at, as suggested. However, it was particularly concerning that I Ching, for instance, was at one point placed over the top of Diana Prince on the comic cover in this story arc. However, the title quickly returned to the female-centred Wonderverse in 1972. In the present stories, Zeus as father brings with it several family issues in the family squabbles of Azzarello's version, the hunting down of Zeus's children in James Robinson's Rebirth stories, and the three brothers in The New 52 and Rebirth reboots, whose stories have taken over her own.

The reboots and revisions of continuity and histories take place within DC's extended transmedia universe in which there are multiple variants of stories that transcend specific media platforms and storyworlds.[11] These various narratives diverge from the main history and storyworld of the character and are developed across a range of media and promoted to diffuse audiences. A story arc in a specific medium is better viewed as part of an extensive narrative system with story information communicated through books, films, television, comics, animations and other media, along with toys and cultural practices such as cosplay. Each component of the stories is constructed to address the specificities of various media, each a relatively autonomous experience. 'The richest understanding of the story world is understood by those who follow the narrative across various channels.'[12]

Narratives in mass media of the early twenty-first century changed because of the ways stories and characters were produced, distributed and received by audiences. Superhero universes became the most lucrative genre in early twenty-first century media and most were

owned by DC, part of Warner Bros., and Marvel, part of Disney.[13] DC and Marvel Comics developed their major characters into films, video games and television series that overlapped and interconnected. Cheaper computer generated imagery (CGI) enabled the production of sophisticated effects for television, film and video games.

In the superhero genre, the concept of extended universe creation was led by Marvel/Disney who developed their transmedia universe from the storyworld model in which most of their major characters were produced.[14] As noted in Chapter 3, Marvel produced their storyworld through an organic vision with a discrete group of creators over a seven-year period.[15] From the beginning of the Marvel universe the heroes knew and interacted with each other (usually through fighting). However, this character interaction, coupled with the close working proximity of the 1960s Marvel Bullpen, enabled more effective cohesion when Marvel produced their extended universe on film.

In creating their universe, Marvel executives looked to the model established by the Marvel Bullpen in the early 1960s. They developed their storyworld in three phases: Phase One (2008–12) to introduce characters such as Iron Man, Captain America and Thor and consolidate the storyworld through a team up *Marvel's Avengers Assemble* (2012); Phase Two (2013–15) developed character interaction and backstories, also some lesser-known characters and teams such as Ant Man and Guardians of the Galaxy; Phase Three (2016–present) introduced lesser-known characters such as Doctor Strange, Ant-Man and the recently acquired Spider-Man. The films were supplemented by a spin-off television series that showed the effects of a world containing superheroes for ordinary people, in television shows such as *Marvel Agents of SHIELD* and street-level heroes like Daredevil, Luke Cage and Jessica Jones who teamed up in *The Defenders*.[16] With the acquisition of characters owned by Fox Entertainment in 2017, other high-profile characters such as the Fantastic Four and the X-Men will likely be incorporated into the forthcoming films and stories.

DC had a more complex problem, for their characters appeared over a longer timespan across the so-called 'Golden Age' in the 1940s to the

1960s. DC rebooted characters from the 1940s in the 1950s and 1960s, in what was dubbed by comics collectors as the 'Silver Age'. DC were therefore at a disadvantage to Marvel because their heroes evolved more slowly, over a thirty-year period, and therefore had more time to develop their own storyworlds that operated under different rules of physics and narrative constructs. For instance, rules of magic differed in the Batman and Superman storyworlds and Aquaman's Atlantis differed from Atlantis in the Superman Family. As discussed in Chapter 4, DC reboots since the mid-1980s attempted to rationalize inconsistencies in these storyworlds.

In the live action adaptations, up to 2016 Warner/DC concentrated on television series to develop their universe. DC television series often dealt with tangential aspects of their superhero characters in prequels, spin-offs and animations of lesser-known characters, the latter often more faithful adaptations of comics.[17] *Gotham* (2015–19) is a stand-alone prequel to Batman and recounts the origins of villains such as The Penguin, The Riddler, The Joker, Catwoman and Poison Ivy through the exploits of Detective Gordon and the Gotham police department. *Gotham* was distinct from the Arrowverse television storyworld which featured *Arrow* (2013–present), *The Flash* (2015–present), *Supergirl* (2016–present) and a group of time-travelling superheroes in *DC Legends of Tomorrow* (2016–present).

Stories in the DC universe are often rationalized through parallel worlds and time travel and this is the rationale for characters meeting in the Arrowverse. *Arrow* and *The Flash* are set on Earth 1, *Supergirl* is set on Earth 52. Every year there is a crossover event. In 2017, the crossover event featured evil counterparts to the heroes from Earth X. The storyworlds in the DCEU are, in some cases, separate. For instance, Barry Allen/The Flash is played by Grant Gustin in the television series and Ezra Miller in *The Justice League of America* (2017). However, the characters in these storyworlds each represent a distinct set of values, as Will Brooker suggests when discussing Batman, a brand that is recognized by fans.[18]

Wonder Woman was imagined in various iterations that overlapped and differed throughout the DC universe. However, all provided a sense of her brand identity and what she represented.

Along with the flagship *Wonder Woman* title, DC published several other comics starring the character. *Sensation Comics* (2014–15) consisted of stand-alone stories that extrapolated Wonder Woman's character and tangential narratives, a large percentage written and drawn by female creators. In *Superman and Wonder Woman* (2013–16) and *The Justice League of America* (2011–present) Wonder Woman was shown in her relationships with other characters of the DCEU. There were also tangential narratives including alternative histories such as *Bombshells* (2011–present) set in the Second World War featuring a version of Wonder Woman inspired by Rosie the Riveter (discussed Chapter 7). *Superhero Girls* (2015–present) is set in an imagined high school for superheroes. The stories are aimed at younger girls and presented in an animated television series, graphic novels, dolls, Lego revisions and comics.[19] Two stand-alone graphic novels, Grant Morrison and Yannick Paquette's *Wonder Woman: Earth One* (2016)[20] and Jill Thompson's *Wonder Woman: The True Amazon* (2017), explored her origin story and her mission, and the former emphasized her LGBT qualities.[21] The Rebirth series included *The Legend of Wonder Woman* (2016), written and drawn by Renae de Liz, which explored the affinity of Diana's body with Themyscira, seemingly returning to the psychic connections of Diana with Themysciran. As a creature created of Themysciran clay, her body is psychically connected with the health and spiritual well-being of the island. There was also a Steve Trevor mini-series.[22] The flagship *Wonder Woman* comic, however, focused on Diana's relationship with her family and this reflected ongoing cultural and political debates in America in the early twenty-first century.

The New 52 *Wonder Woman*: Dysfunctional Families, Absent Fathers and Negligent Mothers

In rebooting Wonder Woman, DC gave writer Brian Azzarello and artist Cliff Chiang three years to revise her entire backstory and universe. Azzarello and Chiang provided stability to the comic book

and their profile as fan favourites attracted new readers. Sales of the comic rose from 30,000 (pre-Azzarello) to 75,000 in 1 September 2011 settling down to 51,314 by March 2012.[23] Although Azzarello and Chiang improved her sales figures, their iteration of the character drew criticism from some fans. Neal Curtis (2017) summed up the criticisms as follows, by discarding her origin as a clay statue brought to life by Aphrodite, in favour of Zeus as her father, Wonder Woman's feminism is tamed: 'It seems that women can be portrayed as strong as long as they mimic patriarchal representations of strength, and more importantly bend their knee to male authority as the normative source'.[24] However, Curtis does not account for the cultural changes that contributed to this change in Diana's origin. In addition to the decision to make the character more marketable with the male parentage, the revised origin provided Azzarello with the opportunity to explore her newly formed family.

In giving Diana a family background Azzarello responded to demographic changes in America concerning the family that impacted upon social and political concerns, especially for the right wing. At the heart of Azzarello's stories are the relationships between parents and children, often absent or cruel fathers, negligent or wicked mothers who traumatize their children. These dysfunctional family relationships reflected debates on the impact of the family in American life of the early twenty-first century. The twenty-first century saw diversity in family make-up with the decline of the traditional two-parent family and the development of the blended or merged family comprising step-parents, grandparents, step-siblings and single parents, usually mothers.[25] Jane Waldfogel, Terry-Ann Craigie and Jeanne Brooks-Gunn's study on the American family stated that 40 per cent of children born 2007 were living in fragile families: 'research overwhelmingly concludes that they fare worse than children born into married-couple households ... Many studies ... concur that traditional families with two married parents tend to yield the best outcomes for children'.[26] Single mothers or mothers co-habiting with a partner contributed to the growth of fragile families, mainly due to poorer resources.

Changes in the family demograph were noted with alarm by several writers in the early twenty-first century. Mitch Pearlstein, for instance, described family fragmentation as 'the overwhelming social disaster of our times.'[27] Pearlstein claimed that the disintegration of the family led to a decline in education and ultimately America. This was not only in disadvantaged families but all groups. In this argument he cited Jane Waldfogel et al.'s study which highlighted five key areas affecting children's well-being: 'parental resources; parental mental health; parental relationship quality; parenting quality; and father involvement.'[28] Different mechanisms affect the well-being of children within fragile families beyond family income such as the role of the father, particularly the absent father.

Writers such as Phyllis Schlafly looked back to the 1950s as a golden age of the family, claiming that family disintegration was the fault of 'feminists, judges, lawmakers, psychologists, college professors and courses government incentives and disincentives, and Democratic politicians seeking votes oppose the traditional American nuclear family as we knew it and as it was depicted on TV fifty years ago.'[29] However, as discussed in Chapter 2, Schlafly's rosy vision of the paradise of the 1950s traditional family was also flawed. It was based upon a fantasy model of white, middle-class heteronormative family units. It ignored issues discussed in Chapter 2 in which the absent father in 1950s family life, it was claimed, was responsible for homosexuality and juvenile delinquency. Just as the cultural concerns of America in the 1950s were blamed on the absent father and the dominant mother, in the twenty-first century poor parenting was blamed for poor child cognitive development and behavioural problems. Azzarello reflected cultural concerns of dysfunctional families in the squabbling, murderous and negligent relationships of the Greek pantheon and the children so carelessly spawned by Zeus. Some of his children live in affluent conditions, yet his negligence and the violence visited upon them, by his family, cause trauma, and in an age when aggressive male sexuality is condemned in the #MeToo campaign, is Zeus a character that should be valorized?

Azzarello's *Wonder Woman* is filled with intergenerational conflict, dysfunctional families and violence. The inciting incident, and the absence at the heart of the story arc is the disappearance of Zeus, the king of the gods. With his disappearance, his children squabble over who should take the throne of heaven. The main heirs apparent are Firstborn, Apollo, and Lastborn. Apollo first takes the throne of Olympus. However, his rule is challenged by Firstborn, the child born of Zeus and Hera. Firstborn is the first child of Hera and Zeus but it was foretold that Zeus's child would usurp him and reign over Olympus, a narrative which repeats that of Zeus, his father Kronos and his grandfather Ouranos. Firstborn is consigned to the depths of the earth without being named. He spends 7000 years clawing his way out of the earth full of hate at his betrayal. Wonder Woman, also one of Zeus's offspring, born of the passion between Zeus and Hippolyta is tasked with protecting Zack, the Lastborn. Zack is the child of Zola, a waitress, and Zeus. Wonder Woman protects the baby against the machinations of her predatory family and the murderous intent of Hera. In doing so, Wonder Woman's role is as caregiver rather than hero and this accords with Stuller's notion of the representation of the heroine as a quasi-mother figure.

In considering this revision of Wonder Woman, it is worth reflecting upon violence, for it is a theme that fans applauded in Azzarello's comic series *One Hundred Bullets*. In Azzarello's story, the Amazons are violent and their society is more dysfunctional than Pérez's utopian Themyscira. Azzarello adds an extra dystopian theme as he introduces a patriarchal model of conception which is characterized by brutality and violence. The Amazons do not conceive through creating and bringing to life clay statues. They seize ships, and seduce and murder the sailors. Of the resulting offspring, females are reared as Amazons whilst males are sold into slavery to Hephaestus, the disfigured Blacksmith God. Therefore, Firstborn and Wonder Woman's births share similar characteristics and illustrate the different gendered responses to violence.

In Azzarello's stories, birth is aligned with pain and suffering, often through negligent or murderous parents. Zeus and Hera, as Primal Father and Mother, are at the heart of many of these stories. The children,

caught between an All Powerful but absent father and powerless mother, are psychologically or physically damaged. One daughter, Siracca, sees her mother killed in front of her. She is disintegrated but re-formed by Zeus as a spirit. Zola, Lastborn's mother, is pursued by Hera and thrown off a cliff.

Hera is one of several mothers who contribute to the dysfunctional families that psychologically and, in some cases physically, damage children. The Amazons are malicious mothers who birth children, the sons sold into slavery, the daughters raised on lies. Wonder Woman's birth, like that of other Amazon children, is hidden behind a lie of parthenogenesis by Hippolyta to conceal her true heredity. Like Firstborn, her birth erases her true identity. Firstborn does not possess a name and his birth is not recorded. Through Hera's intervention he is buried under the earth. His body is huge, muscular, and bears testament to his suffering, covered as it is by scars when he first introduces himself as, 'The one with no name. The crippler of souls.'[30] Having known only cruelty, he exacts his revenge by forming an army and killing everything in his path. In return he is attacked, injured and suffers torture from his half-brother, Apollo. The injuries inflicted upon him, however, become the outward expression of an inner scarring. When his mother Hera confronts him, begging him for love to desist from violence, he states, 'What I do I do out of hate. Of you. Of everything.'

Wonder Woman expresses a similar repudiation of her mother, Hippolyta. Wonder Woman is hidden from the wrath of the gods at birth by Hippolyta who devises a fairy tale of her conception and birth in which Wonder Woman is represented as a Chosen One of the gods, a myth that is a twin source of pain and romanticism. Her birth is described by Hermes in *Wonder Woman* 2, 'Gods Draw Blood', and it is a story that hails a cherished universal belief of a sexless special origins: 'On a moonless night, she fashioned a child out of clay and prayed to the gods for a miracle … and with the sun above, Hippolyta was awakened by her child.'[31] That she is divinely conceived through parthenogenesis presents Diana as the Chosen One to other Amazons as she is 'the perfect Amazon – no male seed created her.'[32]

However, this magical birth is also a source of systemic violence. Jealousy of her Chosen status inspires insults from her childhood nemesis, Aleka. In a fight, Aleka states Diana will never be a true-born Amazon, throws mud at her and calls her 'Clay'. 'The mud stings, but not as much as Aleka's words.'[33] She is described as a golem, a statue without a soul by Aleka, in a reflection of Gail Simone's story 'The Circle' in which members of Hippolyta's chosen guard attempt to kill Diana as 'the Dragon' the child who should never have been born as it violated Amazon lore.[34] Yet, even though she feels alienated by her parthenogenetic birth, it forms the cornerstone of Diana's sense of identity as the Chosen One. For this is an extraordinary birth, a birth that is magical and special. Diana, the Wonder Child, is blessed with the gifts of the gods. So, when mocked by other Amazon children, she runs into the forest and cries into a pool. In a sly allusion to 1960s Marvel bombast, she declares: 'What have I done to deserve such a fate? To be formed from clay. To not have real parents. To never fit in!! I may look like my sisters, but I will never be like them . . . and they will always know that in their hearts!'[35] The myth is shattered when Diana's mother, Hippolyta, reveals details of her affair with Zeus: 'He . . . we . . . were glorious.'[36] This insinuates Wonder Woman into the primal scene of her conception, something no child should hear. Instead of the myth of her birth, where her powers are conferred by the gods, like the Sleeping Beauty fairy tale, she finds she owes her powers to her father Zeus. In fury, she denies her Amazon name and heritage, telling Hyppolita: 'I'm a lie. You're a fool. And you made one out of me.' Denying her heritage, she insists she be called Wonder Woman, eradicating her identity as an Amazon princess.

Redemption in these stories of abandoned children is produced by the intercession of sympathetic father figures and love. Wonder Woman, abandoned by Zeus, finds a father figure and mentor in Ares, God of War, who trains her to become the greatest Amazon warrior. When War vows to train Wonder Woman, they are watched by an owl and the moon, totems of Diana's past mentors, Artemis and Athena. Wonder Woman is given a series of tests by War to test her worth as a warrior. War pits her against the Minotaur, symbol of essential masculinity. The

Minotaur, half-man, half-bull, is violent because of parental cruelty, the victim of abandonment by his mother who conceived him through her lust for a beautiful bull sent from the sea by Poseidon. The Minotaur is ugly and bears a resemblance to the Gimp in *Pulp Fiction*. As such he is a distortion of William Marston's notion of submission/domination, an exaggerated version of S&M style. Conscious of his cruel past, Diana spares the Minotaur's life. This act of kindness redeems the monster when in 'This Monster's Gone Eleven' he refuses Firstborn's command to kill Diana.

Yet, while Azzarello seems to accede to Wonder Woman as redeeming through love, he also incorporates her into the myth of the dying/reviving god, the myth of male heroism through brutality and patricide discussed in the Introduction. Both Firstborn and Wonder Woman assume they are the Chosen One. Firstborn determines to take over the throne of Olympus by force and rallies an army to achieve this. Wonder Woman and Firstborn know that as Ares, God of War, becomes old and infirm, his death is imminent. Whoever kills him, as in myths of the dying/reviving God, will assume his godhood and become all-conquering. In 'God Down' Firstborn and Ares fight and Wonder Woman is forced to intercede.[37] Wonder Woman, who regards Ares as her surrogate father, kills him to prevent Firstborn becoming God of War. This is accepted as necessary by Ares as, 'no other way, but the warrior's path you took. I'm proud of you. I would have done the same.'[38] Thus, Wonder Woman follows the model of the dying/reviving god laid out by James Gordon Frazer: she adopts a masculine model of heroism and succession by killing the failing father/Divine King to renew the vigour of War.[39]

Yet, Azzarello also revises the dying/reviving god myth, for Firstborn and Wonder Woman, who both believe they are the Chosen One, are confounded. Firstborn is defeated and banished into the earth again. In this way his story achieves closure. Wonder Woman becomes a protector of the real Chosen One, the baby Zack, Lastborn of Zeus, making her a secondary character in her own story. Zack, however, is revealed as the reincarnated Zeus, making him, like his son Dionysus, a twice-born god

and the character whose narrative trajectory conforms to the dying/reviving god narrative.

Like the hero of the Messiah myth, Diana kills her quasi-father, Ares, to become God of War. Unlike the myth, however, Wonder Woman does not do this from desire or lust for power, but from love; for, as Firstborn states when killing Ares, 'I will take my birthright ... the sole throne! But first I will take yours ... I will be God of War!'[40] She denies the traditional violent masculine action of killing to take the throne. Rather, she kills to deny the throne to Firstborn and out of love for her quasi-father, Ares. However, she also denies the cycle of generative violence. When her uncle, Hades, asks, 'Are you going to finish him [Firstborn] off?' She responds, 'There's been enough killing today.' Hades responds, 'You will make an interesting God of War.'[41]

Firstborn, like many male heroes, displays scars on his body, undergoes physical torture (including having his continuously regenerating spleen eaten by his half-brother, Apollo) to illustrate masculine suffering. Wonder Woman, however, tends to feel the pain of symbolic violence, the taunt of her fairy-tale origin as Clay, and systemic violence of being regarded as 'no true Amazon' because of her birth, to a greater depth than the physical violence she suffers in battle. She brings to her tenure as God of War a subtle approach to the violence she knows is inherent in the role. Turning the notion of war as necessarily relating to physical violence on its head, she looks to the origins of conflict in love as shown in her actions in becoming War. This differing attitude to war can be seen in *Superman/Wonder Woman*, Annual 2, February 2016 (just before the Rebirth reboot), when Wonder Woman informs her lover, Superman, that she has assumed the mantle of God of War. Superman's response is, 'feelings aside, is it even possible to act as God of War and the interest of peace? Love? Justice? They're antithetical notions.' Wonder Woman responds, 'That's the issue, Clark! It's about pushing no feelings aside ... They're not antithetical notions. Justice and peace are outcomes of my role as Wonder Woman and as God of War. And Love isn't war's opposite ... Love is war's genesis. Everything we love, we fight for.'[42] This exchange illustrates the differing

attitudes towards war between male/female. Superman sees war from the angle of violence visited upon the material body. Wonder Woman, however, regards violence as motivated by emotions. The two attitudes respond to differences in the ways male and female heroes respond to violence discussed in the Introduction. These differences are one of the ways that models for female heroism differ from those of male heroism founded upon their physical and emotional responses to violence. However, they are articulated through the perspective of a male writer.

Azzarello tried to stay true to Wonder Woman's values, not necessarily those laid out by Marston, but utilizing a twenty-first-century approach. Like Marston, Azzarello's Wonder Woman is prepared to do physical battle but she would rather redeem through love. However, Azzarello cannot quite discard his patriarchal values. He places Wonder Woman within an archaic male-centred myth that relies upon violence for its narrative trajectory and upon the centrality of the father as both problem and salvation. Azzarello's depiction of Wonder Woman denies her Utopian and feminist roots, turning them mundane and profane by attempting to explain her sacred origins.[43]

The Dying/Reviving God and the Messiah in The New 52 and Rebirth

Azzarello's origin formed the foundation for iterations of Wonder Woman in the DCEU, particularly in Patty Jenkins's film and the *Rebirth Wonder Woman* comic. In *Justice League of America* 50, July 2017, a twist to her story is presented when it is revealed that Diana has a twin brother, Jason. Jason's birth was not explored until 2017 when James Robinson, best known for his revision of *Starman* in The Justice Society of America, took on the writing duties of *Wonder Woman*. As the child of Hippolyta and Zeus, Jason was introduced as a Greek fisherman.[44] As a baby he was secreted away from Themyscira and given to Glaucus, one of the Argonauts, to raise as his own son. Hippolyta's abandonment of Jason seems strange. However, she knows she cannot hide him from

Hera's wrath on an island of women. In this act she reflects Hera's abandonment of Firstborn, although Jason's formative years are more affectionate for he is parented by Glaucus and trained by Hercules in the art of combat. Diana discovers her brother when she inherits the estate of her half-brother Hercules on his death. Hercules is murdered by an Amazon, Grail, born on the same night as Diana and Jason. Grail, Jason and Diana form a trinity of abused children who seek the acknowledgement of their parents, but mainly their fathers.

Grail is the daughter of Darkseid, the demon God of Apokolips, a dystopian world which he rules with extreme cruelty.[45] At her birth, Grail is foretold to cause death and destruction. Sure enough, shunned by Darkseid, Grail turns him into a baby, and, in a twisted version of Amazon values, she vows to raise him with love and, in doing so, heal their toxic relationship. In effect, Grail becomes his daughter/mother, reflecting Stuller's notion of the female superhero as a mother figure in some cases. Born on the same night as Diana, Grail is her dark twin. Her quasi-mother/daughter nurturing of Darkseid mirrors that of Diana's nurturing of Zack/Zeus. Grail and Darkseid use violence as they go on a quest to restore him by draining demi-gods' life forces. Grail seeks out the children of Zeus and turns them over to Darkseid. Together, they kill Hercules and Perseus.

Like Azzarello's stories, Robinson's stories feature intergenerational conflicts, family squabbling and the quest of the Chosen One. Grail's story mirrors that of Diana and Jason in that it dwells upon the father/ child relationship. Darkseid, like Zeus, is absent. He casts Grail and her mother aside. She attempts to gain respect and acknowledgement from Darkseid with no success.

Jason shares similar narrative trajectories with Grail and Diana for he is also reared outside of a traditional family. Like Firstborn, Jason is angry with his mother rather than his father who is the source of his exclusion. He complains that Hippolyta never sought him out. When Glaucus tells him of his origins, Jason states, 'I've never needed a mother. And I have a father in front of me ... the best a boy could ask for.'[46] However, Jason's pseudo-fathers, Glaucus and Hercules, prove

unreliable. Hercules comes and goes and, when he is sixteen, Glaucus also leaves stating, 'It's my way ... like the birds ... I'm driven to roam.' Jason adds, 'Glaucus lied ... he never came back.'[47] Obviously, continuous abandonment by his father figures has a negative effect on Jason. In these fragile family situations, Firstborn, Grail and Jason exhibit behavioural problems. Jason's past life means he is weighed down by the chains of his past and in the first introduction of Diana to Jason he is shown enveloped by the chains attached to his fishing boat's anchor. Jason sides with Grail and tricks Diana into trusting him only to betray her to Grail and Darkseid.

There are several Chosen Ones in the Jason story arc. Jason's Messiah-like qualities are indicated in his origin story. He is born of royalty but reared in obscurity. This is an element of many heroic, mythic and religious tales such as Krishna, Christ, King Arthur and Oedipus. It is identified by Lord Raglan as one of the twenty-two elements making up the heroic narrative and it is also identified by Richard Reynolds as a significant element of the superhero narrative.[48] Jason and Diana also conform to the good twin/bad twin trope. In revealing Jason's existence, Diana is told by a dying Hercules, 'Family [...] Nothing more important ... Find him. Find Jason.'

Zeus and Darkseid also conform to a Chosen One/Dying/Reviving God narrative model. Both are twice born and have a hand in their own regeneration. Zeus is shown as a trickster God, like Odin the Norse All-Father God. Zeus uses his powers of transformation in Classical Greek myth to seduce women. In *Wonder Woman* he disguises himself as Zack and later as lawyer, Blake Hooper, who informs Diana of her inheritance from Hercules. In both cases, he instigates her quest, in the first instance to become the God of War, in the second to discover her twin. In both cases she is in a secondary role to the Chosen One, her brother. Although Darkseid is turned into a baby by Grail, he instructs her how to restore his power and maturity. Ultimately, Darkseid and Zeus also re-enact the dying/reviving god myth. Zeus is from the Classical pantheon of gods, the gods of the Old World. Darkseid is of the New gods created in the DC universe by Jack Kirby.

He represents a more youthful, potent godhood that defeats and absorbs Zeus's life force.

The final element in this analysis of the Jason story arc is the coda to the Zeus/Darkseid battle. Diana takes on Jason as a mentee, housing him in her beach house. It is not a successful act for he cannot cope with the plethora of opportunities, hedonism and responsibilities a superhero life offers. He trashes her beach house after a wild party and Diana remonstrates with him:

> 'I'm a superhero. I have enemies. I just can't have anyone in here . . .
> Jason are you sure you want to be part of my life . . . you said you
> wanted to be a hero . . . This isn't being a hero . . .'
> Jason: 'I should probably start coming with you on adventures . . .'
> Diana: '"Adventures?" You make it sound like it's all fun and games . . .
> I've seen people become heroes because they got their power, out
> of some vague sense of duty or because they thought it would be
> "cool." They never last.'
> Jason: 'So this is the brush off? Your way of saying you want me
> gone? . . . Don't worry, after being abandoned by our mother, I can
> walk alone.'[49]

This exchange is a typical parent/child conversation with Jason playing on Diana's guilt that their mother, Hippolyta, never contacted him. Typically, she concedes, stating that he is dramatizing the event and her responsibility is to keep him alive and ensure he is properly trained. In this way she acts as a protector, yet again, to a family member. Stuller states that the female superheroine tends to protect their community and their quasi-families. Mentoring other women is rare (although it was successful in William Marston stories where Diana mentored Paula von Gunther and the Holliday Girls). Usually superheroines are mentored by father figures as discussed in Diana's relationship with Ares in Azzarello's stories. Diana does not even get the opportunity to mentor Jason, however, for, after a disastrous encounter with one of her foes, Silver Swan, Jason decides to leave. Before he can do so of his own accord, he is enveloped in a purple cloud and disappears.[50]

Diana's fall from her position as Chosen One is made clear when Jason reappears a week later wearing battle armour.[51] His armour quotes the Amazon's armour in Patty Jenkins's film and an earlier iteration of Diana's armour designed by David Finch for *Wonder Woman* 41, June 2015, as it fully covers the body and has a protective kirtle from the waist. Jason's powers differ from Diana's: in addition to recuperative powers he is strong, can fly and has power over the elements with the ability to create tsunamis. However, with his armour he becomes even more powerful. He can fly faster, he can control the elements. Yet he does not know what happened in the missing week: 'I know this armour is a gift . . . but again, I don't know who it's from or how it came to be on me. I know it's a gift given with love . . . but that it comes with a price.'[52] However, he is unsure of how he got the powers and where from: 'It's been like a haze . . . a dream . . . a dream of giants.'[53] The page is a double spread and the panel showing Jason's encounter with the gods locates him as a small figure in an immense landscape. Jason is not mentored by Wonder Woman when he returns. Instead, his training is entrusted to Steve Trevor, who is sceptical about his abilities and loyalty.

The last two issues of this story arc reconcile Jason and Diana with their parents.[54] Jason searches for and discovers Glaucus, who is imprisoned. He releases Glaucus and, on explaining his new armour and powers, Glaucus surmises the armour may be a gift from Athena, another instance where Jason usurps the myth of Diana's birth origins in which she receives the gods' gifts. In this story arc which follows on from The New 52, the story of the gods bestowing gifts was shown to be a sham. Instead, Jason receives Athena's boon. Later in the story arc, Jason travels through a rift in the dimensional barrier that divides Themyscira from the mortal plane. There he meets and reconciles with Hippolyta who gives him a trident as a weapon.

In addition to denying the heroine's agency in these stories, they lose the essential characteristic of hope that the character embodies. True, Diana defeats Darkseid through her love for her murdered siblings and father. However, her autonomy as the heroine is denied in favour of her family, and especially her father, Zeus, who save her. In denying this role

to the heroine, DC deny a role model to the marginalized, disempowered and disadvantaged audiences that the character was invented to hail. This optimistic aspect of Wonder Woman was, to a certain extent, revived in Patty Jenkins's live action film *Wonder Woman* (2017), released to enthusiastic audiences, and their responses are discussed in the next chapter.

The Once and Future Princess

Nostalgia, Diversity and the Intersectional Heroine

The previous chapter discussed the importance of creating role models for the disadvantaged, marginalized and disempowered. This chapter discusses how DC produced a worthy role model in Patty Jenkins's film *Wonder Woman* (2017), using nostalgia and hope as a means of engaging fans, and looks to the future to reflect on where the character's appeal to diversity might be developed. The previous chapter showed how Wonder Woman's story lost its optimism and its female heroic trajectory in Azzarello and Robinson's revisions of the character. To a certain extent this lack of optimism may have been a reflection on the political times. The president, Barack Obama, was voted in on the ticket of optimism and hope. However, as discussed below, that optimistic frame masked concerns in certain groups who felt marginalized and their opposition became manifest in the election of Donald Trump as president in 2016.

In the twenty-first century, inspired by the success of Marvel's extended universe, as discussed in Chapter 6, DC introduced live action films to develop their own superhero universe. The first of these, *Superman/Batman: Dawn of Justice* (2016), introduced Batman, Superman and Wonder Woman as a precursor for *The Justice League* (2017). *Superman/Batman: Dawn of Justice* was criticized for being incoherent and too complex, a criticism also levelled at *The Justice League* (2017). However, in both films Gal Gadot as Wonder Woman was praised. Wonder Woman's success also signalled a change in the direction of superhero films towards a more marginal and diverse heroism. The popularity of the film, and also the *Supergirl* television

series, inspired an interest in creating more female heroic roles such as Batgirl, Ms. Marvel and Captain Marvel. This was capitalized on in the runaway success of *Black Panther*,[1] which bore similarities in its 'lost civilizations' narrative and female Amazon-like warriors to *Wonder Woman*, the Patty Jenkins film of 2017.

Wonder Woman (2017) was the first live action cinematic film of the character.[2] In it Gal Gadot reprised her Wonder Woman role and Chris Pine played Steve Trevor. It was received with acclaim by fans who, for many years, had waited for a film to do justice to their understanding of the character. The film also gave a massive boost to the impact, perceptions and understanding of the character outside of fandom. Initially, there were few expectations of the film with critics claiming a modest profit of $100 million would be deemed a success. The budget for the film was $149 million by 6 July 2017. To date it has made $821.74 million and it has broken several records: top of the Rotten Tomatoes aggregated scores for a superhero film as of October 2017, the highest-grossing film in the DCEU, the highest profit for an origin story (since overtaken by *The Black Panther*), the biggest film with a woman director and the biggest film of summer 2017.[3]

Patty Jenkins's film was promoted through feminist ideals and a strong female presence: it was the first superhero film to be directed by a woman. Jenkins earned the highest wage of a female director (though lower than male directors' wages) and it was the first successful superheroine franchise.[4] It even garnered praise from hardened Marvel fans and creators.[5] Kevin Feige commented: 'The success of Wonder Woman is wonderful. It makes us incredibly happy. Finally, we can put to rest the falsehood that audiences don't want to see female characters.'[6] The film carried the unreasonable burden of future superheroine franchises and the success of the DCEU, unlike male-centred franchises. It attracted different audiences to a film genre deemed to be for young males and it was hailed as a new direction in the superhero genre for it appealed to girls, women and marginalized groups in addition to 'traditional' audiences. Its appeal to these audiences was in the depiction of the Amazons. Unlike the comics, the Amazons of the film are warriors

who are supreme and noble in battle. Their active bodies inspired audiences, especially female and gay people.

Girls, especially, were inspired. On 11 June 2017, Patty Jenkins tweeted a story sent by a kindergarten teacher about how the film affected students. They included a boy obsessed with Iron Man asking parents to get him a Wonder Woman lunchbox, a girl's birthday party revamped from Beauty and the Beast to Wonder Woman, and seven girls who wanted to be Wonder Woman when playing in school break agreed they would be Amazons and 'work together to defeat evil'. Jenkins's tweet was retweeted 44,510 times and garnered 100,134 likes. Many women and children dressed as the character, cried during screenings and reported feeling chills at key moments. Many recorded that they had been waiting for this film all their lives.

Wonder Woman appealed to audiences on several levels for its revision of the origin story, its feminist credentials, its optimism and its nostalgic reinvention of older Wonder Woman stories. Like many origin stories, it was a rite of passage showing how Diana, the Amazon princess, entered man's world to save humanity from war. Unlike many 'Chosen One' narratives, where the protagonist reluctantly takes on the heroic mantle, Diana, Princess of the Amazons, actively embraces her destiny to defeat Ares, God of War.

The film begins by explaining the origin of the Amazons, created by Zeus, King of the gods, to save humanity from Ares. Diana saves American spy Steve Trevor, after he crashes in the seas off Themyscira but realizes that Ares must be responsible when he tells her of the bloodshed in the First World War. Convinced she must defeat Ares, Diana accompanies Steve to the battle front. There, with a group of misfit male recruits, Diana leads the soldiers into No Man's Land deflecting bullets, toppling a tower, saving a village from slavery and falling in love with Steve. Her actions in battle align her with the legendary Angel of Mons, an imaginary character associated with the medieval warrior Joan of Arc.[7] They also lend a mythical quality to Wonder Woman's story akin to Richard Donner's *Superman* (1978). Fan rhetoric mentions this connection in several social media posts. Other

films likened to *Wonder Woman* are *Captain America: The First Avenger* (2011) as she shares his optimism and origin as a supreme warrior.[8]

Many critics and fans, gratified with the film's success and the raised profile of the heroine, argued that the film broadly encapsulated her spirit. Fans and critics alike reported being overwhelmed with emotion at the introduction of the Amazons in the scene when the Germans invade Themyscira. In an article for Princeton University blog (2017), Adrienne Mayor, an expert in Amazon history, stated, 'The grandeur of the fighting scenes—the sheer physicality and diversity of the Amazons— arouses surging emotions of exhilaration in viewers, empowering for women and girls, a revelation for men and boys.'[9] The look and movement of the Amazons and Wonder Woman was augmented by Jenkins's use of freeze frame, time-dilated close-ups and wire work 'to demonstrate how powerful, agile, and graceful they are in comparison to the grubby German soldiers'.[10] At key points of the battle, the picture would freeze in contemplation of the action body. Unlike Laura Mulvey's notion of the male gaze disempowering the female star's body in its empowering gaze,[11] Jenkins's freeze frame time-dilated close-ups of the active Amazon bodies in action works on the principle that the action is frozen in a gaze that does not aim to stimulate desire so much as joy, inspiration and empowerment, something of which William Marston might approve. The responses on several websites seem to reinforce this notion for audiences reported emotions ranging from tears, to punching the air and cheering:

> [We were] overwhelmed with the pure joy of seeing for the first damn time in your life a bunch of amazing women being total righteous honourable badasses, the feeling you get – it's like you've been drinking water your whole life, and then you get handed a glass of champagne.[12]

> I was punching the fucking air and crying when she pulled that whole Not Today Satan bit, doffing her cloak and crossing No Man's Land like a goddamn badass.[13]

> I'm watching the culmination of years of bullshit over bringing Wonder Woman to the screen, and Gal Gadot is KILLING it, and deflecting

bullets and just REGAL AND STRONG AS FUCK and then she digs in with that shield and I.am.DONE. And then I look over at my wife and she's leaning forward in her seat, and one hand over her mouth and SHE's crying because as much as this meant to me, it's multiplied exponentially for her. So I'm like great, we look like a couple of dorks crying at Wonder Woman in what's ostensibly a rah rah fight scene ... except on my right were a group of 4–5 high school girls ... also crying. and next to my wife, an older couple ... that woman was crying as well.[14]

There were criticisms amongst the general acclaim – some were rooted in feminism, gender and ethnicity (below). Members of the LGBT community commented that the film missed the opportunity to foreground the character's queer aspect. Feminist commentators criticized the Zeus as her father storyline and the use of an all-male coterie that follows Diana into the trenches, claiming it lost its feminist credentials by reinstating a phallocentric narrative trajectory. A further criticism was in her use of a sword as weapon, regarded as inappropriate compared with her lasso in earlier iterations of the character.[15] The use of the sword as her weapon of choice, however, was signalled in Azzarello's comics run. The sword was claimed as the God Killer in the film plot, yet it was ultimately shown as useless. Rather, it was revealed that Wonder Woman's body was the god killer.

Nostalgia as a Promotional Tool in the DCEU

In some fandoms nostalgia is the driving force behind the accumulation of authenticity and the narrative and continuity within fandom. Nostalgia is a process in which fandom repositions the older with newer introductions to subcultural values and meanings.

Nostalgia longs for a non-existent past, a theme adopted by Ryan Lizardi, who argues that contemporary media fosters narcissistic nostalgia 'to develop individualized pasts that are defined by idealized versions of beloved lost media texts'.[16] This argument suggests that fans

are media dupes lost in a reverie of nostalgic melancholia, something belied by the diverse responses of fandom to media texts. Lincoln Geraghty, adopting a more optimistic approach to nostalgia in fandom, describes their responses as 'transformative nostalgia', first, nostalgia is the reason they become fans, second, fans use social media to discuss, recover and transform cult or beloved texts.[17] Media producers are complicit in encouraging fans' nostalgia for cult or iconic texts in constant remakes that can be described as retro logic 'to exploit the connections one feels to the texts one grew up with'.[18] Nostalgia is also present in popular culture where the past 'always exists in the present – either through the remediation of film and television online or in high street stores that sell repackaged and relaunched merchandise to eager fans'.[19] From this brief overview it is possible to identify a relationship between producers, fans and texts, each informed by and contributing to the generation and development of narratives.

As critical consumers, fans are active and critical audiences of texts and they do not always embrace a remake or adaptation. Comics fans are also knowledgeable about the titles they love, a fact that has been invaluable in researching and writing this book. In addition to following comics, they collect, attend comicons and discuss narratives and create their own narratives and adaptations, often in minute detail. Producers acknowledge fan audiences in the ways they present their adaptations. Producers discuss their adaptations with fans as, for instance, Peter Jackson recognized fans as important potential audiences when he adapted *The Lord of the Rings* and he engaged with online fandom when bringing his vision of Middle Earth to the screen.[20]

In the DCEU films and television shows, like many other longstanding transmedia universes, producers appeal to fandom by inserting 'Easter eggs', intertextual allusions through quoting past iterations, into new narratives. These Easter eggs hail contemporary fan practices that Henry Jenkins notes when he observes, 'the migratory behaviour of media audiences who will go almost anywhere in search of the kinds of entertainment experiences'.[21] This is a promotional strategy to hail fans' notions of authenticity and embed new iterations into the universe's

continuity. For instance, superhero narratives often use nostalgia in recurring actors, characters, narrative tropes and iconography to hail fandom but also develop a myth and the character's brand.[22] Lynda Carter appeared in the *Supergirl* television series as the President of the USA. There was an intertextual allusion to Wonder Woman in DC's *Legends of Tomorrow*, season 3, episode 6, broadcast 14 November 2017, in which Helen of Troy, a temporal aberration, appears in Hollywood of the 1930s and unwittingly causes chaos because men cannot resist her allure.[23] After she begs not to be sent back to Troy, she is placed on Themyscira where she can do no more damage.

Referring to my earlier point that the DCEU relied on alternative realities and parallel worlds to stitch its universe together, tangential Wonder Woman narratives also evoke a nostalgic gaze on the character. One such is the alternative history *Bombshells* (2011–present). The Bombshells iteration of Wonder Woman originated from a set of prints by conceptual artist Ant Lucia for the Chicago convention 2011 and based upon good girl art. The prints were developed by DC Collectibles into nine-inch statuettes by Tim Miller and released in 2013. Unlike good girl art, the figures' poses were meant to connote power and strength to appeal to male and female audiences.[24] The Wonder Woman statuette featured her breaking the chains of oppression, an image that quoted Harry G. Peter's drawing of Wonder Woman accompanying William Marston's article 'Why 100,000 Americans Read Comics', *American Scholar*, 13, 1943–44. Peter's image itself was a quote of Lou Rogers's 'Tearing off the Bonds' suffrage image featured in *Judge*, 19 October 1912.[25] Using this image reinforced Wonder Woman's feminist message but there was also an allusion to another feminist icon, Rosie the Riveter, in this image and a seemingly paradoxical allusion to good girl art.[26] DC also published a digital comic written by Marguerite Bennett and drawn by Marguerite Savage in July 2015, running for 100 issues, and in hardcopy in August 2015. The comics continue DC's recent tradition of using more women creators on the Wonder Woman narratives.[27] In an interview for DC News for the San Diego Comicon, 2015, Bennett stated that one of her main aims was to feature the

narrative around the female characters who are strong enough to be heroines on their own terms.[28] Each character starred in a complete world, and in an interview for San Diego Comicon, 2016, Bennett situated these stories in a wartime setting thus reiterating the context of Marston's origin stories.[29]

The most significant appeal to nostalgia was in DC's use of Lynda Carter's image in a series of collectables and comics that referred to the television series, the publicization of Carter's support for the film and fans' comparisons between Carter and Gadot. The television series gave Lynda Carter a significant presence in fandom as it was the main live action representation of the character. The television show cleaned up Wonder Woman and sanctified the character to the extent that Lynda Carter's influence on the representation of the character was a huge influence on later comic-book representations and adaptations.[30] Artists such as Phil Jimenez described Carter as 'the living, physical embodiment of this character'[31] and Alex Ross stated she was 'an object of energy in motion, not . . . of corrupted sexuality or . . . something that is just for the boys'.[32] This statement forgot the television production companies' representation of the character in a sexy and sometimes demeaning manner as outlined in Chapter 3.[33] Carter is also cited as epitomizing Wonder Woman by feminist artist and writer Trina Robbins who spent decades researching the character's lost histories and comics: 'She absolutely *was* Wonder Woman. You know, and I know a lot of people got turned on to Wonder Woman, just from that show.'[34] Robbins is well known for the stories and artwork she produced for *Wonder Woman* comics and her championing of more realistic representations of female characters.

Within superhero discourses, fan responses are often directed by nostalgia and the need to 'pull towards what they used to be' and in the case of Wonder Woman, Lynda Carter's influence is just as important, certainly better known than Marston's.[35] The 1970s *Wonder Woman* television series and its repeats were the main encounter of the character with mass audiences that 'made [Lynda Carter] a permanent part of popular culture for the average American'.[36] Such is the connection

between Carter and Wonder Woman that Carter's image is used in collectables, comics, television and her influence was used in promoting the film. For instance, Carter's image was used in producing statues and collectables by Cryptozoic, Tweeterhead and DC Collectables.

Carter's image was used in a number of titles referring to the television series in *Wonder Woman '77*. *Wonder Woman '77* was first published as a digital comic with beautifully rendered images of Carter by Nicola Scott. The success of the series led to the publication of tangential titles *Batman '66 Meets Wonder Woman '77* and *Wonder Woman '77 Meets the Bionic Woman*. *Wonder Woman '77 Meets the Bionic Woman* was a six-part mini-series published in collaboration between DC, Dynamite, Warner Bros. and Universal. The comics were written by Andy Mangels, a comics writer, super fan and collector of the character and the Lynda Carter television series. Mangels has subcultural capital because in addition to his extensive knowledge of the character, he also owns one of the largest Wonder Woman comics and memorabilia collections in the world. His knowledge of the character translates into attention to detail of the character *Wonder Woman '77 Meets the Bionic Woman* and this was shown in the letters page, 'Empowered Words', where letters were universally positive and praised the authenticity of the characters' portrayals. For instance, in issue 3 a fan wrote, 'the two characters have been a beloved part of my life since my earliest memories ... Andy's love and knowledge of Diana and Jaime shines throughout every bit of dialogue.' A writer in issue 4 wrote that the comics 'distilled in just 22 pages the essence of what has always made Diana and Jaime endearing to fans all over the world'. Both writers recollect watching the show when very young and they remained fans. Another writer in issue 3 reported passing her love of the character onto her daughter with box sets.

The film, like the comics, uses nostalgia to hail fans. Patty Jenkins claimed the inspirations for the film were in Marston's aim to inspire girls and boys with a strong heroine, Lynda Carter's depiction of the character in the television series (1975–79), and Pérez's focus on the Greek gods and in his depiction of Ares. These iterations from the comics

and Lynda Carter's portrayal represented a strong, moral, sexy and powerful woman. Jenkins aimed to replicate these qualities through the film's star, Gal Gadot, whom she likened to Carter and described as 'utterly kind, incredibly strong'.[37] Jenkins claimed that her version of Wonder Woman was inspired by Marston's concept of what the character stands for and Lynda Carter's interpretation of the character's positive attributes.[38] In likening Gadot to Carter, Jenkins therefore, set up a narrative continuity within fandom, a 'passing the torch' moment when the iconic past iteration gives way to the present adaptation: 'the king is dead, long live the king'. For instance, Christopher Reeve, the most iconic of all Superman impersonations, appeared as Dr Virgil Swann, in season two of *Smallville* when, underscored by the *Superman* film music, he told Clark Kent of his destiny.[39] Such appearances lend cultural authenticity to adaptations and reinforce the actor's affiliation with the character. The most overt appeals to nostalgia are in the range of comics that continued the television series. There are precedents for the continuation of a cancelled television series in a comic. This practice started with a similar exercise when *Buffy the Vampire Slayer* television show was cancelled in 2003 and the series continued in comics. *Smallville*, cancelled in 2011 after season 10, continued in a comics title labelled season 11. It also introduced Diana, Princess of Themyscira.[40]

Fan nostalgia was also addressed in some of the first promotional images of Gal Gadot as Wonder Woman. These images refer to iconic moments in the character's history. Gal Gadot's pose in an early poster is a nod to the cover of *Sensation Comics* 1, January 1942. In both pictures the heroine, curiously static, faces the audience whilst deflecting bullets. The second image is of the iconic defence position in which the arms are crossed, the bracelets clash together and this makes the 'boosch' sound. This pose became integral to Wonder Woman's powers in the film for when she clashed her bracelets together in this defence position she created a sonic boom. So, from the jiggle television 'boosch' that emphasized Wonder Woman's cleavage, the film turned the posture into a power pose. In their 'quoting' of previous Wonder Woman iterations

producers made use of the nostalgic gaze, a fan gaze based upon authenticity evoked by nostalgia, and one that Henry Jenkins (2006) identified when he talked of 'the migratory behaviour of media audiences'.[41]

The introduction of Gal Gadot as Wonder Woman is a significant moment in fandom for it constitutes a rite of passage with one icon succeeding another, a phenomenon that is rare in comics.[42] Carter's name and image are so synonymous with the character that she is a spokesperson for the character, holds subcultural capital in Wonder Woman fandom and articulates the character's values in her star image.[43] So, Lynda Carter's approval of Gal Gadot's portrayal of Wonder Woman would enable Gadot's depiction to accumulate subcultural capital. It seems, from reports of their meetings, that the two actresses have mutual respect. Hence, Carter appeared in the 2016 nomination of Wonder Woman as UN Ambassador for Girls alongside Gal Gadot. After viewing the film, Lynda Carter tweeted, 'Gal Gadot is fabulous as Wonder Woman. I had so much fun at the premiere.'[44] On 5 June, she tweeted, 'Wonder Woman is breaking box office records!!! Bravo, Patty Jenkins! Bravo, Gal Gadot! Bravo, Chris Pine!' Carter also acknowledged her iconic status in a 'passing the torch' moment: 'I am the bearer of the torch and now I'm passing it forward to Gal and to Patty ... The three of us share some sisterhood by living and breathing this character.'[45]

The Future Princess

In a postmedia age, Wonder Woman is instantly recognizable in her many guises. She can be regarded as inspirational, sexual, mythical, feminist, queer and immigrant. Emerging future directions for the character acknowledge the necessity of using the character's potential for narratives dealing with ethnic diversity and Wonder Woman's queer profile.

It is a truism to propose that the superhuman body acts as a metaphor for the body within wider culture. As discussed in previous chapters, the superheroine body brings with it issues of gender, sexuality and objectification. It is also an indicator of the moods and concerns of culture in a particular era as noted by Jeffery A. Brown: '[the action heroine] is one of the most intriguing, progressing and disputed signs of changing gender norms in popular culture'.[46] The action heroine, and by extension the superheroine, is a disputed sign but her representation can help identify changing attitudes to female power, especially in representations of Wonder Woman. My aim in this book was to show how Wonder Woman's body, and those of the females around her, could be analysed through a cultural and historical lens going beyond gender and sexuality and into politics, comics and popular culture. The study mapped the female body from the early 1940s to the present and as Cocca suggested, illustrated how the superheroine body showed the tensions between expectations and the potential of women.[47]

In each era Wonder Woman's body and mind are represented as perfection. Like Pygmalion of legend or Rotwang in *Metropolis*, Marston and Peter created the perfect woman. In the 1940s her body was that of the showgirl. In the 1950s and early 1960s, she was the fairy-tale princess. In the late 1960s and early 1970s she was the swinging action chick. In the 1980s consumerism and her birth as the Chosen One conceptualized her as a Goddess. Post-9/11 Rucka reflected how, as a foreigner, she was treated with suspicion in patriarchy. The DCEU of the early twenty-first century developed many iterations of the character to appeal to diverse audiences, her appeal promoted by the nostalgic gaze on previous incarnations of the character, and these were used to prove her authenticity. From these diverse depictions of the character, it is clear that Wonder Woman is not a homogeneous character but constructed of many previous iterations and the diversity of her contemporary representations shows there is not one Wonder Woman but many.

In all her previous iterations Wonder Woman's body inhabits public rather than the private space. As a symbol for female power, Wonder

Woman is an impossibility: an Amazon warrior and goddess (in her latest incarnation), she suggests femininity as power and glamour, untrue for the majority of women. Further, Wonder Woman's lack of domesticity, her command of public spaces, are not indicative of most female life experiences. Her body is that of the professional, independent woman, a woman whose agency commands the space. As such, it is the body of the woman with a public rather than private profile. There are other types of bodies that are indicated in some of her stories over the past seventy-plus years, and fan debate that may point to future directions for the character including race and ethnicity, 'traditional' female roles, and LGBT roles, all issues that contemporary superhero narratives address. It may be apt to consider these diverse, yet ubiquitous, aspects of her character through the lens of intersectionality.

Intersectionality assumes that identities are formed by diverse discourses such as race, ethnicity, sexuality, gender and class. Intersectional analysis was inspired by the difficulties faced by women of colour when they attempted to analyse their experiences based upon traditional analytical models.[48] Pamela Hill Collins notes that, 'When it comes to social inequality, people's lives and the organization of power in a given society are better understood as being shaped not by a single axis of social division, be it race, gender or class, but by many axes that work together and influence each other.'[49]

As a character with a diverse and extensive history, and many iterations that hail her queer, feminist, sexual, class and racial identities, Wonder Woman can be described as an intersectional character. Although this book dwelt upon the body as the base for analysis, the discourses evoked in the analysis were diverse and ranged from political, technological, familial, fantastic, racial, national, institutional and consumerist in addition to gender and sexuality. To provide an indication of just how complex issues of intersectional debate regarding ethnicities and race can be, the next section maps out some of the main areas of critical and fan discussion that might indicate potential directions for the character from political, cultural and social discourses of the early twenty-first century.

Ethnic, Racial and Gender Issues in Early Twenty-First Century America

To contextualize changing political, cultural and social discourses it is useful to consider the changing presidencies of Barack Obama and Donald Trump. Both presidents represented a volte-face in attitudes towards ethnicity, race and gender, and some of these changes can be identified in the representations of Wonder Woman in the twenty-first century. Growing multiculturalism developed from the early twenty-first century and found its apogee when Barack Obama became president. Obama's inauguration as president suggested America as a land free of racism. In his 2004 keynote speech to the Democratic National Convention Obama stated, 'There is not a black America and a White America and a Latino America and an Asian America: There's the United States of America.' According to Sarah Nilsen and Sarah E. Turner, this speech denied the racial anxieties of white moderates and independents.[50] The election of Obama in 2008 led to what Nilsen and Turner describe as 'colourblind racism' that proposes 'racism is a thing of the past and that race and racism do not play an important role in current and economic realities.'[51]

Greater acceptance of biracial roots also reflected demographic trends in America and California.[52] Up to 2016, there were shifts in ethnic populations and identities driven, in part, by youth culture. As noted above, young people had a more open attitude towards race.[53] The changing demography in America is towards younger people of whom 36 per cent aged 'eighteen and younger fell under the racial classification of non-white in 1999'.[54] This multicultural population is now as large as baby boomers. Therefore, the idea of an ethnic white majority in the early twenty-first century was exposed as a myth for, as Neil Howe and William Strauss argued, 'demographically, this is America's most racially and ethnically diverse, and least Caucasian generation.'[55] Millennials represent a lucrative marketing opportunity for consumerism and cinematic audiences, elements that no doubt contributed to Gal Gadot's selection for the role of Wonder Woman.

Trump's appointment as president revealed the disaffection felt in several marginalized and disadvantaged white groups. His campaign focused on racial differences, immigration control and securing the border between America and Mexico. In expressing these issues, Trump revived debates on race, ethnicity and nationality with controversial views of Mexicans and Islamists and a failure to denounce right-wing and racial extremists. For instance, he encouraged former grand wizard of the Ku Klux Klan David Duke to campaign for Congress in Louisiana. In protests at a white nationalist rally in Charlottesville, Virginia, on 12 August 2017, a sports car driven by James Fields Jnr., a right-wing extremist, collided with a crowd of counter-protestors, killing one person and injuring twenty-eight others. Writing after the announcement of Donald Trump's victory in winning the presidential election on 17 November 2016, Cornel West noted with dismay that Obama's administration was negligent in addressing black suffering and social conditions, and their self-congratulatory celebrations of their neo-liberal successes did not seem to speak to those who felt disadvantaged.[56] Many people in these groups were pivotal in the appointment of Donald Trump as president in 2016 despite his seeming indifference, and in some cases antipathy, to their issues.

Trump was appointed president in a world that seemed more dominated than ever by men out to prove their masculine authority, often by abusing or proclaiming their dominance over women and LGBT groups in politics, war and entertainment. Terror groups used women and children as suicide bombers, for sex and forced marriages. There were the abductions of 276 schoolgirls in Chibok, Nigeria by terrorist organization Boko Haram in 2014 and, in 2018, up to a hundred schoolgirls in Dapchi, Nigeria. There have been scandals of child sexual abuse in Britain involving figures who presented a benign public face such as entertainers Jimmy Savile, Rolf Harris and Rochdale MP Cyril Smith. The police and the judiciary were shown as negligent in disregarding female testimony of child-grooming rings and in the release of John Worboys after eight years of an indefinite sentence for drugging and raping twelve women. Worboys was guilty of up to one

hundred other offences. A higher-profile case was of Donald Trump, accused of sexual harassment when footage of a 2005 interview for *Access Hollywood* was leaked to *The Washington Post* on 8 October 8 2016. It recorded him stating that, as a star, you can do anything and 'when he meets beautiful women he feels able to "grab them by the pussy".'[57] However, the case that galvanized most disapprobation was that of Hollywood film producer Harvey Weinstein, who in 2017 was accused of sexually harassing, assaulting and raping more than a dozen women.

The latter two cases inspired campaigns that united people across the world in protest. The 'Me Too' movement started in October 2017 to highlight cases of sexual harassment and misconduct after the Weinstein case. It was publicized by several high-profile celebrities sharing their experiences of Weinstein's activities. The extent of women's exploitation was demonstrated when it went viral on Twitter with #MeToo. The condemnation of exploitation in Hollywood was further highlighted when celebrities wore black as a protest at the 2018 Golden Globes.

Protest at Donald Trump's inauguration as president for his views on women's, workers' and LGBT rights, racial equality and religion took place with a National Women's March on 21 January, 2017. Between three and five million people attended marches across America and seven million across the world. Part of the visual protests was the wearing of pink pussyhats by many participants. The Pussyhat Project was started by Krista Suh and Jayna Zweiman who aimed to support women's rights by creating and wearing pink pussyhats, thereby reclaiming 'pussy' as a derogatory term: 'In this day and age, if we have pussies we are assigned the gender of "woman." Women, whether transgender or cisgender, are mistreated in this society.'[58] The aim was to make a pink pussyhat a visual symbol of protest, a sea of pink pussyhats. Bringing together the ethnicity, racial, and gender issues was the poster painted by Abigail Gray Swartz who took part in the march in which she reimagined Rosie the Riveter as black and wearing a pussyhat. The image appeared on the cover of *The New Yorker* on 6 February 2017.

Both the #MeToo and the Women's March protests attracted backlashes. In an article for SBS Australia on 31 January 2017, Helen Razer argued that by reimaging Rosie as black, she was subsumed in white women's history. This thereby expunged black women's history.[59] #The Me Too movement also attracted criticisms for disregarding the various levels of sexual misconduct, ignoring the rights of sex workers who seemed to be regarded as fair game, disregarding the roles of women of colour such as Tarana Burke who started #Me Too against sexual victimization in 2006. What is significant for my argument is that, in these protests, black, LGBT and female rights are merged into the intersectional discipline.

In reflecting upon Wonder Woman as an intersectional character it is worth looking at ethnicity and gender in early and recent stories and debate about the character to identify future developments.

Race and Ethnicity

The first Wonder Woman story in *Sensation Comics* 1, as discussed in Chapter 1, claims that, 'The story of Wonder Woman is the story of her race.' Yet Marston and Peter chose to represent her as North European Caucasian to provide her with the perfect immigrant body. Further, the comics of Marston and Peter reverted to racial stereotypes for Asian and black characters in popular culture that conformed to racial attitudes of their time where they were either supporting characters, evil Axis agents or comedic characters. Subsequent creators tended to overlook racial diversity in what has been described as passive racism.

Over the seventy-plus years of her existence, there have been few people of colour as regular characters in Wonder Woman comics. Some of the first major characters of colour in Wonder Woman appeared in the late sixties and early seventies. Dennis O'Neil's unfortunately named I Ching, in the 'white costume era', conformed to a stereotypical perception of Asian people as mysterious, mystical and experts in martial arts. When Robert Kanigher took over writing duties, after

Wonder Woman regained her powers in 1973, he introduced Nubia, Wonder Woman's sister formed from black clay. As detailed in Chapter 3, Nubia was stolen from Paradise Island by Ares and raised to hate the Amazons. Other sources of conflict were the Bana-Mighdall, introduced by George Pérez in *Wonder Woman* v. 2, 29, April 1989, detailed in Chapter 4. The Bana-Mighdall were the lost tribe of Amazons, led by Antiope, Hippolyta's sister. They settled in Egypt and became mercenaries and weapons manufacturers. The Bana-Mighdall scorned what they regarded as Themysciran decadence and indulgence, and their nomadic nature could be coded as Native American, Jewish or Middle Eastern. For instance, their dress was reminiscent of Native Americans, they were a lost Amazon tribe, reminiscent of the Lost Tribe of the Jews but they were also located in Egypt as arms manufacturers. Significantly, in many cases they represented diverse races and ethnicities. Nubia and the Bana-Mighdall represent conflict and dissent within the Amazon race as their harder upbringings predisposed them to resentment and, in some cases, hatred of the Themyscirans for what they believe is their lost birthright and humanity.

However, recently there have been positive black characters. In *Wonder Woman* v. 2 170, July 2001, Phil Jiminez introduced Trevor Barnes, a human rights advocate, as a new love interest for Diana. Barnes, however, was not popular with fans and the character was killed off in one of the many culls of supporting characters in that era as outlined in Chapter 5. The most influential introduction of mixed-race characters was George Pérez's 1987 reboot of Wonder Woman. In this story arc, Pérez introduced Phillipus, Hippolyta's general and chief adviser, who ruled Themyscira when Hippolyta was in exile. In the Rebirth *The Legend of Wonder Woman* graphic novel, Alcippe, previously known as Phillipus, is a black Amazon described as 'a brute' and their greatest warrior. Alcippe trains Diana in the arts of war and the Amazon Way: 'We respect our opponents. We understand them. We only attack when there is no option and we will only kill when we must.'[60] She feels Themyscira at an instinctual level. Like Diana, Alcippe understands the growing sickness of Themyscira in which crops and livestock are dying.

In the introduction of Amazons of various ethnicities and races, Pérez reverted to a more historically based Amazon mixed-race physiology and, as noted below, this contributed to the mixed-race representations of the Amazons in the 2017 film.[61] In general, there was acclaim for ethnic diversity of the Amazons in the film. Adrienne Mayor, who published an analysis of the cultural representations of the Amazons, was full of praise for the diversity of Amazon bodies as 'tall and short, robust and lithe, young and mature, lean and muscle-bound, stolid and mercurial; pale and dark—and everything in between.'[62] In her monograph on Amazons, Mayor claims that ancient Greek, Roman and Chinese records of Amazons confirm they presented a variety of racial types with all hair and eye colours.[63] In doing so, Mayor established a historical precedent for multiracial Amazons.

Nevertheless, there were measured responses to ethnic diversity in the film and these are noted in an article for Sequart.org by Nicholas Yanes who reports feedback on the film from academics.[64] Typical of these is Vanessa Flora-Nakoski: 'This film represents a major victory for feminism, but only for a specific kind of *white* feminism. In the era of Beyoncé and Hillary Clinton, who was rejected by large numbers of white women, the rallying cry of intersectionality is louder than ever.' Chamara Moore praises the diversity of Amazons in the film but notes passive racism: 'once we leave Paradise Island both blackness and black femininity are left completely behind.'[65] A major criticism of the role of black women in the film was in the role of Alcippe/Phillipus. The film follows Rebirth *The Legend of Wonder Woman* in making Alcippe/Phillipus Diana's mentor and trainer. However, there are critiques of her representation for it corresponds to stereotypes of black women: she is a large, strong woman who is instinctive rather than intellectual. Where, in Rebirth *The Legend of Wonder Woman* Alcippe trains Diana, in the film she is trained by Antiope. Alcippe becomes Diana's nanny/child minder, conforming to the mammy stereotype of the traditional Hollywood film.

The film also transforms some previous Caucasian-looking characters to black. There are precedents for changing a character's race. Other DCEU characters have changed colour such as Iris West in *The*

Flash television series. In the *Marvel Extended Universe*, Johnny Storm, a blue-eyed blond teenager, became a black teenager for the film *The Fantastic Four*.[66] There were Indian and Latino versions of Spider-Man revised through the multiverse that have been produced as an animated series by Disney. As noted above, Rosie the Riveter (a character often associated with Wonder Woman because both were created through graphic design), was also re-envisaged as black to pay homage to the racial diversity of woman who fought and served in the Second World War, and as a protest against the attack on women and the rights of diverse races and ethnicities.[67]

The announcement that Gal Gadot was to play the role of Wonder Woman in 2013 was made under the Barack Obama administration which promoted multiculturalism. However, the film was released in 2017, under the presidency of Donald Trump. Gal Gadot, like Wonder Woman, has a Caucasian-looking body but she was chosen to reflect a growing acceptance of multiracialism in politics and Hollywood of the early twenty-first century. When Gadot was first announced as playing Wonder Woman, 6 December, 2013, The Nerds of Color website commented that Gadot had 'just enough Mediterranean swarthiness to read 'dainty exotic' to the Western male gaze'.[68] This suggests that Wonder Woman connotes modified exoticism acceptable to the West, the concept she represented in Marston and Peter's stories. However, it also signals a change in cultural awareness in the early twenty-first century with the use of biracial stars in action films.

Biracial stars are regarded as signs of greater multiculturalism and the movement of ethnic populations in the 1990s which resulted in what Danzy Senna describes as the 'mulatto millennium'.[69] According to Jeffrey A. Brown and Mary C. Beltrán, the growth of multiracial or 'ethnically ambiguous' looking stars also indicates a cultural predilection for 'multiracial chic'.[70] Nowadays the multicultural star incorporates their ethnicity in publicity and in their romantic relationships. There was a boom in mixed-race marriages of younger people from the 1990s, an issue that extends to the British royal family with the marriage of Prince Harry to Meghan Markle. Stars from previous generations now

seem more comfortable in revealing their multiracial ethnicities. For instance, Raquel Welsh revealed her Bolivian/Irish ethnicity, and Lynda Carter was revealed as a mixture of Mexican and Irish descent.

As a woman whose body reflected Eastern European origins, and in the climate of biracial action heroines, yet who appeared white, Gal Gadot seemed the perfect choice. On 1 June 2017, Matthew Mueller posted an article on Comicbook.com that claimed Gal Gadot as a woman of colour: 'Simply put: LOOKING White, doesn't mean you ARE white.'[71] Debates about the actor who 'passes for white' reflect concerns on how the biracial star in action cinema epitomizes Otherness whilst enabling a colour blindness in audiences.[72] Jeffrey A. Brown states that contemporary biracial action heroines 'function in direct opposition to the idea of passing for white' and they are usually marked as non-white performers 'to signify a tempered exotic Otherness'.[73] This, Brown argues, signals a shift in how we regard race in contemporary Western culture: 'By featuring actresses of mixed racial identities as heroines, the action genre is able to both utilize ethnic stereotypes about women and to sidestep racial issues, such as discrimination and miscegenation.'[74]

A further debate about Gadot centred around her ethnicity as Ashkenazi Jew. Gadot's stint as a trainer in the Israeli army and her expression of loyalty to her homeland incited passionate debate amongst comic-book aficionados. In 2014 Gadot tweeted, 'I am sending my love and prayers to my fellow Israeli citizens. Especially to all the boys and girls who are risking their lives protecting my country against the horrific acts conducted by Hamas, who are hiding like cowards behind women and children ... We shall overcome!!! Shabbat Shalom!' Keith Chow on the blog The Nerds of Color responded on 30 July:

> Wonder Woman is supposed to be an ambassador of peace – Diana of Themyscira only goes to war for those who cannot fight for themselves. Is it possible that, were Wonder Woman real, her view of the conflict in Gaza would be filled with more compassion for the oppressed? Isn't that the kind of justice that a character like Wonder Woman is supposed to inspire?[75]

Given all of these racial and ethnic issues, there is much scope to make Wonder Woman a character who can speak for marginalized groups. The release and subsequent success of *Black Panther* shows there is an appetite for marginal characters in the superhero genre.[76]

Gender

In an era when male/female power relations increasingly come under scrutiny, neglecting female/female relationships, early twenty-first-century stories of Wonder Woman increasingly concentrate on her relationships with men. In Patty Jenkins's film she leaves her all-female society to join the war. Instead of gathering to her a group of female supporters like the Holliday Girls and Etta Candy, she becomes part of a group of male fighters. Etta Candy is barely included in the narrative and is consigned to working off the front line. In comics, too, Diana's relationship with male characters is emphasized from Steve Trevor to her father, Zeus. This section explores Wonder Woman as housewife and mother.

Wonder Woman's family is not traditional, it is blended, as discussed in the previous chapter, and consists of an absent father, murderous relations and a negligent, often absent, mother. Wonder Woman does not conform to typical female roles within the family. She is rarely shown as a wife or mother as such, she speaks little to the majority of female experience, a facet of the character lost in discussions of gender, race and sexuality. It is a topic that William Marston considered but did not follow up. In, *Sensation Comics* 9, September 1942, Wonder Woman confesses to Diana Prince/White, the wife and mother with whom she swaps places: 'I'm glad to get my position [as Wonder Woman] back. But I envy you yours, as a wife and mother.'[77] Often, as in DC's experimentation with stories in its titles, possibilities for alternative lives of stock characters are explored either in imaginary stories or parallel universes. Examples of her more traditional role in a family is as the wife of Steve Trevor on Earth Two. On this earth, they have a

daughter, Hippolyta (Lyta) Trevor.[78] Lyta Trevor was one of the characters written out of continuity in the *Crisis on Infinite Earths* reboot in 1986 but played a pivotal role in the acclaimed *Sandman* comics of Neil Gaiman.[79] In *Dark Knight III: The Master Race*, a sequel to Frank Miller's *The Dark Knight Returns*, Wonder Woman has a son, Jonathan, and a daughter, Lara.[80] *Kingdom Come*, a four-issue *Elseworlds* comic by Mark Waid and Alex Ross, features the son of Superman and Wonder Woman.[81] In *Justice League* volume 3, 26, Wonder Woman's son, Hunter Prince, from twenty years in the future visits the present to berate his mother for abandoning him. In all of these stories there is but the sketchiest image of Wonder Woman as a mother: battling evil with a son in a baby sling; fighting her daughter.

A contemporary story of Wonder Woman in the family situation is of Diana as domestic goddess in Milk Wars, a Doom Patrol and Justice League of America crossover. In a dream world, she is Wonder Wife in a story in which Retco, an interdimensional company, appropriates and retcons stories for new markets using radioactive milk and psychic cows.[82] After drinking radioactive milk, members of the Justice League of America are transformed into bland, and more sinister, versions of themselves. Superman is re-envisaged as Milkman Man, Batman as Father Wayne and Wonder Woman as a Stepford Wife-type housewife, concerned only with pleasing her husband, Steve Trevor. This role counters everything Diana represents and reflects Betty Friedan's notion of the captive housewife in *The Feminine Mystique* (1963) (see Chapter 2). In this role she completely sublimates her identity and goes so far as to attend a march in favour of obeying patriarchy; as such, this representation is a reminder of why Wonder Woman was created. The story also reverts to the fantasy family that was a key ingredient of 1950s and early 1960s *Wonder Woman* comics, as discussed in Chapter 2. It is significant that notions of domesticity, fantasy and the perfect housewife and mother refer back to Friedan's *Feminine Mystique*.

Gender debates concerning the queer representation of Wonder Woman emerge from fandom and the media industry and can be illustrated through two stories. In *Sensation Comics* v. 2, issue 16 of 2015,

Wonder Woman officiates at a lesbian wedding.[83] When Superman questions this Diana responds: 'Clark, my country is all women. To us, it's not "gay" marriage. It's just marriage.'[84] Wonder Woman was born and raised on an island of women so, for her, the wedding is not extraordinary but part of everyday life. Indeed, in the latest iterations of the character, female partnerships are written into Amazon culture, a notion reinforced by Greg Rucka. Hippolyta and Phillipus are in a relationship. When Amazons fall in battle in the *Wonder Woman* film, it is apparent through the lamentations of other characters that they are romantically partnered. The second story is from the film of 2017 and concerns Diana's biological gender. Diana and Steve are in a boat, travelling to London, and discuss marriage and sex. When Diana invites Steve to sleep with her Steve tells her that outside of the confines of marriage it's not polite to assume that a man and a woman will sleep together. Diana then reveals her naivety when she tells Steve she was sculpted from a clay statue by her mother and brought to life by Zeus. She does, however, know about reproductive biology having studied it from a book, although she suggests that men are unnecessary for pleasure. The point of these two examples is that, while Diana comes from this unisex culture, she is aware of how heterosexual sexuality and gender is performed culturally and biologically. Culturally she performs various identities once she knows the regulations that govern behaviour.

Wonder Woman, however, seems more at ease as a character when performing or acknowledging a queer identity, as noted by Cocca.[85] Her queerness is in keeping with contemporary notions of gender as a fluid concept. Here it is useful to refer back to Judith Butler's notions of gender as performed identity and perceived masculine and feminine roles as in continuous flux. Diana's queerness is noted by Greg Rucka, one of the key comics writers of *Wonder Woman* in the past twenty years, who stated that, as a society of only women, same-sex relationships were inevitable.[86] Acknowledging and developing queerness can, in part, be attributed to the diverse range of creators who worked on the character such as Trina Robbins, Nicola Scott, Gail Simone, Renae de Liz and members of the LGBT community such as Phil Jiminez and

Greg Rucka. These creators' sensitive treatment of the character, at times, emphasized her sympathetic, intelligent, emotional and affective responses to the challenges of yielding power in a male-dominated society.

Nowadays, myriad gay and lesbian identities are condoned in Western culture to the extent that a number of countries allow marriage or a form of civil partnership. These diverse identities reinforce Foucault's notion of perverse implantation, the notion that the identification of specific behaviours and identities as 'deviant' does not deter the continuation of these practices, but rather it opens up the body to new pleasures.[87] Taking perverse implantation to its logical conclusion, transgender is an emerging trend in body culture. Now the body is not punished to make it conform to 'norms' of gender performance, through surgery and electro convulsive therapy. Rather, surgery can adjust gender to conform to individual pleasures and there are growing numbers of gendered roles. The performative basis for these roles is acknowledged in some surprising organizations one generally assumes to be reactive, such as the Church of England and the Girl Guides.[88] Both suggest that the individual can choose which gender to align themselves with on a given day. Gender reassignment is also now on the rise and can be identified in the numbers of people undergoing surgery or even opting to follow an androgynous lifestyle.

Signs of transgender body images can be identified in superheroes in the DCEU and MEU transmedia universes. Most transgender revisions are from male to female, presumably to address the gender bias towards masculinity in the superhero genre. Characters such as Doctor Fate in the DCEU, and Thor, Captain Marvel and Captain America in Marvel comics, caused controversy and outrage in some fandoms. In the DCEU, Doctor Fate was revised as female. Often this realignment happens because of the acknowledgement that there is not one but a multiplicity of universes. Gender reassignment transformed Wonder Woman into Wonder Man in an alternative universe, Earth-11, where all gender roles are reversed. Dane of Elysium is a male version of Diana Prince.[89] Her brother, Jason, as discussed in the previous chapter, might just be a

male version of Wonder Woman. Several fans suggested this is in keeping with other spin-off characters in the DCEU such as Supergirl and Batwoman. They point out that Wonder Woman has no similar male characters. Perhaps this is an issue DC identified needed development in the Wonder Woman family.

Wonder Woman's body speaks to us of diversity. From her beginnings as a queer, immigrant and feminist character, she speaks of the disadvantaged, the marginalized and the Other. In a film blog of 31 May 2017, Monique Jones suggested that Wonder Woman's image has been overwritten on issues of disability, race and LGBT. However, 'The biases, both conscious and unconscious, have still found their way into her story.'[90] As such, Wonder Woman is often aligned and adopted by marginalized groups such as women, ethnically diverse peoples, the disabled and LGBT groups, one of the reasons she was initially chosen to represent female empowerment for the UN in 2016. That this initiative ultimately failed is, as proposed in the Introduction, partially due to her paradoxical nature as a feminist icon wearing sexy clothing. Yet, third-wave feminists might argue that, so what, shouldn't a woman be able to articulate what culture deems paradoxical themes such as sexiness and empowerment? That she does not conform fully with typical hegemonic masculinity may be a factor in her favour. Wonder Woman has the potential to explore such issues and, if traditional media producers are not willing to entertain this notion, then fans certainly are, whether in fan fiction, art, collections or debates in social forums. For she is the most famous and iconic superheroine. She inspires great devotion in her fandom, itself filled with women, members of the LGBT community and marginalized groups. Her representation and the paradoxes between her perfection and her monstrosity, her humanity and her deity, her public and private personas demonstrate why the character has remained so elusive.

Appendix: Main Story Arcs and Body Themes in Comics

Title	Volume	Dates and Issue Numbers	Writer	Artists	Story Arc	Body Themes
All-Star Comics		December 1941, 8–	William Marston	Harry G. Peter	Secretary and member of Justice Society of America. This is an anthology of superhero stories held together by the JSA.	
Sensation Comics		January 1942, 1–	William Marston	Harry G. Peter	Star feature of the issue.	Chapter 1
Wonder Woman	1	Summer 1942, 1–	William Marston, Joye Murchison, Robert Kanigher	Harry G. Peter		Chapter 1
Wonder Woman	1		Robert Kanigher	Harry G. Peter	Gradual softening of William Marston's feminist message. See Sandifer and Hanley for the subtleties of the changing ideological agenda in the comics.	Romance
Wonder Woman	1	1958–1968 98–177	Robert Kanigher	Ross Andru and Mike Esposito, Vince Colletta	Imaginary stories featuring the Wonder Family on Paradise Island, romance, spies.	Chapter 2
The Brave and the Bold		63	Bob Haney	Michael Rosenberger	Revolt of the Super Chicks!	Romance imagery, idealized images of women

Wonder Woman	1	1968–1972 178–99	Dennis O'Neil, Mike Sekowsky, Samuel Delany, Robert Kanigher	Mike Sekowsky, Don Heck, Dick Giordano	The I-Ching/white costume era.	Chapter 3
Wonder Woman	1	1974–75 215–16	Robert Kanigher	Don Heck, Michael Rosenberger	Return of powers, introduction of Nubia Wonder Woman's twin sister, a warrior of colour raised by Mars to attack the Amazons.	Race and ethnicity
Wonder Woman	1	1975–77	Martin Pasko	Various	12 Labors of Wonder Woman – Having renounced her powers Wonder Woman quit the Justice League of America. In this story arc she is tested twelve times by members before she is readmitted.	Testing the body
Wonder Woman	1	August 2006, 600–July 2010, 614	Joseph Michael Straczynski	Don Kramer	Alternative universe storyline, Diana forgets her Amazon origins and is hunted down by the Morrigan. Controversial costume change by Jim Lee.	Costume
Wonder Woman	2	February 1987, 1–62	Len Wein, George Pérez	George Pérez, Chris Marrinan	Wonder Woman is reimagined as ambassador for Themyscira. She comes to man's world as the innocent abroad and is publicized by Myndi Mayer's promotion company.	Chapter 4

Title	Volume	Dates and Issue Numbers	Writer	Artists	Story Arc	Body Themes
War of the Gods		September–December 1991, 1–4	George Pérez	George Pérez et al.	Crossover – The Amazons are blamed for a series of murders. Different Gods worldwide begin to wage war with each other. Wonder Woman is returned to clay and dies. The villain Circe is revealed as the manipulator.	Birth, death, war, disappearing bodies
Wonder Woman	1 & 2	1985, 326–28; 1989–1990, 36–46, 49	Mindy Newell	Jill Thompson, Romeo Tanghal	Worked with Pérez on issues such as 'Chalk Drawings'.	Suicide, see Chapter 4
Wonder Woman	2	June 1992–July 1995 0, 63–100	William Messner-Loebs	Chris Marrinan, Mike Deodato Jnr,	Introduction of the Bana-Migdhall and Artemis. A split in the Amazon race and early intimations of Hippolyta's duplicitous nature.	Chapter 4
Wonder Woman	2	September 1995, 101–August 1998, 136	John Byrne	John Byrne,	Hippolyta becomes Wonder Woman in the 1940s. Wonder Woman becomes the Goddess of Truth. Introduction of the New Gods into the Wonder Woman continuity.	Mother/daughter rivalry, goddess body

Elseworlds: Kingdom Come		1996	Mark Waid, Alex Ross	Alex Ross	The morality of vigilantism is questioned when a new generation of superheroes, sometimes the children of the older generation, enact their own forms of justice.	Intergenerational relationships, the morality and responsibility of the superhero
Wonder Woman	3	January, 2001, 164– April, 2001, 167, July, 2001, 170 2002, 188	Phil Jiminez	Various	Introduced Trevor Barnes as love interest, explored sex and warrior women.	Race, Sexual ritual
Wonder Woman	3	October 2003, 195– April, 2006, 226	Greg Rucka	Various	Killing Maxwell Lord, imprisonment and retribution – intertwined with *Amazons Attack!* story arc (see below).	See Chapter 5
Wonder Woman	3	August– November 2006, 1–4 also published as 'Who is Wonder Woman?'	Allan Heinberg	Terry and Rachel Dodson	Diana goes missing and her place is taken by Donna Troy. When Diana returns she disguises herself as Diana Prince of the Department of Metahuman Affairs.	Intertextual reference to the white suit era. Career women. Romance.
Amazons Attack!	3	June– December2007, 1–6	Will Pfeifer	Pete Woods	Amazons attack America. They are manipulated by Circe and also Darkseid. Diana is forced to take sides.	Chapter 5

Title	Volume	Dates and Issue Numbers	Writer	Artists	Story Arc	Body Themes
Wonder Woman	3	December 2006– August, 2007, 6–10 also published as 'Love and Murder'	Jodi Picoult	Terry and Rachel Dodson	Wonder Woman disguises herself as Diana Prince of the Department of Metahuman Affairs.	Intertextual references to the white suit and focus on Diana Prince as agent.
Wonder Woman	3	September– November 2007, 11–13 'Hubris'	Joseph Torres	Terry and Rachel Dodson	Diana and her love interest Nemesis have to find her boss Sarge Steel who is being manipulated by Doctor Psycho. This is part of the *Amazons Attack!* story arc.	Romance, contagion/ chemical warfare, betrayal
Wonder Woman	3	January 2008–July 2010, 14–44. These story arcs also published as 'The Circle', 'Ends of the Earth', 'Rise of the Olympian', 'Warkiller', 'Contagion',	Gail Simone	Aaron Lopresti, Bernard Chang	The main stories in this run include the Olympian, Achilles, the Warkiller, created by Zeus to rival the Amazons, these stories incorporate Wonder Woman having to battle male opponents intent on taking her title or attacking her home.	Testing, male/ female conflict, invasion

Title		Date	Writer	Artist	Summary	Themes
Elseworlds: Wonder Woman, Amazonia		1997	William Messner-Loebs	Phil Winslade	The story is set in 1888 with Jack the Ripper on the English throne. Diana is abducted from Paradise Island and forcibly married to Steve Trevor. In the early twentieth century she stars in the theatre and stages a coup to overthrow King Jack.	Entertainment, alternative reality
Wonder Woman	4	2011–2014, 1–35	Brian Azzarello	Cliff Chiang, Dan Green	The clay parthenogenesis birth discarded in favour of Diana as the illegitimate daughter of Zeus and Hippolyta. She becomes the God of War, charged with saving another of Zeus's children from Hera's wrath.	Violence, birth, family, the heroine's journey (Chapter 6)
Superman/ Wonder Woman	4	October, 2013–16, 1–29	Charles Soule	Tony Daniel	Superman and Wonder Woman as the power couple in the DC universe.	Said to be targeting the *Twilight* audience, how two characters with similar powers explore each other's backgrounds and approaches to life.

Title	Volume	Dates and Issue Numbers	Writer	Artists	Story Arc	Body Themes
Wonder Woman	4	November, 2014–2016, 35–42, 44–46, 48–50	Meredith Finch	David Finch	New controversial costume. This story arc is set in mythological fantasy world of the Amazons. Wonder Woman is queen of the Amazons. Gods play games with mortals, reinvention of Donna Troy as villain and pretender to the Amazon throne.	Conflicting roles of women's lives, reconciling violence as God of War with love for humanity
Smallville: Season 11		2013, 16-19	Bryan Q. Miller	Jorge Jiminez	Story arc 'Olympus' features Princess Diana before she became Wonder Woman.	Visual quotes of the white suit referencing her role in the Department of Metahuman Affairs and white suit era before Diana adopts her traditional battle armour.

Title		Year	Writer	Artist	Description	Themes
Rebirth: Wonder Woman	5	2016–17	Greg Rucka	Matthew Clark, Liam Sharp, Jeremy Colwell, Sean Parsons, Laura Martin	These stories are told alternately bi-monthly and they are published twice a month. They tell of Wonder Woman's entrance to man's world and her mission to redeem through love. They also introduce origins of villains such as Veronica Cale, Cheetah and Silver Swan.	Truth, the gods, genetics, evil and Themyscira
Wonder Woman: Heart of the Amazon	5	2017	Shea Fontana	Mirka Andolfo, David Messina	Stories featuring disease and hereditary conditions where individuals attempt to discover cures but turn into monsters.	Genetics, disease, ethic of genetic research
Wonder Woman: Children of the Gods; Swan's Song	5	2017–18	James Robinson	Emanuela Lupacchino, Carlo Pagulayan, Carmen Carnero	Introduces Jason, Wonder Woman's twin.	Family relationships, the immortal body

Notes

Introduction: Wonder Woman and the Body in Popular Culture

1 Hadley Freeman, 'James Cameron: "The downside of being attracted to independent women is that they don't need you"', *Guardian*, 24 August 2017. Available at https://www.theguardian.com/film/2017/aug/24/james-cameron-well-never-be-able-to-reproduce-the-shock-of-terminator-2 (accessed 17 January 2018).

2 Concerned United Nations staff members, 'Petition: Wonder Woman shouldn't be the UN's Honorary Ambassador for the Empowerment of Women and Girls', *Care2 Petitions*, 2016. Available at http://www.thepetitionsite.com/en-gb/741/288/432/reconsider-the-choice-of-honorary-ambassador-for-the-empowerment-of-women-and-girls/ (accessed 17 January 2018).

3 Ibid.

4 Patty Jenkins, @PattyJenks, Twitter, 24 August 2017. Available at https://twitter.com/PattyJenks?ref_src=twsrc%5Etfw&ref_url=https%3A%2F%2Fwww.vox.com%2Fculture%2F2017%2F8%2F25%2F16201518%2Fwonder-woman-james-cameron-patty-jenkins (accessed 27 August 2017).

5 Carolyn Cocca, *Superwomen: Gender, Power, and Representation* (New York: Bloomsbury, 2016), p. 3.

6 Tony Bennett, 'The Bond phenomenon: theorising a popular hero', *Southern Review* 16/2 (1983), pp. 195–225.

7 Andrew R. Spieldenner, 'Altered egos: gay men reading across gender difference in *Wonder Woman*', *Journal of Graphic Novels and Comics* 4/2 (2013), pp. 235–44.

8 Jeffrey A. Brown, *Dangerous Curves: Action Heroines, Gender, Fetishism and Popular Culture* (Jackson, MS: University of Mississippi Press, 2011), p. 235.

9 Many critiques are founded on feminist writings about the sexualization of the female body in superhero comics including Trina Robbins, *The Great*

Women Superheroes (Northampton, MA: Kitchen Sink Press, 1996); Cocca, *Superwomen*; Brown, *Dangerous Curves*.

10 Mitra C. Emad, 'Reading Wonder Woman's body: mythologies of gender and nation', *Journal of Popular Culture* 39/6 (2006), pp. 954–84; Benedict R. O'G. Anderson, *Imagined Communities: Reflections on the Origin and Spread of Nationalism* (London: Verso, 1991).

11 Dawn Heinecken, *The Warrior Women of Television: A Feminist Cultural Analysis of the New Female Body in Popular Media* (New York: Peter Lang, 2003).

12 Joan Ormrod, 'Body issues in Wonder Woman 90–100 (1994–1995): good girls, bad girls and macho men', in Elyce Rae Helford, Shiloh Carroll, Sarah Gray and Michael R. Howard (eds), *The Woman Fantastic in Contemporary American Media Culture* (Jackson, MS: University of Mississippi Press, 2016), pp. 159–76.

13 Heinecken, *The Warrior Women of Television*; Jennifer Stuller, 'Love will bring you to your gift', in Charles Hatfield, Jeet Heer and Kent Worcestor (eds), *The Superhero Reader* (Jackson, MS: University Press of Mississippi, 2013), pp. 216–36.

14 Ibid., p. 3.

15 Stuller, 'Love will bring you to your gift'. This notion was brought to my attention by a paper of Peter Coogan in the Wonder Woman Symposium, Cleveland, OH, 22–24 September 2016.

16 William Moulton Marston wrote under the pen name Charles Moulton, taking the middle name of his publisher, Maxwell Charles Gaines, and his own middle name. To avoid confusion, I refer to him as William Marston throughout.

17 Judith Butler, *Gender Trouble* (New York: Routledge, 1999).

18 Sarah Thornton, *Club Cultures: Music, Media and Subcultural Capital* (Cambridge: Polity Press, 1995); Patty Jenkins (dir.), *Wonder Woman* (Warner Brothers, USA, 2017).

19 Bradford W. Wright, *Comic Book Nation: The Transformation of Youth Culture in America* (Baltimore, MD: Johns Hopkins University Press, 2001); David Hajdu, *'The Ten-Cent Plague': The Great Comic-Book Scare and How it Changed America* (New York: Picador, 2009); Cocca, *Superwomen*.

20 Ibid.; Robbins, *The Great Women Superheroes*.

21 Jean-Paul Gabilliet, *Of Comics and Men: A Cultural History of Comic Books*, trans. Bart Beaty, and Nick Nguyen (Jackson, MS: University of

Mississippi Press, 2010); Noah Berlatsky, *Wonder Woman: Bondage and Feminism in the Marston/Peter Comics, 1941–1948* (New Brunswick, NJ: Rutgers University Press, 2015), p. 10; Cocca, *Superwomen*, pp. 28–9.

22 *All-Star Comics* 8, December 1941; *Wonder Woman* 1 Summer Issue 1942.

23 The spelling of Hippolyta's name varies in some iterations. Pérez calls her Hippolyte. For simplicity, I use Hippolyta throughout.

24 William Moulton Marston and Harry G. Peter (illus.), *Sensation Comics* 1/1 (January 1942), p. 3A. There were five stories in a *Wonder Woman* comic. The pages in these early comics are numbered according to the story. The first story pages would be appended with 'A', the second story pages, 'B', and so forth.

25 Ibid., p. 5A.

26 Ibid.

27 Marston tends to treat Greek and Roman gods as interchangeable. Initially, he cites the God of War as Ares, thereafter as Mars. Diana is the Roman goddess, Artemis her Greek equivalent.

28 William Moulton Marston and Harry G. Peter (illus.), *Wonder Woman* 1/1 (1942), p. 6A.

29 Nicola Love, 'Grant Morrison interview: "Wonder Woman story has more to it than Batman"', *Edinburgh Festivals Blog*, 28 August 2013. Available at http://www.edinburgh-festivals.com/blog/2013/08/28/grant-morrison-interview/ (accessed 12 January 2014).

30 Molly Rhodes, 'Wonder Woman and her disciplinary powers: the queer intersection of scientific authority and mass culture', in Roddey Reid and Sharon Traweek (eds), *Doing Science + Culture: How Cultural and Interdisciplinary Studies are Changing the Way we Look at Science and Medicine* (London: Routledge, 2000), pp. 95–118, p. 96.

31 This is discussed more fully in the next chapter.

32 This was started by Max Gaines in *Famous Funnies* (July 1934–July 1955, bi-monthly 1933).

33 Jerry Siegel and Joe Shuster, 'Superman', *Action Comics* 1/1 (June 1938).

34 Richard Reynolds, *Super Heroes* (Jackson, MS: University of Mississippi Press, 1994), pp. 12–17.

35 Tim Hanley, *Wonder Woman Unbound: The Curious History of the World's Most Famous Heroine* (Chicago, IL: Chicago Review Press, 2014), pp. 7–10.

36 Here I refer to Richard Slotkin, *Gunfighter Nation: The Myth of the Frontier in Twentieth-Century America* (New York: Atheneum, 1992), *Regeneration*

through Violence: The Mythology of the American Frontier, 1600–1860
(Middletown, CN: Wesleyan University Press, 1973) and *The Fatal
Environment: The Myth of the Frontier in the Age of Industrialization, 1800–
1890* (New York: Atheneum, 1985). Slotkin's analysis of dime novels and early
American literature about the frontier proposes that the archetypal American
hero is founded on the principle of the frontier myth, a myth in which the
hero uses violence to clean up a corrupt society. This idea was adapted by John
Shelton Lawrence and Robert Jewett, *The Myth of the American Superhero*
(Grand Rapids, MI: W.B. Eerdmans, 2002), to apply to superheroes.

37 For more information on Marston's lifestyle see Les Daniels and Chip
Kidd, *Wonder Woman* (San Francisco, CA: Chronicle Books, 2000);
Berlatsky, *Wonder Woman*; Hanley, *Wonder Woman Unbound*; Philip
Sandifer, *A Golden Thread: An Unofficial History of Wonder Woman*
(Danbury, CT: Eruditorum Press, 2013); Jill Lepore, *The Secret History of
Wonder Woman* (Brunswick, NJ: Scribe Publications, 2014). In the case of
Lepore it is worth noting that the Marston family dispute some of the
research in her book. In an article with Lepore for *Newsarama*, Christie
Marston makes extended critiques of Lepore's research in comments on
12 October 2014 (Zack Smith, 'Jill Lepore Reveals THE SECRET
HISTORY OF WONDER WOMAN', *Newsarama*, 28 October 2014.
Available at https://www.newsarama.com/22568-jill-lepore-reveals-the-
secret-history-of-wonder-woman.html (accessed 15 August 2017)).

38 Geoffrey C. Bunn, 'The lie detector, Wonder Woman and liberty: the life
and work of William Moulton Marston', *History of the Human Sciences*
10/1 (1997), pp. 91–119, takes the concept of the cultural amphibian from
Roger Cooter and Stephen Pumfrey. 'Separate spheres and public places:
reflections on the history of science popularization and science in popular
culture', *History of Science* 32/97 (1994), pp. 237–67, p. 251.

39 Hanley, *Wonder Woman Unbound*; Sandifer, *A Golden Thread*; Berlatsky,
Wonder Woman; Rhodes, 'Wonder Woman and her disciplinary powers'.

40 Ibid., p. 97. The notion of queer is addressed below.

41 Ibid. For more information on Marston's popular output see also Sandifer,
A Golden Thread; Hanley, *Wonder Woman Unbound*.

42 William Moulton Marston, C.D. King and Elizabeth Holloway Marston,
Integrative Psychology: A Study in Unit Response (New York: Harcourt,
Brace, 1931).

43 Marston and Peter, *Wonder Woman* 1/1. Marston did not entitle his stories so I quote the issue number.

44 Cocca, *Superwomen*.

45 Noah Berlatsky, writing on *Wonder Woman*, goes into great depth on how the stories were produced and how Murchison replicated Marston's values. Though they disapprove of Kanigher's writing, it is worth checking Hanley, *Wonder Woman Unbound* and Sandifer, *A Golden Thread* for the overlap in writing duties and Kanigher's storytelling practices.

46 Fredric Wertham, *Seduction of the Innocent* (London: Museum Press, 1955), p. 34.

47 For a full discussion of the effects of the CCA regulations see Hajdu, '*The Ten-Cent Plague*'; Wright, *Comic Book Nation*.

48 The effects of the CCA are explored in more depth in Chapter 2.

49 Ibid.

50 Despite the objection of feminists, the comics of this brief story arc are quoted in later storylines and have a strong fan following. For instance, in Gail Simone's run (Gail Simone, Terry Dodson (illus.) and Bernard Chang (illus.), 'The Circle', *Wonder Woman* 3/14–17 (January–April 2008); Gail Simone, Aaron Lopresti (illus.) and Bernard Chang (illus.), 'Ends of the earth', *Wonder Woman* 3/20–23 (July–October 2008); Gail Simone, Terry Dodson (illus.) and Bernard Chang (illus.), 'Rise of the Olympian', *Wonder Woman* 3/26–33 (January–August 2009); Gail Simone, Aaron Lopresti (illus.) and Matt Ryan (illus.), 'Warkiller', *Wonder Woman* 3/36–9 (November 2009–February 2010); Gail Simone, Nicola Scott (illus.), Fernando Dagnino (illus.), Aaron Lopresti (illus.), Matt Ryan (illus.) and Doug Hazelwood (illus.), *Wonder Woman: Contagion* (New York: DC Comics, 2010), Wonder Woman adopts her secret identity as secret agent Diana Prince, and she is portrayed in a white outfit. *Trinity* (Matt Wagner, *Batman/Superman/Wonder Woman – Trinity* (New York: DC Comics, 2008) also features the character in a white suit. A series in 2011, entitled *Retroactive Wonder Woman*, featured Diana Prince in the white outfit on the front cover and a story set in this era. Finally, Cathy Lee Crosby's portrayal of Wonder Woman in the first full television film of the character in 1974 was based upon a spy with no powers. For a more comprehensive account of Wonder Woman's costumes see Carol A. Strickland's webpage, 'A brief history of the Wondie suit!', *Carol A Strickland*, n.d. Available at

http://www.carolastrickland.com/comics/wwcentral/costume_indices/ wwcost1.html (accessed 25 July 2017).

51 Spieldenner, 'Altered egos'.

52 Marc Andreyko, Jeff Parker and David Hahn (illus.), *Batman '66 Meets Wonder Woman '77* (Mt Laurel, NJ: DC Comics, 2017); Andy Mangels and Judy Tondora (illus.), *Wonder Woman '77 Meets The Bionic Woman* (Mt Laurel, NJ: Dynamite, 2017. Nicola Scott and Phil Jimenez also produced the front and variant covers of *Wonder Woman '66*.

53 Susan Faludi, *Backlash: The Undeclared War against American Women* (New York: Crown, 1991).

54 Frank Miller, *The Dark Knight Returns*; Alan Moore and Dave Gibbons (illus.), *Watchmen*.

55 Wright, *Comic Book Nation*; Cocca, *Superwomen*; Will Brooker, *Batman Unmasked: Analysing a Cultural Icon* (London: Continuum, 2000).

56 Richard Beland, 'Girls read comics', *Jungle Frolics*, 19 March 2011. Available at http://junglefrolics.blogspot.co.uk/2011/03/girls-read-comics. html?fref=gc (accessed 22 August 2017). Beland reports that the statistics did not cover daily newspaper cartoons or Sunday funnies.

57 Cocca, *Superwomen*, pp. 10–13, provides a thorough analysis of the effects of distribution, fandom and creators on masculinizing the comics industry.

58 Robbins, *The Great Women Superheroes*.

59 This observation is from personal experience of travelling across the UK in the 1980s.

60 Ibid., p. 11; Carolyn Cocca, 'The "Broke Back test"': a quantitative and qualitative analysis of portrayals of women in mainstream superhero comics, 1993–2013', *Journal of Graphic Novels and Comics* 5/4 (2014), pp. 411–28; Jeffrey A. Brown, 'Gender, sexuality, and toughness: the bad girls of action film and comic books', in Sherrie Innes (ed.), *Action Chicks: New Images of Tough Women in Popular Culture* (London: Palgrave Macmillan, 2015), pp. 47–74; Ormrod, 'Body issues in Wonder Woman 90–100'. Despite the focus on masculine interests, there was a solid core of female fans for superheroes as shown in Mel Gibson, '"You can't read them, they're for boys!" British girls, American superhero comics and identity', *International Journal of Comic Art* 5/1 (2003), pp. 239–49.

61 The comics in this story arc are analysed in Ormrod, 'Body issues in Wonder Woman 90–100'.

62 The Appendix lays out the main storylines from this era to frame analyses in Chapters 5, 6 and 7. It also compiles a list of the main themes underpinning these stories.

63 Grant Morrison and Yanick Paquette, *Wonder Woman: Earth One* (Burbank, CA: DC Comics, 2016); Jill Thomson, *Wonder Woman: The True Amazon* (Burbank, CA: DC Comics, 2016).

64 Jay Oliva and Michael Chang (dirs), *Young Justice* (USA: Warner Bros. Television Distribution, 2010); Joaquim dos Santos and Dan Riba (dirs), *Justice League Unlimited* (USA: Warner Bros. Television Distribution, 2004–6); Momcilo 'Butch' Lukic and Paul Dini (dirs), *Justice League* (USA: Cartoon Network, Warner Bros., 2001–4). For a complete list of films in the DC Extended Universe, refer to the DC Universe Animated Original Movies at https://en.wikipedia.org/wiki/DC_Universe_Animated_Original_Movies. A discussion of feminism in animated stories of Wonder Woman can be found in Cocca, *Superwomen*, pp. 45–8. An interesting analysis of superheroes and foreign policy can be found in Kevin D. Williams, '(R)Evolution of the television superhero: comparing Superfriends and Justice League in terms of foreign relations', *Journal of Popular Culture* 44/6 (2011), pp. 1333–52.

65 *Princessions* can be found online at https://fanlore.org/wiki/Princessions.

66 Slotkin, *Regeneration through Violence*, *Gunfighter Nation* and *The Fatal Environment*.

67 Slotkin, *Regeneration through Violence*, p. 19.

68 Ibid., p. 17.

69 Cocca, *Superwomen*.

70 Peter Coogan, *Superhero: The Secret Origin of a Genre* (Austin, TX: Monkey Brain Books, 2006), p. 33.

71 Barbara Brownie and Danny Graydon, *The Superhero Costume: Identity and Disguise in Fact and Fiction* (London: Bloomsbury, 2016).

72 Scott Bukatman, 'Secret identity politics', in Angela Ndalianis (ed.), *The Contemporary Comic Book Superhero* (Abingdon: Routledge, 2009), pp. 109–25, p. 114.

73 Marston William Moulton and Harry G. Peter, *Sensation Comics* 1/6 (June 1942), p. 13.

74 Although it is not a lie detector, it forces those bound to tell the truth. The lie detector only indicates when someone is telling a lie.

75 Reynolds, *Super Heroes*, p. 34.

76 Claire Pitkethly, 'Recruiting an Amazon: the collision of old world ideology and new world identity in *Wonder Woman*', in Angela Ndalianis (ed.), *The Contemporary Comic Book Hero* (New York: Routledge, 2009), pp. 164–83, p. 164.

77 Page DuBois, *Centaurs and Amazons: Women and the Pre-History of the Great Chain of Being* (Ann Arbor, MI: University of Michigan Press, 1991).

78 Lepore, *The Secret History of Wonder Woman*; Gillmore, *Angel Island*; Eastman, *Child of the Amazons*. Lepore reports how these two pieces of literature may have influenced the creation of *Wonder Woman* (pp. 86–7). Eastman's first poem is about an Amazon child who wishes to marry a man, against the Amazon code. Gillmore's novel is about five American men shipwrecked on an island inhabited by Amazons.

79 In describing the Amazons as an 'absent presence', I borrow from Chris Shilling's description of the body in social sciences debate which, despite its absence from scholarly debate, yet is, 'at the very heart of the sociological imagination' (Chris Shilling, *The Body and Social Theory* (London: Sage, 2003), p. 7). This is discussed in more detail below.

80 Victor W. Turner (Victor Witter) and Edith L.B. Turner, *Image and Pilgrimage in Christian Culture: Anthropological Perspectives* (New York: Columbia University Press, 1978).

81 Adrienne Mayor, *The Amazons: Lives and Legends of Warrior Women Across the Ancient World* (Princeton, NJ: Princeton University Press, 2014); William Blake Tyrrell, *Amazons: A Study in Athenian Mythmaking* (Baltimore, MD: Johns Hopkins University Press, 1984); DuBois, *Centaurs and Amazons*.

82 Matthew J. Smith, 'The tyranny of the melting pot metaphor: Wonder Woman as the Americanized immigrant', in Matthew P. McAllister, Edward H. Sewell Jr and Ian Gordon (eds), *Comics and Ideology* (New York: Peter Lang, 2001), pp. 129–50.

83 Sandifer, *A Golden Thread*.

84 Brown, *Dangerous Curves*, p. 25.

85 Cocca, *Superwomen*.

86 Matt Santori, 'Exclusive interview: Greg Rucka on queer narrative and Wonder Woman', *Comicosity*, 28 September 2016. Available at http://www.comicosity.com/exclusive-interview-greg-rucka-on-queer-narrative-and-wonder-woman/ (accessed 19 April 2017).

87 Donna B. Knaff, 'A most thrilling struggle: Wonder Woman as wartime and post-war feminist', in Joseph J. Darowski (ed.), *The Ages of Wonder Woman: Essays on the Amazon Princess in Changing Times* (Jefferson, NC: McFarland and Co, 2014), pp. 22–9; Lori Landay, *Madcaps, Screwballs, and Con Women: The Female Trickster in American Culture* (Philadelphia, PA: University of Pennsylvania Press, 1998).

88 Ibid.

89 See Chapter 4.

90 Indeed, there is a film, *Professor Marston and the Wonder Women* (2017), produced about his life.

91 Berlatsky, *Wonder Woman*.

92 Ibid., p. 191.

93 Robinson, *Wonder Women*.

94 Robbins, *The Great Women Superheroes*.

95 Berlatsky, *Wonder Woman*.

96 Ibid., p. 5.

97 Bunn, 'The lie detector'.

98 Cocca, *Superwomen*; Hanley, *Wonder Woman Unbound*; Sandifer, *A Golden Thread*.

99 Now identified as Elizabeth Sandifer.

100 Cocca, *Superwomen*.

101 Michelle R. Finn, 'William Marston's feminist agenda', in Darowski (ed.), *The Ages of Wonder Woman*, pp. 7–21; Jason, 'What a woman wonders: this is feminism?', ibid., pp. 79–89; Ruth McClelland-Nugent, '"Steve Trevor, equal?" Wonder Woman in an era of second-wave feminist critique', ibid., pp. 136–50; David R. Hammontree, 'Backlash and bracelets: the patriarch's world, 1986–1992', ibid., pp. 163–73.

102 Finn, 'William Marston's feminist agenda'; Alison Mandaville, 'Out of the refrigerator: Gail Simone's Wonder Woman, 2008–2010', in Darowski (ed.), *The Ages of Wonder Woman*, pp. 205–22.

103 Knaff, 'A most thrilling struggle'; Lori Maguire, 'Wonder Woman comic books and military technology', in Darowski (ed.), *The Ages of Wonder Woman*, pp. 42–51; Joan Ormrod, 'Cold War fantasies: testing the limits of the familial body', ibid., pp. 52–65; Fernando Gabriel Pagnoni Berns, 'War, foreign policy and the media: The Rucka years', ibid., pp. 194–204.

104 Matthew J. Smith, 'Working girl: Diana Prince and the crisis of career moves', in Joseph J. Darowski (ed.), *The Ages of Wonder Woman: Essays on*

the Amazon Princess in Changing Times (Jefferson, NC: McFarland and
Co., 2014), pp. 151–62; Francine Valcour, 'Retiring romance: the
superheroine's transformation in the 1960s', ibid., pp. 66–78; Jeffrey K.
Johnson, 'Super-wonder: the Man of Steel and the Amazonian princess as
the ultimate 1990s power couple', ibid., pp. 184–93.

105 Craig This, 'Containing Wonder Woman: Fredric Wertham's battle against
the mighty Amazon', in Joseph J. Darowski (ed.), *The Ages of Wonder
Woman: Essays on the Amazon Princess in Changing Times* (Jefferson, NC:
McFarland and Co., 2014), pp. 30–41.

106 Joseph J. Darowski, '"I no longer deserve to belong": the Justice League,
Wonder Woman and the twelve labors', in Darowski (ed.), *The Ages of Wonder
Woman*, pp. 126–35; Joseph J. Darowski and Virginia Rush, 'Greek, Roman or
American? Wonder Woman's roots in DC's New 52', ibid., pp. 223–32.

107 Richard J. Stevens, *Captain America: Masculinity, and Violence* (Syracuse,
NY: Syracuse University Press, 2015).

108 Lawrence and Jewett, *The Myth of the American Superhero*.

109 The original meaning refers to the harmony of mind and body in war and
it applies to men. However, later definitions, for instance, by Plato in *The
Republic*, did not assign this to one gender.

110 Cocca, *Superwomen*, p. 28.

111 Pitkethly, 'Recruiting an Amazon'.

112 Smith, 'The tyranny of the melting pot metaphor'.

113 This is dealt with in more depth in Chapter 4.

114 See above.

115 Mike Madrid, *The Supergirls: Fashion, Feminism, Fantasy, and the History
of Comic Book Heroines* (Minneapolis, MN: Exterminating Angel Press,
2009).

116 Brooker, *Batman Unmasked*.

117 The Original Wonder Woman Club Facebook page asserts: 'For Fans of
The Original Wonder Woman Created by Charles Marston and portrayed
by Lynda Carter, . . . Not for fans of the medieval Gal Gadot version or any
interpretation of what DC has done with her today . . . This Group is
totally Dedicated to the one and only Classic Red White & Blue Original
Wonder Woman. Which Means Pre 52 series Rebirth or any multiverse
interpretations. Any and all post of the Gladiator Xena type imagery are
deleted immediately and the user is dismissed without warning' (https://
www.facebook.com/groups/1798016217093542/).

118 Bryan S. Turner, 'Body', *Theory, Culture and Society* 23/2–3 (2006), pp. 223–9, p. 1.

119 Shilling, *The Body and Social Theory*.

120 Ibid.; Joanne Entwistle, *The Fashioned Body: Fashion, Dress and Modern Social Theory* (Cambridge: Polity Press, 2000); Turner, 'Body'.

121 Drew Leder, *The Absent Body* (Chicago, IL: University of Chicago Press, 1990), p. 3.

122 Judith Butler, 'Gender insubordination', in Diana Fuss (ed.), *Inside/Out: Lesbian Theories, Gay Theories* (London: Routledge, 1991), pp. 13–32.

123 Anne Marie Balsamo, *Technologies of the Gendered Body* (Durham NC: Duke University Press, 1996), p. 3.

124 Michel Foucault, *Discipline and Punish: The Birth of the Prison*, trans. Alan Sheridan (New York: Pantheon Books, 1977).

125 Michel Foucault, *The Foucault Reader*, ed. Paul Rabinow (New York: Pantheon Books, 1984), p. 180.

126 Pierre Bourdieu *Distinction: A Social Critique of the Judgment of Taste*, trans. Richard Nice (London: Routledge, 1986); Susan Bordo, *Unbearable Weight: Feminism, Western Culture, and the Body* (Berkeley, CA: University of California Press, 1993); Mike Featherstone, 'The body in consumer culture', *Theory, Culture and Society* 1/2 (1982), pp. 18–33; Erving Goffman, *The Presentation of Self in Everyday Life* (Garden City, NY: Doubleday, 1959).

127 Maurice Merleau-Ponty, *Phenomenology of Perception*, trans. Colin Smith (London: Routledge & Kegan Paul, 1962); Henri Bergson, *Matter and Memory*, trans. Nancy M. Paul and W. Scott Palmer (London: George Allen and Unwin, 1911); Gilles Deleuze and Felix Guattari, *A Thousand Plateaus: Capitalism and Schizophrenia*, trans. Brian Massumi (Minneapolis, MN: University of Minnesota, 1987).

128 Maxine Sheets-Johnstone, *The Phenomenology of Dance* (Philadelphia, PA: Temple University Press, 2015) and 'On movement and objects in motion: the phenomenology of the visible in dance', *Journal of Aesthetic Education* 13.2 (1979), pp. 33–46.

129 Merleau-Ponty, *Phenomenology of Perception*.

130 This is a broad generalization as genre is a fluid concept and science fiction/horror frequently cross over, as in Ridley Scott's *Alien*.

131 Caroline A. Jones and Bill Arning, *Sensorium: Embodied Experience, Technology, and Contemporary Art* (Cambridge, MA: MIT, 2006); Donna

Haraway, 'A cyborg manifesto: science, technology, and socialist-feminism in the late twentieth century', in her *Simians, Cyborgs and Women: The Reinvention of Nature* (New York: Routledge, 1991), pp. 149–81; Mark Oelhart, 'From Captain America to Wolverine: cyborgs in comic books: alternative images of cybernetic heroes and villains', in Barbara M. Kennedy and David Bell (eds), *The Cybercultures Reader* (London: Routledge, 2000), pp. 112–23; Brian Massumi, *Parables for the Virtual* (Durham, NC: Duke University Press, 2002).

132 Angela Ndalianis, 'Horror aesthetics and the sensorium', in Angela Ndalianis (ed.), *The Horror Sensorium: Media and the Senses* (Jefferson, NC: McFarland and Co., 2012), pp. 15–39.

133 Mikhail M. Bakhtin, *Rabelais and his World* (Cambridge, MA: MIT Press, 1968).

134 Ibid.

135 Catherine Hakim, *Honey Money* (London: Allen Lane, 2011), p. 2.

136 Shilling, *The Body and Social Theory*, p. 10.

137 Bourdieu, *Distinction*; Bordo, *Unbearable Weight*; Featherstone, 'The body in consumer culture'; Goffman, *The Presentation of Self in Everyday Life*.

138 José Alaniz, *Death, Disability, and the Superhero: The Silver Age and Beyond* (Jackson, MS: University Press of Mississippi, 2014).

139 Brown, *Dangerous Curves*, p. 235.

140 Richard Dyer, *Heavenly Bodies: Film Stars and Society* (Basingstoke: Macmillan, 1986), p. 3.

1 Beautiful White Bodies: Gender, Ethnicity and the Showgirl Body in the Second World War

1 William Moulton Marston and Harry G. Peter (illus.), *Wonder Woman* 1/1 (1942), p. 1A. There were generally five stories in *Wonder Woman* comics of this time. All of them were scripted by Marston and drawn in Peter's studio. Rather than giving the stories titles, they were differentiated by letters so the first story was numbered 1A, 2A, 3A, etc., the second 1B, 2B, 3B, etc.

2 This is noted by one of her more celebrated writers of recent times, Greg Rucka, and is discussed in Chapter 7.

3 Ibid.

4 Greenwald, Maurine Weiner, *Women, War, and Work: The Impact of World War I on Women Workers in the United States* (Westport, CN: Greenwood Press, 1980), p. 125.

5 Geoffrey C. Bunn, 'The lie detector, Wonder Woman and liberty: the life and work of William Moulton Marston', *History of the Human Sciences* 10/1 (1997), pp. 91–119; Noah Berlatsky, *Wonder Woman: Bondage and Feminism in the Marston/Peter Comics, 1941–1948* (New Brunswick, NJ: Rutgers University Press, 2015); Tim Hanley, *Wonder Woman Unbound: The Curious History of the World's Most Famous Heroine* (Chicago, IL: Chicago Review Press, 2014); Philip Sandifer, *A Golden Thread: An Unofficial History of Wonder Woman* (Danbury, CT: Eruditorum Press, 2013); Molly Rhodes, 'Wonder Woman and her disciplinary powers: the queer intersection of scientific authority and mass culture', in Roddey Reid and Sharon Traweek (eds), *Doing Science + Culture: How Cultural and Interdisciplinary Studies are Changing the Way we Look at Science and Medicine* (London: Routledge, 2000), pp. 95–118.

6 *Wonder Woman* 1/10 (1943), p. 2A.

7 William Moulton Marston and Harry G. Peter, *Wonder Woman: The Complete Newspaper Strips 1944–1945* (San Diego, California: D. Mullaney, 2014), p. 73.

8 Catherine Hakim, *Honey Money* (London: Allen Lane, 2011), p. 2.

9 William Moulton Marston, 'Why 100,000,000 Americans read comics', *The American Scholar* 13/1 (1944), pp. 35–44, p. 43.

10 Linda Mizejewski, *Ziegfeld Girl: Image and Icon in Film and Culture* (Durham, NC: Duke University Press, 1999).

11 James Roger Alexander, 'The art of making war: the political poster in global conflict', in M. Paul Holsinger and Mary Anne Schofield (eds), *Visions of War: World War II in Popular Literature and Culture* (Bowling Green, OH: Bowling Green State University Press, 1992), pp. 114–26.

12 Sue Hart, 'Madison Avenue goes to war: patriotism in advertising during World War II', ibid., pp. 114–26.

13 1940. 'She may look clean but.' University of Minnesota Libraries, Social Welfare History Archives. Accessed 5 July 2019. https://umedia.lib.umn.edu/item/p16022coll223:8.

14 1940. 'She may be a bag of trouble / Syphilis and Gonorrhea.' University of Minnesota Libraries, Social Welfare History Archives. Accessed 5 July 2019. https://umedia.lib.umn.edu/item/p16022coll223:16.

15 Taken to its logical extreme, the Nazis used eugenics to enforce their racial purity agenda in concentration camps.

16 Brian E. Hack, 'Weakness is a crime: Captain America and the eugenic ideal in early twentieth-century America', in Robert Weiner (ed.), *Captain America and the Struggle of the Superhero: Critical Essays* (Jefferson, NC: McFarland and Co., 2014), pp. 79–89.

17 Michel Foucault, *The History of Sexuality*, Vol. 1: *An Introduction*, trans. Robert Hurley (New York: Random House, 1978), p. 125.

18 Mizejewski, *Ziegfeld Girl*, p. 119.

19 Nathan Vernon Madison, *Anti-Foreign Imagery in American Pulps and Comic Books, 1920–1960* (Jefferson, NC: McFarland and Co., 2012).

20 Ibid.

21 Unknown, 'Keep this horror from your home', *The United States in World War II: Historical Debates about America at War*, http://oberlinlibstaff.com/omeka_hist244/items/show/231 (accessed 5 July 2019).

22 Mizejewski, *Ziegfeld Girl*.

23 Clinton Stoddard Burr, *America's Race Heritage* (New York: National Historical Society, 1922); Madison Grant, *The Passing of the Great Race: Or, the Racial Basis of European History* (New York: Charles Scribner's Sons, 1916); William Z. Ripley, *The Races of Europe: A Sociological Study* (New York: D. Appleton and Company, 1899).

24 Grant, *The Passing of the Great Race*, p. 167.

25 Office of the Historian, 'Milestones: 1921–1936', The Immigration Act of 1924 (The Johnson–Reed Act), 2015. Available at https://history.state.gov/milestones/1921-1936 (accessed 11 May 2017).

26 Timothy Ashby, 'Alabama's anti-immigration law – xenophobia is also part of American history', p. 13 December 2011. Available at http://timashby.com/50/#more-50 (accessed 27 November 2016).

27 Peter Baofu, *The Future of Post-Human Migration* (Newcastle upon Tyne: Cambridge Scholars Publishing, 2012), p. 200.

28 Matthew J. Smith, 'The tyranny of the melting pot metaphor: Wonder Woman as the Americanized immigrant', in Matthew P. McAllister, Edward H. Sewell Jr and Ian Gordon (eds), *Comics and Ideology* (New York: Peter Lang, 2001), pp. 129–50, p. 131.

29 Brian Fry, *Nativism and Immigration: Regulating the American Dream* (New York: LFB Scholarly Publishing LCC, 2007), p. 5.

30 Marble, 'Wonder Women of History: Florence Nightingale'; Marble, 'Wonder Women of History: Nurse Edith Cavell'; Marble, 'Wonder Women of History: Madame Chiang Kai-Shek'.

31 Marble, 'Wonder Women of History: Madame Chiang Kai-Shek', p. 40.

32 Judy Barrett Litoff and David C. Smith, *We're in This War, Too: World War II Letters from American Women in Uniform* (New York: Oxford University Press, 1994), pp. 29–30.

33 Donna B. Knaff, 'A most thrilling struggle: Wonder Woman as wartime and post-war feminist', in Joseph J. Darowski (ed.), *The Ages of Wonder Woman: Essays on the Amazon Princess in Changing Times* (Jefferson, NC: McFarland and Co., 2014), pp. 22–9.

34 D'Ann Campbell, *Women at War with America* (Cambridge, MA: Harvard University Press, 1984).

35 Susan M. Hartmann, *The Home Front and Beyond* (Boston, MD: Twayne Publishers, 1982).

36 Litoff and Smith, *We're in This War, Too.*

37 Lori Landay, *Madcaps, Screwballs, and Con Women: The Female Trickster in American Culture* (Philadelphia, PA: University of Pennsylvania Press, 1998), p. 149.

38 Honey, *Creating Rosie the Riveter: Class, Gender, and Propaganda During World War II*; Knaff, *Beyond Rosie the Riveter: Women of World War II in American Popular Graphic Art.* The connection between Wonder Woman and Diana Prince was made in the contemporary comics series, *Bombshells*, in which Wonder Woman is depicted as a superhuman Rosie. This is discussed in Chapter 6.

39 Lori Landay, *Madcaps, Screwballs, and Con Women: The Female Trickster in American Culture* (Philadelphia, PA: University of Pennsylvania Press, 1998).

40 Delmer Daves (dir.), *Hollywood Canteen* (USA: Warner Brothers, 1944).

41 H. Bruce Humberstone (dir.), *Pin Up Girl* (USA: 20th Century Fox, 1944).

42 Landay, *Madcaps, Screwballs and Con Women*, pp. 94–154.

43 William Moulton Marston and Harry G. Peter (illus.), *Sensation Comics* 1/2 (February 1942).

44 William Moulton Marston and Harry G. Peter (illus.), *Wonder Woman* 1/5 (1943), p. 2A. See also Michelle R. Finn, 'William Marston's feminist agenda', in Darowski (ed.), *The Ages of Wonder Woman*, pp. 7–21.

45 Ibid., p. 1A.

46 Ibid., p. 6A.

47 Ibid., p. 16A.

48 Marston and Peter, *Sensation Comics* 1/20, p. 2.

49 Litoff and Smith, *We're in This War, Too.*

50 Marston and Peter, *Sensation Comics* 1/20, p. 2.

51 Ibid., p. 4 (emphasis original).

52 Mizejewski, *Ziegfeld Girl.*

53 Ibid., p. 110.

54 Ibid., p. 76.

55 Scott Bukatman, 'Secret Identity Politics', in Angela Ndalianis (ed.), *The Contemporary Comic Book Superhero* (Abingdon: Routledge, 2009), pp. 109–25.

56 Ibid. p. 114.

57 Mizejewski, *Ziegfeld Girl*, pp. 94–5.

58 Ibid.

59 Hedy Lamarr was not only beautiful but a great inventor. She invented Spread Spectrum Technology, a radio guidance system and precursor of wifi. Like Hedy Lamarr, Wonder Woman was also a great inventor. In *Wonder Woman* 1 she invented the purple healing ray, a ray based upon light frequency, to bring Steve Trevor back to life. In *Sensation Comics* 27, 1944, Wonder Woman invented a tablet that increased petrol yield by five times and in doing so solved fuel shortages in the war.

60 Goulding and Gilbert, *Love*; Thalberg, *Flesh and the Devil.*

61 Loos, *Gentlemen Prefer Blondes*; Rosson, *Blonde or Brunette?*

62 Marston, *Emotions of Normal People*, p. 98.

63 Olenina, 'The Doubly Wired Spectator'. See also Bunn, 'The Lie Detector, Wonder Woman and Liberty'; Hanley, *Wonder Woman Unbound*; Sandifer, *A Golden Thread*; Lepore, *The Secret History of Wonder Woman.*

64 Marston, 'Bodily Symptoms of Elementary Emotions', p. 85. Cited in Olenina, 'The Doubly Wired Spectator', p. 42.

65 Mizejewski, *Ziegfeld Girl*, 101–2. Marston and Peter, 'Sensation Comics 1'.

66 Ibid., p. 3.

67 Ibid. Interestingly, there is a parallel comment in the newspaper strips of June 15–17, 1944, a young male newspaper seller states, 'Gee – you're some baby! What're you, a chorus girl getting publicity?' (Marston and Peter, *Wonder Woman*, 23).

68 Marston and Peter (illus.), *Wonder Woman* 1/4 (April/May 1943), p. 8A.

69 Ibid.

70 Stuller, 'Love will bring you to your gift', p. 217.

71 Slotkin, *The Fatal Environment*; Slotkin, *Gunfighter Nation*; Slotkin, *Regeneration through Violence*; Lawrence and Jewett, *The Myth of the American Superhero*. Discussed in the Introduction.

72 Finn, 'William Marston's Feminist Agenda' deals with Wonder Woman as love leader at length as does Berlatsky, *Wonder Woman*, pp. 88–92.

73 Indeed, in a later book, based upon his experiments with Ziegfeld showgirls, Marston promoted the notion of love leaders. He admonished the film industry to 'Make your screen heroines ... conscious of the fact that woman is, and always has been, the love leader in the affairs of the heart. Make them conquer the world, or at least enough of it to give them a good living. Then show how their economic conquest enables the girls to captivate the men of their choice.' Pitkin and Marston, *The Art of Sound Pictures*, p. 161.

74 Marston and Peter, *Wonder Woman*, p. 21.

75 William Marston, letter to Dr Sones, Director of Curriculum Study, Department of Education, University of Pittsburgh, 20 March 1943, Smithsonian.

76 Hanley, *Wonder Woman Unbound*, pp. 45–7.

77 Lepore, *The Secret History of Wonder Woman*, 234.

78 Ibid., pp. 234–5.

79 Hanley, *Wonder Woman Unbound*; Berlatsky, *Wonder Woman*; Lepore, *The Secret History of Wonder Woman*.

80 Ibid., pp. 84–6.

81 Knudde, 'Harry G. Peter'.

82 Marston, 'Why 100,000,000 Americans Read Comics'.

83 Babic, 'Wonder Woman as Patriotic Icon'; Berlatsky, *Wonder Woman*; Finn, 'William Marston's Feminist Agenda'; Hanley, *Wonder Woman Unbound*; Sandifer, *A Golden Thread*.

84 Hanley, *Wonder Woman Unbound*, p. 72.

85 Berlatsky, *Wonder Woman*, p. 13.

86 Marston and Peter, 'Sensation Comics 6', p. 6.

87 Ibid., p. 13.

88 Marston and Peter, 'Sensation Comics 19'.

89 Ibid., p. 10A.

90 Ibid., p. 13A. This story reflects notions of the controlled female body in melodrama. In the film *Now Voyager* (1942), Charlotte Vale, the daughter of an influential Boston family, has a nervous breakdown. The anarchic state of her psyche is replicated in her body, which is uncontrolled, overweight and does not benefit from a good girdle (stated in script directions).

91 Marston, William Moulton (w), and Harry G (a) Peter. 'Wonder Woman 2', p. 11D.

92 Marston, *Emotions of Normal People*, pp. 121–5.

93 Ibid, p. 8A.

94 Marston and Peter, *Wonder Woman 7*, p. 1D

95 Ibid., p. 4D.

96 Ibid., p. 6D.

97 This story is weirdly reminiscent of the 2016 presidential election in which the candidate, Professor Manly, uses fake news and is exposed as a charlatan. Manly also bears a surprising resemblance to Donald Trump.

98 Ibid., 13B. In a newspaper strip 9–11 April 1945, Wonder Woman expresses similar sentiments when she counsels a soldier on his fiancée. 'She could wind me around her finger,' he tells Wonder Woman, who responds: 'And you loved it! ... Men are always happier submitting to a loving girl.' Marston and Peter, *Wonder Woman*, p. 108.

99 Berlatsky, *Wonder Woman*, p. 15.

100 Marston and Peter, *Wonder Woman 6*, p. 4A.

101 Beard, *A Don's Life*, Paragraph 1.

102 Radner, *Shopping Around*, p. 3.

103 J. to C. Moulton [W.M. Marston], 9 September 1943. MSS 1619B, Smithsonian Institution Libraries, Washington, DC 20560.

104 Marston, letter to Max C. Gaines, 15 September 1943. Max Gaines was the co-publisher of All-American Comics who published *Wonder Woman*. All-American Comics was a sister company to Detective Comics. They merged with National Comics Publications in 1944 to form DC Comics. Marston took Max Gaines's middle name and his own middle name for his pseudonym Charles Moulton as the author of *Wonder Woman*.

105 Ibid.

106 Marston and Peter, 'Sensation Comics 9'.

107 Ibid.

108 Ibid., p. 13.

109 Marston, *Emotions of Normal People*, p. 396.

110 Marston and Peter, 'Sensation Comics 11'.

111 Women are given a fishing line and snare men. This also connects with Marston's notion of the vagina as an organ of entrapment, discussed below.

112 Ibid., p. 13.

113 William Moulton Marston and Harry G. Peter (illus.), *Wonder Woman* 1/3 (1943), p. 6C.

114 Ibid., p. 7C.

115 Ibid., p. 8C.

116 Luce Irigaray, 'This sex which is not one' [1977], in Carole R. McCann and Seung-Kyung Kim (eds), *Feminist Theory Reader: Local and Global Perspectives*, 2nd edn (New York: Routledge, 2010), pp. 384–9, p. 384.

117 Marston and Peter, 'Sensation Comics 2', 9.

118 Ibid., p. 10.

119 Marston and Peter, 'Sensation Comics 16'.

120 Ibid., p. 10.

121 Letter, Josette Frank to Sheldon Mayer, 1944. Smithsonian Institution.

122 My italics. Letter from William Marston to Josette Frank, 20 February 1943. Smithsonian Institution.

123 Ibid.

124 The term 'good girl comics' was invented by collectors of good girl art in the 1970s.

125 Sandifer, *A Golden Thread*, p. 56.

126 Berlatsky, *Wonder Woman*.

127 Sandifer, *A Golden Thread*, pp. 54–61.

128 Anon., 'Wonder Woman/Covers'.

129 Ibid.

130 Hanley, *Wonder Woman Unbound*; Sandifer, *A Golden Thread*.

2 'Here Be Monsters': The Mutating, Splitting and Familial Body of the Cold War

1 Philip Sandifer, *A Golden Thread: An Unofficial History of Wonder Woman* (Danbury, CT: Eruditorum Press, 2013), p. 74.

2 Tim Hanley, *Wonder Woman Unbound: The Curious History of the World's Most Famous Heroine* (Chicago, IL: Chicago Review Press, 2014).

3 Lori Maguire, 'Wonder Woman comic books and military technology', in
 Joseph J. Darowski (ed.), *The Ages of Wonder Woman: Essays on the
 Amazon Princess in Changing Times* (Jefferson, NC: McFarland and Co.,
 2014), pp. 42–51.

4 Craig This, 'Containing Wonder Woman: Frederic Wertham's battle against
 the mighty Amazon', in Darowski (ed.), *The Ages of Wonder Woman*,
 pp. 30–41.

5 Alice Marble, 'Wonder women of history', *Wonder Woman*, May 1954.
 Hanley, *Wonder Woman Unbound*, goes into great detail on the transitional
 features.

6 It is significant that the 1950s was the era in which fairy tales were popular.
 Walt Disney developed Disneyland in California in 1955 which used the
 fairy-tale castle as its signature logo. Disney also released *Cinderella* (1950)
 and *Sleeping Beauty* (1959), two of its princesses in the 1950s, and there
 were cinematic and television versions of *Cinderella*, for instance *The Glass
 Slipper* (1955), starring Leslie Caron and the Rodgers and Hammerstein
 televised musical *Cinderella* (1957) starring Julie Andrews.

7 Sandifer, *A Golden Thread*; Wright, *Comic Book Nation*; Cocca,
 Superwomen.

8 The heroines in this series seemed fated to die. In *Wonder Woman* 98
 fifteen-year-old Alaskan schoolgirl Margie Jean Snyder dies in a fire saving
 her brother, sister and their friend.

9 Frederic Wertham, *Seduction of the Innocent* (London: Museum Press,
 1955).

10 For more information on Wertham's attack on comics see David Hajdu,
 *'The Ten-Cent Plague': The Great Comic-Book Scare and How it Changed
 America* (New York: Picador, 2009); Bradford W. Wright, *Comic Book
 Nation: The Transformation of Youth Culture in America* (Baltimore, MD:
 Johns Hopkins University Press, 2001); Carol L. Tilley, 'Seducing the
 innocent: Fredric Wertham and the falsifications that helped condemn
 comics', *Information and Culture* 47/4 (2012), pp. 383–413.

11 Wertham, *Seduction of the Innocent,* p. 114.

12 Ibid., p. 34.

13 This, 'Containing Wonder Woman'.

14 Ross Andru and Mike Esposito collaborated on comics within their own
 comics company, MR Publications and Mikeross Publications, in which
 they published Westerns, war, satirical and romance comics. They worked

with Robert Kanigher on *Metal Men* (1963–68), *Rose and the Thorn* (in *Lois Lane* comics, 1970) and *The Brave and the Bold*. Their working relationship was easy-going, and Kanigher allowed them to design characters, under his direction.

15 Sandifer, *A Golden Thread*. Hanley, *Wonder Woman Unbound* (pp. 73–88), deals with the gradual change from feminist features in the extra stories and comic strips from Marston to Kanigher. Sandifer explores the transition between Marston and Kanigher (*A Golden Thread*, pp. 54–62, 74–84).

16 This story has a precursor in *Wonder Woman* v. 1 23, May/June, 1946, Marston and Peter, 'The Coming of the Kangas', which has Hippolyta showing family album pictures to the Holliday Girls.

17 Jeffrey Jerome Cohen, 'Monster culture (seven theses)', in Jeffrey Jerome Cohen (ed.), *Monster Theory* (Minneapolis, MN: University of Minnesota Press, 1998), pp. 3–25; Susan Stewart, *On Longing: Narratives of the Miniature, the Gigantic, the Souvenir, the Collection* (Durham, NC: Duke University Press, 1993).

18 Ibid.

19 There are two explanations for the invisible plane. In Robert Kanigher, Ross Andru and Mike Esposito, 'The origin of the amazing invisible plane!', *Wonder Woman* 1/128 (February 1962), the plane is revealed as the winged horse, Pegasus, magically transformed. But in their 'Attack of the human iceberg', *Wonder Woman* 1/135 (January 1963), Wonder Woman describes her weapons as produced through 'the wonder of science' (p. 7). This may result from Kanigher's carelessness in maintaining continuity in his stories; however, rather than spending much fruitless effort in rationalizing the logic of these stories where the real and fantasy are so confused, it is more appropriate to go along with the paradoxical nature of the narratives. I will not, therefore, try to explain why Kanigher's confusion of the real and the fantastic is possible, as even he confuses his own ideas about how the magic-eye camera, amongst other fantastic devices, works.

20 Tom Engelhardt, *The End of Victory Culture: Cold War America and the Disillusioning of a Generation* (New York: Basic Books, 1995).

21 Peter J. Kuznick and James Gilbert, 'US culture and the Cold War', in Peter J. Kuznick and James Gilbert (eds), *Rethinking Cold War Culture* (Washington, DC: Smithsonian Institution Press, 2001), pp. 1–13.

22 Ibid., p. 11.

23 William M. Tuttle, 'America's children in an era of war, hot and cold: the Holocaust, the Bomb, and child rearing in the 1940s', ibid., pp. 14–35.

24 Paul S. Boyer, *By the Bomb's Early Light* (New York: Pantheon, 1985), p. xvii.

25 Michael Barson and Steven Heller, *Red Scared! America's Struggle Against the Commie Menace* (San Francisco, CA: Chronicle Books, 2001).

26 Elaine Tyler May, *Homeward Bound: American Families in the Cold War Era* (New York: Basic Books, 1988); Garret Keizer, *Homeward Bound. New York Times Book Review* (New York: Basic Books, 2012).

27 Jancovich, *Rational Fears*, p. 117.

28 Philip Wylie, *Generation of Vipers* (New York: Holt, Rinehart and Winston, 1955).

29 I use Wylie's own spelling of 'Proserpine', also known as Persephone or Proserpina. It is worth noting that the story of Proserpine is one of masculine violence against women. Proserpine becomes the Queen of Hell because she is abducted and raped by Hades.

30 Joanne Meyerowitz, 'Beyond the feminine mystique: a reassessment of postwar mass culture, 1946–1958', *The Journal of American History* 79/4 (1993), pp. 1455–82.

31 Bill Osgerby, *Playboys in Paradise: Masculinity, Youth and Leisure-Style in Modern America* (Oxford: Berg, 2001).

32 Robert J. Moskin, George B. Leonard and William Attwood, *The Decline of the American Male* (Washington, DC: Random House, 1958).

33 Michael Kimmel, *Manhood in America: A Cultural History* (Oxford: Oxford University Press, 2017), p. 147.

34 Robert Kanigher, Ross Andru and Mike Esposito, 'Wonder queen fights Hercules', *Wonder Woman* 1/132 (August 1962), p. 27.

35 Robert Kanigher, Ross Andru and Mike Esposito, 'The secret origin of Wonder Woman', *Wonder Woman* 1/105 (April 1959).

36 Ibid., p. 10 (emphasis original).

37 Ibid.

38 Kanigher et al., 'Amazon magic-eye album!', p. 21.

39 Ibid., p. 6.

40 For instance, Robert Kanigher, Ross Andru and Mike Esposito, 'The Impossible Day!', *Wonder Woman* 1/124 (August 1961), p. 16.

41 Kanigher et al., 'Attack of the human iceberg'. This is corroborated in their 'Wonder Woman's surprise honeymoon!', *Wonder Woman* 1/127 (January

1962), when Steve dreams he marries Wonder Woman, only to discover she cannot cook.

42 This concept may have been inspired by an earlier story in Marston and Peter, 'Wonder Woman and the Coming of the Kangas', in *Wonder Woman* 23. In this story Hippolyta invites the Holliday Girls and Etta Candy to look at the Amazon family album: 'All our family records are on films' (p. 2C).

43 Kanigher et al., 'Amazon Magic-Eye Album!'

44 Imaginary stories were published from the late 1950s in several DC titles, mostly in the Superman Family. They offered readers the opportunity to see what might happen if Superman was split in two or Lois Lane married Superman. Some stories appeared in Batman comics. In the 1990s imaginary stories appeared under the banner of Elseworlds. Marvel too had their imaginary stories under the title 'What If'.

45 Kanigher et al., 'The Impossible Day!', p. 1.

46 Bergson, 'Matter and Memory'.

47 Kanigher et al., 'Amazon magic-eye album!', pp. 3–4.

48 Kanigher et al., 'The Impossible Day!', p. 5.

49 Ibid.

50 Interestingly, in this story, Kanigher posits the existence of virtual reality.

51 Teasers were introduced in American television to entice audiences into watching the show after the advertisements. Raymond Williams, 'Programming as sequence or flow', in Sue Thornham, Caroline Bassett and Paul Marris (eds), *Media Studies: A Reader* (Edinburgh: Edinburgh University Press, 2009), pp. 192–8.

52 Fred J. MacDonald, *One Nation Under Television* (New York: Pantheon, 1990), p. 54.

53 Nadel, 'Cold War television and the technology of brainwashing', p. 147.

54 Kanigher et al., 'Amazon magic-eye album!', p. 21.

55 McCloud, *Understanding Comics*, 104.

56 Jean Baudrillard, *Ecstasy of Communication*, ed. Sylvère Lotringer, trans. Bernard and Caroline Schutze (New York: Autonomedia, 1988).

57 Baudrillard claims that through technology images become simulations of other images. The simulated image is also a simulation of other images and this is so pervasive in contemporary culture that the notion of the original is jeopardised. Using the Mona Lisa as an example, we cannot know the original woman except through the painting produced by Leonardo da

Vinci. When print culture with etchings and engravings became prevalent
in the West the painting image was reproduced in multiple versions. With
the advent of the Internet these images proliferate and are parodied so that
we come to know the Mona Lisa only through its reproduction.
Baudrillard claims this induces a state akin to schizophrenia in the
onlooker where the real cannot be distinguished from the simulation.

58 Jacques Derrida, Catherine Porter and Philip Lewis, 'No apocalypse, not
now (full speed ahead, seven missiles, seven missives)', *Diacritics* 14/2
(1984), pp. 20–31, p. 23.

59 David Seed, *American Science Fiction and the Cold War: Literature and
Film* (Edinburgh: Edinburgh University Press, 1999).

60 Gigantic and shrinking bodies can be identified in other superhero
comics of DC – for instance, Superman comics of this era feature giants
from the giant dimension and the freakish effects of red kryptonite on his
body and behaviour. In the Superman family, Jimmy Olsen and Lois Lane
comics also dwelt upon freakish body mutations; Jimmy Olsen, for
instance, becomes Elasti-lad, an obese man or an animal/human hybrid.
Many of these strange transformations were the result of editor Mort
Weisinger's attempts to appeal to his youthful audiences. He often took the
advice of children in focus groups when they suggested storylines. The
mutating human body can also be attributed to fears of radioactive
contamination.

61 Kanigher et al., 'The Million Dollar Penny!'

62 Kanigher et al., 'The Forest of Giants!'

63 Kanigher et al., 'The Impossible Day!', p. 5.

64 Ibid., p. 11.

65 Kanigher et al., 'The return of Multiple Man!'

66 Kanigher et al., 'Attack of the human iceberg'. To avoid confusion I refer to
the creature as Multiple Man.

67 Rosemary Jackson, *Fantasy: The Literature of Subversion* (London:
Methuen, 1981), p. 82.

68 Ibid., p. 90.

69 Here I refer to Marx's notion of the false consciousness induced by
ideology. This concept is developed by Louis Althusser in 'Ideology and
ideological state apparatuses', in which he suggests we are born into
and interpolated by ideology. Consequently, we cannot step outside
of it and can only understand through and become subjects of ideology

(Antony Easthope and Kate McGowan (eds), *A Critical and Cultural Theory Reader* (Maidenhead: Open University Press, 1992), pp. 42–50).

70 Diana Prince is a palpable presence in other Kanigher stories at this time, but she represents a more traditional alter-ego role of the third and overlooked member of a strange eternal triangle in which the superhero and alter ego vie for the affections of an ordinary mortal. Richard Reynolds (*Super Heroes* (Jackson, MS: University of Mississippi Press, 1994)) notes this in his identification of the main tropes of Superman stories in the late 1940s, in which Superman and Clark Kent vie for Lois Lane's affections. In both sets of relationships, the hero/ine often pines after the object of affection/mortal whilst their glamorous identity treats them with disdain.

71 Cohen, 'Monster Culture (Seven Theses)'.

72 Robert Kanigher, Ross Andru and Mike Esposito, 'The human charm bracelet!', *Wonder Woman* 1/106 (May 1959).

73 Anne Lake Prescott, 'The odd couple: Gargantua and Tom Thumb', in Cohen (ed.), *Monster Theory*, pp. 75–91.

74 Robert Kanigher, Ross Andru and Mike Esposito, 'Wonder Girl in Giant Land!', *Wonder Woman* 1/109 (October 1959).

75 Stewart, *On Longing*, p. 71. In speaking of the fabulous monstrous creatures of medieval art, John Block Friedman (*The Monstrous Races in Medieval Art and Thought* (Cambridge, MA: Harvard University Press, 1981)) notes that as early as the thirteenth century Jacques de Vitry wrote: 'just as we consider Pygmies to be dwarves, so they consider us giants [...] And in the land of the Giants, who are larger than we are, we would be considered dwarfs by them' (pp. 163–4).

76 Kanigher et al., 'The Impossible Day!' It might be argued that this claim reflects America's unstoppable progress as a world leader in politics and culture in that period.

77 Ibid., p. 7 (emphasis original).

78 Ibid., p. 11.

79 Ibid., p. 21.

80 Antti Amatus Aarne and Stith Thompson, *The Types of the Folk-Tale* (Helsinki: Suomalainen Tiedeakatemia, 1928). 'The magician and his apprentice' is Tale Type 325, 'The giant without a heart' is Tale Type 302.

81 Stewart, *On Longing*.

82 Ibid., p. 70.

83 Ibid., p. 80.

84 Kanigher et al., 'Attack of the human iceberg', p. 4.

85 Julia Kristeva, *Powers of Horror: An Essay in Abjection*, trans. Leon S. Roudiez (New York: Columbia University Press, 1982); Mikhail M. Bakhtin, *Rabelais and his World* (Cambridge, MA: MIT Press, 1968).

86 Cohen, 'Monster culture (seven theses)', p. 17.

87 Ibid., p. 6.

88 Ibid., p. 7, citing Jacques Derrida, *Of Grammatology* (Baltimore, MD: Johns Hopkins University Press, 1976).

89 Nathan H. Duran (dir.), *The Attack of the Fifty Foot Woman* (USA: Monogram Pictures, 1958); Jack Arnold (dir.), *The Incredible Shrinking Man* (USA: Universal-International, 1957).

90 Cohen, 'Monster Culture (Seven Theses)', p. 5.

91 Kanigher et al., 'I . . . the Bomb!'; Kanigher et al., 'The Fury of Egg Fu!'.

92 Kanigher, 'The Academy of Arch-Villains!'

93 Kanigher and Peter, 'The Invisible Trail!'

94 Sandifer, *A Golden Thread*; Peter Coogan, *Superhero*.

95 Kanigher et al., 'The Brain Pirate of the Inner World!', p. 2.

96 Ibid., p. 24.

97 Kanigher et al., 'I . . . the Bomb!', p. 11.

3 The New Diana Prince! Makeovers, Movement and the Fab/ricated Body, 1968–72

1 Dennis O'Neil and Mike Sekowsky (illus.), 'Can you believe you're looking at Diana Prince?', *Wonder Woman* 1/177 (August 1968), p. 31.

2 Drury Muroz, 'Readers' letters', *Wonder Woman* 1/182 (1968), p. 26.

3 There were guest appearances in Mike Sekowsky, 'The widow-maker!', *The Brave and the Bold* (January 1970); Bob Haney and Jim Aparo (author and illus.), 'Play now – die later!', *The Brave and the Bold* (February 1973); Robert Kanigher and Irving Novick, 'The Superman–Wonder Woman team!', *Lois Lane Superman's Girl Friend* 1/93 (July 1969). It is interesting that Kanigher wrote the latter issue where she becomes the victim of a Kryptonian villainess.

4 John F. Kennedy, 'The new frontier', *American Rhetoric Online Speech Bank*, 1960. Available at http://www.americanrhetoric.com/speeches/jfk1960dnc.htm (accessed 16 April 2016).

5 Ibid.

6 Michel Foucault, 'Docile bodies', in Paul Rabinow (ed.), *Essential Works of Foucault* (New York: Pantheon Books, 1984), pp. 179–87, p. 180.

7 Jennifer Craik, *The Face of Fashion: Cultural Studies in Fashion* (London: Routledge, 1993), p. 4.

8 Mike Featherstone, 'The body in consumer culture', *Theory, Culture and Society* 1/2 (1982), pp. 18–33, p. 64.

9 Erving Goffman, *The Presentation of Self in Everyday Life*.

10 Ibid., 113.

11 Barbara Brownie and Danny Graydon, *The Superhero Costume: Identity and Disguise in Fact and Fiction* (London: Bloomsbury, 2016), p. 2.

12 Scott McCloud and Robert Lappan, *Understanding Comics: The Invisible Art* (New York: Turtleback Books, 1999), p. 30.

13 Terry Castle, *Masquerade and Civilization: The Carnivalesque in Eighteenth-Century English Culture and Fiction* (Stanford, CA: Stanford University Press, 1986).

14 Mike Sekowsky and Dick Giordano, 'A time to love, a time to die!', *Wonder Woman* 182 (June 1969), p. 9.

15 See Chapter 1.

16 Marnie Fogg, *Boutique: A '60s Cultural Phenomenon* (London: Mitchell Beazley, 2003).

17 Umberto Eco, 'Narrative structures in Fleming', in Christoph Lindner (ed.), *The James Bond Phenomenon: A Critical Reader* (Manchester: Manchester University Press, 2003), pp. 34–55.

18 The white clothing was sometimes a white miniskirt. However, nearer the end of the run it became a series of white trouser suits. The white suit is 'quoted' in later stories, for instance, in 2002, when Wonder Woman adopts a secret identity in the Department of Metahuman Affairs (DMA) (see Chapter 5).

19 Tim Hanley, *Wonder Woman Unbound: The Curious History of the World's Most Famous Heroine* (Chicago, IL: Chicago Review Press, 2014); Peter W. Lee, 'Not quite mod: the new Diana Prince, 1968–1973', in Joseph J. Darowski (ed.), *The Ages of Wonder Woman: Essays on the Amazon Princess in Changing Times* (Jefferson, NC: McFarland and Co., 2014), pp. 101–16;

Jason LaTouche, 'What a woman wonders: this is feminism?', ibid., pp. 79–89; Philip Sandifer, *A Golden Thread: An Unofficial History of Wonder Woman* (Danbury, CT: Eruditorum Press, 2013).

20 Paul R. Kohl, 'Wonder Woman's lib: feminism and the 'new' amazing Amazon', in Darowski (ed.), *The Ages of Wonder Woman*, pp. 90–100.

21 Bradford W. Wright, *Comic Book Nation: The Transformation of Youth Culture in America* (Baltimore, MD: Johns Hopkins University Press, 2001).

22 Jeffrey A. Brown, *Black Superheroes, Milestone Comics, and Their Fans* (Jackson, MS: University Press of Mississippi, 2001).

23 Mike Brake, *Comparative Youth Culture: The Sociology of Youth Cultures and Youth Subcultures in America, Britain, and Canada* (London: Routledge & Kegan Paul, 1985).

24 Dennis Hopper (dir.), *Easy Rider* (USA: Columbia Pictures, 1968).

25 Wright, *Comic Book Nation*, pp. 226–34.

26 This series spanned 1970–76 and featured stories on drug addiction, sinister cults, racial prejudice and pollution.

27 Mike Sekowsky and Dick Giordano (illus.), 'Red for death', *Wonder Woman* 189 (August 1970).

28 Heinecken, *The Warrior Women of Television: A Feminist Cultural Analysis of the New Female Body in Popular Media*; Stuller, 'Love Will Bring You to Your Gift.' Stuller notes that family is not just about parents and relations but includes the people the heroine attracts to herself to help with her fight against evil.

29 Jennifer Stuller, *Ink-Stained Amazons and Cinematic Warriors: Superwomen in Modern Mythology* (London: I.B. Tauris, 2010), p. 105.

30 The story arc began with Dennis O'Neil and Neal Adams (illus.), 'No evil shall escape my sight!', *Green Lantern Green Arrow* 2/76 (April 1970).

31 LaTouche, 'What a woman wonders', p. 88.

32 Kohl, 'Wonder Woman's lib'.

33 Maurice Merleau-Ponty, *Phenomenology of Perception* (London: Routledge, 2002).

34 Hilary Radner, 'Queering the Girl', in Hilary Radner and Moya Luckett (eds), *Swinging Single: Representing Sexuality in the Sixties* (Minneapolis, MN: University of Minnesota Press, 1999), pp. 1–35, p. 15. See also Moya Luckett, 'Sensuous women and single girls: reclaiming the female body on 1960s television', in Hilary Radner and Moya Luckett (eds), *Swinging Single:*

Representing Sexuality in The Sixties (Minneapolis, MN: University of Minnesota Press, 1999), pp. 277–98.

35 Finn and Fogg, *Boutique*.

36 Becky E. Conekin, 'From haughty to nice: how British fashion images changed from the 1950s to the 1960s', *Photography and Culture* 3/3 (2010), pp. 283–96.

37 In private correspondence, Dennis O'Neil, the writer of many of the stories, states that his inspiration came from *Modesty Blaise*, a comic strip written by Peter O'Donnell and drawn by Jim Holdaway. In 1966 it was made into a film by Joseph Losey. O'Neil was vehement that he was not aware of *The Avengers* when he penned the stories. *The Avengers* was promoted in early *Cosmopolitan* magazines. If O'Neil was not aware of *The Avengers*, Mike Sekowsky certainly was, stating: 'We were all in love with Diana Rigg and that show she was on' (Les Daniels and Chip Kidd, *Wonder Woman* (San Francisco, CA: Chronicle Books, 2000), p. 129).

38 This could be identified in second-wave feminists changing attitudes towards Doris Day. Originally viewed and mocked as the eternal virgin, in her 1974 feminist reading of female cinematic roles Molly Haskell proposed that Day was an assertive female icon who remained a virgin by narrative plot devices rather than an ideological agenda (Molly Haskell, *From Reverence to Rape: The Treatment of Women in the Movies* (New York: Rinehart & Winston, 1974)).

39 Michael Denning, 'Licensed to look: James Bond and the heroism of consumption', in Lindner (ed.), *The James Bond Phenomenon*, pp. 56–75.

40 Brake, *Comparative Youth Culture*, p. 185.

41 Amis, Kingsley, 'Looking-in Is Looking Up!', *TV Times*, 9–15 February 1964, p. 7.

42 Emma Peel was so named as she had m – male appeal.

43 Cynthia Grenier, 'Secret agent girls', *Cosmopolitan* (1966), p. 55.

44 The originator of the miniskirt is debated. Many people believe Mary Quant or André Courrèges designed the first miniskirt. Marit Allen, who edited the British *Vogue* 'Young Ideas', claimed that John Bates, who designed as Jean Varon, designed the miniskirt.

45 *Secret Six* was created by Nelson E. Bridwell and Frank Springer and published by DC Comics, May 1968–May 1969. *Lady Penelope* was the secret agent of *Thunderbirds*. She starred in a British comic named after her, published by City Publications. In these comic strips she is shown in the Mondrian-inspired mod miniskirts as the height of fashion. Her comic

also featured strips based on *The Man from U.N.C.L.E.* and *The Girl from U.N.C.L.E.* Both of these television series were also produced as comics by Gold Key in the USA. *Nick Fury, Agent of Shield*, a Marvel comic, started in *Strange Tales* 135, August 1965 and featured Sharon Carter. All stories were plotted by Stan Lee or Jack Kirby except for *Strange Tales* 167, January 1967, which was plotted by Dennis O'Neil.

46 Dick Wood, Mike Sekowsky (illus.) and Frank Giacola, 'The Achilles heel', *The Man from U.N.C.L.E. 13* (July 1967).

47 Smithsonian, 'The flag in the sixties', *The Star-Spangled Banner: The Flag That Inspired the National Anthem*, 2017. Available at https://amhistory.si.edu/starspangledbanner/the-flag-in-the-sixties.aspx (accessed 16 April 2016).

48 In 1974 Captain America, a hero who wore the patriotic costume, also renounced his title and costume when he perceived American values of truth and justice were defunct in a corrupt political climate. He donned a black costume and called himself Nomad – a man with no country, hence no political and national affiliation. Black is a non-colour. It connotes cool or an absence from which meaning has been drained.

49 Betty Friedan, *The Feminine Mystique* (New York: W.W. Norton, 1963).

50 Simone de Beauvoir, *The Second Sex*, ed. and trans. H.M. Parshley (London: Penguin Books, 1997), p. 47.

51 Sherry B. Ortner and Harriet Whitehead, *Sexual Meanings: The Cultural Construction of Gender and Sexuality* (Cambridge: Cambridge University Press, 1981), p. 253.

52 Germaine Greer, *The Female Eunuch* (London: Paladin, 1971), cited in Joanne Hollows, *Feminism, Femininity, and Popular Culture* (Manchester: Manchester University Press, 2000), pp. 13–14; Friedan, *The Feminine Mystique*.

53 Judith Butler, *Gender Trouble* (New York: Routledge, 1999).

54 Hollows, *Feminism, Femininity, and Popular Culture*, p. 113.

55 Elizabeth Wilson, *Adorned in Dreams: Fashion and Modernity* (New Brunswick, NJ: Rutgers University Press, 2003), p. 140.

56 Caroline Evans and Minna Thornton, *Women and Fashion: A New Look* (London: Quartet, 1989), p. 7.

57 Hilary Radner, *Shopping Around: Feminine Culture and the Pursuit of Pleasure* (New York: Routledge, 1995).

58 Helen Gurley Brown, *Sex and the Single Girl* (London: New English Library, 1964).

59 Rapper, *Now Voyager*. Elizabeth Ford and Deborah C. Mitchell, *The Makeover in Movies* (Jefferson, NC: McFarland and Co., 2004).

60 In Marston's story the myth of Pygmalion and Galatea is replicated in Hippolyta carving a statue brought to life by Aphrodite.

61 Dennis O'Neil and Mike Sekowsky (illus.), 'Wonder Woman's rival', *Wonder Woman* 1/178 (October 1968), p. 7.

62 Michel Foucault, *Discipline and Punish: The Birth of the Prison*, trans. Alan Sheridan (New York: Pantheon Books, 1977).

63 Jennifer Craik, *Uniforms Exposed: From Conformity to Transgression* (Oxford: Berg, 2005), p. 4.

64 O'Neil and Sekowsky, 'Wonder Woman's rival', p. 13.

65 Fogg, *Boutique*.

66 Buxton, *From the Avengers to Miami Vice*, 73.

67 McCloud and Lappan, *Understanding Comics*, p. 30.

68 Dennis O'Neil and Mike Sekowsky (illus.), 'A death for Diana', *Wonder Woman* 1/180 (February 1969), p. 10.

69 Ibid., p. 12.

70 Dennis O'Neil and Don Heck (illus.), 'Tribunal of fear!', *Wonder Woman* 1/199 (April 1972), p. 9.

71 Kohl, 'Wonder Woman's lib'.

72 Sekowsky and Giordano, 'A time to love, a time to die!', p. 9.

73 Brownie and Graydon, *The Superhero Costume*.

74 Neil Glossop, 'Reader's letters', *Wonder Woman* 1/197 (1971), p. 48.

75 Dennis O'Neil and Mike Sekowsky (illus.), 'The wrath of Doctor Cyber!', *Wonder Woman* 1/181 (April 1969).

76 Ibid., p. 21.

77 Buxton, *From the Avengers to Miami Vice*, p. 77.

78 Louis Turner and John Ash, *The Golden Hordes: International Tourism and the Pleasure Periphery* (New York: St. Martin's Press, 1976).

79 Buxton, *From the Avengers to Miami Vice*.

80 Coogan, *Superhero*.

81 Eco, 'Narrative structures in Fleming'.

82 Haraway, 'A Cyborg Manifesto'.

83 Ibid., p. 181.

84 Derrida, *Of Grammatology*.
85 Dennis O'Neil and Mike Sekowsky (illus.), 'Wonder Woman's last battle!', *Wonder Woman* 1/179 (December 1968), p. 13.
86 Ibid.
87 Ibid., p. 14.
88 In making this argument, I am aware that the gender transformation might have taken place as a last-minute decision by O'Neil. However, the gender transition is in keeping with my cyborg discussion.
89 O'Neil and Sekowsky, 'The wrath of Doctor Cyber!', p. 1.
90 Butler, *Gender Trouble*, p. 136.
91 Ibid.
92 O'Neil and Heck, 'Tribunal of fear!'; Dennis O'Neil and Don Heck (illus.), "The beauty hater!', *Wonder Woman* 1/200 (June 1972).
93 Bill Osgerby, *Playboys in Paradise: Masculinity, Youth and Leisure-Style in Modern America* (Oxford: Berg, 2001).
94 Luckett, 'Sensuous women and single girls', p. 282.
95 Hugh M. Hefner, 'The *Playboy* philosophy', *Playboy*, December 1962, p. 42.
96 Foucault, 'Docile bodies'.
97 Gloria Steinem, 'Introduction', in *Wonder Woman* (New York: Holt, Rinehart & Winston, 1972).
98 Hanley, *Wonder Woman Unbound*; LaTouche, 'What a woman wonders'.
99 Andy Mangels, 'Catsuits and karate: Diana Prince leaves Wonder Woman behind', *Back Issue* 17 (2006), pp. 35–43, p. 36.
100 See the Appendix for a list of different storylines and themes of Wonder Woman.
101 Andy Mangels, 'Catsuits and karate: Diana Prince leaves Wonder Woman behind', *Back Issue* 17 (2006), pp. 35–43, p. 42.
102 McClelland-Nugent, "Steve Trevor, equal?' Wonder Woman in an era of second wave feminist critique.'
103 O'Neil, 'Wonder Woman's write in', 34.
104 Darowski, '"I no longer deserve to belong": the Justice League, Wonder Woman and the twelve labors'. For a more extensive account of 1972–86 comics see the Appendix.
105 Jeffords, *Hard Bodies*; Faludi, *Backlash*.
106 Colon, 'Wonder Words', 21.
107 Ibid.

108 For the background to this sitcom pitch and the example see Bowie, 'Wonder Woman: an early attempt'.

109 For instance, in season 1, episode 3, 'Fausta, the Nazi Wonder Woman', Wonder Woman convinces a Nazi agent, Fausta Grables, to become a member of the Resistance by showing her the Nazis' ill treatment of women. In season 1, episode 12, 'Formula 407', Wonder Woman redeems a woman who has been seduced into believing Nazi lies. In season 3, episode 6, 'Formicidia', Wonder Woman reforms an eco-terrorist.

110 Spelling and Goldberg, 'Charlie's Angels'; Fielding, 'Bionic Woman'; Gerber, 'Police Woman'. For a feminist perspective on these television series see also Lehman, *Those Girls*.

111 Levine, *Wallowing in Sex*.

112 Lehman, *Those Girls*, p. 160; Levine, *Wallowing in Sex*, p. 1. This was a term of Paul Klein, an NBC executive, in describing ABC's use of pornographic aesthetics in female representations.

113 Sandifer, *A Golden Thread*, p. 150.

114 The lip service paid to feminism in the series is discussed at length in 'Sandifer, *A Golden Thread*, pp.141–152.

115 Chapter 2.

116 Wallerstein, 'Wonder Woman 12: Formula 407'.

117 For a fuller account of the shape and development of the series see https://en.wikipedia.org/wiki/Wonder_Woman_(TV_series)#Wonder_Woman_.281975-1979.29. See also Pingel, *The Q Guide to Wonder Woman*.

4 The Goddess, the Iron Maiden and the Sacralization of Consumerism

1 The dates for this iteration are February 1987–December 1991.

2 Greg Potter and George Pérez, 'The princess and the power', *Wonder Woman: Gods and Mortals* (New York: DC Comics, 1987).

3 Ibid., p. 9.

4 The logline 'beautiful as Aphrodite, wise as Athena, as strong as Hercules, and as swift as Hermes' appeared at the front of all the *Wonder Woman* stories from 1959 (105) until the Diana Prince comics of 1968.

5 Richard Donner, *Superman* (USA: Warner Bros., 1989), *Superman*.

6 Thomas Andrae, 'From menace to messiah: the prehistory of the Superman in science fiction literature', *Discourse* 2 (1980), pp. 84–112; John Shelton Lawrence and Robert Jewett, *The Myth of the American Superhero* (Grand Rapids, MI: W.B. Eerdmans, 2002); Joseph Campbell, *Hero with a Thousand Faces* (Princeton, NJ: Princeton University Press, 1972). DC recognized the similarity in story arcs such as Dan Jurgens et al., *The Death of Superman* (New York: DC Comics, 1992).

7 George Pérez and Dick Giordano, 'Creatures of the dark', *Wonder Woman* 2/18 (July 1988), p. 5. This statement is similar to the statement in the previous chapter about the Impossible Day that Wonder Woman makes true.

8 George Pérez and Bob McLeod, 'Who killed Myndi Mayer?', *Wonder Woman* 2/20 (September 1988), p. 14.

9 Susan Faludi, *Backlash: The Undeclared War against American Women* (New York: Crown, 1991); Naomi Wolf, *The Beauty Myth: How Images of Beauty Are Used against Women* (New York: W. Morrow, 1991).

10 Susan Jeffords, *Hard Bodies: Hollywood Masculinity in the Reagan Era* (New Brunswick, NJ: Rutgers University Press, 1994).

11 Ibid., p. 6.

12 Ibid., p. 24.

13 Faludi, *Backlash*, pp. 290–313.

14 Beverly LaHaye, *The Spirit-Controlled Woman* (Irvine, CA: Harvest House, 1976).

15 See Chapters 5 and 6.

16 Colin Higgins (dir.), *9 to 5* (USA: 20th Century Fox, 1980); Bryan Forbes, *Stepford Wives* (USA: Columbia Pictures, 1975).

17 Robert Benton (dir.), *Kramer vs. Kramer* (USA: Columbia Pictures, 2001).

18 Adrian Lyne (dir.), *Fatal Attraction* (USA: Paramount Pictures, 1987); Faludi, *Backlash,* pp. 125–7, 129–36.

19 Wolf, *The Beauty Myth*, p. 12.

20 Chris Shilling, *The Body and Social Theory* (London: Sage, 2003).

21 Entwistle, *The Fashioned Body: Fashion, Dress, and Modern Social Theory.*

22 Mansfield, '"Sexercise": working out heterosexuality in Jane Fonda's fitness books'.

23 See also Tim Hanley, *Wonder Woman Unbound* pp. 197–206 for his extensive discussion of the connections between feminism, originary matriarchy and the Amazons.

24 Elaine Morgan, *The Descent of Woman* (London: Souvenir Press, 1972).

25 Merlin Stone, *When God Was a Woman* (New York: Harcourt Brace Jovanovich, 1978); Starhawk, *The Spiral Dance: A Rebirth of the Ancient Religion of the Great Goddess* (New York: HarperSanFrancisco, 1999); Robert Graves, *The White Goddess: A Historical Grammar of Poetic Myth* (New York: Farrar, Straus and Giroux, 1966); Carol P. Christ and Judith Plaskow, *Womanspirit Rising: A Feminist Reader in Religion* (San Francisco, CA: Harper & Row, 1979).

26 Phyllis Chesler, 'The Amazon legacy: an interpretive essay', in Gloria Steinem (ed.), *Wonder Woman* (New York: Holt, Rinehart and Winston, 1972), n.p.

27 Ibid.

28 Margot Adler, *Drawing down the Moon : Witches, Druids, Goddess-Worshippers, and Other Pagans in America Today* (Boston, MA: Beacon Press, 1986), p. 23.

29 Haraway, 'A cyborg manifesto: science, technology, and socialist-feminism in the late twentieth century', 181.

30 See previous chapter.

31 Russell W. Belk, Melanie Wallendorf and John F. Sherry Jr, 'The sacred and the profane in consumer behavior: theodicy on the Odyssey', *Journal of Consumer Research* 16/1 (1989), pp. 1–38'.

32 Mircea Eliade, *The Sacred and the Profane: The Nature of Religion*, trans. Willard R. Trask (New York: Harcourt, Brace & World, 1959), p. 6.

33 Belk, Wallendorf and Sherry Jr, 'The sacred and the profane in consumer behavior'.

34 Durkheim, *The Elementary Forms of the Religious Life*, p. 8.

35 George Pérez and Mindy Newell, 'Forbidden fruit', *Wonder Woman* 2/38 (January 1990), p. 5.

36 George Pérez, 'Strangers in Paradise', *Wonder Woman* 2/37 (January 1989), p. 21.

37 Pérez and Newell, 'Forbidden fruit', p. 6.

38 Ibid.

39 Ibid.

40 Ibid. p. 14.

41 Hoffman, *Sport and Religion*.

42 Rojek, *Celebrity*.

43 Eliade, *Patterns in Comparative Religion*.

44 Ibid., 7.

45 Csordas, *Embodiment and Experience*, p. 6.

46 Charlesworth, *A Phenomenology of Working Class Experience*, 83.

47 Pérez and Wein, 'Blood of the cheetah'.

48 Pérez et al., 'Common ground', p. 5.

49 Her visions are recorded in William Messner-Loebs and Mike Deodato Jr (illus.), 'The contest', *Wonder Woman* 2/90, 00, 91, 92 (September–December 1994).

50 The history of Gaea's Girdle has been simplified to streamline the analysis in the main text. Briefly, Amazon queens Hippolyta and her sister Antiope were each given a girdle. Antiope gave her girdle to Hippolyta when Hippolyta's was stolen by Herakles. Antiope then took her Amazon acolytes to live as nomads in Man's world. The Bana-Mighdall, as they became known, stole back Hippolyta's girdle and it became an heirloom, detached from its mythic roots and therefore desacralized in the profane world. The goddess Hesta used Antiope's girdle to make the Lasso of Truth. In a storyline where Diana discovers the lost Amazon tribe, the Girdle calls to her lasso and, on retrieval, the Girdle once more becomes sacralized.

51 This concept is explored further in Messner-Loebs and Deodato Jr.'s 'The contest' for when Diana returns to Themyscira from man's world she notices how her sisters experience time at a slower pace.

52 Pérez and Newell, 'The ties that bind', p. 13.

53 Eliade and Trask, *The Sacred and the Profane: The Nature of Religion*, p. 5.

54 Pérez and Newell, 'Forbidden fruit'. p. 2.

55 Ibid.

56 Belk et al., 'The sacred and the profane in consumer behavior'.

57 Pérez, 'Time passages', p. 20.

58 Wolf, *The Beauty Myth*, p. 59.

59 Pérez and Wein, 'Blood of the cheetah', p. 8.

60 Pérez, 'Bird of paradise/bird of prey'.

61 Pérez and Newell, 'The armageddon aria', p. 17.

62 Pérez, 'Bird of paradise/bird of prey', p. 6.

63 Entwistle, *The Fashioned Body*.

64 Pérez, 'Rebirth'.

65 Ibid., p. 15.

66 Ibid., p. 18.

67 Pérez and McLeod, 'Who killed Myndi Mayer?', p. 4.

68 Cornfeld and Edwards, *Quintessence*.

69 Pérez and McLeod, 'Eve of destruction', 3.

70 Pérez, 'Testament'.

71 Pérez and Newell, 'The ties that bind', p. 3.

72 Bakhtin, *Rabelais and His World*.

73 Ibid., p. 20.

74 Pérez and Newell, 'Chalk drawings', p. 1.

75 Ibid., p. 19.

76 In Jean Baudrillard, *Simulations*, trans. Paul Foss (New York City: Semiotext(e), 1983), the Middle Ages represents the second age of simulacra. In this age, the religious icon or the body parts of saints or religious objects stand in for the proof of God.

77 Pérez and McLeod, 'Who killed Myndi Mayer?', p. 22. It is also noteworthy that this comment connects the Silver Swan to these two women, as the Swan, Valerie Beaudry, 'just wanted to keep flying higher. Until she ran out of sky', but she is redeemed through the friendship of Maxine Sterenbuch.

78 Indeed, since this story arc Wonder Woman has become a goddess twice more, once in the John Byrne era as Goddess of Truth, once in Azzarello's run as God of War.

79 McCue and Bloom, *Dark Knights*, 101.

80 See Jones and Jacobs, *The Comic Book Heroes*, for a full account of the development of image. For discussions of the bad girl phenomena see Brown, 'Gender, sexuality, and toughness'; Cocca, 'The "Broke back test": a quantitative and qualitative analysis of portrayals of women in mainstream superhero comics, 1993–2013'; Cocca, *Superwomen: Gender, Power, and Representation*; Ormrod, 'Body issues in Wonder Woman 90–100 (1994–1995): good girls, bad girls and macho men.' The brokeback pose derives from pornography in which the woman is depicted arching her back to enhance her breasts. This position is impossible to achieve unless one has broken one's back.

81 Darkseid was created by Jack Kirby in 1970 where he appeared in a Jimmy Olsen story. His first proper appearance was in *Forever People* 1, 1971. Darkseid is one of the overarching villains of the DC Universe.

82 Byrne, 'Ascension'.

83 Chapter 6.

84 Azzarello and Chiang, 'Birth right'.

5 Taming the Unruly Woman: Surveillance, Truth and the Mass Media Post-9/11

1 Ibid., p. 195.
2 Ibid.
3 Rucka et al., *The Hiketeia*.
4 Sandifer, *A Golden Thread*, pp. 214–20.
5 Rucka, 'Infinite Crisis Crossover', p. 4.
6 See Chapter 1. Doctor Psycho surfaces in several different ages of Wonder Woman. He is a malevolent creature who hates women because they are repulsed by his body. As he is telepathic he can manipulate minds.
7 One-Man Army Corps (OMAC) was originally a concept of Jack Kirby in 1974. The concept was revised so that OMACs were humans whose bodies were infected by a nano-virus and transformed into cyborgs.
8 'Metahuman' is a word that is interchangeable with 'superhuman'. Both body types exhibit extraordinary abilities, usually beyond those of an ordinary human body whether through genetic, cyber enhancement or special powers.
9 Foucault, *The Birth of the Clinic*; Foucault, *Discipline and Punish*; Foucault, *The History of Sexuality*.
10 Ibid., p. 93.
11 Berns, 'War, foreign policy and the media'.
12 Slotkin, *Regeneration through Violence*.
13 Ibid., p. 53.
14 Anker, 'Villains, victims and heroes'.
15 Bush, 'State of the Union Address: text of George Bush's speech'.
16 Ibid.
17 Faludi, *The Terror Dream*.
18 Zahn, 'Some articles point to heroic image of firefighters as example of return of manly man'.
19 Toh, 'The white fireman and the American heartland in the memory of 9/11'.
20 Straczynski, Romita Jr., and Hanna, 'Stand tall', p. 13.
21 Straczynski et al., 'Mr Parker goes to Washington: part three of three'.
22 Rucka at al., 'Down to earth (2/4)', p. 9.
23 Ibid., p. 15.
24 Ibid.
25 Rucka et al., 'Down to earth (1/4)', p. 16.

26 Chapter 4.

27 Rucka et al., 'Down to earth (2/4)', p. 20.

28 Santori, 'Exclusive Interview'. Rucka states this in relation to his run in the Rebirth reboot 2016. However, his vision of the character has always been that she is queer or bisexual. This is discussed in the final chapter.

29 Rucka, 'Down to earth (1/4)', p. 17.

30 Ibid.

31 Rucka et al., 'Down to earth (4/4)', p. 19.

32 Rucka et al., 'Down to earth (1/4)'. See Chapter 1.

33 Rucka et al., 'Down to earth (2/4)', p. 22.

34 Ibid., p. 4.

35 Ibid., p. 23.

36 Ibid., p. 4.

37 Ibid., p. 7.

38 Theoharis, *Abuse of Power*.

39 Lyon, *Surveillance After September 11*.

40 Lyon, *Surveillance Studies*.

41 Foucault, 'Docile bodies', p. 87.

42 Lyon, *Surveillance Studies*.

43 Gilliom and Monahan, *Supervisione Surveillance Society*, p. 2.

44 Lyon, *Surveillance Society*.

45 Mann, Steve, and Joseph Ferenbok, 'New Media and the Power Politics of Sousveillance in a Surveillance-Dominated World', *Surveillance and Society*, (2013) 11/1–2 (2013), pp.18–34.

46 Rucka et al., 'Join the mission', p. 4.

47 Rucka, 'Down to earth (1/4)'.

48 Rucka et al., 'Sacrifice', p. 20.

49 Rucka, 'Down to earth (2/4)', p. 6.

50 Rucka, 'Leaks', p. 18.

51 Ibid.

52 Hollinger, *In the Company of Women*, p. 207.

53 Rucka, 'Bitter pills (3/3)'.

54 Rucka, 'Leaks'.

55 Rucka, 'Bitter pills (3/3)', p. 14.

56 Rucka, 'Stoned (5/5)', p. 3.

57 Rucka et al., 'Sacrifice aftermath: affirmative defense', p. 12.

58 Rucka, 'Stoned (5/5)', p. 6.

59 Mirzoeff, *The Visual Culture Reader*.

60 Here I refer to 'Disjuncture and difference in the global cultural economy', in which Appadurai marks the global flow of ideas, religions, people and technologies as a complex landscape of global flows.

61 Abercrombie and Longhurst, *Audiences*, p. 69.

62 Mirzoeff, *The Visual Culture Reader*, p. 1.

63 Hill, *Reality TV*, p. 214.

64 Rucka et al., 'The Bronze Doors', p. 14.

65 Rucka et al., 'Sacrifice (4/4)'.

66 Rucka et al., 'The Calm'.

67 Interestingly, DC brought out a chessboard 2012 in which their characters played similar roles.

68 Rucka et al., 'Sacrifice (4/4)', p. 3.

69 Ibid., p. 22.

70 Ibid., p. 21.

71 O'Reilly, 'The wonder woman precedent', p. 280.

72 Rucka and Raiz, 'Counting coup part 1', p. 9. This situation is similar to that of the twelve labours (Chapter 2) where she was tested by other members of the Justice League. However, in the twelve labours, it was when she regained her powers. In this story arc it is when she is perceived as becoming weaker.

73 Rucka et al., 'Sacrifice', p. 20.

74 Ibid., 21.

75 Rucka et al., 'Sacrifice aftermath', p. 22.

76 Rucka et al., 'Stoned (5/5)', p. 1.

77 Rucka et al., 'Infinite crisis crossover: war in paradise', p. 1.

78 Ibid., p. 4.

79 Ibid., p. 5.

80 Ibid., pp. 14–15.

81 Ibid.

82 Foucault, *The History of Sexuality*, p. 94.

83 They are Diana, Cassandra Sandsmark, daughter of Dr Helena Dansmark and Zeus and Donna Troy, Diana's sister (I simplified this relationship but an explanation can be found on the Donna Troy page of the DC Universe http://dc.wikia.com/wiki/Donna_Troy).

84 There were crossovers of *Wonder Woman*, *Teen Titans*, *Supergirl* and *Catwoman*. See Anon., 'Amazons Attack!'.

85 The stories were collected in a graphic novel, Simone et al., *The Circle.*

6 Whose Story Is It Anyway? Revisiting the Family in the DC Extended Universe

1 I have simplified the events of Flashpoint, The New 52 and Rebirth for reasons of space. However, it is important to include the account of these revisions to contextualize the changing direction of *Wonder Woman* and the character's adaptation in the film. This sets up my discussion of transmedia universes.

2 Stuller, *Ink-Stained Amazons and Cinematic Warriors*, p. 107.

3 Carol Pearson and Katherine Pope, *The Female Hero in American and British Literature* (New York: R.R. Bowker Company, 1981), p. 177, cited in Stuller, *Ink-Stained Amazons and Cinematic Warriors*, p. 108.

4 Campbell, *Hero with a Thousand Faces.*

5 Slotkin, *The Fatal Environment*; Slotkin, *Regeneration through Violence*; Slotkin, *Gunfighter Nation*; Lawrence and Jewett, *The Myth of the American Superhero.*

6 Reynolds, *Super Heroes.*

7 Coogan, *Superhero*, p. 24.

8 Cocca, *Superwomen.*

9 Ibid.

10 Stuller, 'Love will bring you to your gift', p. 94.

11 Thon, 'Converging worlds'.

12 Jenkins, 'Game design as narrative architecture', p. 124.

13 Russo, 'Super group' suggests that copying character interaction was led by Marvel studios president, Kevin Feige. Interest in the developing Marvel Universe was fuelled by a teaser trailer for *The Avengers* at the end of *Iron Man*. It is also useful to note that not all the characters are owned by Disney. Spider-Man was owned by Sony until 2015 when he was reincorporated into MCU and will form part of phase three. X-Men and the Fantastic Four are owned by Fox Entertainment and until 2017. In 2017 Disney bought Fox Entertainment 2017 for $39 billion which changed the whole Marvel EU.

14 Yockey, *Make Ours Marvel.* Hereafter Marvel, as it is Marvel Studios who develop the Marvel Extended Universe.

15 Sweeney, 'From stories to worlds'. For more information about the rise of Marvel see Chapters 2 and 3.

16 *The Defenders* eight-part mini-series was distributed through Netflix. Netflix is an excellent example of how contemporary media work. They stream on demand series and films in over 190 countries. They acknowledge different audience behaviours by offering the entire television series simultaneously encouraging binge-watching like DVD box sets. Rainey, 'How binge-watching has changed TV forever'.

17 For brevity, I concentrate on live action. For more information and discussions of DC animated features see Cocca, *Superwomen*, pp. 45–50. For an overview of *Justice League* and *Super Friends* animations, see Williams, '(R)Evolution of the television superhero'.

18 Brooker, *Batman Unmasked*.

19 Coyle and Aronovich, 'DC superhero girls'.

20 Morrison and Paquette, *Wonder Woman Earth One*.

21 Thomson, *Wonder Woman*. The graphic novel received the Eisner Award 2017 for best original graphic novel. I have not included all the iterations of the character such as the Lego universe and primer reading books in the contemporary media for reasons of space. For a discussion of 'cute' superheroes in the DCEU see Brown, '"I'm the Goshdarn Batman!"'.

22 Seeley et al., 'The River of Lost Years'. *Wonder Woman: Steve Trevor Special* 1, no. 1 (2017).

23 Miller, 'Monthly sales figures 2011, September'.

24 Curtis, 'Wonder woman's symbolic death', p. 308.

25 Pew Research Center, 'Parenting in America'.

26 Waldfogel et al., 'Fragile families and child wellbeing'.

27 Pearlstein, *From Family Collapse to America's Decline*, p. xvii.

28 Waldfogel et al., 'Fragile families and child wellbeing'.

29 Schlafly, *Who Killed the American Family?*, xviii–xiv.

30 Miller, 'Monthly sales figures 2011, September'.

31 Azzarello and Chiang, 'Gods draw blood', p. 10.

32 Ibid., p. 11.

33 Azzarello and Chiang, 'The past unleashed!'.

34 Chapter 5.

35 Ibid., p. 10.

36 Azzarello and Chiang, 'Clay', p. 12.

37 Azzarello and Chiang, 'God down'.

38 Ibid., p. 22.

39 Frazer, *The Golden Bough*.

40 Azzarello and Chiang, 'God down'.

41 Ibid.

42 Tomasi and Santucci, 'Beginnings and Ends', n.p.

43 Eliade and Trask, *The Sacred and the Profane*. See Chapter 4 for an extended discussion of the sacred and the profane.

44 Robinson et al., 'Times past: Jason'. This story covers sixteen issues at the time of writing. As a result, the analysis cannot be as rich as the Azzarello stories that covered thirty-six issues. I include it to show how the heroine's story has been overtaken by that of her brothers and father.

45 See Chapter 4.

46 Robinson and Lupacchino, 'Times past: Jason'.

47 Ibid.

48 Raglan, Fitzroy Richard Somerset, *The Hero: A Study in Tradition, Myth and Drama* (New York: Dover Publications Inc., 2003).

49 Robinson and Lupacchino, 'Swan's song: part one', n.p.

50 Robinson and Lupacchino, 'Swan's end', n.p.

51 Robinson and Segovia, 'Amazons attacked: part one', n.p.

52 Robinson and Lupacchino, 'Amazons attacked: part two', n.p.

53 Robinson and Merino, 'Amazons attacked: part two', n.p.

54 Robinson and Lupacchino, 'Amazons attacked: finale'; Robinson and Segovia, 'The dark gods: part one'.

7 The Once and Future Princess: Nostalgia, Diversity and the Intersectional Heroine

1 Coogler, *Black Panther*.

2 There was a made-for-television film starring Cathy Lee Crosby in 1974; however, this was produced on a small budget and was not a great success.

3 Hughes, '"Wonder Woman" Is Officially the Highest-Grossing Superhero Origin Film'. Marvel's *Black Panther* (2018) has since broken this record.

4 Part of the promotional campaign were female-only screenings in Austin, Texas and Brooklyn, New York. These backfired with complaints from men of gender discrimination. They also did not account for the character's large gay fandom.

5 For instance, *Deadpool* (2016) star Ryan Reynolds posted an Instagram
 14 July 2017 'hearting' *Wonder Woman* when the film beat *Deadpool* at the
 box office. A list of responses to the film can be found at the *Superhero
 News* website in Begley, 'Celebrities React to "Wonder Woman", Gal Gadot,
 and Patty Jenkins'.

6 Sobon, 'Kevin Feige Discusses Marvel/DC Rivalry, Praises Wonder Woman'.
 Ironically Feige said this after April 2017 when Marvel's VP of Sales David
 Gabriel claimed that Marvel sales were slumping because of diverse/female
 characters, a claim that many fans and retailers disputed. Elderkin, 'Marvel
 VP of Sales Blames Women and Diversity for Sales Slump'.

7 The Angel of Mons was an urban myth connected with a short story by Arthur
 Machen, 'The Bowmen', published in *London Evening News*, 29 September
 1914. The bowmen, ghosts of Agincourt soldiers, helped British soldiers in
 their retreat at Mons with a cloud of arrows. The story was regarded as truth
 and out of it grew several stories of angelic helpers from soldiers.

8 Johnston, *Captain America: The First Avenger*. Jenkins set the film in the
 First World War to differentiate it from *Captain America*.

9 Mayor, 'Amazons in all shapes, sizes, and colors: what the Wonder Woman
 movie got right'.

10 Suderman, 'Wonder Woman's battle scenes show how to use — and not use
 — CGI in super-movies'.

11 Mulvey, 'Visual pleasure and narrative cinema'.

12 Becks66, 5 June 2017.

13 TravellingFay, 5 June 2017.

14 Oneragga, 10 June 2017, response to Wampler, 'Wonder Woman is having
 an awesome effect on the world'.

15 Previous chapter, also in Neil Curtis, 'Why Wonder Woman being made the
 daughter of Zeus was wrong' and 'Wonder Woman's symbolic death'.

16 Ryan Lizardi, *Mediated Nostalgia: Individual Memory and Contemporary
 Mass Media* (Lanham, MD: Lexington Books, 2015), p. 2.

17 Geraghty, *Cult Collectors*, p. 2.

18 Lizardi, *Mediated Nostalgia*, p. 6.

19 Geraghty, *Cult Collectors*.

20 Brayton, 'Fic Frodo slash Frodo: fandoms and The Lord of the Rings'.

21 Jenkins, *Convergence Culture*, p. 2.

22 Gordon, *Superman*.

23 Geddes, 'DC Legends of Tomorrow "Helen Hunt"'.

24 Ibid.

25 See Chapter 1.

26 The whole saga can be found at CBR posted 10 February 2015: Dietsch, 'Bombshells: an oral history of the DC collectibles line that exploded in popularity.' See also Chapter 1 for more debate on Rosie the Riveter and good girl art.

27 DC were criticized by fans for using only 1 per cent female creators at the 2011 San Diego Comicon. The Editorial in dccomics.com blog, 29 July 2011, Jim Lee and Dan DiDio DC co-publishers, stated, 'We'll have exciting news about new projects with women creators in the coming months and will be making those announcements closer to publication.' They appear to have kept this promise as there are many more female creators working on several of their superhero titles.

28 Contv.com, 'CONtv Insider: San Diego Comic-Con – Marguerite Bennett Interview'.

29 DC News, 'Marguerite Bennett Talks DC Bombshells at SDCC16'.

30 Hanley, *Wonder Woman Unbound*, p. 221.

31 Stuller, *Ink-Stained Amazons and Cinematic Warriors: Superwomen in Modern Mythology*, p. 43.

32 Ibid.

33 Discussed below.

34 Busch, 'Wonder Woman '77: we interview comics icon Trina Obbins'.

35 Sandifer, *A Golden Thread*, p. 160.

36 Daniels and Kidd, *Wonder Woman*, p. 146.

37 Leyland, 'Amazon Prime: after a 75-year wait, a Wonder Woman Movie is finally upon us', p. 55.

38 Jenkins, 'Amazon Prime, 52'.

39 Marshall, 'Rosetta'.

40 Miller and Pérez, *Smallville Season 11*. Interestingly, a young Wonder Woman was introduced in *Smallville Season 11* 56–8, 60–2, 64–9. In the opening issues she wears a white outfit, later the Gal Gadot costume, quoting the 1970s depowered story arc and looking to the future.

41 Jenkins, 'Welcome to convergence culture'.

42 Stuller, *Ink-Stained Amazons and Cinematic Warriors*, p. 133. Although Stuller refers to the mother/daughter mentorship and passing on the legacy, this notion could be adapted to a passing on the legacy from one generation Wonder Woman to the next.

43 Thornton, *Club Cultures*.
44 Lammers, 'Wonder Woman: Lynda Carter praises "wonderful" movie'.
45 Calvario, 'Lynda Carter and Gal Gadot embrace at "Wonder Woman" red carpet – see the pics!'.
46 Brown, *Dangerous Curves*, p. 235. I use the action heroine and superheroine terms interchangeably as Brown, Cocca and Stuller subsume superheroines in the action heroine category.
47 Cocca, *Superwomen*.
48 Collins and Bilge, 'What is intersectionality?'; Shubha, 'Intersectionality – Bell Hooks'; Cooper, 'Intersectionality'.
49 Collins and Bilge, 'What is intersectionality?', p. 2.
50 Nilsen and Turner, *The Colorblind Screen*.
51 Ibid., pp. 3–4.
52 Beltrán, 'The new Hollywood racelessness'.
53 Ibid., 50. See also Halter, *Shopping for Identity*, p. 3.
54 Beltrán, 'The new Hollywood racelessness', p. 55.
55 Howe and Strauss, *Millennials Rising*, p. 15.
56 West, 'Goodbye, American neoliberalism'.
57 Jacobs et al., '"You can do anything"'. Fahrenthold, 'Trump recorded having extremely lewd conversation about women in 2005'.
58 Suh and Zweiman, 'PUSSYHAT PROJECTTM design interventions for social change'.
59 Razer, 'Comment: Rosie the Riveter's reimagining as a black woman is false history'.
60 Liz and Dillon, *The Legend of Wonder Woman*.
61 Mayor, *The Amazons*.
62 Mayor, 'Amazons in all shapes, sizes, and colors'. Mayor, *The Amazons*.
63 Ibid.
64 Yanes, 'Academics weigh in on Wonder Woman'. My Italics.
65 Ibid.
66 Trank, *Fantastic Four*.
67 Jones, '"Wonder Woman," women of color, and building a diverse Themiscyra'. Knaff, *Beyond Rosie the Riveter*; Honey, *Creating Rosie the Riveter*.
68 Chow, 'The conversation we should not have about Gal Gadot as Wonder Woman'.
69 Senna, 'The mulatto millennium'.

70 Brown, *Beyond Bombshells*; Beltrán, 'The new Hollywood racelessness'; Beltrán and Fojas, 'Miscegenation'.

71 Mueller, 'Wonder Woman: there IS a person of color in the lead role'. Comicbook was launched in 2013 and comments on popular culture franchises such as *Star Wars*, *The Walking Dead* and DC. Their target audiences are individuals who enjoy 'larger-than-life characters' (http://comicbook.com/page/about).

72 Beltrán, 'The new Hollywood racelessness'.

73 Brown, *Beyond Bombshells*.

74 Ibid., p. 80.

75 Chow, 'Wonder woman on Gaza: what would Diana do?'.

76 Coogler, *Black Panther*.

77 Marston and Peter, '*Sensation Comics 9*', p. 13.

78 Thomas et al., 'Beautiful dreamer, death unto thee!'.

79 In the *Sandman* story arc, Lyta is the wife of the original Sandman, Hector Hall, and is pregnant with his child. The child, Daniel, ultimately assumes the mantle of the Lord of Dreams in a dying/reviving God narrative.

80 Miller et al., 'Dark Kn. III master race'.

81 Waid and Ross, *Kingdom Come*.

82 Castellucci et al., 'Milk wars part 3'.

83 Kittredge and Hampton, 'A day in our lives'.

84 Ibid, n.p.

85 Cocca, *Superwomen*.

86 Santori, 'Exclusive interview'.

87 Foucault, *The History of Sexuality*.

88 Roberts, 'Church of England tells schools to let children "explore gender identity"'. Anon, 'Supporting trans members: what you should consider to support trans people within girlguiding'.

89 Gray et al., 'Superwoman/Batwoman'.

90 Jones, '"Wonder Woman," women of color, and building a diverse Themiscyra'.

Bibliography

Aarne, Antti Amatus and Stith Thompson, *The Types of the Folk-Tale* (Helsinki: Suomalainen Tiedeakatemia, 1928).

Abercrombie, Nicholas, and Brian Longhurst, *Audiences: A Sociological Theory of Performance and Imagination* (London: Sage, 1998).

Adler, Margot, *Drawing down the Moon: Witches, Druids, Goddess-Worshippers, and Other Pagans in America Today* (Boston, MA: Beacon Press, 1986).

Alaniz, José, *Death, Disability, and the Superhero: The Silver Age and Beyond* (Jackson, MS: University Press of Mississippi, 2014).

Alexander, James Roger, 'The art of making war: the political poster in global conflict', in M. Paul Holsinger and Mary Anne Schofield (eds), *Visions Of War: World War II in Popular Literature and Culture* (Bowling Green, OH: Bowling Green State University Press, 1992), pp. 114–26.

Althusser, Louis, 'Ideology and ideological state apparatuses', in Antony Easthope and Kate McGowan (eds), *A Critical and Cultural Theory Reader* (Maidenhead: Open University Press, 1992), pp. 42–50.

Amis, Kingsley, 'Looking-in Is Looking Up!', *TV Times*, 9–15 February 1964, p. 7.

Anderson, Benedict R. O'G., *Imagined Communities: Reflections on the Origin and Spread of Nationalism* (London: Verso, 1991).

Andrae, Thomas, 'From menace to messiah: the prehistory of the Superman in science fiction literature', *Discourse* 2 (1980), pp. 84–112.

Andreyko, Marc, Jeff Parker and David Hahn (illus.), *Batman '66 Meets Wonder Woman '77* (Mt Laurel, NJ: DC Comics, 2017).

Andreyko, Marc, Trina Robbins, Ruth Fletcher Gage, Amanda Deibert, Amy Chu, Richard Ortiz (illus.), Christian Duce (illus.) et al., *Wonder Woman '77* (Burbank, CA: DC Comics, 2016).

Anker, Elisabeth, 'Villains, victims and heroes: melodrama, media, and September 11', *Journal of Communication* 55/1 (2005), pp. 22–37.

Anon. 'Amazons attack!' *Comic Book Reading Orders*, 2007. https://comicbookreadingorders.com/dc/events/amazons-attack-reading-order/ (accessed 18 March 2016).

Anon. 'Supporting trans members: what you should consider to support trans people within girlguiding'. *We Discover, We Grow, Girlguiding*, 2018. https://www.girlguiding.org.uk/making-guiding-happen/running-your-unit/

including-all/lgbt-members/supporting-trans-members/ (accessed 19 March 2018).

Anon. 'Wonder Woman/Covers'. *DC Database*, 2018 http://dc.wikia.com/wiki/Wonder_Woman/Covers (accessed 16 March 2018).

Appadurai, Arjun, 'Disjuncture and difference in the global cultural economy', *Public Culture* 2/2 (1990), pp. 1–24.

Arnold, Jack (dir.), *The Incredible Shrinking Man* (USA: Universal-International, 1957).

Ashby, Timothy, 'Alabama's anti-immigration law – xenophobia is also part of American history', 13 December 2011. Available at http://timashby.com/50/#more-50 (accessed 20 November 2016).

Azzarello, Brian and Cliff Chiang, 'Gods draw blood', *Wonder Woman* 4/2 (December 2011).

Azzarello, Brian and Cliff Chiang, 'Clay', *Wonder Woman* 4/3 (January 2012).

Azzarello, Brian and Cliff Chiang, 'Birth right', *Wonder Woman* 4/12 (October 2012).

Azzarello, Brian and Cliff Chiang, 'Sin of the father', *Wonder Woman* 4/13 (October 2012).

Azzarello, Brian and Cliff Chiang, 'God down', *Wonder Woman* 4/23 (October 2013).

Babic, Annessa Ann, 'Wonder Woman as patriotic icon: the Amazon princess for the nation and femininity', in Annessa Ann Babic (ed.), *Comics as History, Comics as Literature: Roles of the Comic Book in Scholarship, Society, and Entertainment* (Madison, NJ: Fairleigh Dickinson University Press, 2013), pp. 93–106.

Bakhtin, Mikhail M., *Rabelais and his World* (Cambridge, MA: MIT Press, 1968).

Balsamo, Anne Marie, *Technologies of the Gendered Body* (Durham, NC: Duke University Press, 1996).

Baofu, Peter, *The Future of Post-Human Migration* (Newcastle upon Tyne: Cambridge Scholars Publishing, 2012).

Barson, Michael and Steven Heller, *Red Scared! America's Struggle Against the Commie Menace* (San Francisco, CA: Chronicle Books, 2001).

Baudrillard, Jean, *Simulations*, trans. Paul Foss (New York: Semiotext(e), 1983).

Baudrillard, Jean, *Ecstasy of Communication*, ed. Sylvère Lotringer, trans. Bernard and Caroline Schutze (New York: Autonomedia, 1988).

Beard, Mary, 'The public voice of women', *A Don's Life* blog, *TLS*, 15 February 2014. Available at https://www.the-tls.co.uk/the-public-voice-of-women/ (accessed 20 April 2017).

Begley, Chris, 'Celebrities react to "Wonder Woman", Gal Gadot, and Patty Jenkins', *Superhero News*, 4 June 2017. Available at http://batman-news. com/2017/06/04/celebrities-react-wonder-woman-gal-gadot/ (accessed 16 July 2017).

Beland, Richard, 'Girls read comics', *Jungle Frolics*, 19 March 2011. Available at http://junglefrolics.blogspot.co.uk/2011/03/girls-read-comics.html?fref=gc (accessed 22 August 2017).

Belk, Russell W., Melanie Wallendorf and John F. Sherry Jr, 'The sacred and the profane in consumer behavior: theodicy on the Odyssey', *Journal of Consumer Research* 16/1 (1989), pp. 1–38.

Beltrán, Mary C., 'The new Hollywood racelessness: only the fast, furious, (and multiracial) will survive', *Cinema Journal* 44/2 (2005), pp. 50–67.

Beltrán, Mary C. and Camilla Fojas, 'Miscegenation: mixed race and the imagined nation', in Mary C. Beltran and Camilla Fojas (eds), *Mixed Race Hollywood* (New York: New York University Press, 2008), pp. 1–20.

Bennett, Tony, 'The Bond phenomenon: theorising a popular hero', *Southern Review* 16/2 (1983), pp. 195–225.

Benton, Robert (dir.), *Kramer vs. Kramer* (USA: Columbia Pictures, 2001).

Bergson, Henri, *Matter and Memory*, trans. Nancy M. Paul and W. Scott Palmer (London: George Allen & Unwin, 1911).

Berlatsky, Noah, *Wonder Woman: Bondage and Feminism in the Marston/Peter Comics, 1941–1948* (New Brunswick, NJ: Rutgers University Press, 2015).

Berns, Fernando Gabriel Pagnoni, 'War, foreign policy and the media: The Rucka years', in Joseph J. Darowski (ed.), *The Ages of Wonder Woman: Essays on the Amazon Princess in Changing Times* (Jefferson, NC: McFarland and Co., 2014), pp. 194–204.

Bilson, Bruce (dir.), 'Pilot: The New Original Wonder Woman' (USA: ABC, 1975).

Bordo, Susan, *Unbearable Weight: Feminism, Western Culture, and the Body* (Berkeley, CA: University of California Press, 1993).

Bourdieu, Pierre, *Distinction: A Social Critique of the Judgment of Taste*, trans. Richard Nice (London: Routledge, 1986).

Bowie, Stephen, 'Wonder Woman: An Early Attempt', *Television Obscurities: Keeping Obscure TV From Fading Away Forever*, 2016. Available at http:// www.tvobscurities.com/articles/wonder_woman/ (accessed 7 December 2017).

Boyer, Paul S., *By the Bomb's Early Light* (New York: Pantheon, 1985).

Brake, Mike, *Comparative Youth Culture: The Sociology of Youth Cultures and Youth Subcultures in America, Britain, and Canada* (London: Routledge & Kegan Paul, 1985).

Brayton, Jennifer, 'Fic Frodo Slash Frodo: Fandoms and The Lord of the Rings', in Ernest Mathijs and Murray Pomerance (eds), *From Hobbits to Hollywood: Essays on Peter Jackson's Lord of the Rings* (Amsterdam: Rodopi, 2006), pp. 137–63.

Brooker, Will, *Batman Unmasked: Analysing a Cultural Icon* (London: Continuum, 2000).

Brown, Helen Gurley, *Sex and the Single Girl* (London: New English Library, 1964).

Brown, Jeffrey A., *Black Superheroes, Milestone Comics, and Their Fans* (Jackson, MS: University Press of Mississippi, 2001).

Brown, Jeffrey A., *Dangerous Curves: Action Heroines, Gender, Fetishism and Popular Culture* (Jackson, MS: University of Mississippi Press, 2011).

Brown, Jeffrey A., 'Gender, sexuality, and toughness: the bad girls of action film and comic books', in Sherrie Innes (ed.), *Action Chicks: New Images of Tough Women in Popular Culture* (London: Palgrave Macmillan, 2015), pp. 47–74.

Brown, Jeffrey A., *Beyond Bombshells: The New Action Heroine in Popular Culture* (Jackson, MS: University of Mississippi Press, 2018).

Brown, Jeffrey A., '"I'm the goshdarn Batman!" Affect and the aesthetics of cute superheroes', *Journal of Graphic Novels and Comics* 9/2 (2018), pp. 119–36.

Brownie, Barbara and Danny Graydon, *The Superhero Costume: Identity and Disguise in Fact and Fiction* (London: Bloomsbury, 2016).

Bukatman, Scott, 'Secret identity politics', in Angela Ndalianis (ed.), *The Contemporary Comic Book Superhero* (Abingdon: Routledge, 2009), pp. 109–25.

Bunn, Geoffrey C., 'The lie detector, Wonder Woman and liberty: the life and work of William Moulton Marston', *History of the Human Sciences* 10/1 (1997), pp. 91–119.

Burr, Clinton Stoddard, *America's Race Heritage* (New York: National Historical Society, 1922).

Busch, Jenna, 'Wonder Woman '77: we interview comics icon Trina Obbins', *Legion of Leia*, 2016. http://legionofleia.com/2016/09/wonder-woman-77-we-interview-comics-icon-trina-robbins/ (accessed 22 November 2017).

Bush, George, 'State of the Union address: text of George Bush's speech',
Guardian, 21 September 2001. Available at https://www.theguardian.com/
world/2001/sep/21/september11.usa13 (accessed 14 August 2017).

Butler, Judith, 'Gender insubordination', in Diana Fuss (ed.), *Inside/Out:
Lesbian Theories, Gay Theories* (London: Routledge, 1991), pp 13–32.

Butler, Judith, *Gender Trouble* (New York; London: Routledge, 1999).

Buxton, David, *From the Avengers to Miami Vice: Form and Ideology in
Television Series* (Manchester: Manchester University Press, 1990).

Byrne, John, 'Ascension', *Wonder Woman* 127 (November 1997).

Calvario, Liz, 'Lynda Carter and Gal Gadot embrace at "Wonder Woman" red
carpet – see the pics!', *ET*, 25 May 2017. Available at http://www.etonline.
com/news/218415_lynda_carter_and_gal_gadot_embrace_at_wonder_
woman_red_carpet_see_the_pics/ (accessed 9 July 2017).

Campbell, D'Ann, *Women at War with America* (Cambridge, MA: Harvard
University Press, 1984).

Campbell, Joseph, *Hero with a Thousand Faces* (Princeton, NJ: Princeton
University Press, 1972).

Castellucci, Cecil, Frank Quitely, Mirka Andolfo, and Sonny Liew, 'Milk Wars
Part 3', *Shade the Changing Girl/Wonder Woman 1* 1/3 (February 2018).

Castle, Terry, *Masquerade and Civilization: The Carnivalesque in Eighteenth-
Century English Culture and Fiction* (Stanford, CA: Stanford University
Press, 1986).

CBR News, 'Gal Gadot responds to her Wonder Woman detractors', 2014.
Available at http://community.comicbookresources.com/showthread.
php?35916-Gal-Gadot-Responds-To-Her-Wonder-Woman-Detractors&hi
ghlight=gadot+body (accessed 31 July 2017).

Charlesworth, Simon J., *A Phenomenology of Working Class Experience*
(Cambridge: Cambridge University Press, 2000).

Chesler, Phyllis, 'The Amazon legacy: an interpretive essay', in Gloria Steinem
(ed.), *Wonder Woman* (New York: Holt, Rinehart and Winston, 1972), n.p.

Chow, Keith, 'The conversation we should not have about Gal Gadot as
Wonder Woman'. *The Nerds of Color*, 2013. https://thenerdsofcolor.
org/2013/12/06/the-conversation-we-should-not-have-about-gal-gadot-
as-wonder-woman/ (accessed 9 January 2018).

Chow, Keith, 'Wonder Woman on Gaza: what would Diana do?' *The Nerds of
Color*, 2014. https://thenerdsofcolor.org/2014/07/30/wonder-woman-on-
gaza-what-would-diana-do/ (accessed 9 January 2018).

Christ, Carol P. and Judith Plaskow, *Womanspirit Rising: A Feminist Reader in Religion* (San Francisco, CA: Harper & Row, 1979).

Cocca, Carolyn, 'The "broke back test": a quantitative and qualitative analysis of portrayals of women in mainstream superhero comics, 1993–2013', *Journal of Graphic Novels and Comics* 5/4 (2014), pp. 411–28.

Cocca, Carolyn, 'Negotiating the third wave of feminism in Wonder Woman', *PS: Political Science & Politics* 47/1 (2014), pp. 98–103.

Cocca, Carolyn, *Superwomen: Gender, Power, and Representation* (New York: Bloomsbury, 2016).

Cohen, Jeffrey Jerome (ed.), *Monster Theory* (Minneapolis, MN: University of Minnesota Press, 1998).

Collins, Pamela Hill, and Sirma Bilge, 'What is intersectionality?' in Pamela Hill Collins and Sirma Bilge (eds), *Intersectionality*, (Cambridge; Malden MA: Polity Press, 2016), pp. 1–30.

Colon, Eddie, 'Wonder Words,' *Wonder Woman* 1/304 (1983), p. 21.

Concerned United Nations staff members, 'Petition: Wonder Woman shouldn't be the UN's Honorary Ambassador for the Empowerment of Women and Girls', *Care2 Petitions*, 2016. Available at http://www.thepetitionsite.com/en-gb/741/288/432/reconsider-the-choice-of-honorary-ambassador-for-the-empowerment-of-women-and-girls/ (accessed 19 March 2017).

Conekin, Becky E., 'From haughty to nice: how British fashion images changed from the 1950s to the 1960s', *Photography and Culture* 3/3 (2010), pp. 283–96.

Contv.com. 'CONtv Insider: San Diego Comic-Con – Marguerite Bennett interview', *San Diego Comicon*, 2016. https://www.youtube.com/watch?v=hcQHD6XcFok (accessed 4 December 2017).

Coogan, Peter, *Superhero: The Secret Origin of a Genre* (Austin, TX: Monkey Brain Books, 2006).

Coogler, Ryan (dir.), *Black Panther* (USA: Walt Disney Studios, 2018).

Cooper, Brittney, 'Intersectionality', in Lisa Disch and Mary Hawksworth (eds), *The Oxford Handbook of Feminist Theory* (Oxford: Oxford University Press 2015), pp. 1–15.

Cooter, Roger and Stephen Pumfrey, 'Separate spheres and public places: reflections on the history of science popularization and science in popular culture', *History of Science* 32/97 (1994), pp. 237–67.

Cornfeld, Betty and Owen Edwards, *Quintessence: The Quality of Having It* (New York: Black Dog and Leventhal, 1983).

Coyle, Jennifer and Cecelia Aronovich, *DC Superhero Girls* (USA: Warner Bros. Animation, DC Comics, 2015).

Craik, Jennifer, *The Face of Fashion: Cultural Studies in Fashion* (London: Routledge, 1993).

Craik, Jennifer, *Uniforms Exposed: From Conformity to Transgression* (Oxford: Berg, 2005).

Creed, Barbara, *The Monstrous Feminine: Film, Feminism, Psychoanalysis* (London: Routledge, 1993).

Csordas, Thomas J., *Embodiment and Experience: The Existential Ground of Culture and Self* (Cambridge: Cambridge University Press, 1994).

Curtis, Neal, 'Wonder Woman's symbolic death: on kinship and the politics of origins', *Journal of Graphic Novels and Comics* 8/4 (2017), pp. 307–20.

Daniels, Les and Chip Kidd, *Wonder Woman* (San Francisco, CA: Chronicle Books, 2000).

Darowski, Joseph J., '"I no longer deserve to belong": the Justice League, Wonder Woman and the twelve labors', in Joseph J. Darowski (ed.), *The Ages of Wonder Woman: Essays on the Amazon Princess in Changing Times* (Jefferson, NC: McFarland and Co., 2014), pp. 126–35.

Darowski, Joseph J. and Virginia Rush, 'Greek, Roman or American? Wonder Woman's roots in DC's New 52', in Joseph J. Darowski (ed.), *The Ages of Wonder Woman: Essays on the Amazon Princess in Changing Times* (Jefferson, NC: McFarland and Co., 2014), pp. 223–32.

Daves, Delmer (dir.), *Hollywood Canteen* (USA: Warner Brothers, 1944).

de Beauvoir, Simone, *The Second Sex*, ed. and trans. H.M. Parshley (London: Penguin Books, 1997).

Deleuze, Gilles and Felix Guattari, *A Thousand Plateaus: Capitalism and Schizophrenia*, trans. Brian Massumi (Minneapolis, MN: University of Minnesota, 1987).

Denning, Michael, 'Licensed to look: James Bond and the heroism of consumption', in Christoph Lindner (ed.), *The James Bond Phenomenon: A Critical Reader* (Manchester: Manchester University Press, 2003), pp. 56–75.

Derrida, Jacques, *Of Grammatology* (Baltimore, MD: Johns Hopkins University Press, 1976).

Derrida, Jacques, Catherine Porter and Philip Lewis, 'No apocalypse, not now (full speed ahead, seven missiles, seven missives)', *Diacritics* 14/2 (1984), pp. 20–31.

Deschanel, Zooey, Molly McAleer and Sophie Rossi, 'The "Wonder Woman" Amazon warriors have the most badass jobs', *Hello Giggles*, Facebook, 2017.

Available at https://www.facebook.com/hellogiggles/videos/
1598245100199888/ (accessed 31 July 2017).

Dietsch, T.J. 'Bombshells: an oral history of the DC collectibles line that
exploded in popularity', *CBR Comic News*, 2015. https://www.cbr.com/
bombshells-an-oral-history-of-the-dc-collectibles-line-that-exploded-in-
popularity/ (accessed 4 December 2017).

Donner, Richard (dir.), *Superman* (USA: Warner Bros., 1989).

Dormehl, Luke, 'The wonder stuff', *SFX* 288 (2017), pp. 51, 53.

dos Santos, Joaquim and Dan Riba (dirs), *Justice League Unlimited* (USA:
Warner Bros. Television Distribution, 2004–6).

DuBois, Page, *Centaurs and Amazons: Women and the Pre-History of the Great
Chain of Being* (Ann Arbor, MI: University of Michigan Press, 1991).

Duran, Nathan H. (dir.), *The Attack of the Fifty Foot Woman* (USA: Monogram
Pictures, 1958).

Durkheim, Émile, *The Elementary Forms of the Religious Life*, trans. Joseph
Ward Swain (New York: Free Press, 1965).

Dyer, Richard, *Heavenly Bodies: Film Stars and Society* (Basingstoke:
Macmillan, 1986).

Eastman, Max, *Child of the Amazons* (New York: M. Kennerley, 1913).

Eco, Umberto, 'Narrative structures in Fleming', in Christoph Lindner (ed.),
The James Bond Phenomenon: A Critical Reader (Manchester: Manchester
University Press, 2003), pp. 34–55.

Elderkin, Beth, 'Marvel VP of sales blames women and diversity for sales
slump', *Gizmodo*, 1 April 2017. Available at http://io9.gizmodo.com/marvel-
vp-blames-women-and-diversity-for-sales-slump-1793921500 (accessed
31 July 2017).

Eliade, Mircea, *Patterns in Comparative Religion* (New York: Sheed & Ward,
1958).

Eliade, Mircea, *The Sacred and the Profane: The Nature of Religion*, trans.
Willard R. Trask, (New York: Harcourt, Brace & World, 1959).

Emad, Mitra C., 'Reading Wonder Woman's body: mythologies of gender and
nation', *Journal of Popular Culture* 39/6 (2006), pp. 954–84.

Engelhardt, Tom, *The End of Victory Culture: Cold War America and the
Disillusioning of a Generation* (New York: Basic Books, 1995).

Entwistle, Joanne, *The Fashioned Body: Fashion, Dress and Modern Social
Theory* (Cambridge: Polity Press, 2000).

Evans, Caroline and Minna Thornton, *Women and Fashion: A New Look*
(London: Quartet, 1989).

Fahrenthold, David A., 'Trump recorded having extremely lewd conversation about women in 2005', *The Washington Post*, 8 October 2016. https://www.washingtonpost.com/politics/trump-recorded-having-extremely-lewd-conversation-about-women-in-2005/2016/10/07/3b9ce776-8cb4-11e6-bf8a-3d26847eeed4_story.html?postshare=3561475870579757&tid=ss_tw&utm_term=.470583f85bb6 (accessed 9 January 2016).

Faludi, Susan, *Backlash: The Undeclared War against American Women* (New York: Crown, 1991).

Faludi, Susan, *The Terror Dream: Fear and Fantasy in Post-9/11 America* (New York: Metropolitan Books, 2007).

Featherstone, Mike, 'The body in consumer culture', *Theory, Culture and Society* 1/2 (1982), pp. 18–33.

Featherstone, Mike, 'Lifestyle and consumer culture', *Theory, Culture and Society* 4/1 (1987), pp. 55–70.

Fielding, Jerry (dir.), *The Bionic Woman* (USA: ABC, 1976).

Finn, Michelle R., 'William Marston's feminist agenda', in Joseph J. Darowski (ed.), *The Ages of Wonder Woman: Essays on the Amazon Princess in Changing Times* (Jefferson, NC: McFarland and Co., 2014), pp. 7–21.

Fogg, Marnie, *Boutique: A '60s Cultural Phenomenon* (London: Mitchell Beazley, 2003).

Forbes, Bryan (dir.), *The Stepford Wives* (USA: Columbia Pictures, 1975).

Ford, Elizabeth and Deborah C. Mitchell, *The Makeover in Movies* (Jefferson, NC: McFarland and Co., 2004).

Foucault, Michel, *Discipline and Punish: The Birth of the Prison*, trans. Alan Sheridan (New York: Pantheon Books, 1977).

Foucault, Michel, *The History of Sexuality*, Vol. 1: *An Introduction*, trans. Robert Hurley (New York: Random House, 1978).

Foucault, Michel, 'Docile bodies', in Paul Rabinow (ed.), *Essential Works of Foucault* (New York: Pantheon Books, 1984), pp. 179–87.

Foucault, Michel, *The Foucault Reader*, ed. Paul Rabinow (New York: Pantheon Books, 1984).

Frazer, Sir James George, *The Golden Bough: A Study in Magic and Religion* (Oxford: Oxford University Press, 1998).

Freeman, Hadley, 'James Cameron: "The downside of being attracted to independent women is that they don't need you"', *Guardian*, 24 August 2017. Available at https://www.theguardian.com/film/2017/aug/24/james-cameron-well-never-be-able-to-reproduce-the-shock-of-terminator-2 (accessed 27 August 2017).

Friedan, Betty, *The Feminine Mystique* (New York: W.W. Norton, 1963).

Friedman, John Block, *The Monstrous Races in Medieval Art and Thought* (Cambridge, MA: Harvard University Press, 1981).

Fry, Brian, *Nativism and Immigration: Regulating the American Dream* (New York: LFB Scholarly Publishing LCC, 2007).

Gabilliet, Jean-Paul, *Of Comics and Men: A Cultural History of Comic Books*, trans. Bart Beaty, and Nick Nguyen (Jackson, MS: University of Mississippi Press, 2010).

Gage, Christos (w), Georges Jeanty (a) and Dan Jackson (a), *Buffy the Vampire Slayer Season 8*. Portland: Dark Horse Comics, n.d.

Geddes, David (dir.), *DC Legends of Tomorrow 'Helen Hunt'* (USA: Warner Bros. Television Distribution, 2017).

Geraghty, Lincoln, *Cult Collectors: Nostalgia, Fandom and Collecting Popular Culture* (New York: Routledge, 2014).

Gerber, David (dir.), *Police Woman* (USA: Sony Pictures Television, 1974).

Gerding, Stephen, 'Wonder Woman: Patty Jenkins would not have cast Gal Gadot', *CBR: Movie News*, 9 June 2017. Available at http://www.cbr.com/wonder-woman-director-not-cast-gal-gadot/ (accessed 29 July 2017).

Gibson, Mel, '"You can't read them, they're for boys!" British girls, American superhero comics and identity', *International Journal of Comic Art* 5/1 (2003), pp. 239–49.

Gillmore, Inez Haynes, *Angel Island* (New York: New American Library, 1988).

Glossop, Neil, 'Readers' letters', *Wonder Woman* 1/197 (1971), p. 48.

Goffman, Erving, *The Presentation of Self in Everyday Life* (Garden City, NY: Doubleday, 1959).

Gordon, Ian, *Superman: The Persistence of an American Icon* (New Brunswick, NJ: Rutgers University Press, 2017).

Goulding, Edmund and John Gilbert (dirs). *Love*. USA: Metro-Goldwyn-Mayer, 1927.

Grant, Madison *The Passing of the Great Race: Or, the Racial Basis of European History* (New York: Charles Scribner's Sons, 1916).

Graves, Robert, *The White Goddess: A Historical Grammar of Poetic Myth* (New York: Farrar, Straus and Giroux, 1966).

Greenwald, Maurine Weiner, *Women, War, and Work: the impact of World War I on women workers in the United States* (Westport, CT: Greenwood Press, 1980).

Greer, Germaine, *The Female Eunuch* (London: Paladin, 1971).

Grenier, Cynthia, 'Secret agent girls', *Cosmopolitan* (April 1966), pp. 56–7.

Hack, Brian E., 'Weakness is a crime: Captain America and the eugenic ideal in early twentieth-century America', in Robert Weiner (ed.), *Captain America and the Struggle of the Superhero: Critical Essays* (Jefferson, NC: McFarland and Co., 2014), pp. 79–89.

Hajdu, David, *'The Ten-Cent Plague': The Great Comic-Book Scare and How It Changed America*, (New York: Picador, 2009).

Hakim, Catherine, *Honey Money* (London: Allen Lane, 2011).

Halter, Marilyn, *Shopping for Identity: The Marketing of Ethnicity* (New York: Schocken Books, 2000).

Hanley, Tim, *Wonder Woman Unbound: The Curious History of the World's Most Famous Heroine* (Chicago, IL: Chicago Review Press, 2014).

Haraway, Donna, *Simians, Cyborgs and Women: The Reinvention of Nature* (New York: Routledge, 1991).

Hart, Sue, 'Madison Avenue goes to war: patriotism in advertising during World War II', in M. Paul Holsinger and Mary Anne Schofield (eds), *Visions of War: World War II in Popular Literature and Culture* (Bowling Green, OH: Bowling Green State University Press, 2015), pp. 114–26.

Hartmann, Susan M., *The Home Front and Beyond* (Boston, MD: Twayne Publishers, 1982).

Haskell, Molly, *From Reverence to Rape: The Treatment of Women in the Movies* (New York: Rinehart and Winston, 1974).

Hefner, Hugh M., 'The *Playboy* philosophy', *Playboy*, December 1962.

Heinberg, Allan, Terry Dodson (illus.) and Rachel Dodson (illus.), 'Who is Wonder Woman?', *Wonder Woman* (August 2006).

Heinecken, Dawn, *The Warrior Women of Television: A Feminist Cultural Analysis of the New Female Body in Popular Media* (New York: Peter Lang, 2003).

Higgins, Colin (dir.), *9 to 5* (USA: 20th Century Fox, 1980).

Hill, Annette, *Reality TV: Audiences and Popular Factual Television* (London: Routledge, 2005).

History.state.gov. 'The Immigration Act of 1924 (The Johnson–Reed Act) – 1921–1936 – Milestones – Office of the Historian', Washington, 2015. http://history.state.gov/milestones/1921-1936/immigration-act (accessed 30 April 2017).

Hoffman, Shirl J., *Sport and Religion* (Champaign, IL: Human Kinetics Books, 1992).

Hollinger, Karen, *In the Company of Women: Contemporary Female Friendship Films* (Minneapolis, MN: University of Minnesota Press, 1998).

Hollows, Joanne, *Feminism, Femininity, and Popular Culture* (Manchester: Manchester University Press, 2000).

Honey, Maureen, *Creating Rosie the Riveter: Class, Gender, and Propaganda During World War II,* (Amherst, MA: University of Massachusetts Press, 1985).

Hopper, Dennis (dir.), *Easy Rider* (USA: Columbia Pictures, 1968).

Howe, Neil, and William Strauss, *Millennials Rising: The Next Great Generation* (New York: Vintage, 2000).

Hughes, Mark, "'Wonder Woman' is officially the highest-grossing superhero origin film', *Forbes*, n.d. https://www.forbes.com/sites/markhughes/2017/11/02/wonder-woman-is-officially-the-highest-grossing-superhero-origin-film/#9d23180ebd9e (accessed 13 November 2017).

Humberstone, H. Bruce (dir.), *Pin Up Girl* (USA: 20th Century Fox, 1944).

Irigaray, Luce, 'This sex which is not one' [1977], in Carole R. McCann and Seung-Kyung Kim (eds), *Feminist Theory Reader: Local and Global Perspectives*, 2nd edn (New York: Routledge, 2010), pp. 384–9.

Jackson, Rosemary, *Fantasy, The Literature of Subversion* (London: Methuen, 1981).

Jacobs, Ben, Sabrina Siddiqui and Scott Bixby, '"You can do anything": Trump brags on tape about using fame to get women', *Guardian*, 8 October 2016. https://www.theguardian.com/us-news/2016/oct/07/donald-trump-leaked-recording-women (accessed 1 April 2017).

Jancovich, Mark, *Rational Fears: American Horror in the 1950s* (Manchester: Manchester University Press, 1996).

Jeffords, Susan, *Hard Bodies: Hollywood Masculinity in the Reagan Era* (New Brunswick, NJ: Rutgers University Press, 1994).

Jenkins, Henry, *Convergence Culture: Where Old and New Media Collide* (New York: New York University Press, 2007).

Jenkins, Henry, "Welcome to convergence culture." *Confessions of an ACA-Fan*, 2006. http://henryjenkins.org/blog/2006/06/welcome_to_convergence_culture.html.

Jenkins, Henry, 'Game design as narrative architecture', *Response* 44/3 (2003), pp. 118–30. Available at http://homes.lmc.gatech.edu/~bogost/courses/spring07/lcc3710/readings/jenkins_game-design.pdf (accessed 9 July 2017).

Jenkins, Patty, @PattyJenks, Twitter, 24 August 2017. Available at https://twitter.com/PattyJenks?ref_src=twsrc%5Etfw&ref_url=https%3A%2F%2Fwww.vox.com%2Fculture%2F2017%2F8%2F25%2F

16201518%2Fwonder-woman-james-cameron-patty-jenkins (accessed 27 August 2017).

Jenkins, Patty (dir.), *Wonder Woman* (Warner Brothers, USA, 2017).

Johns, Geoff, Jason Fabok, Brad Anderson and Francis Manapul, *Justice League Volume 8: Darkseid War Part 2* (Burbank, CA: DC Comics, 2016).

Johnston, Joe (dir.), *Captain America: The First Avenger* (USA: Paramount Pictures, 2011).

Jones, Caroline A. and Bill Arning, *Sensorium: Embodied Experience, Technology, and Contemporary Art* (Cambridge, MA: MIT Press, 2006).

Jones, Gerard and Will Jacobs, *The Comic Book Heroes: The First History of Modern Comic Books – From the Silver Age to the Present* (Rocklin, CA: Prima Publishing, 1997).

Jones, Monique, '"Wonder Woman," women of color, and building a diverse Themiscyra', *Film: Blogging the Reel World*, 2017. http://www.slashfilm.com/women-of-color-in-wonder-woman/2/ (accessed 23 November 2017).

Jurgens, Dan, Louise Simonson, Roger Stern, Jerry Ordway, Karl Kesel, William Messner-Loebs and Gerard Jones, *The Death of Superman* (New York: DC Comics, 1992).

Kanigher, Robert, Ross Andru and Mike Esposito, 'The secret origin of Wonder Woman', *Wonder Woman* 1/105 (April 1959).

Kanigher, Robert, Ross Andru and Mike Esposito, 'The human charm bracelet!', *Wonder Woman* 1/106 (May 1959).

Kanigher, Robert, Ross Andru and Mike Esposito, 'Wonder Girl in Giant Land!', *Wonder Woman* 1/109 (October 1959).

Kanigher, Robert, Ross Andru and Mike Esposito, 'Amazon magic-eye album!', *Wonder Woman* 1/123 (July 1961).

Kanigher, Robert, Ross Andru and Mike Esposito, 'The Impossible Day!', *Wonder Woman* 1/124 (August 1961).

Kanigher, Robert, Ross Andru and Mike Esposito, 'Wonder Woman's surprise honeymoon!', *Wonder Woman* 1/127 (January 1962).

Kanigher, Robert, Ross Andru and Mike Esposito, 'The origin of the amazing invisible plane!', *Wonder Woman* 1/128 (February 1962).

Kanigher, Robert, Ross Andru and Mike Esposito, 'The return of Multiple Man!', *Wonder Woman* 1/129 (April 1962).

Kanigher, Robert, Ross Andru and Mike Esposito, 'Wonder queen fights Hercules', *Wonder Woman* 1/132 (August 1962).

Kanigher, Robert, Ross Andru and Mike Esposito, 'Attack of the human iceberg', *Wonder Woman* 1/135 (January 1963).

Kanigher, Robert, Ross Andru and Mike Esposito, 'The kite of doom!', *Wonder Woman* 1/138 (May 1963).

Kanigher, Robert, Ross Andru, Mike Esposito, and Don Heck, 'The second life of Wonder Woman!', *Wonder Woman* 1/204 (February 1973).

Kanigher, Robert and Irving Novick, 'The Superman-Wonder Woman Team!', *Lois Lane Superman's Girl Friend* 1/93 (July 1969).

Keizer, Garret, 'Homeward bound', *New York Times Book Review* (2 March, 2012).

Kennedy, John F., 'The new frontier', *American Rhetoric Online Speech Bank*, 1960. Available at http://www.americanrhetoric.com/speeches/jfk1960dnc. htm (accessed 19 August 2017).

Kittredge, Caitlin and Scott Hampton, 'A day in our lives', *Sensation Comics Featuring Wonder Woman* 1/16 (2016).

Knaff, Donna B., 'A most thrilling struggle: Wonder Woman as wartime and post-war feminist', in Joseph J. Darowski (ed.), *The Ages of Wonder Woman: Essays on the Amazon Princess in Changing Times* (Jefferson, NC: McFarland and Co., 2014), pp. 22–9.

Knaff, Donna B., *Beyond Rosie the Riveter: Women of World War II in American Popular Graphic Art* (Lawrence, KS: University Press of Kansas, 2012).

Knudde, Kjell, 'Harry G. Peter', *Lambiek Comiclopedia*, 2018. https://www. lambiek.net/artists/p/peter-hg.htm (accessed 16 March 2018).

Kohl, Paul R., 'Wonder Woman's lib: feminism and the "new" amazing Amazon', in Joseph J. Darowski (ed.), *The Ages of Wonder Woman: Essays on the Amazon Princess in Changing Times* (Jefferson, NC: McFarland and Co., 2014), pp. 90–100.

Kristeva, Julia, *Powers of Horror: An Essay in Abjection*, trans. Leon S. Roudiez (New York: Columbia University Press, 1982).

Kuznick, Peter J. and James Gilbert, 'US culture and the Cold War', in Peter J. Kuznick and James Gilbert (eds), *Rethinking Cold War Culture* (Washington, DC: Smithsonian Institution Press, 2001), pp. 1–13.

LaHaye, Beverly, *The Spirit-Controlled Woman* (Irvine, CA: Harvest House, 1976).

Lammers, Timothy, 'Wonder Woman: Lynda Carter praises "wonderful" movie', *ScreenRant*, 27 May 2017. Available at http://screenrant.com/ wonder-woman-movie-lynda-carter/ (accessed 9 July 2017).

Landay, Lori, *Madcaps, Screwballs, and Con Women: The Female Trickster in American Culture* (Philadelphia, PA: University of Pennsylvania Press, 1998).

LaTouche, Jason, 'What a woman wonders: this is feminism?', in Joseph J. Darowski (ed.), *The Ages of Wonder Woman: Essays on the Amazon Princess in Changing Times* (Jefferson, NC: McFarland and Co., 2014), pp. 79–89.

Lawrence, John Shelton and Robert Jewett, *The Myth of the American Superhero* (Grand Rapids, MI: W.B. Eerdmans, 2002).

Leder, Drew, *The Absent Body* (Chicago, IL: University of Chicago Press, 1990).

Lee, Peter W., 'Not quite mod: the new Diana Prince, 1968–1973', in Joseph J. Darowski (ed.), *The Ages of Wonder Woman: Essays on the Amazon Princess in Changing Times* (Jefferson, NC: McFarland and Co., 2014), pp. 101–16.

Lehman, Katherine J., *Those Girls: Single Women in Sixties and Seventies Popular Culture* (Lawrence, KS: University Press of Kansas, 2011).

Leonard, Robert Z. (dir.), *Ziegfeld Girl* (USA: Metro-Goldwyn-Mayer, 1941).

Lepore, Jill, *The Secret History of Wonder Woman* (Brunswick, NJ: Scribe Publications, 2014).

Levine, Elana, *Wallowing in Sex: The New Sexual Culture of 1970s American Television (Console-Ing Passions)* (Durham, NC: Duke University Press, 2007).

Leyland, Matthew, 'Amazon Prime: after a 75-year wait, a Wonder Woman movie is finally upon us', *SFX* 288 (2017), pp. 48–55.

Litoff, Judy Barrett and David C. Smith, *We're in this War, Too: World War II Letters from American Women in Uniform* (New York: Oxford University Press, 1994).

Liz, Renae de, and Ray Dillon, *The Legend of Wonder Woman* (Burbank, CA: DC Comics, 2017).

Lizardi, Ryan, *Mediated Nostalgia: Individual Memory and Contemporary Mass Media* (Lanham, MD: Lexington Books, 2015).

Loos, Anita, *Gentlemen Prefer Blondes,* (New York: Boni & Liveright, 1925).

Luckett, Moya, 'Sensuous women and single girls: reclaiming the female body on 1960s television', in Hilary Radner and Moya Luckett (eds), *Swinging Single: Representing Sexuality in the Sixties* (Minneapolis, MN: University of Minnesota Press, 1999), pp. 277–98.

Lukic, Momcilo 'Butch' and Paul Dini (dirs), *Justice League* (USA: Cartoon Network, Warner Bros., 2001–4).

Lyne, Adrian (dir.), *Fatal Attraction* (USA: Paramount Pictures, 1987).

Lyon, David, *Surveillance Society: Monitoring Everyday Life* (Philadelphia, PA: Open University Press, 2001).

Lyon, David, *Surveillance After September 11: Linguistics, Racial Anthropology and Genetics in the Dialectic of Volk* (Malden, MA: Blackwell Publishing, 2003).

Lyon, David, *Surveillance Studies: An Overview* (Cambridge, Malden MA: Polity Press, 2007).

MacDonald, Fred J., *One Nation Under Television* (New York: Pantheon, 1990).

Madison, Nathan Vernon, *Anti-Foreign Imagery in American Pulps and Comic Books, 1920–1960* (Jefferson, NC: McFarland and Co., 2012).

Madrid, Mike, *The Supergirls: Fashion, Feminism, Fantasy, and the History of Comic Book Heroines* (Minneapolis, MN: Exterminating Angel Press, 2009).

Maguire, Lori, 'Wonder Woman comic books and military technology', in Joseph J. Darowski (ed.), *The Ages of Wonder Woman: Essays on the Amazon Princess in Changing Times* (Jefferson, NC: McFarland and Co., 2014), pp. 42–51.

Mangels, Andy, 'Catsuits and karate: Diana Prince leaves Wonder Woman behind', *Back Issue* 17 (2006), pp. 35–43.

Mangels, Andy, 'Wonder Woman sales figures', *Comicbook Resources*, 2017. Available at http://community.comicbookresources.com/showthread.php?1988-Wonder-Woman-Sales-Figures (accessed 7 July 2017).

Mangels, Andy and Judy Tondora (illus.), *Wonder Woman '77 Meets the Bionic Woman* (Mt Laurel, NJ: Dynamite, 2017).

Mann, Steve and Joseph Ferenbok, 'New media and the power politics of sousveillance in a surveillance-dominated world', *Surveillance and Society* 11/12 (2013), pp. 18–34.

Mansfield, Louise, '"Sexercise": working out heterosexuality in Jane Fonda's fitness books', *Leisure Studies* 30/2 (2011), pp. 237–55.

Marble, Alice, 'Wonder women of history: Florence Nightingale', *Wonder Woman* 1/1 (Summer 1942): 29–42.

Marble, Alice, 'Wonder women of history: Nurse Edith Cavell', *Wonder Woman* 1/3 (February/March 1943), pp. 33–36.

Marble, Alice, 'Wonder women of history: Madame Chiang Kai-Shek', *Wonder Woman* 1/6 (Fall 1943), pp. 36–40.

Marble, Alice, 'Wonder women of history', *Wonder Woman*, May 1954.

Marble, Alice, 'Wonder women of history', *Wonder Woman* 1/66 (May 1954), p. 31.

Marshall, James (dir.), *Rosetta* (USA: Warner Bros. Television, 2003).

Marston, William Moulton, *Emotions of Normal People* (London: Kegan Paul, Trench, Trubner & Co. Ltd, 1928).

Marston, William Moulton, 'Why 100,000,000 Americans read comics', *The American Scholar* 13/1 (1944), pp. 35–44.

Marston, William Moulton and Harry G. Peter (illus.), *Sensation Comics* 1/1 (January 1942).

Marston, William Moulton and Harry G. Peter (illus.), *Sensation Comics* 1/2 (February 1942).

Marston, William Moulton and Harry G. Peter (illus.), *Sensation Comics* 1/6 (June 1942).

Marston, William Moulton and Harry G. Peter (illus.), *Sensation Comics* 1/9 (September 1942).

Marston, William Moulton and Harry G. Peter (illus.), *Sensation Comics* 1/11 (November 1942).

Marston, William Moulton and Harry G. Peter (illus.), *Wonder Woman* 1/1 (1942).

Marston, William Moulton and Harry G. Peter (illus.), *Wonder Woman* 1/2 (1942).

Marston, William Moulton and Harry G. Peter (illus.), *Sensation Comics* 1/16 (April 1943).

Marston, William Moulton and Harry G. Peter (illus.), *Sensation Comics* 1/19 (July 1943).

Marston, William Moulton and Harry G. Peter (illus.), *Sensation Comics* 1/20 (August 1943).

Marston, William Moulton and Harry G. Peter (illus.), *Wonder Woman* 1/3 (1943).

Marston, William Moulton and Harry G. Peter (illus.), *Wonder Woman* 1/5 (1943).

Marston, William Moulton and Harry G. Peter (illus.), *Wonder Woman* 1/6 (1943).

Marston, William Moulton and Harry G. Peter (illus.), *Wonder Woman* 1/7 (1943).

Marston, William Moulton and Harry G. Peter (illus.), *Wonder Woman* 1/10 (1943).

Marston, William Moulton, C.D. King and Elizabeth Holloway Marston, *Integrative Psychology: A Study in Unit Response* (New York: Harcourt, Brace, 1931).

Massumi, Brian, *Parables for the Virtual* (Durham, NC: Duke University Press, 2002).

May, Elaine Tyler, *Homeward Bound: American Families in the Cold War Era* (New York: Basic Books, 1988).

Mayor, Adrienne, 'Amazons in all shapes, sizes, and colors: what the Wonder Woman movie got right', Princeton University Press Blog, 13 June 2017. Available at http://blog.press.princeton.edu/2017/06/13/amazons-in-all-shapes-sizes-and-colors-what-the-wonder-woman-movie-got-right/ (accessed 27 July 2017).

Mayor, Adrienne, *The Amazons: Lives and Legends of Warrior Women Across the Ancient World* (Princeton, NJ: Princeton University Press, 2014).

McClelland-Nugent, Ruth, '"Steve Trevor, equal?" Wonder Woman in an era of second wave feminist critique', in Joseph J. Darowski (ed.), *The Ages of Wonder Woman: Essays on the Amazon Princess in Changing Times* (Jefferson, NC: McFarland and Co., 2014), pp. 136–50.

McCloud, Scott and Robert Lappan, *Understanding Comics: The Invisible Art* (New York: Turtleback Books, 1999).

McCue, Greg S, and Clive Bloom, *Dark Knights: The New Comics in Context* (London: Pluto Press, 1993).

Merleau-Ponty, Maurice, *Phenomenology of Perception*, trans. Colin Smith (London: Routledge & Kegan Paul, 1962).

Merleau-Ponty, Maurice, *Phenomenology of Perception* (London: Routledge, 2002).

Messner-Loebs, William and Mike Deodato Jr (illus.), 'The contest', 1–4, *Wonder Woman* 2/90, 0, 91, 92 (September–December 1994).

Meyerowitz, Joanne, 'Beyond the feminine mystique: a reassessment of postwar mass culture, 1946–1958', *The Journal of American History* 79/4 (1993), pp. 1455–82.

Miller, Bryan Q. and Jorge Jiménez (illus.), 'Olympus', *Smallville Season 11* vol. 5 (New York: DC Comics, 2014).

Miller, Frank, *The Dark Knight Returns* (London: Titan, 1986).

Miller, John Jackson, 'Monthly sales figures 2011, September', *Comichron: A Resource for Comics Research!*, 2011. http://www.comichron.com/monthlycomicssales/2011/2011-09.html (accessed 27 December 2017).

Mirzoeff, Nicholas (ed.), *The Visual Culture Reader* (London: Routledge, 2002).

Mizejewski, Linda, *Ziegfeld Girl: Image and Icon in Film and Culture* (Durham, NC: Duke University Press, 1999).

Montgomery, Lauren (dir.), *Wonder Woman* (USA: Warner Home Video, 2009).

Moore, Alan and Dave Gibbons (illus.), *Watchmen* (London: Titan, 1987).

Morgan, Elaine, *The Descent of Woman* (London: Souvenir Press, 1972).

Morrison, Grant and Yanick Paquette, *Wonder Woman: Earth One*, 2 vols (Burbank, CA: DC Comics, 2016).

Moskin, Robert J., George B. Leonard and William Attwood, *The Decline of the American Male* (Washington, DC: Random House, 1958).

Mulvey, Laura, 'Visual and Other Pleasures', *Film Quarterly* 43/4 (1990): 59–60.

Muroz, Drury, 'Readers' letters', *Wonder Woman* 1/182 (1968), p. 26.

Nadel, Alan, 'Cold War television and the technology of brainwashing', in Douglas Field (ed.), *American Cold War Culture* (Edinburgh: Edinburgh University Press, 2005), pp. 146–63.

Ndalianis, Angela (ed.), *The Horror Sensorium: Media and the Senses* (Jefferson, NC: McFarland and Co., 2012), pp. 15–39.

Nicalove, and Grant Morrison. 'Wonder Woman story has more to it than Batman', Edinburgh Festivals Blog, 12 January 2014. http://www.edinburgh-festivals.com/blog/2013/08/28/grant-morrison-interview/ (accessed 14 April 2017).

Nichols, Charles A. (dir.), *Super Friends* (USA: Taft Broadcasting, Warner Bros. Television Distribution, n.d.).

Nilsen, Sarah, and Sarah E. Turner, *The Colorblind Screen: Television in Post-Racial America,* (New York, NY: New York University Press, 2014).

O'Neil, Dennis and Neal Adams (illus.), 'No evil shall escape my sight!', *Green Lantern Green Arrow* 2/76 (April 1970).

O'Neil, Dennis and Mike Sekowsky (illus.), 'Can you believe you're looking at Diana Prince?', *Wonder Woman* 1/177 (August 1968), p. 31.

O'Neil, Dennis and Mike Sekowsky (illus.), 'Wonder Woman's rival', *Wonder Woman* 1/178 (October 1968).

O'Neil, Dennis and Mike Sekowsky (illus.), 'Wonder Woman's last battle!', *Wonder Woman* 1/179 (December 1968).

O'Neil, Dennis and Mike Sekowsky (illus.), 'A death for Diana', *Wonder Woman* 1/180 (February 1969).

O'Neil, Dennis and Mike Sekowsky (illus.), 'The wrath of Doctor Cyber!', *Wonder Woman* 1/181 (April 1969).

O'Neil, Dennis and Don Heck (illus.), 'Tribunal of fear!', *Wonder Woman* 1/199 (April 1972).

O'Neil, Dennis, 'Wonder Woman's Write In', *Wonder Woman* 1/199 (April 1972) p. 34.

O'Neil, Dennis and Dick Giordano (illus.), 'The beauty hater!', *Wonder Woman* 1/200 (June 1972).

O'Reilly, Julie D., 'The Wonder Woman precedent: female (super)heroism on trial', *The Journal of American Culture* 28/3 (2005), pp. 273–83.

Oelhart, Mark, 'From Captain America to Wolverine: cyborgs in comic books: alternative images of cybernetic heroes and villains', in Barbara M. Kennedy and David Bell (eds), *The Cybercultures Reader* (London: Routledge, 2000), pp. 112–23.

Olenina, Ana, 'The doubly wired spectator: Marston's theory of emotions and psychophysiological research on cinematic pleasure in the 1920s', *Film History: An International Journal* 27/1 (2015), pp. 29–57.

Oliva, Jay and Michael Chang (dirs), *Young Justice* (USA: Warner Bros. Television Distribution, 2010).

Ormrod, Joan, 'Body Issues in *Wonder Woman* 90–100 (1994–1995): Good Girls, Bad Girls, Macho? Men', in Elyce Helford, Shiloh Carroll, Sarah Gray, Michael R. Howard (eds.), *The Woman Fantastic in Contemporary American Media Culture* (Jackson: University of Mississippi Press, 2016), pp. 159–176.

Ormrod, Joan, 'Cold War fantasies: testing the limits of the familial body', in Joseph J. Darowski (ed.), *The Ages of Wonder Woman: Essays on the Amazon Princess in Changing Times* (Jefferson, NC: McFarland and Co., 2014), pp. 52–65.

Ortner, Sherry B. and Harriet Whitehead, *Sexual Meanings: The Cultural Construction of Gender and Sexuality* (Cambridge: Cambridge University Press, 1981).

Osgerby, Bill, *Playboys in Paradise: Masculinity, Youth and Leisure-Style in Modern America* (Oxford: Berg, 2001).

Pearlstein, Mitch, *From Family Collapse to America's Decline: The Educational, Economic, and Social Costs of Family Fragmentation,* (Lanham, MD: Rowman & Littlefield Education, 2011).

Pearson, Carol and Katherine Pope, *The Female Hero in American and British Literature,* (New York: R.R. Bowker Company, 1981).

Pérez, George, 'Rebirth', *Wonder Woman* 2/7 (August 1987).

Pérez, George, 'Time passages', *Wonder Woman* 2/8 (September 1987).

Pérez, George, 'Bird of paradise/bird of prey', *Wonder Woman* 2/16 (May 1988).

Pérez, George and Dick Giordano, 'Creatures of the dark', *Wonder Woman* 2/18 (July 1988).

Pérez, George, 'Testament', *Wonder Woman Annual* 2/1 (August 1988).

Pérez, George, 'Strangers in paradise', *Wonder Woman* 2/37 (January 1989).

Pérez, George and Bob McLeod, 'Who killed Myndi Mayer?', *Wonder Woman* 2/20 (September 1988).

Pérez, George and Bob McLeod, 'Eve of destruction', *Wonder Woman* 2/21 (October 1988).

Pérez, George and Mindy Newell, 'Forbidden fruit', *Wonder Woman* 2/38 (January 1990).

Pérez, George and Mindy Newell, 'The ties that bind', *Wonder Woman* 2/41 (April 1990).

Pérez, George and Mindy Newell, 'The Armageddon aria', *Wonder Woman* 2/43 (June 1990).

Pérez, George and Mindy Newell, 'Chalk drawings', *Wonder Woman* 2/46 (September 1990).

Pérez, George and Len Wein, 'Blood of the Cheetah', *Wonder Woman* 2/9 (October 1987).

Pérez, George, Chris Marrinan and Will Blyberg, 'Bloodvine', *Wonder Woman* 2/29 (April 1989).

Pérez, George, Jill Thompson and Romeo Tanghal, 'Common ground', *Wonder Woman* 2/47 (October 1990).

Pew Research Center, 'Parenting in America: the American family today', *Pew Research Center*, 2015. http://www.pewsocialtrends.org/2015/12/17/1-the-american-family-today/ (accessed 30 March 2018).

Pingel, Mike, *The Q Guide to Wonder Woman* (New York: Alyson Books, 2008).

Pitkethly, Claire, 'Recruiting an Amazon: the collision of old world ideology and new world identity in *Wonder Woman*', in Angela Ndalianis (ed.), *The Contemporary Comic Book Hero* (New York: Routledge, 2009), pp. 164–83.

Pitkin, Walter B., and William Moulton Marston, *The Art of Sound Picture* (New York: Appleton, 1930).

Potter, Greg and George Pérez, 'The princess and the power', *Wonder Woman*, 2/1 (February 1987).

Prescott, Anne Lake, 'The odd couple: Gargantua and Tom Thumb', in Jeffrey Jerome Cohen (ed.), *Monster Theory* (Minneapolis, MN: University of Minnesota Press, 1998), pp. 75–91.

Radner, Hilary, *Shopping Around: Feminine Culture and the Pursuit of Pleasure* (New York: Routledge, 1995).

Rainey, Sarah, 'How binge-watching has changed TV forever', *The Telegraph Online*, 22 January 2015. http://www.telegraph.co.uk/culture/tvandradio/11361212/How-binge-watching-has-changed-TV-forever.html (accessed 15 December 2017).

Rapper, Irving (dir.), *Now Voyager* (USA: Warner Bros., 1942).

Razer, Helen, 'Comment: Rosie the Riveter's reimagining as a black woman is false history', *SBS*, 2017. https://www.sbs.com.au/topics/life/culture/article/2017/01/31/comment-rosie-riveters-reimagining-black-woman-false-history (accessed 30 November 2017).

Reynolds, Richard, *Super Heroes* (Jackson, MS: University of Mississippi Press, 1994).

Rhodes, Molly, 'Wonder Woman and her disciplinary powers: the queer intersection of scientific authority and mass culture', in Roddey Reid and Sharon Traweek (eds), *Doing Science + Culture: How Cultural and Interdisciplinary Studies are Changing the Way we Look at Science and Medicine* (London: Routledge, 2000), pp. 95–118.

Ripley, William Z., *The Races of Europe: A Sociological Study* (New York: D. Appleton & Company, 1899).

Robbins, Trina, *The Great Women Superheroes* (Northampton, MA: Kitchen Sink Press, 1996).

Roberts, Rachel, 'Church of England tells schools to let children 'explore gender identity', *Independent*, 13 November 2017. https://www.independent.co.uk/news/uk/home-news/church-of-england-schools-let-children-explore-gender-identity-transgender-gender-fluid-a8051406.html (accessed 19 March 2018).

Robinson, James, and Emanuela Lupacchino (illus.), 'Swan's end', *Wonder Woman*, 5/40 (April 2018).

Robinson, James and Stephen Segovia, 'The dark gods: part one', *Wonder Woman* 5/46 (July 2018).

Robinson, James and Stephen Segovia, 'Amazons attacked: part one', *Wonder Woman* 5/41 (April 2018).

Robinson, James, and Jesus Merino, 'Amazons attacked: part two', *Wonder Woman* 5/42 (May 2018).

Robinson, James, and Emanuela Lupacchino, 'Amazons attacked: finale', *Wonder Woman* 5/44 (February 2018).

Robinson, James, Emanuela Lupacchino and Ray McCarthy, 'Times past: Jason', *Wonder Woman*. 5/33 (December 2017).

Robinson, Lillian, *Wonder Women* (New York: Routledge, 2004).

Rojek, Chris, *Celebrity* (London: Reaktion Books, 2001).

Rosson, Richard (dir.), *Blonde or Brunette?* (USA: Paramount Pictures, 1927).

Rucka, Greg, Drew Johnson (illus.) and Ray Snyder (illus.), 'Join the mission', *Wonder Woman* 2/195 (October 2003).

Rucka, Greg, Drew Johnson (illus.) and Ray Snyder (illus.), 'Down to earth, part 1', *Wonder Woman* 2/196 (November 2003).

Rucka, Greg, Drew Johnson (illus.) and Ray Snyder (illus.), 'Down to Earth, part 2', *Wonder Woman* 2/197 (December 2003).

Rucka, Greg, Drew Johnson (illus.) and Ray Snyder (illus.), 'Down to earth, part 4', *Wonder Woman* 2/199 (December 2003).

Rucka, Greg, Drew Johnson (illus.) and Ray Snyder (illus.), 'Down to earth: conclusion', *Wonder Woman* 2/200 (March 2004).

Rucka, Greg, Drew Johnson (illus.) and Ray Snyder (illus.), 'Stoned, part 6', *Wonder Woman* 2/210 (January 2005).

Rucka, Greg, Cliff Richards (illus.) and Ray Snyder (illus.), 'Infinite crisis crossover: war in paradise', *Wonder Woman* 2/224 (February 2006).

Rucka, Greg, David Lopez (illus.) and Javier Bergantiño (BIT) (illus.), 'Affirmative defense', *Wonder Woman* 2/220 (October 2005).

Rucka, Greg, Stephen Sadowski (illus.) and Andrew Currie (illus.), 'Leaks', *Wonder Woman* 2/202 (May 2004).

Rucka, Greg, Tom Derenick (illus.) and Georges Jeanty (illus.), Karl Kerschl (illus.), David Lopez (illus.) and Rags Morales (illus.), 'Sacrifice (4)', *Wonder Woman* 2/219 (September 2005).

Rucka, Greg, Tom Derenick (illus.) and Georges Jeanty (illus.), 'Sacrifice (4/4)', *Wonder Woman* (September 2005).

Russo, Tom, 'Super group', *The Boston Globe*, 29 April 2012. Available at http://archive.boston.com/ae/movies/articles/2012/04/29/the_avengers_collects_all_your_favorite_marvel_characters_in_one_handy_wannabe_blockbustersuper_groupthe_avengers_assembles_all_your_favorite_marvel_characters_in_one_handy_wannabe_blockbuster/ (accessed 21 June 2017).

Sandifer, Philip, *A Golden Thread: An Unofficial History of Wonder Woman* (Danbury, CT: Eruditorum Press, 2013).

Santori, Matt, 'Exclusive interview: Greg Rucka on queer narrative and Wonder Woman', *Comicosity*, 28 September 2016. Available at http://www.comicosity.com/exclusive-interview-greg-rucka-on-queer-narrative-and-wonder-woman/ (accessed 19 March 2017).

Schlafly, Phyllis, *Who Killed the American Family?* (Washington, DC: WND Books, 2014).

Scott, Ridley (dir.), *Alien* (USA: 20th Century Fox, 1979).

Sekowsky, Mike and Dick Giordano (illus.), 'A time to love, a time to die!', *Wonder Woman* 182 (June 1969).

Sekowsky, Mike and Dick Giordano (illus.), 'The widow-maker!', *The Brave and the Bold* (January 1970).

Sekowsky, Mike and Dick Giordano (illus.), 'Red for death', *Wonder Woman* 189 (August 1970).

Senna, Danzy, 'The mulatto millennium', in Claudine Chiawaei O'Hearn (ed.), *Half and Half: Writers on Growing Up Biracial + Bicultural* (New York: Random House, 1998), pp. 12–27.

Sheets-Johnstone, Maxine, 'On movement and objects in motion: the phenomenology of the visible in dance', *Journal of Aesthetic Education* 13/2 (1979), pp. 33–46.

Sheets-Johnstone, Maxine, *The Phenomenology of Dance* (Philadelphia, PA: Temple University Press, 2015).

Shilling, Chris, *The Body and Social Theory* (London: Sage, 2003).

Shubha, Bhattacharya, 'Intersectionality – bell hooks', *Indian Journal of Dalit and Tribal Social Work* 1 (2012), pp. 61–90.

Siegel, Jerry and Joe Shuster, 'Superman', *Action Comics* 1/1 (June 1938).

Simone, Gail, Terry Dodson (illus.) and Bernard Chang (illus.), 'The circle', *Wonder Woman* 3/14–17 (January–April 2008).

Slotkin, Richard, *Regeneration through Violence: The Mythology of the American Frontier, 1600–1860* (Middletown, CN: Wesleyan University Press, 1973).

Slotkin, Richard, *The Fatal Environment: The Myth of the Frontier in the Age of Industrialization, 1800–1890* (New York: Atheneum, 1985).

Slotkin, Richard, *Gunfighter Nation: The Myth of the Frontier in Twentieth-Century America* (New York: Atheneum, 1992).

Smith, Matthew J., 'The tyranny of the melting pot metaphor: Wonder Woman as the Americanized immigrant', in Matthew P. McAllister, Edward H. Sewell Jr and Ian Gordon (eds), *Comics and Ideology* (New York: Peter Lang, 2001), pp. 129–50.

Smith, Matthew J., 'Working girl: Diana Prince and the crisis of career moves', in Joseph J. Darowski (ed.), *The Ages of Wonder Woman: Essays on the Amazon Princess in Changing Times* (Jefferson, NC: McFarland and Co., 2014), pp. 151–62.

Smith, Zack, 'Jill Lepore reveals THE SECRET HISTORY OF WONDER WOMAN', *Newsarama*, 28 October 2014. Available at https://www.newsarama.com/22568-jill-lepore-reveals-the-secret-history-of-wonder-woman.html (accessed 15 August 2017).

Smithsonian, 'The flag in the sixties', *The Star-Spangled Banner: The Flag That Inspired the National Anthem*, 2017. Available at https://amhistory.si.

edu/starspangledbanner/the-flag-in-the-sixties.aspx (accessed 30 May 2016).

Spelling, Aaron and Leonard Goldberg, *Charlie's Angels* (USA: Sony Pictures Television, n.d.).

Spieldenner, Andrew R. 'Altered egos: gay men reading across gender difference in *Wonder Woman*', *Journal of Graphic Novels and Comics* 4/2 (2013), pp. 235–44.

Starhawk, *The Spiral Dance: A Rebirth of the Ancient Religion of the Great Goddess* (New York: HarperSanFrancisco, 1999).

Steinem, Gloria, *Wonder Woman* (New York: Holt, Rinehart and Winston, 1972).

Stevens, J. Richard, *Captain America: Masculinity, and Violence* (Syracuse, NY: Syracuse University Press, 2015).

Stewart, Susan, *On Longing: Narratives of the Miniature, the Gigantic, the Souvenir, the Collection* (Durham, NC: Duke University Press, 1993).

Stone, Merlin, *When God Was a Woman* (New York: Harcourt Brace Jovanovich, 1978).

Straczynski, J. Michael, Tyler Kirkham and Sal Regla (illus.), 'Mr Parker goes to Washington: part three of three', *The Amazing Spider-Man*, 1/531 (June 2006).

Straczynski, J. Michael, John Romita Jr., and Scott Hanna (illus.), 'Stand tall', *The Amazing Spider-Man* 2/36 (December 2001).

Stuller, Jennifer, *Ink-Stained Amazons and Cinematic Warriors: Superwomen in Modern Mythology* (London: I.B. Tauris, 2010).

Stuller, Jennifer, 'Love will bring you to your gift', in Charles Hatfield, Jeet Heer and Kent Worcestor (eds), *The Superhero Reader* (Jackson, MS: University Press of Mississippi, 2013), pp. 216–36.

Suderman, Peter, 'Wonder Woman's battle scenes show how to use – and not use – CGI in super-movies', *Vox*, 6 June 2017. Available at https://www.vox.com/culture/2017/6/6/15730568/wonder-woman-battle-scenes-cgi (accessed 27 July 2017).

Suh, Krista and Jayna Zweiman, 'PUSSYHAT PROJECT™ Design Interventions for Social Change', *The Pussyhat Project*, 2017. https://www.pussyhatproject.com/our-story/ (accessed 1 April 2017).

Sweeney, David, 'From stories to worlds: the continuity of Marvel superheroes from comics to film', *Intensities: The Journal of Cult Media* 1/5 (2013), pp. 133–50. Available at http://radar.gsa.ac.uk/3178/7/from-stories-to-worlds-the-continuity-of-marvel-superheroes-from-comics-to-film-david-sweeney.pdf (accessed 27 July 2017).

Thalberg, Irving (dir.), *Flesh and the Devil* (USA: Metro-Goldwyn-Mayer, 1926).

Theoharis, Athan, *Abuse of Power: How Cold War Surveillance and Secrecy Policy Shaped the Response to 9/11* (Philadelphia, PA: Temple University Press, 2011).

This, Craig, 'Containing Wonder Woman: Frederic Wertham's battle against the mighty Amazon', in Joseph J. Darowski (ed.), *The Ages of Wonder Woman: Essays on the Amazon Princess in Changing Times* (Jefferson, NC: McFarland and Co., 2014), pp. 30–41.

Thomas, Roy, Dann Thomas, Gene Colan, Ross Andru, Keith Giffen, Jan Duursema, Dick Giordano, Rich Buckler and Keith Pollard, 'Beautiful Dreamer, Death Unto Thee!' *Wonder Woman* 1/300 (February 1983).

Thomson, Jill, *Wonder Woman: The True Amazon* (Burbank, CA: DC Comics, 2016).

Thon, Jan-Noël, 'Converging worlds: from transmedial storyworlds to transmedial universes', *Storyworlds: A Journal of Narrative Studies* 7/2 (2015), pp. 21–53.

Thornton, Sarah, *Club Cultures: Music, Media and Subcultural Capital* (Cambridge: Polity Press, 1995).

Tilley, Carol L., 'Seducing the innocent: Fredric Wertham and the falsifications that helped condemn comics', *Information and Culture* 47/4 (2012), pp. 383–413.

Toh, Justine, 'The white fireman and the American heartland in the memory of 9/11', *Critical Race and Whiteness Studies* 6/1 (2010), pp. 1–17.

Tomasi, Peter and Marco Santucci, 'Beginnings and ends', *Superman/Wonder Woman Annual* 1/2 (December 2016).

Trank, Josh (dir.), *Fantastic Four* (USA: 20th Century Fox, 2015).

Turner, Bryan S., *The Body and Society* (London: Sage, 2008).

Turner, Louis and John Ash, *The Golden Hordes: International Tourism and the Pleasure Periphery* (New York: St. Martin's Press, 1976).

Turner, Victor W. (Victor Witter) and Edith L.B. Turner, *Image and Pilgrimage in Christian Culture: Anthropological Perspectives* (New York: Columbia University Press, 1978).

Tuttle, William M., 'America's children in an era of war, hot and cold: the Holocaust, the Bomb, and child rearing in the 1940s', in Peter J. Kuznick and James Gilbert (eds), *Rethinking Cold War Culture* (Washington, DC: Smithsonian Institution Press, 2001), pp. 14–35.

Tyrrell, William Blake, *Amazons: A Study in Athenian Mythmaking* (Baltimore, MD: Johns Hopkins University Press, 1984).

Waid, Mark, and Alex Ross (illus.), *Kingdom Come* (New York: DC Comics, 2000).

Waldfogel, Jane, Terry-Ann Craigie and Jeanne Brooks-Gunn, 'Fragile families and child wellbeing', *Future Child* 20/2 (2010), pp. 87–112.

Wallerstein, Herb (dir.), 'The Feminum Mystique, Part 2', *Wonder Woman* 6 (USA: ABC, 1976).

Wallerstein, Herb (dir.), 'Formula 407', *Wonder Woman* 12 (USA: ABC, 1977).

Wampler, Scott, 'Wonder Woman is having an awesome effect on the world', *Birth Movies Death*, 12 June 2017. Available at http://birthmoviesdeath. com/2017/06/12/wonder-woman-is-having-an-awesome-effect-on-the-world (accessed 31 July 2017).

Wertham, Frederic, *Seduction of the Innocent* (London: Museum Press, 1955).

West, Cornel, 'Goodbye, American neoliberalism. A new era is here', *Guardian*, 2016. https://www.theguardian.com/commentisfree/2016/nov/17/ american-neoliberalism-cornel-west-2016-election (accessed 30 November 2017).

Williams, Kevin D., '(R)Evolution of the television superhero: comparing Superfriends and Justice League in terms of foreign relations', *Journal of Popular Culture* 44/6 (2011), pp. 1333–52.

Williams, Raymond, 'Programming as sequence or flow', in Sue Thornham, Caroline Bassett and Paul Marris (eds), *Media Studies: A Reader* (Edinburgh: Edinburgh University Press, 2009), pp. 192–8.

Wilson, Elizabeth, *Adorned in Dreams: Fashion and Modernity* (New Brunswick, NJ: Rutgers University Press, 2003).

Wolf, Naomi, *The Beauty Myth: How Images of Beauty Are Used against Women* (New York: W. Morrow, 1991).

Wood, Dick, Mike Sekowsky (illus.) and Frank Giacola, 'The Achilles Heel', *The Man from U.N.C.L.E. 13* (July 1967).

Wright, Bradford W., *Comic Book Nation: The Transformation of Youth Culture in America* (Baltimore, MD: Johns Hopkins University Press, 2001).

Wylie, Philip, *Generation of Vipers* (New York: Holt, Rinehart and Winston, 1955).

Yanes, Nicholas, 'Academics weigh in on Wonder Woman', *Sequart Organisation*, 2017. http://sequart.org/magazine/66970/academics-weigh-in-on-wonder-woman/ (accessed 9 January 2017).

Zahn, Paula, 'Some articles point to heroic image of firefighters as example of return of manly man', *CNN Live at Daybreak*, 8 November 2001. Available at http://edition.cnn.com/TRANSCRIPTS/0111/08/lad.09.html (accessed 1 August 2017).

Index

Index